BERLIN

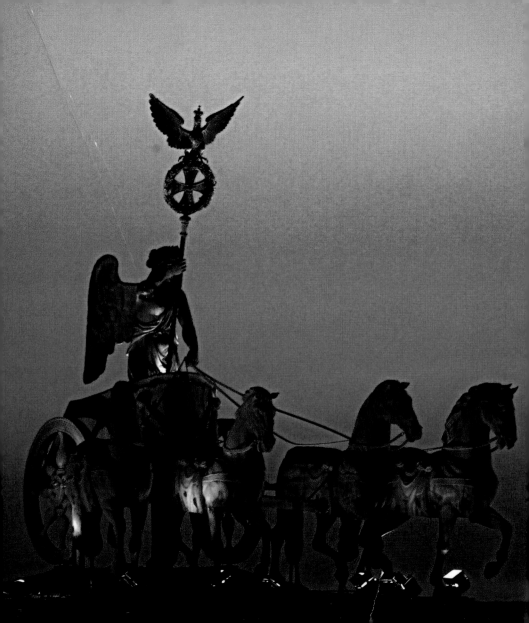

ART & ARCHITECTURE

BERLIN

Edelgard Abenstein and Jeannine Fiedler

With contributions by
Holger Möhlmann, Clemens Schmidlin
and Julian von Heyl

h.f.ullmann

Front cover: Brandenburg Gate, Photo © Murat Taner/zefa/Corbis

Back cover: *Queen Louise as Hebe in front of Brandenburg Gate*, painting (1812) by
Karl Wilhelm Wach (1787–1845) after Peter Eduard Ströhling, oil on copper, Photo © picture alliance

Frontispiece: Quadriga on Brandenburg Gate, Photo © picture alliance

All texts by Edelgard Abenstein, except for pp. 14–25, 50–51, 76–77, 236–237, 242–243, 276–277, 324–327,
378–379, 386–389, 417–421 (Jeannine Fiedler); pp. 428–431 (Holger Möhlmann);
pp. 120–121, 132–135 (Clemens Schmidlin); pp. 28–33 (Julian von Heyl)

Original title: *Kunst & Architektur Berlin*
ISBN 978-3-8331-4565-0

Concept: Jeannine Fiedler
Project management: Lucas Lüdemann, Kristina Scherer
Editors: Anja Breloh, Christina Kuhn (Appendix)
Layout: buschfeld.com - graphic and interface design
Coverdesign: Simone Sticker
Cartography: Bien + Giersch Projektagentur Berlin (www.panorama-berlin.de),
except for pp. 292, 399, 444, 445: Ingenieurbüro für Kartographie Dr. Hans-Joachim Kämmer
Picture research: Dr. Harro Schweizer, Tanja Göbl

Translation from German: Cathy Lara, Sebastopol
Editor: Dr. Harro Schweizer, Berlin
Typesetting: Prill Partners producing, Berlin
Project coordination for the English edition: Kristina Scherer

Printed in China

ISBN 978-3-8331-4566-7

10 9 8 7 6 5 4 3 2 1
X IX VIII VII VI V IV III II I

www.ullmann-publishing.com

Table of Contents

Historical Berlin

12 **A Brief Biography of the City of the House of Hohenzollern**
26 Genealogy of the House of Hohenzollern
28 Berlin in Numbers
29 Chronological Table
34 Important Berlin Museums

36 **Plazas in Berlin**
40 Pariser Platz
42 *Brandenburg Gate*
44 Potsdamer Platz
46 Gendarmenmarkt
48 Bebelplatz
50 *Architectural Visions*
 for the New Berlin
52 Alexanderplatz
54 Ernst-Reuter-Platz
55 Spittelmarkt
56 *From Fontane to Döblin –*
 Berlin and its Writers
58 Breitscheidplatz
60 Walkabout in West Berlin

Gendarmenmarkt

64 **Boulevards**
66 Unter den Linden
70 Friedrichstraße and Leipziger Straße
72 *Berlin Department Store Tradition –*
 KaDeWe as Beacon of Capitalism
74 Kurfürstendamm and Tauentzien
76 *Germania – on the Megapolis Program of*
 National Socialist Senior Master Builder
 Albert Speer
78 Straße des 17. Juni to Heerstraße
80 Walking Tour: Neoclassical

Unter den Linden

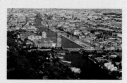

Spree Bridges

84 **Bridges**
87 Schlossbrücke (Palace Bridge)
88 *Karl Friedrich Schinkel*
 and Neo-Classicism in Prussia
92 Oberbaumbrücke
93 Weidendamm Bridge
95 Glienicke Bridge
96 Walking Tour: Old-Berlin style

Government Quarter

100 **Government Quarter**
103 Reichstag (Parliament)
104 Band des Bundes
106 Rotes Rathaus and Rathaus Schöneberg
107 National Socialist Architecture
108 Walking Tour: Capital Style

112 **Museums and Culture Forums**
115 Museumsinsel/Museum Island
116 Bode Museum
120 *Wilhelm von Bode as Founding Director*
 of the Berlin Collections
122 Pergamon Museum
132 *Highlights of the Berlin Collection of Classical Antiquities –*
 Archaeological Excavations in the 19th century

Museum Island

136 Neues Museum
137 Alte Nationalgalerie
140 *Adolph von Menzel –*
 Chronicler of the 19th century
142 Altes Museum
148 German Historical Museum
152 Humboldt University
154 *Brothers Wilhelm and*
 Alexander von Humboldt
158 Staatsbibliothek Unter den Linden
160 Kulturforum Potsdamer Straße
161 Gemäldegalerie
167 Kupferstichkabinett

Neue Nationalgalerie

168 Musical Instruments Museum
170 Philharmonie
172 Staatsbibliothek at Potsdamer Straße
174 Neue Nationalgalerie
178 Museum Center Dahlem
184 The "Old" West
184 Brücke Museum
186 Bauhaus Archive
188 Bröhan Museum
190 Collection of Photography
 and Helmut Newton Foundation
192 Museum Berggruen
194 Käthe Kollwitz Museum
198 Invalidenmeile
198 Hamburger Bahnhof
200 Natural History Museum
204 Other "Capital" Museums
204 Jewish Museum
206 Märkisches Museum –
 Stiftung Stadtmuseum Berlin
208 Berlinische Galerie
210 Museum of Communication
212 German Museum of Technology
214 Martin Gropius Building

216 Theaters, Opera Houses, Movie Theaters
220 Schauspielhaus (Concert Hall) at Gendarmenmarkt
222 Staatsoper Unter den Linden and Deutsche Oper
224 Deutsches Theater
225 Komische Oper
226 Maxim Gorki Theater
227 Berliner Ensemble
228 *The Golden Twenties, Its Theaters*
 and the Revue
232 Film and Movie Theaters, Babylon and International
236 *Marlene Dietrich –*
 a "Prussian Princess" in Hollywood

Bauhaus Archive

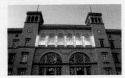
Hamburger Bahnhof

Jewish Museum

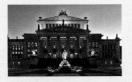
Concert Hall
at Gendarmenmarkt

Funkturm and ICC

238 Media Centers and Trade Fairs
241 Funkturm, Fairgrounds and House of Radio
 Broadcasting
242 *We are broadcasting from Berlin –*
 a brief television history
244 Television Tower Berlin Mitte
245 The New Media Centers
247 ICC – International Congress Center

248 Traffic Areas and Transit Complexes
250 Railway Stations
252 U and S Train Stations
254 *The Architect of Local Transit –*
 Alfred Grenander
256 Tempelhof and Tegel Airports
258 Walking Tour: Technical

Central Station

262 Industrial Monuments and Public Buildings
264 Hackesche Höfe
266 Breweries
267 Water Towers and Gasometers
268 AEG Turbine Hall
269 Postfuhramt
270 Shell House
271 Königliche Porzellan-Manufaktur
272 Adlershof
274 Einstein Tower
275 Siemensstadt
276 *Zoological and Botanical Gardens in Berlin*
278 Embassies
279 Ludwig Erhard House
279 Moabit Prison
280 Walking Tour: Jewish Culture

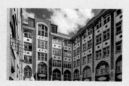

Hackesche Höfe

284 Sports Facilities
286 Strandbad Wannsee
287 Historical Swimming Halls

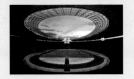

Olympic Stadium

288 Swimming and Cycling Center
 on Landsberger Allee
289 Olympic Stadium
290 *Olympic Games 1936*
292 Walking Tour: Athletic

296 Churches and Synagogues
298 Marienkirche
300 Nikolaikirche
301 Friedrichwerdersche Kirche
302 Parochialkirche
302 Sophienkirche
303 Berlin Cathedral
306 *The Romanisches Café –*
 Famous Venue for Literati and Artists
308 Kaiser Wilhelm Memorial Church
310 *Rahel Varnhagen*
 and Jewish Culture in Berlin
314 Synagogues

316 Memorials
319 Neue Wache
320 Holocaust Memorial
322 Bendlerblock
323 Berlin Wall Memorial Site
324 *The Berlin Wall –*
 A Monument to Inhumanity
328 Luftbrückendenkmal
329 Soviet War Memorials
330 Walking Tour: Socialist

334 Cemeteries
337 Dorotheenstädtischer Friedhof
338 Invalids' Cemetery
339 Weißensee Jewish Cemetery
340 Municipal Cemetery Stubenrauchstraße
341 Cemeteries Outside Hallesches Tor

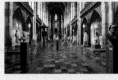

Friedrichwerdersche Kirche

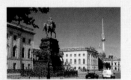

Equestrian statue

Baumschulenweg
Crematorium

Chamissoplatz

342 Villas and Settlement Construction
344 Ribbeck House
345 Ephraim Palais
346 Märkisches Ufer
347 Böhmisch-Rixdorf
348 Neighborhood Buildings
349 Wilhelminian *Gründerzeit* Apartment Buildings
350 *Max Liebermann: Berlin Painter and Gardener*
352 Villa Colony Alsen
353 Grunewald Villas
354 *Max and Bruno Taut*
356 Horseshoe Settlement Britz
357 Ring Settlement Siemensstadt
358 *Hermann Henselmann –*
 Doyen of GDR Architecture
360 Karl-Marx-Allee
361 Le Corbusier House
362 *Awakening after the War:*
 International Architecture Exhibitions
366 Hansa Quarter
367 IBA Buildings in Kreuzberg
368 Walking Tour: Bourgeois

372 Palaces and Gardens
374 Charlottenburg Palace
378 *A New City Palace for Berlin – Many Bones of Contention*
380 Bellevue Palace
381 Tegel Palace
382 Friedrichsfelde Palace
384 Köpenick Palace
386 *Peter Joseph Lenné – Gardener in Prussia's Arcadia*
390 Jagdschloss Grunewald
392 Spandau Citadel
393 Pfaueninsel
395 Klein-Glienicke Palace
396 Babelsberg Palace
398 Walking Tour: Ritzy

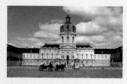

Charlottenburg Palace

402 **Potsdam**
404 Sanssouci Palace
408 Chinese Tea House
410 Belvedere on Mount Klausberg
411 Orangery
413 Picture Gallery
414 Neues Palais
417 *Frederick II and the Craft of Applied Arts in Prussia*
422 The Communs
423 Mount of Ruins
424 Charlottenhof Palace
426 Roman Baths
428 *From Louise to "Dona" – Prussia's Queens*
432 Marmorpalais
434 Pomona Temple
434 Russian Colony Alexandrowka
436 Cecilienhof Palace
438 Potsdam City Gates
439 Old Market
440 Marstall/Royal Stables
441 Pump House
442 Nikolaikirche
443 French Church
444 Walking Tour: Arcadian

448 **Appendix**
450 Glossary
456 Biographies
467 Brief Graphic Genealogy
 of Building in Berlin
474 Name Index
476 Subject Index
480 Illustration Credits

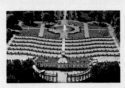

Sanssouci Palace

Kaiser Wilhelm Memorial
Church

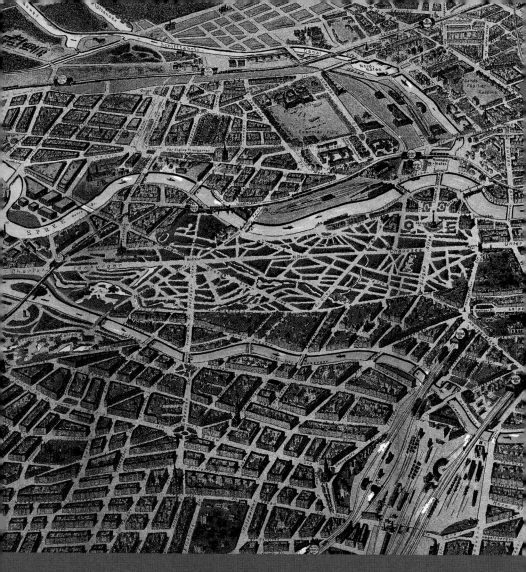

Urban development plan of Berlin dating from 1899;
transit routes structuring the city area are highlighted

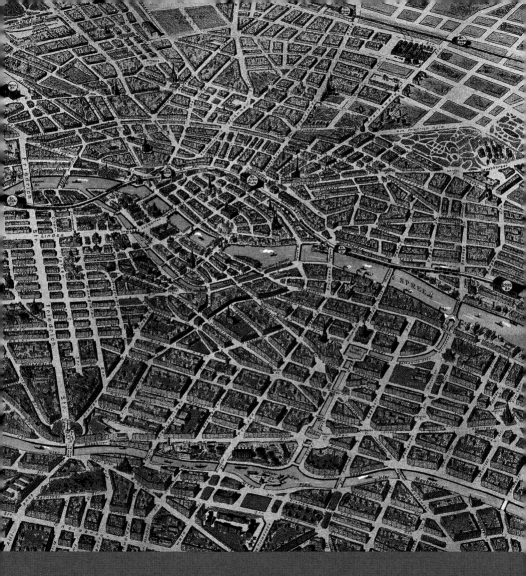

A Brief Biography of the City of the House of Hohenzollern

A Brief Biography of the City of the House of Hohenzollern

In 1648, towards the end of the Thirty Years' War, today's global metropolis which impresses visitors and guests from all over the world with its energy, nonchalance and wittily dry charm, was as yet an insignificant speck of dirt in the electorate of Brandenburg. It was the site of royal residencies as well as of small towns such as Berlin, Cölln, Spandau, and Köpenick. Compared to the gigantic cosmopolitan hubs of London and Paris with their hundreds of thousands of residents, these tiny towns were nothing but backwater burgs on the banks of the river Spree.

In the decade of 1701–1710, a consolidated Berlin, seat of the royal residence, was made the capital of the aspiring kingdom of Prussia. It took the straggler no more than two centuries to cast off its provincial trappings and to become the fastest-growing big city in Europe. Already during the reign of Frederick II, the House of Hohenzollern was able to turn Berlin into a site of splendor, home to a remarkable flourishing of the arts, even though the Hohenzollerns themselves preferred to reside in quaint, quiet Potsdam. It was in the 19th century, however, in the wake of industrialization, that an unprecedented chase to catch up took off; Berlin, then at its economic pinnacle during the period of Wilhelminian Promoterism called Gründerzeit, pulled neck to neck with the glamorous cosmopolitan cities of Paris and Brussels, London and Vienna – and, for a short period after World War I, it even surpassed them. The modest provincial beauty of days gone by was suddenly always a step ahead of the others, a tad more sophisticated than them. Berlin had the most progressive infrastructure; it was untrammeled by those narrow, unhealthy remnants of the medieval days that were left over in other cities. The Golden Twenties are characteristic of how we conceive of this city even today – its verve, its tolerance, its frivolity.

Following the megalomania of the national-socialist dictatorship, World War II, and the disastrous destruction of Berlin's architectural substance, the chase to catch up began again in 1945. The Eastern and Western halves of the now divided city may have sped forward at different speeds; nonetheless, urban construction on both sides of the divide was quite often the vehicle for ideological skirmishes and their ideologically fraught architectural stylistics. Reunification of the two German states and their shared new-old capital Berlin designated, in 1990, the final new beginning so far. Like those gone before, this beginning, too, carved its imprint into this city which had metamorphosed more often than any other metropolis in the 20th century.

From the Founding Phase to the Prussian Capital

The late climber among the bastions of the classical world founded way back by the Romans, such as Lutetia Parisiorum (Paris), Londinium (London) or Vindobona (Vienna), may not contain buildings testifying to antique grandeur; nor does it feature gothic cathedrals or one of the first European universities or similar cultural achievements. Its topographical starting position can yet be called "classical": The Spree Valley, only 5 km wide and facilitating easy passage across the river like nowhere else, invited the first Berliners to rest and trade. Two important trade routes intersected at this point: the road from the River Elbe to the River Oder crossed paths with the cross-country pathway to Saxony and on to Bohemia. After the moraine landscapes of Barnim and Teltow were removed, around 1230, from Slavic ownership, the brothers John I and Otto III, Brandenburgian margraves of Ascanian descent, elevated into cities the settlements that had been existing along the Spree for decades: Cölln was first mentioned in 1237 and Berlin in 1244. In any case, it is certain that people settled in the ancient Berlin river valley long before any cities were founded, as is verified by archaeological discoveries.

It was the geographical proximity between Berlin and Cölln, separated only by the natural watershed of the Spree, which allowed the two cities to make common cause also in commerce and politics. The Treaty of 1307, which merged the cities into a single incorporated entity, thus became a successful model, especially in times of political turmoil. Such turmoil broke out when the Ascanian lineage died out and the margraves of the House of Wittelsbach and their Luxemburgian successors inflicted uncertainty on the March of Brandenburg with their hegemonic tendencies. In 1321, the

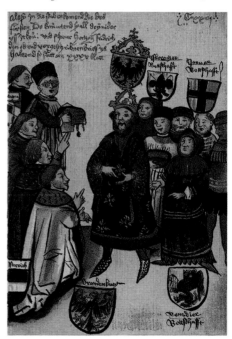

Council of Constance: Frederick I is enfeoffed with the Electoral March Brandenburg, contemporary illumination from the Chronicle of Ulrich von Richenthal, University Library, Prague

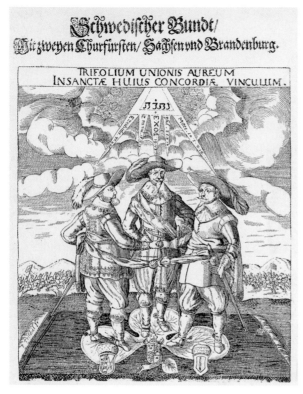

Swedish Alliance with the Electors of Saxony and Brandenburg, 1631, leaflet, contemporary engraving

honor of margrave and elector. The Hohenzollerns would rule in Brandenburg – which they were able to enlarge many times – for 503 years. The subsequent development of Berlin-Cölln, capital and seat of the Margraves of Brandenburg, which numbered about 8,000 inhabitants around 1600, was thus closely linked with the dynasty of the Hohenzollerns. Culturally, however, the city only achieved more than regional significance during the reign of the Grand Elector.

In the 17th century, the development of Brandenburg and Berlin-Cölln occurred under the energetic auspices of Frederick William (1620–1688). Acceding to the throne in 1640 when he was barely 20 years old, and during the still raging Thirty Years' War (1618–1648), the man who later was to be known as the Grand Elector had to lift up a shattered state and an exhausted city. His active politics of immigration led the war-weary March towards a new peak: Qualified craftsmen and merchants were recruited from France, the Netherlands and Saxony; they made Brandenburg one of the first modern "immigrant countries" of the old Europe and, through their expertise, be-

twin city of Berlin-Cölln assumed, as a solid bastion against alien potentates' desires for conquest, for 100 years the leadership position in the Land Peace Treaty of the Middle-March Cities. In 1415, King Sigismund bestowed on Frederick I, a Hohenzollern of the Frankish line, the hereditary

stowed upon its economy a much needed drive. This ambitious Regent, who worked towards an absolutist reorganization of the state on the political level, also deserves credit for crucially stimulating the architectonic reconfiguration of his Berlin-Cölln residence.

The fortification of his residential seat was to help prevent a repetition of the disaster of military powerlessness as it had manifested itself during the Thirty Years' War. On the Berlin side of the city, in August 1658, work was begun at the Stralau Gate in the presence of the Elector; construction in Cölln first started in 1660. The design for the entire site was developed by the electoral engineer Johann Gregor Memhardt; Johann Arnold Nering was responsible for completion of the construction in 1683. Apart from the center, the area next opened for settlement was the Werder which, as electoral property, was integrated into the fortress. This part of the city, now called "Friedrichswerder", belonged to the original districts of the residential city Berlin-Cölln, to which were later added "New-Cölln"– a

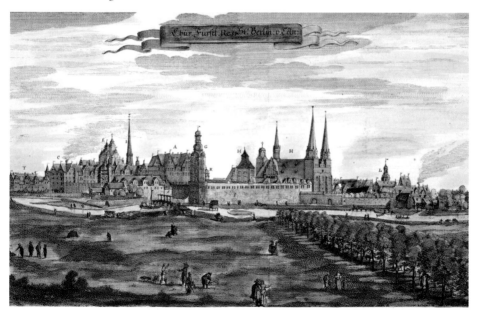

The Electoral Residence City of Berlin and Coelln, copper engraving by Kaspar Merian, from: M. Zeiller, Topographia Electoratus Brandenburgici et Ducatus Pomeraniae, Frankfurt a.M., 1652

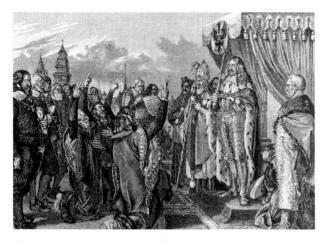

Homage to Elector Frederick William, wood engraving, c. 1880

build. The Grand Elector's son, Frederick III (1657–1713), let himself be crowned the first King in Prussia in 1701 as Frederick I. He was primarily active where his father's busy hand could not reach. His desire to raise architecture, the arts and scholar-ship to the level of the other European major powers was commensurate with his newly achieved plenitude of power as well as the growing political significance of his country: In 1696, he founded the Academy of Arts; the Academy of Sciences followed in 1700. It was under his regency that rapid progress was made in the extension of the Royal Library at Berlin. Last not least, the Stadtschloss (City Palace) as well as the entire, united Residential City of Berlin, now Capital of the Kingdom of Prussia, were to experience a hitherto unprecedented unfolding of baroque splendor. Its royal master-builder was Andreas Schlüter who, until 1706, had been in charge of the magnificent expansion of the City Palace and who created one of late Baroque's most significant sculptures with his equestrian statue of the Grand Elector. Johann Arnold Nering's manuscript shows the Arsenal, constructed from 1694 onwards, and Charlottenburg Palace (first called Lietzenburg), construction of which began in 1695. Johann Arnold Ner-

new settlement on the other side of the Spree canal stretching up to the Oberbaum – "Dorotheenstadt" – a section of the Tiergarten outwork, bequeathed by the Grand Elector to his second spouse Dorothy in 1668 – and, south of Linden boulevard, "Friedrichstadt".

Besides securing the Berlin-Cölln fortifications, the Elector also initiated, again via Memhardt, construction of the Potsdam Castle; however, he paid less attention to the arts. His great historical achievements remain the economic consolidation of the Electorate and its new, tightly organized administration, as well as the establishment of a standing army – reforms which laid the foundation for the administration of a Prussian state, later glorified as so famously efficient, on which his successors could

ing's designs also determined the layout of the public square called Gendarmenmarkt, where construction of the two cathedrals began in the year of the coronation. If, however, we cast a glance at the French super power and the exemplary splendor, a model for all European courts, exhibited by "Sun King" Louis XIV, the first Prussian King's entire endeavors are put back into perspective. When Frederick I died, Berlin, still a modest provincial beauty, had but a total of 60,000 inhabitants.

Frederickian Berlin

The business of government was now taken over by his son, Frederick William I (1688–1740), whose not very congenial sobriquet "Soldier King" is commonly known today. Berlin owes much to his lesser-known penchant for architecture. He was able to almost complete two grand enterprises:

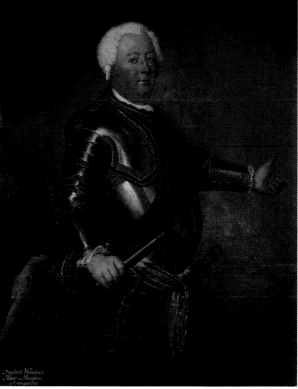

Frederick William I, King of Prussia (1713–1740),
painting, c. 1733 by Antoine Pesne,
oil on canvas, 242 x 149 cm

for one, the partial removal of the fortifications. These had become as good as useless for military purposes because the fast-growing suburbs just outside the glacis required

space. For another, he was committed to enlarging the quarters of Dorotheen- and Friedrichstadt. The latter was assigned three geometrically configured open spaces which

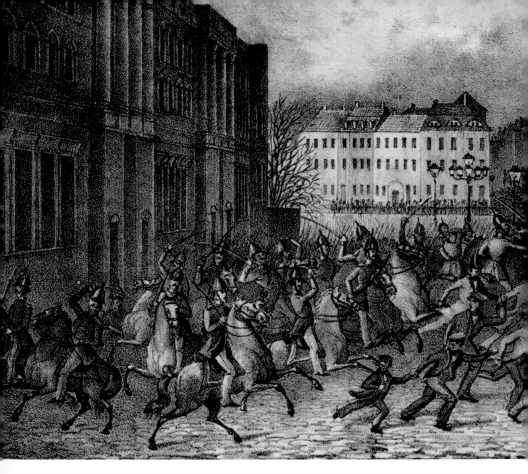

*Street fighting in Berlin on March 18/19, 1848,
chalk lithograph from: J. G. Zschaler,
Das ewig unvergessliche Jahr 1848
(The Forever Unforgettable Year of 1848)*

still today determine the face of central
Berlin: the Rondell (a circular plaza) which
is nowadays known as Mehringplatz, the
octagon of the Leipziger Platz and the
"Quarré" of the Pariser Platz by Branden-
burg Gate. The overarching notion govern-
ing city planning targeted, however, the

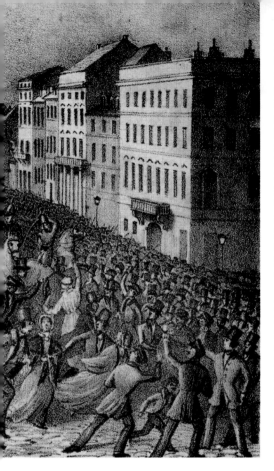

to first create housing for their trades. Under the regency of Frederick II (1712–1786), the Prussian King who was famous for his numerous artistic talents, only a few more city quarters were developed for construction and settlement. The removal of the fortifications was continued and completed in 1746.

Frederick II was especially committed to the architectural and artistic enhancement of the street called Unter den Linden, which evolved into the first grand avenue of Berlin. Between Schlossbrücke (castle bridge) and the top of The Linden, a large square, the Forum Fridericianum, was to be unfurled. The transformation began with the construction of the Opera (1741–1743) by architect Georg Wenzeslaus von Knobelsdorff. However, the expensive wars fought by Frederick the Great, as he was respectfully called even during his lifetime, quickly brought the work to a standstill. Instead of a royal castle on the grounds of today's university, there was built the Palais des Prinzen Heinrich (donated to the University in 1809); in 1775 construction of the Royal Library was begun; the Catholic St Hedwig's Cathedral was built in 1747–1773. Still, the Forum remains, even in its reduced format, an emblem, carved in stone, of the Frederickian spirit and his enlightened notion of statesmanship: of tolerance towards religions other than the Prussian-Protestant faith, of the will to promote education, the sciences and the arts. The Enlightenment put its mark on life and productivity in Frederickian Berlin. It was primarily

reconfiguration of Berlin as a garrison town; the King required quarters for his soldiers. Distinguished persons primarily lived in the northern part of Wilhelm Street where they installed gardens and parks around their palatial mansions. In old Friedrichstadt, however, the guilds had

Kronprinzenpalais (Crown Prince's Palace). On August 31, 1990 the palais captured the headlines when the agreement paving the way to German unification was signed here.

Berlin's Jewish contemporaries on whom Frederick II had bestowed considerable freedoms and rights and who contributed to the intellectual flourishing of the city. And yet, Berlin came to be, under this Prussian King's reign more than under his father's, a military city: Out of a total population of 145,000 inhabitants in the year 1784, the garrison accounted for 33,000 people, including women and children. In any case, Frederick's heart was much more invested in the finer residential city of Potsdam where he could dedicate himself without worries, *"sans souci,"* to his artistic talents.

From the Prussian Residential City to the Capital of the German Empire

Frederick William II (1744–1797), nephew and successor to Frederick the Great had little luck in his eleven years of regency and still less time to inscribe his name in the annals of Berlin historiography. Around 1800, the built-up areas of the city going north to south stretched from Torstraße up to Mehringplatz, and from Pariser Platz in the West to Frankfurt Gate in the east. Compared to London and Paris at close to one million inhabitants respectively, Berlin, with its about 172,000 inhabitants, was still a rather tranquil capital town. Absolutist Prussia came to an end when it was defeated by Napoleon; this defeat, however, caused no detriment to the country at large: Reforms were inaugurated; a new city charter enabled administrative autonomy; its national education would soon prove itself the most progressive in Europe. Frederick William III (1770–1840) and his son Frederick Wilhelm IV (1795–1861), true representatives of Restoration, may not have distinguished themselves as to political resoluteness; still, their respective interest in architecture and city planning provided that Berlin and its visual manifestation was marked by great master-builders – first of all by Karl Friedrich Schinkel. To his genius are owed not only architectural master pieces such as the Altes Museum (1830) or the Schauspielhaus am Gendarmenmarkt (1821). Schinkel's architectural productivity, always expressed in restrained, harmonic variations on Classicism, became synonymous with Prussian style – and so it is to the present day. His successors, Ludwig Persius and Friedrich August Stüler, established the "Schinkel School" which found, in Peter Joseph Lenné, a congenial landscape architect and city planner.

And yet, alongside all this sovereign glory and middle-class solidity, a new epoch was dawning and the city was to grow expo-

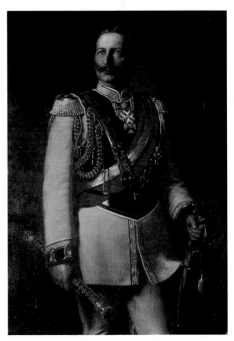

William II, German Emperor (1888–1918), painting by Ludwig Noster, 1906

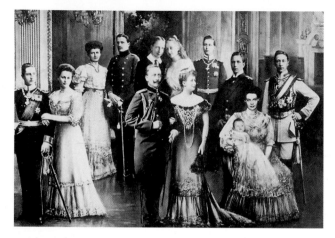

Emperor William II surrounded by his family, photograph, c. 1900

nentially in the course of the 19th century. The industrial revolution had reached Prussia from modern England, and Berlin developed quickly into an industrial metropolis, thanks to steam engines, the railroad and metal working trades. People looking for employment, streaming into the city in vast numbers, needed to be supplied with housing and a functional inner-city infrastructure.

James Hobrecht created a street pattern which, from 1862 into the 20th century was to determine the alignment of Berlin's so characteristic Wilhelminian Gründerzeit streets. What was left of medieval structures and Renaissance architecture now had to clear the way not only for housing but also for the ideas of those Hohenzol-

lerns who, after the founding of the Reich in 1871, wanted to realize their own vision of a proud imperial capital.

William I (1797–1888), Frederick III (1831–1888) and the last of the German emperors, William II (1859–1941), did not stand out as admirers of architecture. Broad, stately streets allowing for military parades and grandiose buildings used for public institutions such as administrative offices and courts determined Wilhelminianism on the level of its the architecture. The solidity of the Gründerzeit years and the eclecticism of their constructions dominated, at least in part, the divided city's image until the so-called Wende (turnaround) in 1990.

The saying – coined already 100 years ago by Karl Scheffler – about Berlin as damned to become forever but never to be, has proven itself across the epochs to be an astonishingly accurate characterization. From today's vantage point though, a look at the city's variable history requires a different prefix: Fateful damnation is out of the question; rather, what is at work here is the inexhaustible force to reinvent itself anew, which sees every fatal failure as an opportunity for an energetic new beginning. It is in this sense that Berlin is a metropolis *avant la lettre*.

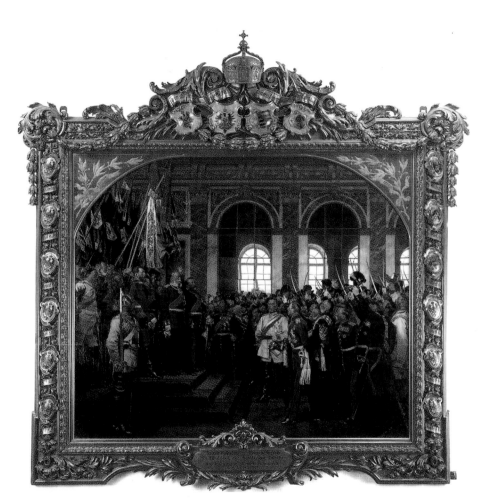

*The Proclamation of the German Empire, 1885, Anton von Werner, oil on canvas,
167 x 202 cm, Bismarck Museum, Friedrichsruh*

Regents				
Frederick William Elector of Brandenburg 1640–1688 *"The Great Elector"*	Frederick III Elector of Brandenburg 1688–1713 **Frederick I King in Prussia** 1701–1713 *Son of the Great Elector*	**Frederick William I King in Prussia** 1713–1740 *Son of Frederick I* *"The Soldier King"*	**Frederick II King in Prussia** 1740–1772 **King of Prussia** 1772–1786 *Son of Frederick William I* *"Frederick the Great"*	**Frederick William II King of Prussia** 1786–1797 *Nephew of Frederick II* *"The Fat Good-for-Nothing"*

| 1620–1688 | 1657–1713 | 1688–1740 | 1712–1786 | 1744–1797 |

Consorts

• Luise Henriette of Nassau-Oranien • Dorothea of Holstein-Glücksburg	• Elisabeth-Henriette of Hessen-Kassel • Sophie Charlotte of Hannover-Braunschweig • Sophie Luise of Mecklenburg-Schwerin	• Sophie Dorothea of Braunschweig	• Elisabeth of Braunschweig-Bevern	• Elisabeth of Braunschweig-Wolfenbüttel • Friederike Luise of Hessen-Darmstadt

Events

• Introduction of a standing army and of excise duty • Edict of Potsdam (Huguenots)	• Order of the Black Eagle • Coronation as King "in" Prussia • Founding of the Academy of Arts and Sciences	• Reorganization of the State (General Directory) • Expansion of the Army	• Conquest of Silesia • King "of" Prussia via the 1. partition of Poland • Evolution towards Constitutional Statehood	• Allgemeines Preußisches Landrecht (Prussian General Common Law) • 2. and 3. partition of Poland

Building

• City Palace • Potsdam • Köpenick Palace • Berlin fortifications	• Zeughaus (Armory) • City Palace • Charlottenburg Palace • French and German Cathedral • Parochialkirche	• Old Charité • Garnisonkirche • Military college • Supreme Court of justice	• Staatsoper (National Opera) • Palais Prinz Heinrich • Kommode (Old Library) • King's Colonnades • Gendarmenmarkt towers • St Hedwig's Cathedral • Sanssouci • Neues Palais	• Brandenburg Gate • Anatomical Theater

Frederick William III	Frederick William IV	William I	Frederick III	William II
King of Prussia **1797–1840** *Son of Frederick William II*	**King of Prussia** **1840–1861** *Son of Frederick William III*	**Regent 1858–1861** **King of Prussia** **1861–1888** **Emperor 1871–1888** *Brother of Frederick William IV*	**Emperor 1888** *Son of William I*	**Emperor 1888–1914** *Son of Frederick III*

 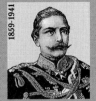

1770–1840	1795–1861	1797–1888	1831–1888	1859–1941

• Luise of Mecklenburg-Strelitz • Auguste Princess of Liegnitz (morganatic)	• Elisabeth of Bavaria	• Augusta of Sachsen-Weimar-Eisenach	• Victoria of Sachsen-Coburg-Gotha, Great Britain and Ireland	• Auguste Viktoria of Schleswig-Holstein-Sonderburg-Augustenburg • Hermine of Schönaich-Carolath

• Reforms from 1807 onwards • Wars of Liberation 1813–1815 • Customs Union 1834 • Potsdam railroad 1838	• Prussian Constitution 1850 • Dreiklassenwahlrecht (Three-Class Franchise)	• Bismarck as Prussian Prime Minister • Founding of the German Empire • "Sozialistengesetz" (law against socialists)	• reigned only for 99 days	• Replacement of Bismarck • Development of 'Wilhelminianism' (an architectural style named after William II) • World War I

• Neue Wache (New Guard House) • Altes Museum (Old Museum) • Schlossbrücke (Palace Bridge) • Friedrichwerdersche Kirche • Schauspielhaus • Bauakademie (School of Architecture)	• Neues Museum (New Museum) • Dome of the City Palace • Bethanien • Kronprinzenpalais (Crown Prince's Palace)	• National Gallery • Siegessäule (victory column) • Anhalter Bahnhof (train station)		• Reichstag (Imperial Parliament) • Berlin Cathedral • Kaiser-Wilhelm-Gedächtniskirche (memorial church) • National Library • Bode Museum

Berlin in Numbers

Location
- 13:25 degrees Eastern longitude,
 52:32 degrees Northern latitude;
 Central European time (GMT+1)
- Central Europe, on the Rivers Spree
 and Havel, 34 m above sea level.
 The city's highest spot is the rubble heap
 on Teufelssee (Devil's Lake) at 120 m
- Germany's capital and its largest city

Surface Area
- City area: 892 km²
- Metropolitan region Berlin/Brandenburg:
 5,370 km²

Population
- Number of inhabitants 2007: 3.42 million
- Second to Munich, the most densely
 populated city in Germany:
 3,834 inhabitants per km²; Berlin-Kreuzberg:
 more than 15,000 inhabitants per km²

Climate and Tourist Season
- Berlin is situated at the juncture
 of oceanic and continental climates:
 Many hot, dry days in summer
 contrast with often extreme coldness
 in winter
- Ideal tourist season is May to October;
 July temperatures during
 extreme hot spells can climb up
 to 35°C (= 95°F)

Administration
- Berlin is managed as a city state governed
 by Federal law
- The Berlin Senate has its seat in the
 Rotes Rathaus (Red City-Hall); the House
 of Delegates (169 mandates) meets in
 the former Prussian Landtag (state
 parliament, lower house)
- Its 23 historical administrative districts
 were redrawn in 2001 and reduced to 12

Climate data

Average temperature in °C	Jan	Feb	Mar	Apr	May	June	July	Aug	Sept	Oct	Nov	Dec
Day	2	3	8							13	7	3
Night	-3	-3	0	4	8	11	13	12	9	6	2	-1
Sunny hours per day	2	3	4	6			7	6	4	4	2	1
Rainy days	17	15	12	13	12	12	14	14	12	14	16	15

Government
- Important government buildings are the Bundeskanzleramt (Federal Chancellery) with the Chancellor's Office, the Reichstag building as seat of the German Bundestag and the Spreebogen complex housing administrative offices of the Bundestag
- 9 out of 14 Federal Ministries have already moved from Bonn to Berlin

Economy
- Berlin has developed from a manufacturing to a service industries center; about 41% of its workforce is employed in the service industry sector
- Berlin strongly promotes seminal fields such as biotechnology, computer science and energy technologies
- TV, radio and print media are especially prominent in Berlin. It is the city with the largest number of daily newspapers published in Germany

Berlin on the Internet
- www.berlin.de – portal offering civil services and emphasis on practical information
- www.visitberlin.de – Website of Berlin's Tourism Organization providing travel and city info as well as access to ticket sales and hotel bookings
- www.berlinonline.de – portal of various Berlin newspapers and city magazines providing info on shows and events, with emphasis on the cultural scene, clubs and lifestyle

Chronological Table

around 720 – 750
The ancestral seat of Spandow, founded on the banks of the River Havel by the Hevellers, a Slavic tribe, is considered the first larger settlement in what will later become the greater Berlin area. Another Slavic tribe, the Sprewans, settle on the banks of the River Spree with Köpenick as their center.

around 1200
Due to its favorable site at the intersection of medieval trade routes, more and more merchants settle on the Spree. The settlements of Cölln and Berlin develop on both sides of the river, which can be crossed especially easily at this point. In 1197, Spandau is first mentioned in an official document; in 1232, it acquires City rights.

1237
Berlin's sister town Cölln, on Spree Island, is first mentioned in documents; its official birthday is October 28, 1237. In 1251, Berlin is first called a town. In 1280, the bear first appears as its heraldic animal. In 1307, Cölln and Berlin conclude a treaty which combines them into a union.

1448
The "Berliner Unwille" (Berlin Indignation) of 1442 through 1448 ends with Berlin's surrender to the growing influence of the Hohenzollern. Under Elector Frederick II, nicknamed "Eisenzahn" (Irontooth), Berlin-Cölln becomes the official residence of the Brandenburgs; this strongly influences its further architectural development. Around 1450, Berlin has about 8,000 inhabitants.

1618

The Defenestration at Prague heads off the Thirty Years' War; by its end in 1648, Berlin's population is cut down by half. Its population starts to grow again with the arrival, from 1685 onwards, of the Huguenots, persecuted in France; their presence stimulates crafts and trades.

1709

Berlin and Cölln finally merge into the single community of Berlin, absorbing likewise the suburbs of Friedrichswerder, Dorotheenstadt and Friedrichstadt, which had developed at the end of the 17th century. In 1737, around 90,000 inhabitants live in the Berlin area, now 13.2 km² large. In 1739, the Berlin stock exchange is founded.

1740

Under Frederick II, called The Great, Prussia becomes a major power. Berlin increasingly rises to the rank of a European capital. The city also gains cultural significance: The "Opera House Unter den Linden" is opened in 1742. And in 1745, Sanssouci Palace in Potsdam is built. In 1748, Gotthold Ephraim Lessing arrives in Berlin and helps turn the city into a center of Enlightenment.

1791

The new Brandenburg Gate is opened. It serves as the city wall's western customs gate. A year later, the causeway from Berlin to Potsdam is opened for traffic; it is Prussia's first paved country road. In 1793, the first steam engine is put to work in Berlin. In 1805, Czar Alexander I visits Berlin. The market place at Georgientor (Georgia gate) is renamed "Alexanderplatz" in his honor.

1806

Berlin is occupied by the French. Napoleon marches into the city through Brandenburg Gate. The occupation lasts until December 1808. Philosopher Johann Gottlieb Fichte inaugurates a new, patriotic liberation movement with his "Addresses to the German Nation". In 1810, he becomes the first chancellor of newly founded Berlin University. More concerned with his compatriots' bodily fitness is Friedrich Ludwig "Turnvater" ('father of gymnastics') Jahn: In 1811, he opens the first public sports ground at Hasenheide park.

1816

The first German steam ship plies the waters of Havel and Spree. In 1819, Berlin's population for the first time exceeds 200,000 inhabitants. On Unter den Linden, a Berlin institution opens its doors in 1825: the coffeehouse and confectioner's "Café-Konditorei Kranzler."

1834

The German states grow closer economically: The German Customs Union is founded in Berlin. The railroad comes to Berlin in 1838; its first trains run from Potsdam via Zehlendorf to the train station at Potsdamer Platz. Berlin's Zoological Garden opens in 1844 as the first German urban zoo. And in 1847, the Telegraphenbau-Anstalt (telegraph construction agency) is founded by Siemens & Halske, today the world-wide famous group Siemens AG.

1848

During the "Märzrevolution" (March Revolution), 216 Berlin citizens lose their lives. Their protest

for a democratic and unified German nation is violently quashed until July 1849 by Prussian and Austrian soldiers.

1854
Advertising, then still called "Reklame" assumes more and more significance: Berlin printer and publisher Ernst Theodor Litfaß (1816–1874) invents the "Litfasssäule" (column) named after him. Besides serving its advertising function, it also becomes an important medium for public announcements.

1861
William I becomes King of Prussia. After integrating Wedding, Moabit, Tempelhof, and Schöneberg, Berlin's population exceeds half a million inhabitants. Its metropolitan area now comprises 59.2 km^2. More and more tenements are built in the ever shrinking, available living space. In 1865, the first horse-drawn tramway starts operations. In 1868, the "Allgemeine Berliner Omnibus AG" (ABOAG) is founded.

1871
Prussian King William I becomes Emperor of Germany; Prussian Prime Minister Otto von Bismarck becomes Imperial Chancellor; Berlin becomes the capital of the newly founded German Empire. This political thrust into significance goes hand in hand with an economical boom which is fueled by 5 billion Francs of war reparations paid by the French. In 1877, Berlin has over a million inhabitants. In 1880, Kurfürstendamm is expanded into a showcase boulevard modeled on its Parisian prototype.

1890
William II, successor to William I and Frederick III during the "Dreikaiserjahr" (three-emperors-year) of 1888, inaugurates a nationalist-conservative era, which is reflected in its "Wilhelminian" architecture: Kaiser Wilhelm Church (today Kaiser Wilhelm Memorial Church) and the Berlin Cathedral are constructed.

1894
Construction of the Reichstag building, designed by architect Paul Wallot in a Neo-Renaissance style, is completed after ten years. On December 6, 1894, its first Reichstag (Imperial parliament) is in session. New types of entertainment are offered to citizens: In 1895, the first movie is shown at the "Wintergarten."

1902
The first underground train, built by Siemens, runs between Stralauer Tor and Potsdamer Platz. The combination of elevated, underground and street-level railways as well as omnibuses – which are motorized as of 1905 – makes Berlin one of the most capacious local traffic systems world-wide; already in 1903, it transports over 30 million riders a year. In 1905, Berlin has over 2 million inhabitants, only about 800,000 of these are native Berliners.

1906
The opening of Teltow Channel between Köpenick and Potsdam links Berlin to waterway traffic routes. Soon, the city has become one of Europe's largest inner harbor cities. As of 1907, the "Kaufhaus des Westens" ("KaDeWe") lures its customers with an unprecedented wealth of

commodities; it is Germany's largest department store. That same year, another symbol of sophisticated splendor opens its doors: the luxury hotel "Adlon" Unter den Linden on Pariser Platz.

1911
Berlin's research institutes join forces under the auspices of the "Kaiser-Wilhelm-Gesellschaft zur Förderung der Wissenschaften" (society for the promotion of the sciences), and help the city gain global status also on the level of scientific research. Its successor today is the Max-Planck-Gesellschaft.

1914
World War I breaks out. The next years are marked by deprivation; food and fuel are scarce. During the "Steckrübenwinter" (turnip winter) of the year 1917, all foods are tightly rationed by official decree; the allotment of bread caps at 1,350 grams a week.

1918
On December 9, 1918, Emperor William II resigns. The SPD-Politician Philipp Scheidemann extols the "German Republic" from the balcony of the Reichstag. In 1919, the Government moves to Weimar for a few months to avoid political unrest—thereby coining the retrospective epithet "Weimar Republic."

1920
Following a territorial reform, 8 towns, 59 rural communities, and 27 farming districts are integrated into "Groß-Berlin" (Greater Berlin). At 3.8 million inhabitants, populating a surface area of 878 km^2 Berlin is now a now a global city, succeeding London and Paris as Europe's third-largest city. The "Golden Twenties" begin, cabarets and vaudeville theaters are in their heyday.

1923
Economic distress after the war comes to a head with hyperinflation, which robs citizens of their savings. Stability is restored on November 20, 1923, with the coercive currency reform: 1 trillion Mark in paper currency makes for 1 Rentenmark. That same year, the radio station Berliner Rundfunk starts broadcasting.

1933
The Reichstag burns; Hitler is named Reichskanzler; the National-Socialists seize power. Political dissidents and Jews are persecuted and detained. The XI Olympic Games, held 1936 in Berlin, are instrumentalized as propaganda platform by the Nazis.

1938
The systematic persecution of Jews reaches its first climax during the night of pogroms on November 9, 1938. In 1939 World War II starts; on February 18, 1943, Goebbels calls for "total war" in a diatribe delivered at Berlin's Sportpalast. At least 50,000 residents lose their lives during aerial attacks in 1943–1945.

1945
German capitulation; Berlin lies in rubble and is partitioned into four sectors by the victorious powers. There are only 2.8 million inhabitants –

of 4.3 million before war). The number of Jews has been reduced from 173,000 to 6,000. The hard years of reconstruction begin.

1948
Economic recovery starts up again slowly with a currency reform and the D-Mark. During the Berlin Blockade, implemented by the Soviet army on June 26, 1948, Berliners receive foods supplied by the "Rosinenbomber" (raisin bombers). As a counterpoint to Humboldt University, now located in East Berlin, the "Free University of Berlin" is founded in the West.

1949
The Federal Republic of Germany is founded. West Berlin acquires status as a federal state. East Berlin becomes the capital of the GDR. In 1953, East Berlin rises up in the "Volksaufstand" (people's uprising) which is bloodily quashed by Soviet troops.

1961
The Berlin Wall is created. West Berlin is hermetically sealed off against East Berlin and the GDR vicinity. In 1963, US President John F. Kennedy visits West Berlin and declares his solidarity with the city in his famous words, "Ich bin ein Berliner."

1967
Societal deficits, produced last not least by an all too fast repression of the Nazi era, lead to the student movement. After student Benno Ohnesorg is shot to death during a demonstration near Deutsche Oper against the visit by the Shah of Persia, the Außerparlamentarische Opposition (APO) (ex-parliamentarian opposition) engages in militant actions.

1971
Following a long Cold War period, Berlin's special status is inscribed in the Four-Power Agreement and recognized by international law. In 1976, the Palast der Republik is inaugurated in East Berlin as convention facility for the GDR "Volkskammer" (people's chamber); it sits at the site of the Berlin Stadtschloss, which was heavily damaged in the war and demolished in 1950.

1989
After weeks of protests in East Berlin, the Wall falls on November 9, 1989. In 1990, Berlin becomes the capital of reunified Germany. Starting in 1994, the area around Potsdamer and Leipziger Platz is given a completely make-over based on designs by such star architects as Renzo Piano and Hans Kollhoff. In the summer of 1995, over 5 million visitors admire the Reichstag wrapped by Christo and Jeanne-Claude.

1999
On April 19, 1999, the Bundestag holds its first session at the refurbished Reichstag; the Government's move from Bonn to Berlin is complete.

2006
After the Alte Nationalgalerie re-opened its doors in 2001, the Bode Museum follows suit on October 17, 2006. Museum Island's unique architectural ensemble was declared a UNESCO world heritage site in 1999 and is slated to be entirely restored by 2015.

Important Berlin Museums

Allied Museum
Clayallee 135
14195 Berlin
030 81 81 99 0
www.alliiertenmuseum.de

Alte Nationalgalerie
Bodestraße 1–3
10178 Berlin
030 20 90 58 01
www.alte-nationalgalerie.de

Altes Museum
Am Lustgarten 1
10178 Berlin
030 20 90 55 77
www.smb.spk-berlin.de

Bauhaus Archive
Museum of Design
Klingelhöferstraße 14
10785 Berlin
030 25 40 02 0
www.bauhaus.de

Berlinische Galerie
Alte Jakob Straße 124–128
10969 Berlin
030 78 90 26 00
www.berlinischegalerie.de

Bode Museum
Bodestraße. 1
10178 Berlin
030 20 90 55 55
www.smb.spk-berlin.de

Bröhan Museum
Schloßstraße 1a
14059 Berlin
030 32 69 06 00
www.broehan-museum.de

Brücke Museum
Bussardsteig 9
14195 Berlin
030 83 12 02 9
www.bruecke-museum.de

Collection of Classical Antiquities
Bodestraße 1–3
10187 Berlin
030 20 90 52 01
www.smb.spk-berlin.de

Collection of Photography and
Helmut Newton Foundation
Jebensstraße 2
10623 Berlin
030 2 66 21 88
www.smb.spk-berlin.de

Museum of Cinema & Television
Potsdamer Straße 2
10785 Berlin
030 30 09 03 59
www.filmmuseum-berlin.de

Ethnological Museum
Lansstraße 8
14195 Berlin
030 83 01 43 8
www.smb.spk-berlin.de

Gemäldegalerie
Stauffenbergstraße 40
10785 Berlin
030 2 66 29 51
www.smb.spk-berlin.de

Georg Kolbe Museum
Sensburger Allee 25
14055 Berlin
030 3 04 21 44
www.georg-kolbe-museum.de

German Historical Museum
Unter den Linden 2
10117 Berlin
030 20 30 44 44
www.dhm.de

German Museum of Technology
Trebbiner Straße 9
10963 Berlin
030 90 25 40
www.dtmb.de

Hamburger Bahnhof
Museum for Contemporary Art
Invalidenstraße 50/51
10557 Berlin
030 39 78 34 12
www.hamburgerbahnhof.de

Jagdschloss Grunewald
Hüttenweg 100
14193 Berlin
030 8 13 35 97
www.spsg.de

Jewish Museum Berlin
Lindenstraße 9–14
10969 Berlin
030 25 99 33 00
www.jmberlin.de

Käthe Kollwitz Museum
Fasanenstraße 24
10719 Berlin
030 8 82 52 10
www.kaethe-kollwitz.de

Kulturforum Potsdamer Platz
Matthäikirchplatz 6
10875 Berlin
030 2 66 36 60
www.smb.spk-berlin.de

Märkisches Museum –
Foundation Stadtmuseum Berlin
Am Köllnischen Park 5
10179 Berlin
030 30 86 62 15
www.stadtmuseum.de

Martin Gropius Bau
Niederkirchnerstraße 7/
Stresemannstr. 110
10963 Berlin
030 25 48 60
www.gropiusbau.de

Museum Berggruen
Schloßstraße 1, opposite
Schloss Charlottenburg
14059 Berlin
030 32 69 58 0
www.smb.spk-berlin.de

Museum Island Berlin Mitte
Bodestraße 1–3
10178 Berlin
030 20 90 55 77
www.smb.spk-berlin.de

Museum of Asian Art
Museum Center Dahlem
Lansstraße 8
14195 Berlin
030 83 01 43 8
www.smb.spk-berlin.de

Museum of Communication
Leipziger Straße 16
10117 Berlin
030 20 29 40
www.museumsstiftung.de

Museum of Decorative Arts
Kulturforum
Tiergartenstraße 6
10785 Berlin
030 2 66 29 02
www.smb.spk-berlin.de

Museum of Decorative Arts
Schloss Köpenick
Schlossinsel 1
12557 Berlin
030 65 66 17 49
www.smb.spk-berlin.de

Museum of European Cultures
Arnimallee 25
14195 Berlin
030 83 90 12 87
www.smb.spk-berlin.de

Museum of Natural History
Invalidenstraße 43
10115 Berlin
030 20 93 85 91
www.naturkundemuseum-
berlin.de

Museum of Prints and Drawings
Matthäikirchplatz 8
10785 Berlin
030 2 66 20 02
www.smb.spk-berlin.de

Musical Instruments Museum
Tiergartenstraße 1
(entrance Ben-Gurion-Str.)
10785 Berlin
030 25 48 11 78
www.mim-berlin.de

Neue Nationalgalerie
Potsdamer Straße 50
10785 Berlin
030 2 66 26 51
www.smb.spk-berlin.de

Neues Museum
Bodestraße 1
10178 Berlin
030 26 63 66 0
www.smb.spk-berlin.de

Pergamon Museum
Bodestraße 1–3,
Am Kupfergraben 5
10178 Berlin
030 20 90 55 77
www.smb.spk-berlin.de

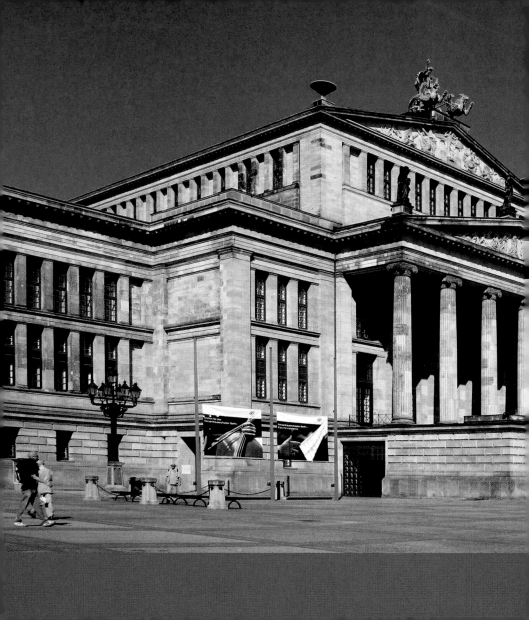

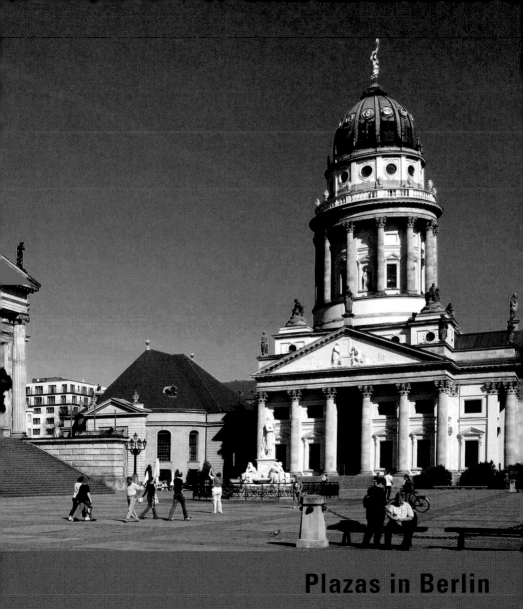

Plazas in Berlin

Plazas in Berlin

Nearly all well-known types of open spaces or plazas have emerged in Berlin during its 700 years of development. Besides market-places and churchyards, there are sites for military marches and drill-grounds – which is the function once performed by what today is called the "Salon" of the city, the Gendar-menmarkt – as well as traffic intersections. At the turn of the century, the metropolitan railway stations created new urban spaces, such as Mexikoplatz which surrounds the Art Nouveau jewel. Typical for Berlin are sites designed at the drawing desk as beautifully "furnished" gems of public spaces. Among them are the Rüdesheimerplatz in Wilmers-dorf, furnished with a fountain and statues, the Viktoria-Luise-Platz in Schöneberg with a colonnade and pond with a water-spout, the Kollwitz-Platz in Prenzlauer Berg with its park-like central area, or the Savignyplatz

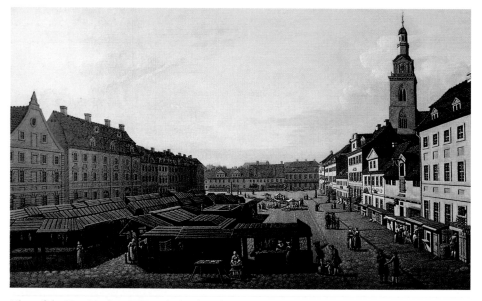

View of the New Market, 1787, painting by Johann Georg Rosenberg, oil on canvas, 56 x 86 cm, Stiftung Stadtmuseum Berlin

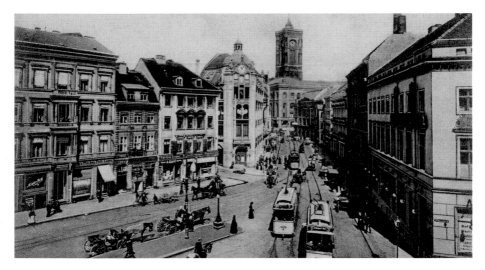

View from Molkenmarkt down Spandauer Straße onto Rotes Rathaus (City Hall), postcard, c. 1900

in the heart of Charlottenburg, which has managed to retain something of old-time Berlin in spite of busy traffic along the Kantstraße. As public spaces, these sites are central to city quarters. They provide meeting-places for everyone. The oldest open spaces in Berlin which, as market places, grew around traffic intersections, have lost their purpose in today's world, like the withered residue of the Molkenmarkt, or they have entirely disappeared, such as the Cöllnische Fischmarkt or the Neue Markt in front of Marienkirche. Instead, we find there a nameless void which reveals no trace of the late medieval quarter where Lessing and Fontane once took strolls, where Moses Mendelssohn worked and where Minna von Barnhelm had lodgings. Between the church, Rotes Rathaus and the Marx-Engels-Monument, a third of Old-Berlin has disappeared under lawns, flower beds and pavement. Today we find there instead, in the form of a gigantic plaza, a piece of the real-existing capital of the GDR. How an open space is not only appendant to the buildings surrounding it, but is created through them is manifested by the elegant Walter-Benjamin-Platz on Leibnizstraße; it was installed in 1998–2000, based on designs by Hans Kollhoff and Helga Timmermann. This site also bears witness to the fact that Berliners do not always accept lightly the changes inflicted on the old that has become so dear to them.

Pariser Platz

Pariser Platz was installed under Frederick William I as Berlin's third grand open space, then called *Quarree*, following the Octogon (Leipziger Platz) and the Rondell (Mehringplatz). It received its contemporary name in 1814 after the conquest of Paris by Prussian troops. In those days it was densely hedged in by a baroque palace and neo-classical urban villas and belonged to the most exclusive areas of the city. Besides the Prussian Secretary of State Friedrich Karl von Savigny, its residents included the juridical reformist Carl Gottlieb von Suarez, Field Marshal Count Friedrich von Wrangel as well as composer Giacomo Meyerbeer. Achim von Arnim grew up here, and Max Liebermann lived next to Brandenburg Gate until his death in 1935. In World War II, Pariser Platz was all but destroyed. Only a few remnants of the Academy of Arts were left standing. It was only after the fall of the Wall that reconstruction of the site, based on a comprehensive design, could be begun in 1993. To this effect, the Berlin Senate issued architectural statutes prescribing building height, material and front view of façades. Only Günter Behnisch's controversial design for the Academy of Arts' glass façade was exempt from these rules. Buildings on both sides of the Gate show how historical elements and modern architecture can produce a "critical reconstruction:" House Sommer/Commerzbank and House Liebermann (Josef Paul Kleihues); on the north side, the Palace on

Pariser Platz (B. Winking/M. Froh), Dresden Bank (Gerkan, Marg und Partner), the French Embassy (Christian de Portzamparc), and to round out this series, the new building of the AGB real estate company with its photograph collection of the Kennedys. The

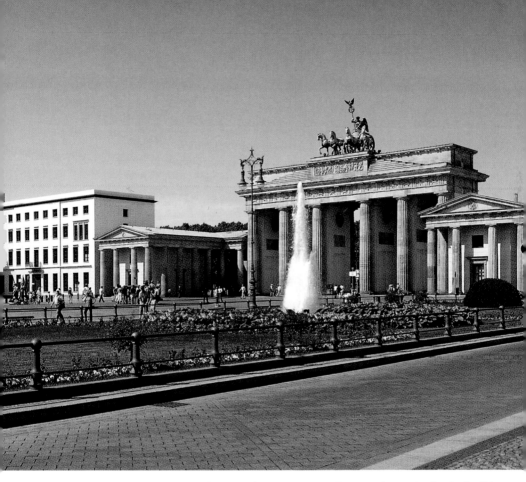

US Embassy (Moore, Rubel, Yudell), formally opened in 2008, is located in the southwest corner; its construction required the relocation of southern residential streets for security reasons. Next to it we find the DZ Bank by Frank O. Gehry who was forced to exercise architectural restraint by the building regulations. His trademark architectonic spectacle now rules the building's interior. The new building of the luxury hotel Adlon (Patzschke, Klotz & Partner) reaches far into Wilhelmstraße.

Brandenburg Gate

by Edelgard Abenstein

It is the emblem of Berlin and the city's most famous landmark. Situated on the border between East and West, Brandenburg Gate has for decades been a symbol of the divided city. It stood flanked by watchtowers, lost in no man's land at the GDR border. Wall and death zone prohibited access. Every western state visit was conducted on a spectator platform facing it. Yet, the beautiful early classicist Gate had represented, around 1800, the ideals of a liberal civil society. The only one left of what were once Berlin's 15 original city gates was erected between 1789 and 1791 under Frederick William II, based on designs by Carl Gotthard Langhans. It was modeled on the *Propylaea* (entrance

Caricature on the return to Berlin of the Quadriga looted by Napoleon in 1806, stipple engraving, 1814, by Daniel Berger

halls) of the Acropolis. Langhans succeeded in creating something tremendously new in Europe. The Gate is a structure made of sandstone 26 m high, 65.5 m wide and 11 m deep; its five passages are accentuated on both sides by six Doric columns, each 15 m high. Its two flanking gate buildings were added in 1868 by Schinkel-apprentice Johann Heinrich Strack after the demolition of the city wall. It is crowned by the Quadriga (1793) with its winged goddess of peace, Irene, fabricated by Johann Gottfried Schadow who also designed the Gate's interior reliefs. The current Quadriga is a perfect copy based on plaster-casts made from the now lost original. It was Napoleon who first bestowed political significance on Brandenburg Gate when he marched into Berlin at the head of his guards following his victory at Jena; he had the Quadriga taken away to Paris. For eight years, the Gate stood bare without its crown until Field Marshal von Blücher brought it back in triumph after his victory over Napoleon. The Gate then became a monument to the liberation wars and the former goddess of peace, now equipped with iron cross and eagle by Schinkel, became Victoria. National celebrations, especially demonstrations of military might, now made the gate their theatrical backdrop. It was here that in 1871 German-Prussian troops marched in glory to celebrate their victory over France. The National Socialists celebrated their seizure of power on January 30, 1933, carrying

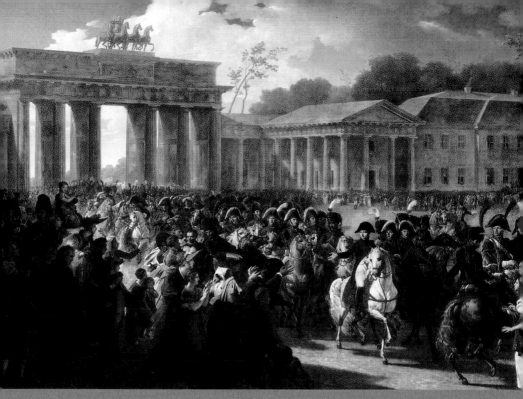

Entry of Napoleon into Berlin on October 27, 1806, painting by Charles Meynier, oil on canvas, 1810, Versailles Palace, Musée Historique

torches in a procession through the Gate; later, it served as a way station for the new *via triumphalis*, which led along Linden Boulevard westward all the way to the Olympia stadium. At the end of the war, the red flag of the Red Army was flown on its roof in deep symbolism, until the Gate became itself a part of the iron curtain. When the wall fell on November 9, 1989, the image of Brandenburg Gate, surrounded by jubilant crowds of people, was broadcast around the world. On December 22, 1989, the Gate was ceremoniously reopened. The former symbol of the Cold War was then transformed into the symbol of German unity. Since then it represents the experience that "German history does not only know wrong ways and special paths, but also fortunate turns." (Günter de Bruyn)

Potsdamer Platz

Potsdamer Platz, one of the city planners' model exhibits, is not only an open space but also, as the name suggests, something more: This is where a city within the city has come to be. Visitors arrived even while it was still the biggest construction site in Europe, and to celebrate the "topping out" ceremony for its first two buildings in 1997, the conductor Daniel Barenboim had nineteen giants made of steel move to the music of Beethoven's Ninth's Symphony in his "Ballet of the Cranes." At one time the busiest traffic hub in Europe, Potsdamer Platz was the "homogeneous cosmopolitan public" (S. Kracauer). After its destruction in World War II, the entire area lay fallow and belonged for decades to the Wall's death zone. Today, the new Potsdamer Platz is again a synonym for Berlin's vibrant vitality, grand hotels, the Musical Theater, traditional eateries such as the historical wine restaurant Weinhaus Huth, bars, movie theaters and a shopping mall. Its two very different hubs, the Sony complex and the Daimler-Chrysler area, allow it to reunite with its old mythology. The area was built up based on Heinz Hilmer's and Christoph Sattler's master plan which was faithful to Berlin's traditional block diagram and had new construction observe restored residential streets. Renzo Piano recruited additional architects like Richard Rogers, Arata Isozaki and Rafael Moneo for the 19 multifaceted buildings of the Daimler-Chrysler Quarter;

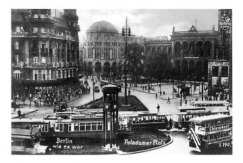

Potsdamer Platz, postcard, c. 1925

he designed the Musical Theater, the Casino and the Imax-Cinema at Marlene-Dietrich-Platz as well as the debis-House, clad with ochre-colored terracotta and topped with a green cube. Helmut Jahn's Sony Center, on the other hand, was made by a single hand and presents a closed glass-steel structure, which creates at its center a plaza covered by a tent roof. There, spared by the bombs, we find a section of the Grand Hotel Esplanade with its famous Kaisersaal (Emperor's Hall); it was transported here in 1995 from its original location 75 m away. In constellation with the Sony Tower and Piano's sharp-angled office building, Hans Kollhoff's staircase-like red brick building forms a prominent ensemble which suggests the shape of a gate in the direction of Leipziger Platz – whose new format retrieves the old octagon – and connects the latter with the museum quarter nearby called the Kulturforum.

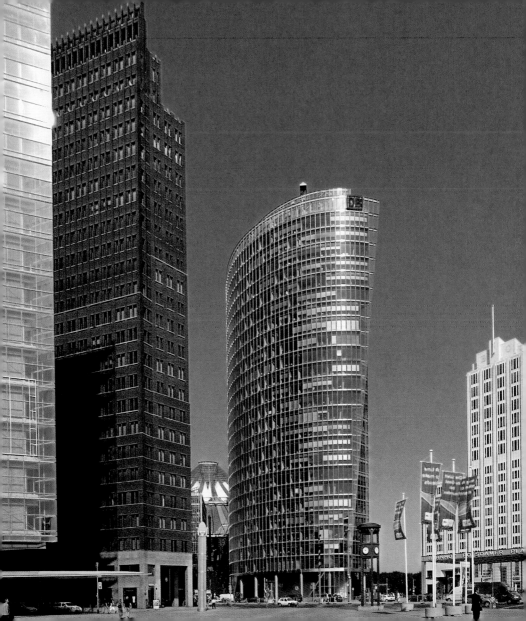

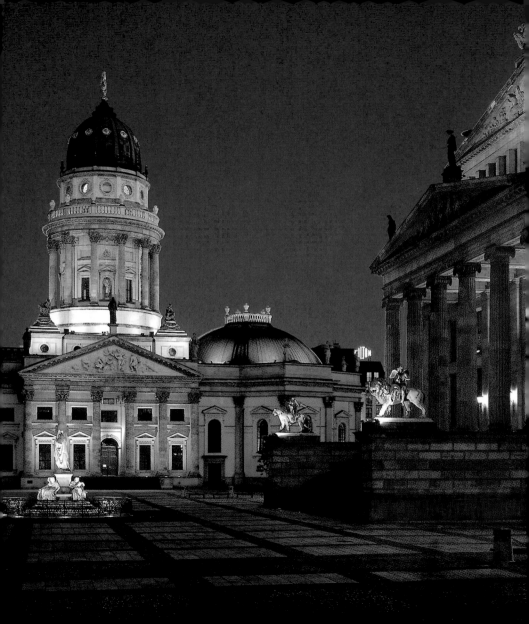

Gendarmenmarkt

The most beautiful square in Berlin, and many believe one of the most beautiful in Europe, is the Gendarmenmarkt. This marketplace owes its name to the regiment of cuirassiers called "gens d'armes" who had their stables there in the middle of the 18th century. Heavily damaged during the war, it regained its old aspect when the local German Academy of Sciences held its 250-year anniversary in 1950. It was then renamed Platz der Akademie. Since German Reunification it is again called by its original name. At the center of the Gendarmenmarkt stands the Schauspielhaus, built by K. F. Schinkel, which today is the Concert House. It was built in 1818-1821 on the foundation of the National Theater that had burnt down in 1817 and which had been designed by C. G. Langhans in 1802 in imitation of the theater of the French Comedy. The Französischer Dom (French Cathedral) on the north side of the space was built in 1701–1705 according to the designs of Jean Louis Cayart; it was made for the Huguenots who had been immigrating into Berlin since 1685. The Huguenot Museum in the tower exhibits their history. The Deutscher Dom (German Cathedral) on the opposite side of the plaza was built at the same time for the Prussian Lutheran population; it was design-

Left: German Cathedral on the south side of the square – right: its counterpart, the French Cathedral, in the north

ed by Martin Grünberg. It was on its steps that, in 1848, democrats killed during street battles – the March Soldiers – were laid out in state. An exhibit on site commemorates these events. The two cathedrals received their characteristic domed towers and their neo-classical porticos only under Frederick II; they were designed by Carl von Gontard who took his inspiration from the twin church cupolas of the Roman Piazza del Popolo. In front of the Theater stands Reinhard Begas' Schiller monument (1859) which was removed by National Socialists in 1935 and only returned by the GDR government in 1987.

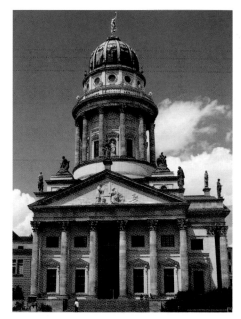

Bebelplatz

Bebelplatz on Unter den Linden boulevard – also called Forum Fridericianum or Lindenforum – is considered, along with the buildings that frame it, one of Berlin's most remarkable sites. The centerpiece of Berlin Rococo is located here. In 1741–1743, Georg Wenzeslaus von Knobelsdorff created, in the style of a Corinthian Temple, the royal opera, today's National Opera Unter den Linden, which was the first detached opera house in Germany and the largest one in Europe. It could hold more than 2,000 people during a time in which Berlin had about 90,000 inhabitants – of whom, of course, only those of noble families were given admission. In 1747–1773, basing himself on Knobelsdorff's designs as well, Johann Boumann the Elder directed the expansion of Catholic St Hedwig's Cathedral, which was to figure as a symbol of Frederickian tolerance after the Silesian wars. Its domed structure and columned portico entrance hall were modeled on the Roman Pantheon. Due to the close proximity of the Dresden Bank building (1889) – occupied today by the high-end inn Hotel de Rome – the church looks a little wedged in. The dramatic façade of the so-called "Kommode" juts into the west side of the plaza; it was once the Royal Library, which was built in 1775-1780 based on a blueprint Fischer von Erlach originally designed for the Vienna Hofburg; today it is the home of Humboldt University's School of Law. For 50 years, William I used to live in the Old Palace next door, first as crown prince, then as king and emperor. Just opposite, Humboldt University was originally conceived as palace for Prince Henry, brother to Frederick the Great; it was de-

signed by Knobelsdorff and built in 1748–1766 by Johann Boumann the Elder. Most of the square was destroyed by the war but has been carefully reconstructed since the 1950s. In the center of Bebelplatz, so named in 1947 to honor the co-founder of the Social-Democratic Party of Germany, August Bebel (1840–1913), stands a memorial created, in 1995, by the Israeli artist Micha Ullmann; it commemorates the book burning by National Socialists on May 10, 1933.

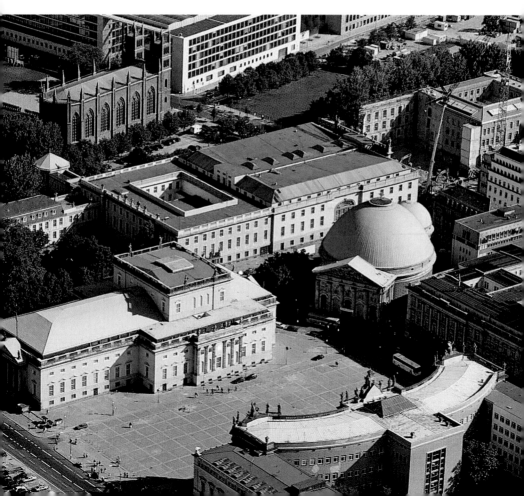

Architectural Visions for the New Berlin

by Jeannine Fiedler

At the latest, it was on October 3, 1990, while citizens celebrated the merging of both Germanies into a federal republic enriched by the new federal states, that vision was once again rated very highly: How should one deal with an infrastructure that was still operating at postwar levels, as was the case in many late GDR localities? Moreover, an infrastructure that precisely for this reason had left in a state of dereliction architectural treasures which, in the booming West, had already decades ago been forced to make way for cheap functional constructions? What was at stake in Berlin was not merely the wrestling for good ideas but for a coherent, comprehensive concept, since the city's division had left behind two halves performing at different degrees of urban development. Additionally it was necessary to heal old wounds of separation:

Alexanderplatz, view of the office high-rises built from 1929–1932, photograph from 1937

Along the entire run of the Wall, cul-de-sacs wanted once again to be turned into functional streets and dead areas into living public spaces. Ugly postwar wasteland was to be developed. Local and regional traffic was redirected into its old, restored tracks; new intercity train stations were created; social facilities such as hospitals were renovated; museums, universities, libraries were modernized, and much more.

In 1991 the German Bundestag decided that the federal capital Berlin was also to be the seat of the federal government, the Bundestag (Lower House) and the Bundesrat (Upper House of the Federal Parliament). The move of almost all ministries from Bonn to Berlin was thus decided and had all but been completed in 1999. The decision to make Berlin the seat of government produced changes not only on the political and economic levels, or in social and cultural fields; it also had an impact on its urban structures and its architectural appearance. Besides the open-mindedness of the Senate as to architectural politics — which is reflected in the selection of internationally renowned architects such as David Chipperfield, Norman Foster, Frank Gehry, Nicholas Grimshaw, Helmut Jahn, Philip Johnson, Josef Paul Kleihues, Hans Kollhoff, Jean Nouvel, Ieoh Ming Pei, Dominique Perrault, Richard Rogers, Oswald Mathias Ungers, and Peter Zumthor —, it was primarily a concept promoted by Hans Stimmann, Senate Building Director for Construction and Habitation, that

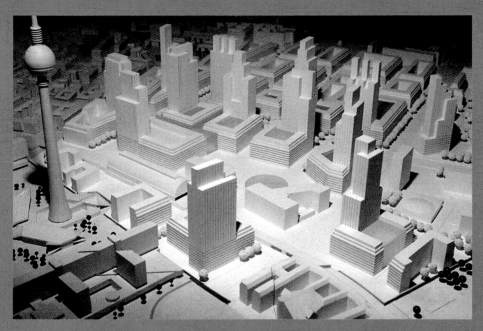

The winning entry for the redesign by Hans Kollhoff envisions thirteen high-rises with up to 142 floors. Hans Kollhoff is a German architect and professor at the ETH Zurich.

was to determine the character of the inner city with respect to all important building projects. Taking its cues primarily from historical heritage and architectural tradition to preserve an identity specific for Berlin, his building philosophy returned to "critical reconstruction," as it had already been articulated in 1987 on the occasion of the Internationale Bauausstellung (IBA, International Architecture Exhibition). Architects were asked to think and design in an urban context that made ground plans and façades fit into preexisting streets and which respected perimeter block development, so typical of Berlin. This turning away from fragmented city planning and solitary structures, of course, roused many critics who called this move regressive. And yet, with its almost completed prospect around Potsdamer Platz and Leipziger Platz, or Kollhoff's design for Alexanderplatz with its 150 m high towers that emphasize the old horseshoe idea by Peter Behrens (slated for completion by 2013), Berlin also offers urban hotspots that can be called "modern" and contemporary at first sight.

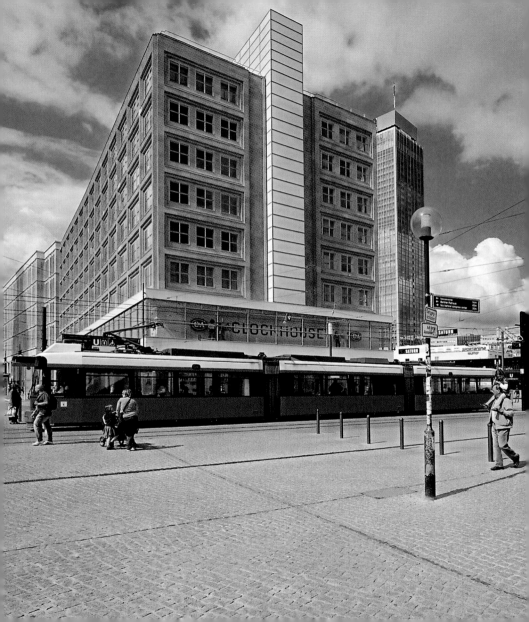

Alexanderplatz

Alexanderplatz, at 3 hectares, is the most spacious plaza in Berlin and the site where, on November 4, 1989, half a million people powerfully heralded the end of the GDR. After the war, the rubble field of the old "Alex" gave way to an area four times its size which to date is dominated by a sober, planned-economy style of architecture. Only two office buildings, the Alexander- and the Berolina House (1932), designed by Peter Behrens, have survived the war. GDR designers reconfigured the plaza until 1969: The traffic-reduced central area is flanked by intersecting thoroughfares and features a few modern structures. There is the department store Centrum, built on the former site of the legendary emporium Tietz (today's Kaufhof), the House of the Press (Berliner Verlag), the House of Electro-Technology (Ministry of the Environment and the Family), the House of Travel (Weekend Club), the House of the Teacher (which features a running mural painted in 1964 by Walter Womacka and showing social life under socialism), and the tallest hotel of the city, today's Park Inn. At the center of the complex we find the Urania world time clock and the Fountain of International Friendship from the 1960s. No other open space in the city besides Alexanderplatz so strongly reflects its GDR past. Mini-Manhattan, planned already back in 1993 in the shape of Kollhoff's skyscraper park, has yet to be built. For years now Alexanderplatz, which owes its name to a state visit by Czar Alexander I in 1805, has been ruled by jackhammers. Already in Alfred Döblin's novel *Berlin Alexanderplatz*, first published in 1929, it is not just the traffic that roars there: "Tremendous crowds people the Alex, all are busy."

Döblin's novel Berlin Alexanderplatz was first turned into a movie by Phil Jutzi in 1931, with the famous actors Heinrich George, Bernhard Minetti and Käthe Haack.

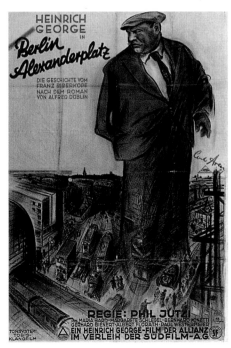

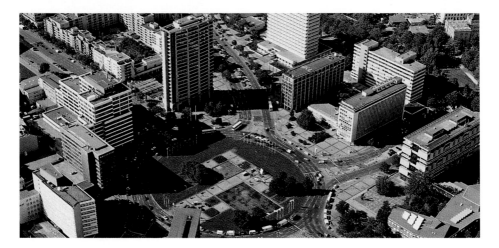

Ernst-Reuter-Platz

What Mies van der Rohe suggested for Alexanderplatz back in the 1920s, was realized at the end of the 1950s at Ernst-Reuter-Platz: Loosely arranged, single buildings grouped around a traffic island form an open urban space consistent with the automobile craze of those years. This space was called the "Knee" because of the way in which the otherwise straight street leading from Berliner Schloss to Charlottenburger Schloss, bends at this point. It was renamed in 1953 in honor of former Berlin mayor Ernst Reuter. Bernhard Hermkes designed it in 1955 as one of the most busy traffic hubs in West Berlin. What once was an intersection now made way for a roundabout encircling a central island decorated with trick fountains; its radius was designed for a speed of 80 km/h. The earlier architecture, arranged as a solid, closed structure around a central area, was now dissolved in favor of individual, discrete office high-rises. Especially conspicuous on the Western side today is the Telefunken High-Rise (1960) by Paul Schwebes and Hans Schoszberger; it is used by the Technical University. Its elegant form references the proportions of the Pirelli High-Rise in Milan as well as the Pan Am Building in New York. To create a contrast to the monumental city planning strategy of the Third Reich, Berlin's then tallest building was deliberately not moved into the middle of the axis leading to Brandenburg Gate. Once celebrated for its progressive flair, Ernst-Reuter-Platz is nowadays considered a prime example of a "no-place."

Spittelmarkt

Spittelmarkt, one of the oldest market places between Fischerinsel (Fisher Island) and the eastern end of Leipziger Straße, was originally located on the western shore of the Spree outside Cölln, Berlin's medieval twin city. Like Hausvogteiplatz close by, it derived from a bastion of the Electoral fortifications, served in World War II as important traffic hub and was then completely reconfigured. Today's Spittelmarkt, named after the Gertrauden Hospital that was once located here, can hardly be called a plaza. The only building to survive the war is the Juwel-Palais at its northern end. Apart from Leipziger Straße, the traffic routes originally merging at this juncture have lost all significance. The buildings surrounding the area consist almost exclusively of uniform residential high-rises which were built in the 1970s as the East's answer to the West's Springer High-Rise. Most prominent among these is a 22-storey high-rise based on a preliminary draft by the architect Zaha Hadid (1996–1998). Unlike its neighbors, it features a design that has two of its floors set back at mid-height which lends it an urban aura when illuminated at night. What is remarkable is the attempt to simultaneously continue the high-rise architecture of Leipziger Straße and to combine it with the new concept of perimeter block development.

Spittelmarkt with Gertraudenbrücke and tower of Petrikirche, photograph, c. 1928, from the series "Berlin und Umgebung"

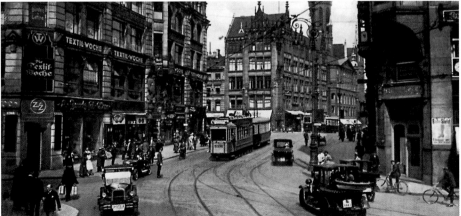

From Fontane to Döblin – Berlin and its Writers

by Edelgard Abenstein

Effi Briest lives in the New West close to the Zoological Garden, Schach von Wuthenow is a regular visitor with the ladies von Carayon at Gendarmenmarkt, Ms. Jenny Treibel holds court in a Wilhelminian Palace on Köpenicker Straße – Theodor Fontane reconstructs with his literary heroes that period in which the old Royal Residence town turns into the new global city. Even though Berlin had been a magnet for writers since the Enlightenment, it is Fontane, critical chronicler of aristocracy and bourgeoisie, who, in his novels of manners, first makes the city an object of global literary renown. Tougher fare is offered by Gerhart Hauptmann's naturalist dramas which indict societal failings and, in a roundabout way, call for political change. The production of *The Weavers* in September 1894 at the Deutsches Theater (German Theater) was so shocking that Emperor William II was prompted to coin the expression "gutter literature" and to cancel his private theater box. Hauptmann,

Author Theodor Fontane (1819–1898), painting, c. 1926, by W. Vogt after a portrait dating from c. 1889

though, who was awarded the Nobel Prize in literature in 1912, only gained in renown after this event. Literary expressionism is yet another Berlin phenomenon. New magazines with programmatic titles – such as Herwarth Walden's *Der Sturm* (The Storm) – were founded; they provided a mouthpiece for Else Lasker-Schüler, Jakob van Hoddis, Georg Heym and Gottfried Benn. With the likes of Raoul Hausmann, Richard Hülsenbeck, George Grosz and the brothers John Heartfield and Wieland Herzfelde, Dada gained a firm footing in the city shattered by war and revolution, and the Russian Revolution sent a tide of intellectual emigrants to Berlin; in the New West called Charlottengrad, Vladimir Nabokov wrote his first novels. Erich Maria Remarque became rich and famous with his anti-war novel *Im Westen nichts Neues* (All Quiet on the Western Front, 1929) which sold 8 million copies. Kurt Tucholsky and Egon Erwin Kisch reinvented the political feuilleton, and women authors also pushed into the lime light: Irmgard Keun, for example, and Vicki Baum, whose novel *Menschen im Hotel* (Grand Hotel), which was made into a movie starring Greta Garbo, soared to the top of bestseller lists in the USA in 1931. The most significant Berlin novel of the 1920s, Alfred Döblin's *Berlin Alexanderplatz* (1929), competes confidently with James Joyce's *Ulysses*, uses montage to register Berlin impressions, and turns into a quintessential metropolitan text. Still, the torn, glittering city on the eve of the Third Reich has nowhere else been as pointedly presented as in young Erich Kästner's *Fabian* (1931). The upshot of the novel is delivered by a moralizing

Medical doctor and author Alfred Döblin (1878–1957), painting by Nelli Nathan-Nordegg

cynic: "As far as this gigantic city is made of stone, it is as it was. As to its residents, it has long resembled an insane asylum [...]."

On February 15, 1933, Heinrich Mann, chairman of the Poetry Section at the Prussian Academy of Arts and brother of Thomas Mann, was forced to resign. Alfred Döblin emigrated on February 28, 1933. The exodus of most German writers of rank had begun.

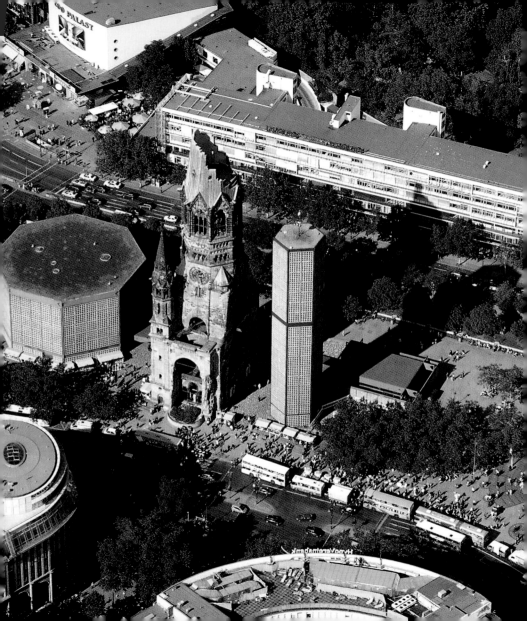

Breitscheidplatz

City-West's most important center is Breitscheidplatz which is flanked by large business and shopping streets: Kurfürstendamm, Tauentzien, Kant und Budapest Streets. Already in the 1920s, Kaiser-Wilhelm-Gedächtniskirche (Emperor William Memorial Church) was the hub of vibrant cultural life featuring cafés und cabarets, theaters and first class stores. After World War II inflicted harsh destruction, the area took on a new aspect made of high-rises and slab-style structures while the railway and subway Zoo Station assumed, after the city's division, the function of Central Railway Station for West Berlin. Based on designs by Paul Schwebes and Hans Schoszberger, the Zoobogen was built in 1955– 1957, the architectural complex with Bikini House (home to the Kunsthalle, Gallery of Art, in the 1970s), and the Zoo Palace (site of the Berlinale competition until 1999). The Zoo cinema, protected by landmark status, is the only one left from the era of the grand moving picture palaces on the Kurfürstendamm; it is to be renovated soon without endangering its 1950's stylistics. Visible from afar is a 22-storey tall high-rise tower which is crowned by the Mercedes star emblem: the Europa Center (Helmut Hentrich, Hubert Petschnigg, Egon Eiermann, Werner Düttmann). Modeled on Mies van der Rohe's Seagram Buildings, it was constructed in 1965 on the site of the Romanisches House (with the famous Romanisches Café) which was destroyed by the war. This was Berlin's first American style shopping center. Like a shop-window into the West, it presented to Berliners the wonderland of the Economic Miracle, but later on it became the prototype of less successful copies, such as the Ku'damm-Karree and the Steglitzer Kreisel (Round-About).

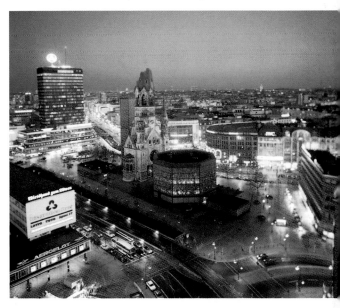

Walkabout in West Berlin

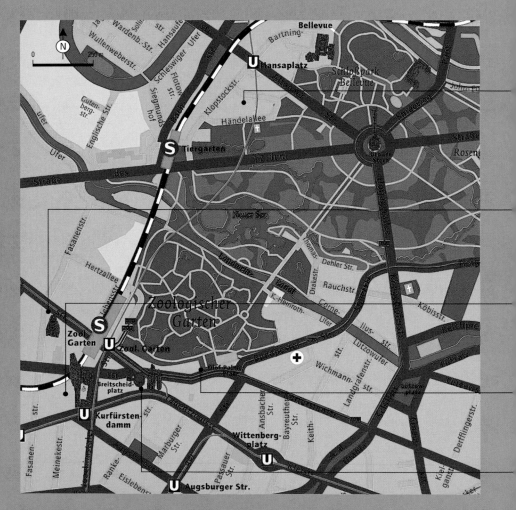

Hansaviertel

Ludwig Erhard House
on Fasanenstraße

Kranzlereck

Elephant Gate

Breitscheidplatz

The Hansaviertel (Hansa quarter) at the edge of the Tiergarten is a Mecca for architecture tourists. It is, still today, one of Berlin's most favorite places to live in. Here we see none of that monotony made of concrete which determined many planned settlements built at a later date. And yet we can still feel some of the excitement of new beginnings, of venturing into modernity of Interbau 1957 (International Architecture Exhibition).

Our point of departure is West Berlin's home for the Academy of Arts which was created with moneys donated by an American sponsor. Werner Düttmann designed this ensemble composed of three buildings in 1958–1960 – with façades made of rough concrete slabs with an exposed-aggregate finish, a copper-covered tent roof and beautiful interior courtyards. A nude fashioned by Henry Moore reclines at the entrance.

Just opposite, five high-rises, each 16 stories tall, impress us with their technical and aesthetic qualities. Yellow stripes run across the cement-grey façade of the building designed by Hans Schwippert (Germany); the balconies at its corners seem to float freely. Raymond Lopez and Eugène Beaudouin (France) checkered their "skyscraper" with blue-grey-white squares; every one of its apartments is equipped with a loggia. The most beautiful entry into a vestibule jutting out in front of the main structure is offered by a building designed by Gustav Hassenpflug (Germany); here residents can choose among various floor

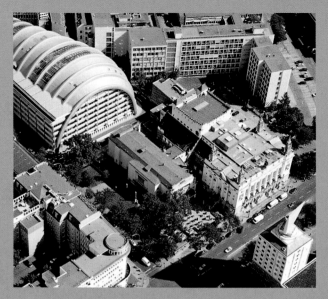

Aerial photograph of Theater des Westens (right) and Ludwig Erhard House

play "Linie 1", we now walk across Altonaer into Klopstock Street. Next to a building faced with white Leca slabs, which was designed by Alvar Aalto, a billboard with ground plan provides directions to the Hansa quarter's buildings by Walter Gropius, Oscar Niemeyer, Arne Jacobsen, and many others.

At Joseph-Haydn-Straße, finally, one of the few remaining old-timers reminds us that, before the war, a Wilhelminian middle-class quarter had stood here full of perimeter block constructions and stucco façades once so typical for Berlin. Beyond the six-lane avenue called Straße des 17. Juni, the Tiergarten welcomes us back with its curlicue pathways; the Schleusenbrücke leads us across the Landwehrkanal; to the left we can see dromedaries through gaps in the zoo's fence. A giant giraffe on the façade of a high-rise shows us how to get to the main entrance of the largest zoological garden in Germany. Even if we are only out for a walk, the large free-range enclosures in the middle of the city make for a wonderful change of scenery. More commendable, though, is our passage through the well-known "Elephant Gate" at Budapester Straße. In the City-West, where Bahn-

plans. The two Dutch architects, Jo van den Broek and Jaap Bakema, turned their 16-story lighthouse into an eye-catching structure by adding yellow, blue, and red tiles. Luciano Baldessari (Italy) textured his construction with rust-red horizontal lines. A few meters to the left, there appears, light and slender, the façade of a building designed by Egon Eiermann; it looks like a shelving unit. Each shelf is a balcony which belongs to one of its 100 one and two bedroom apartments. On past the row of shops and the Grips Theater which became world-famous thanks to its long-running

hof Zoo has to be content again to be nothing but a regional railway junction, big ventures are in the works. On the left, a row of 120-meter-tall office and hotel towers are slated to rise skywards – higher still than Helmut Jahn's glass-faced Neues Kranzler-Eck which, visible from far away, rigorously breaches the top of Berlin eaves on Kurfürstendamm.

Diagonally across, the ponderous Ku'-damm-Eck curls around the corner, equipped with hotel, department store and the "Judgment of Paris," a sculpture by Markus Lüpertz. Before we get there, on the right side of Kantstraße, we catch a glimpse of the 19th century in the shape of

Literaturhaus Café

Clock of Flowing Time in the Europa Center

an imposing Neo-Renaissance façade, the Theater des Westens; and an architectural counterpoint just across from it: Josef Paul Kleihues' high-rise cube with silver aluminum roof sail. Then we take a leisurely stroll through beautiful Fasanenstraße, stopping by briefly at the Literaturhaus, a late-classicist brick building with a picturesque coffeehouse garden, next visiting the adjacent Käthe Kollwitz Museum and the Galerie Pels-Leusden – all of these magnificent urban villas of the Wintergarden complex.

Back on Kurfürstendamm, we walk to the twin landmark of old West Berlin, the Gedächtniskirche (Memorial Church) and the Europa Center. There we find, in the first interior courtyard, the "Flowing-Time Clock". Playing with gravity in a complex manner, the 13-meter-tall chronometer – made of glass spheres, colored water and tubes – tells the time.

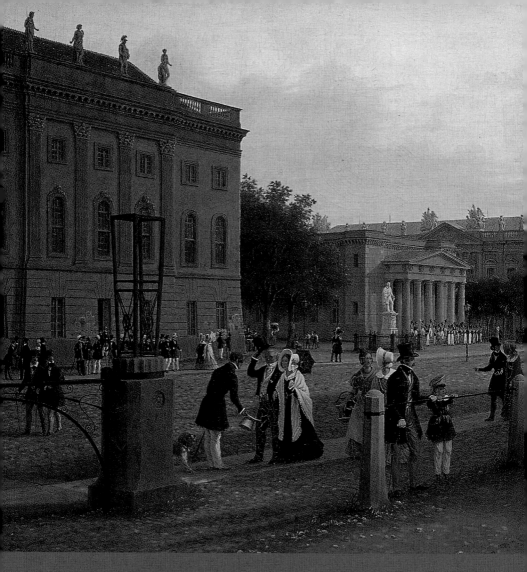

Unter den Linden Blvd. with view of Neue Wache and Zeughaus, painting by Wilhelm Brücke the Younger, 1842, oil on canvas, 70.7 x 106 cm, Niedersächsisches Landesmuseum, Hanover

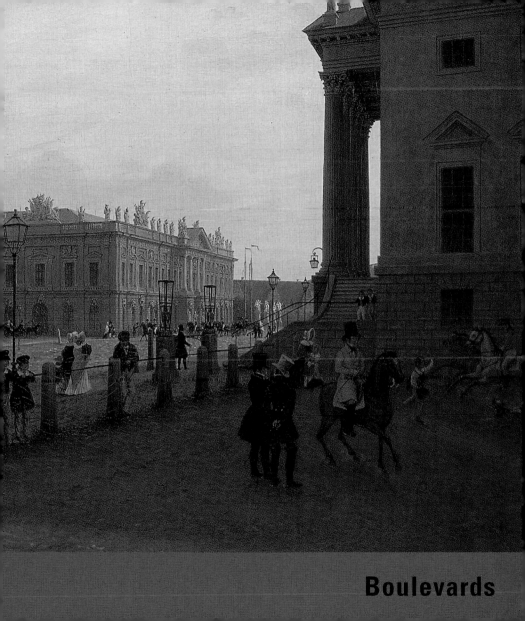

Boulevards

Boulevards

Berlin's boulevards are green – mostly, that is. Rows of trees line the borders of billowing sidewalks, as on Kurfürstendamm, where people can stroll without impediment. On Unter den Linden, they even saunter on the wide center margin which is sheltered by a canopy of leaves in summer. While traffic flows effortlessly along broad car lanes, pedestrians do not merely mind their own business; they walk along Karl-Marx-Allee, that paragon of socialist thoroughfares dating back to the 1950s which was modeled on Moscow, or along spacious Kaiserdamm. Around 1910, Franz Hessel discovered a new type of urban resident here, one who experiences strolling as urban literacy, or "reading of the city." Since those days, not only have many streets undergone radical change, such as those surrounding Wittenbergplatz. The once magnificent residential district around Tauentzienstraße has morphed into a restless business strip. But even after this transformation, one Berlin boulevard has retained its unchangeably sophisticated character, maybe because it has always presented a stage for politics, consumption or nocturnal entertainment.

Unter den Linden

Grand boulevard, Prussian *via triumphalis*, city promenade – the Linden, as Berliners call it, runs from the old center of Berlin, Spree Island, where the royal palace once stood, to Brandenburg Gate. The buildings

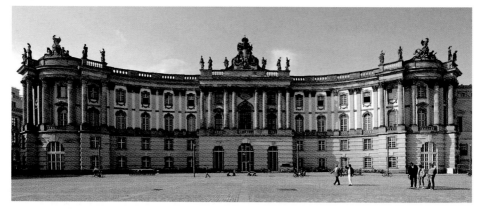

"Kommode" (chest of drawers), seat of Humboldt University Law School

along the Linden mark, in glorious succession, Prussian architectural history from the baroque to neo-classicism. Once a rough bridle path, the Great Elector had it planted with linden trees after the Thirty Years' War. Its first residential building, the future home of the Stadtkommandantur (town major's post), arrived in 1653/54; Bertelsmann's headquarters moved into its ostentatious replica built at the site in 2003. The avenue's first figurehead building, a prototypical baroque structure, was installed at the behest of the first Prussian King, Frederick I. The Zeughaus was constructed by Johann Arnold Nering, Martin Grünberg, Andreas Schlüter, and Jean de Bodt. Today, the magnificent former armory is the home of the Deutsches Historisches Museum (German Historical Museum), to which I.M. Pei added a contemporary extension in 1995, and which also received a roof made of glass covering its interior courtyard. On his accession to the throne in 1740, Frederick the Great immediately launched into busy construction at Unter den Linden. Next to the Kronprinzenpalais (crown princes' palace), sole architectural witness to the era of his father, the Soldier King, Prussian rococo and early neo-classicism now made their appearance. Loyal to the King's architectural vision, Georg Wenzeslaus von Knobelsdorff designed the Forum Fridericianum with its Opera House, St Hedwig's Cathedral and the Palace for Prince Heinrich, today's Humboldt University; the Royal Library was added later. In imitation of its Paris model, the street was built up on both sides with four-storey palatial mansions for its aristocratic residents. Under Frederick William II, Brandenburg Gate was added as the finishing touch. And finally, Schinkel's Neue Wache (New Guard House), the Schlossbrücke (Palace Bridge) and the Museum am Lustgarten (Pleasure Garden) – the first citizen's forum for the arts – constitute this street's architectural highlights to the present day. Its classiest tenements were found in its middle-class section, which starts at Charlottenstraße. Already around 1800, merchants and purveyors to the court started moving there. Banks, restaurants und arcades furnished "this central hub of elegant society." Wilhelminian Promoterism transformed what was once the most distinguished of Berlin's residential streets into a center of business and entertainment – until Hitler had the linden trees chopped down in order to use the boulevard for torch processions and military marches. After 1945, the area was a desert strewn with rubble. Gigantic gaps gaped between buildings well into the 1960s, before Berlin, capital of the GDR, became the center for national reconstruction programs. Following the demolition of the Palace and Schinkel's Bauakademie (Academy of Architecture), valuable architectural monuments such as the Kronprinzenpalais (Crown Prince Palace) and the Opera were elaborately reconstructed by Richard Paulick. Today, banks, corporate headquarters and branch offices of the Bundestag (the lower house of the German parliament) display themselves in new architectural guise.

*Three-dimensional panoramic view
of Unter den Linden Blvd. –
above: the situation in 1928,
below: current condition;
drawing by T. Weishappel
(Typoly Berlin)*

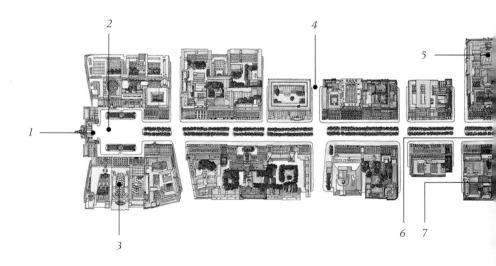

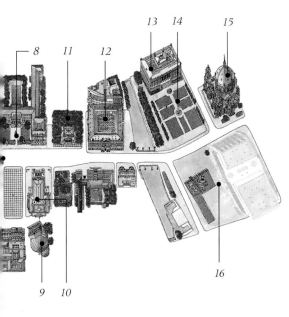

1 Brandenburg Gate
2 Pariser Platz
3 DZ Bank
4 Friedrichstraße
5 Staatsbibliothek (State Library)
6 Equestrian Statue of Frederick II
7 "Kommode" (Old Library)
8 Humboldt University
9 St Hedwig's Cathedral
10 Deutsche Staatsoper (State Opera)
11 Neue Wache (New Guard House)
12 Zeughaus (Armory)
 German Historical Museum
13 Altes Museum (Old Museum)
14 Lustgarten (Pleasure Garden)
15 Berliner Dom (Berlin Cathedral)
16 Schlossplatz (Palace Square)
 with former Palace of the Republic

Friedrichstraße and Leipziger Straße

At 3.3 km long, Friedrichstraße runs straight as an arrow right through the city's center: This was once Berlin's longest street. Its name is tied to Berlin's first cultural scene which, already shortly after 1800, had found in close-by Lutter & Wegner a mythical venue made famous by E. T. A. Hoffmann. With its mixture of music hall and variety shows, the area around Friedrichstraße presented as polar opposite to the New West at Kurfürstendamm, where "intellectual intimacy and wit" (Walter Kiaulehn) was king, while

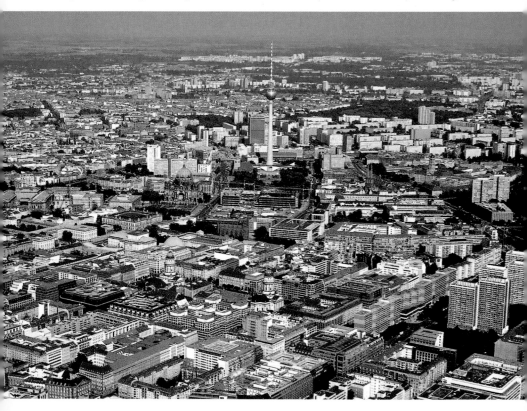

here was offered cosmopolitan entertainment for main stream tastes. In those days, it was called "Saufstraße" (drunkard's street), Leipziger Straße with its department stores was "Kaufstraße" (shoppers' street), and the noble Linden were celebrated as "Laufstraße" (walkers' street). Due to its nearly complete destruction in World War II, barely a dozen historical houses remain standing on Friedrichstraße. During GDR-times, the street led a marginal existence. After the German reunification, grand style con-

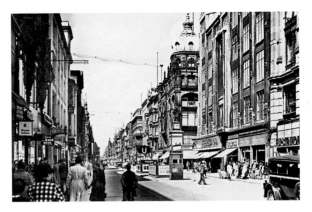

View down Friedrichstraße onto subway station Stadtmitte, photograph, c. 1930

struction began and Friedrichstraße acquired an entirely new function. Highlights of its new architecture – with respect to size as well as opulence – are the Friedrichstadt-Passagen. This monumental architectural complex is composed of three city blocks or "Quartiere" – as they are called in Berlin parlance – which are linked by subterranean passages. *Quartier 207*, a Berlin branch of the Parisian department store Galeries Lafayette, was designed by Jean Nouvel and opened in 1996; it stands out as the sole building made entirely of glass and features elegantly rounded corners and horizontal bands of illumination. It attracts the gaze via its futuristic atrium fashioned from two interpenetrating glass cones 37 m high. The New York architectural firm Pei, Cobb, Freed & Partner designed *Quartier 206*; its façade as well as the black, cream-

colored and brown checker board patterns ornamenting its interior reference elements of 1930's Art-Deco; they are especially compelling by night. Designed by Oswald Mathias Ungers, *Quartier 205*'s façade is a grid composed of squares; it is the most massive building of the triad – and the one most widely critiqued. The fashion shops lining the Friedrichstadt-Passagen specialize principally in high-end brands and constitute one of the city's classiest precincts.

Before the war, Leipziger Straße was famous for its grand department stores such as Wertheim or Tietz, which used to stand at the junction of Jerusalemer Straße. Leipziger Straße ends at Spittelmarkt, where the colonnades, constructed in 1776 by Carl von Gontard, lead a bizarre, shadowy existence amidst tall tenement buildings dropped there in the 1970s.

Berlin Department Store Tradition – KaDeWe as Beacon of Capitalism

by Edelgard Abenstein

At 60,000 m² of retail area, the Kaufhaus des Westens, or KaDeWe ('store of the West'), is the biggest department store on the continent – and a tourist attraction. It is part of Berlin like the Reichstag and Brandenburg Gate. Its delicatessen shop on the sixth floor is legendary. Five hundred of its 2,000 KaDeWe employees work there, 150 of these are cooks and confectioners. They produce and sell around 34,000 different items; 1,300 of these are varieties of cheese alone. On the other floors, too, up to 50,000 visitors spend money on fashion, jewelry and other exquisite gadgets. The house with its glass barrel cupola has always been a first port of call for the refined taste. Competition was strong in this Capital of department stores which, since before World War I, had been one of the most productive and select in the world, even though the winds of trade and change were not always auspicious. Karl Friedrich Schinkel's bold design for a three-wing store Unter den Linden was coolly rejected in 1827, because the "the building site was not amenable to merchant activity." Businessman Adolf Jandorf, encountered similar concerns when he had his Kaufhaus des Westens

Shopping district Tauentzien at Kaufhaus des Westens (KaDeWe)

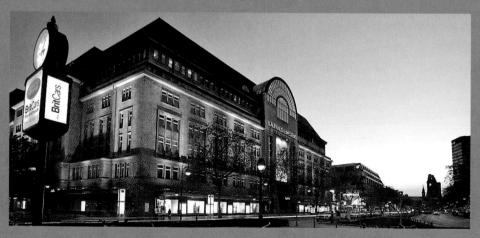

Wertheim Department Store,
photograph, c. 1927

Galeries Lafayette on Friedrichstraße

built by the architect Johann Emil Schaudt at still very tranquil Wittenbergplatz. The site was considered risky since the retail hub was located much farther to the east, at Tietz's, a store on Alexanderplatz, or at Alfred Messel's "Berlin Louvre," as Fedor von Zobeltitz called the Kaufhaus Wertheim on Leipziger Straße. But Jandorf ("What makes for a good site, that's up to me") had been on target. At five stories, his store at Tauentzienstraße was the largest in Germany at its opening in 1907. It started a boom, and the area around Gedächtniskirche, a very distinguished quarter, became the flourishing "Neuer Westen" (new west). While Karstadt at Hermannplatz emerged as a new department store of the first order, the KaDeWe was taken over by the Tietz Group in 1927, which in turn was expropriated by the National Socialists and "Arianized" a few years later. In 1943, a bomber plane fell through the roof of the store which almost burned to the ground. But immediately after the Berlin Blockade and the currency reform it was re-opened in 1950, a beacon in a desert of ruins. Almost 200,000 people celebrated the reclaimed Kaufhaus des Westens, which had survived the war as the only witness to the era of grand department stores in Berlin. It then turned into an icon of the market economy. The frequently reconfigured, heightened and enlarged KaDeWe belongs to that class of rare department stores in the world which – like the Parisian Galeries Lafayette and its Berlin branch (Jean Nouvel) – testify to the old-time attractiveness of shopping palaces with their celebration of luxury and fashions.

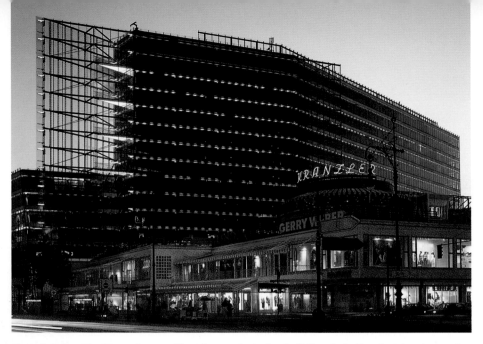

Kranzlereck at Kurfürstendamm with Helmut Jahn's glass building, including the Victoria Areal

Kurfürstendamm and Tauentzien

At first, nothing but a bridle path linked the Royal Residence with the hunting grounds in Grunewald and its homonymous Jagdschloss (hunting castle, 1542). When, at the founding of the Empire, Berlin became its imperial capital, Reichskanzler ('imperial chancellor') Otto von Bismarck took it upon himself, in 1875, to have "Churfürsten Damm" remade as a boulevard modeled on the Champs-Élysées – 4.5 km long and 53 m wide. By the turn of the century, its real estate parcels were appraised at three thousand times the original price. Impressive mansions in all kinds of styles and stylistic mixtures developed, often equipped with gigantic apartments – e. g. 575 m^2 at no. 60. Last witnesses to the bygone epoch are, among others, the Iduna-Haus at no. 59/69 (1905) and the buildings at nos. 201, 213 through 216 and 218 (1896).

Starting in 1910, the Neue Westen (New West) – with Kurfürstendamm and Tauentzienstraße as its vibrant arteries – also functioned as the "industrial zone of the intellect" (Erich Mühsam). Here is where most of the cultural avant-garde congregated; here they had their center and their stage at Café des Westens (today's Café Kranzler) and Romanisches Café (today's Europa Center). There were grand new movie palaces, theater revues and cabarets, high-end restaurants and bars. In the Nelson Theater (it stood at corner house to Fasanenstraße) founded by Rudolf Nelson, in 1926 Josephine Baker conquered Berlin dressed in her tight banana costume. A little further on, Max Reinhardt, star director of the Deutsches Theater, directed plays at two more stages, at the Komödie (founded by himself in 1924) and the Theater am Kurfürstendamm, in which the Brecht-Weill opera *Rise and Fall of the City of Mahagonny* premiered in 1931. Today, these two theater venues, testimonials to an early version of Art-Deco, have been integrated into an architectural offence of the 1970s, the Ku'damm-Karree – where their future is uncertain. In noble Fasanenstraße, the picturesque Wintergartenensemble (1892) suggests a time when Kurfürstendamm first emerged as a sophisticated cosmopolitan boulevard. The better part of that world, however, went down with the Third Reich, succumbing under a hail of bombs. Approximately half of all structures had been destroyed by the end of World War II; what remained was heavily damaged. Amongst the ruins, Hotel Kempinski opened its doors in 1952; Café Kranzler followed suit in 1958 with its famous rotunda, protected by sun blinds but dwarfed, today, by Helmut Jahn's glass structure, the Victoria-Areal – the former embodiment of West-Berlin has lost all luster.

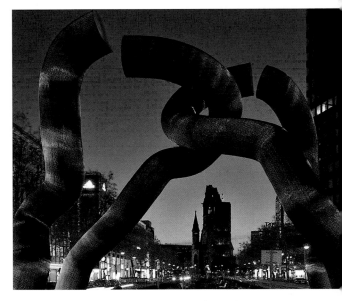

Evening view of shopping district Tauentzien with Kaiser Wilhelm Memorial Church

Germania – on the Megalopolis Program of National Socialist Senior Master Builder Albert Speer

by Jeannine Fiedler

It was the construction of an S-Bahn (metropolitan railway) tunnel between Potsdamer Platz and Stettiner Bahnhof (today's Nordbahnhof) which prompted Berlin's Senior Mayor Heinrich Sahm and NS Official Julius Lippert, in the fall of 1933, to include Reichskanzler Hitler in their decision making process. The dictator – would-be artist and architect of his own graces – saw that the historical hour had arrived to have his fantasies of imperial power cast in concrete, since Berlin, he was convinced, was nothing more than a disorderly desert of stone with only a single prestigious axis, the Linden. This led him to deduce quite consistently that, "Berlin as imperial capital of a people counting 65 millions must be propelled, architecturally and culturally, to such heights as to be able to compete with all capitals in the world. It must be developed to such an extent, that there can never be any doubt, that it is Germany's Imperial Capital likewise on the cultural level, and that it can rival any other big city, such as London, Paris and Vienna." He authorized 40 million Reichsmarks annually for the planning phase – which would be equivalent to about half a trillion euros today. That same year, the Office of City Planning announced the construction of a new North-South Axis. Anhalter and Potsdamer Bahnhof would be sacrificed and a new crossover for the city center would be created at General-Pape-Straße.

However, it took several years until Hitler's assistant and favorite architect Albert Speer presented his ideas on the reconfiguration of "Reichshauptstadt Germania" (World Capital Germania) to Berliners and the German people: Without respect for organically evolved, urban structures or even the residents of these enormous areas of transformation, it was arranged, in 1938, to cut two swaths across the

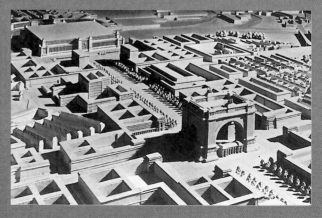

Albert Speer's model of Imperial Capital Germania, 1938/39

city, an East-West and a North-South Axis. They were to intersect in the Tiergarten, south of the current Platz der Republik at the Reichstag building. The East-West Axis would have run for 12 km from Frankfurter Tor to Adolf-Hitler-Platz (today's Theodor-Heuss-Platz). Up to 1940, some segments were completed, such as the widening of Charlottenburger Chaussee (today's Straße des 17. Juni) or the transplantation (and heightening) of the Victory Column, which was moved from the Reichstag to the Großer Stern.

Speer and Hitler (from left) examine the designs for the "House of Tourism" in Berlin, Obersalzberg 1936.

The incomparably more elaborate project requiring the demolition of countless residential blocks was stopped by the war. A majestic thoroughfare, 7 km long, would have been created between the new traffic hubs of a southern railway station at General-Pape-Straße (today's Südkreuz) and a northern railway station in northern Moabit. The central train stations, too, similarly arranged as triumphal statements of power, would have demoted New York's Grand Central terminal to a provincial railroad station. Hitler's gigantomania was not content to act itself out in anything smaller than his study of 900 m² in the new Führer-Palace across from the Reichstag, which in turn would have been rededicated as a library. But even such measurements would have paled in comparison to the most important projects planned along the north-southerly Via Triumphalis: the Triumphbogen and Große Halle. The first was to have consisted of an architectural volume 12 times larger than its model, the Arc de Triomphe in Paris. The Great Hall with a planned capacity of about 180,000 visitors would have been topped with a dome – 250 m in diameter suspended above a pedestal 74 m tall – all in all, it would have been loftier than the sphere of the TV tower at Alexanderplatz.

Expropriations, evictions, and the deployment of concentration camp prisoners in rock quarries as well as forced labor at Berlin construction sites were par for the course. Goebbels' doubts, whether twenty years were enough to build this capital megalopolis, were silenced within a few bitter years by the catastrophe of World War II, brought on by the National Socialist regime.

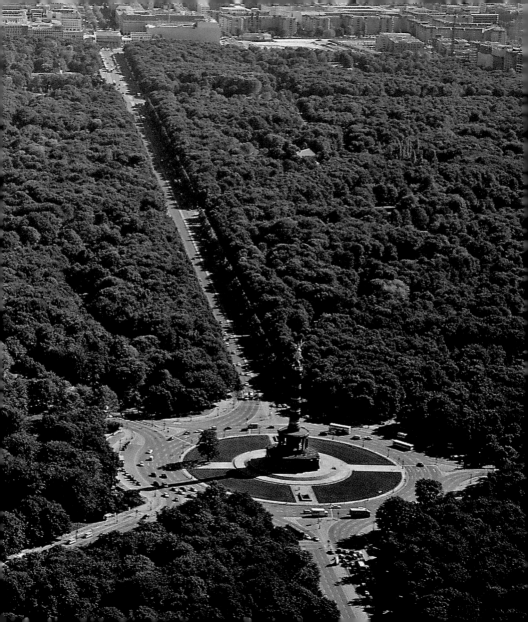

Straße des 17. Juni to Heerstraße

The East-West axis, which leads from the eastern outskirts diagonally across Berlin to the city's western border by way of Brandenburg Gate, cuts across Tiergarten under the name of Straße des 17. Juni, and merges into Ernst-Reuter-Platz, home to the buildings of Technical University only to continue in a straight line along Bismarckstraße and Kaiserdamm. On it goes past the ICC (International Congress Center) and the Funkturm (radio-tower), visible from afar, across Theodor-Heuss-Platz into Heerstraße, which bends slightly before reaching the River Havel. To the south, Grunewald park isn't far, to the north are situated the Georg-Kolbe-Museum, the Le-Corbusier-House and finally the gigantic facilities of the Olympic Stadium. What today is called Straße des 17. Juni originally connected the Summer Castle of Prussia's first queen, Sophie Charlotte, today's Schloss Charlottenburg, with the Berlin Royal Residence; in honor of the Queen, its name had been Charlottenburger Chaussee for 330 years. It was during the Third Reich that it was first widened to its current width to accommodate the planned reconstruction of Berlin as the so-called Global Capital Germania. In 1935, this newly developed grand boulevard destined for military pageants was given the official designation of Ost-West-Achse (east-west axis). In 1938, furthermore, the Siegessäule (victory column), originally decorating the Königsplatz (today's Platz der Republik), was transplanted to the Großer Stern (big star) roundabout. Since then, it has functioned as the highly conspicuous symbol of Straße des 17. Juni, which acquired its name by Senate decree on June 22, 1953, in memory of the people's uprising in the GDR. While the Allied forces conducted their annual military parades here until 1989, the street today provides urban terrain for any kind of big events.

Left: Großer Stern (Great Star) with Victory Column
right: statue of Louise, Queen of Prussia, in Tiergarten

Walking Tour: Neoclassical

Hotel Adlon, Akademie der Künste (Academy of Arts) and DZ Bank

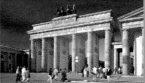

Brandenburg Gate

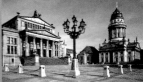

Gendarmenmarkt

Zeughaus (Armory)

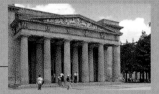
Neue Wache (New Guard House)

Bebelplatz

Friedrichwerder Church

People wanting to go to the Linden, coming from Tiergarten or the Reichstag, will walk through Brandenburg Gate. We shall walk as we did in 1791 when it was first opened, on foot. There are no cars on Pariser Platz either. It's a place for strollers, indeed. Since its last structural gap was closed with the building of the American Embassy, the former "Quarree" (square) – which had been completely destroyed – now presents itself as a unified composition of contemporary architecture, partly reflecting historical prototypes: architect Josef Paul Kleihues' twin buildings which respectfully take up their positions on either side of Berlin's emblem; the moderately futuristic French Embassy; Günter Behnisch's glass palace of the Akademie der Künste (Academy of Arts), Hotel Adlon's new building, and Frank O. Gehry's audacious DZ Bank. Because the architecture heading east is not very exciting – the Linden only first turns into a glorious boulevard in further course with Andreas Schlüter's, Georg Wenzeslaus von Knobelsdorff's and Karl Friedrich Schinkel's best structures – we are walking along the center margin under the trees, very comfortably, on a broad parkway. On our right hand, the Russian Embassy appears, a grandiose Stalinist structure built in 1949–51; its ground plan includes spacious front gardens and resumes 18th century traditionalism.

There is a jewel to be discovered on the left in Schadowstraße: the residence and workshop of Johann Gottfried Schadow, with its beautiful interior courtyard and

finely decorated façade. On past the Zollernhof on our left and the House of Switzerland, built in 1936 and featuring national hero William Tell who decorates one of its corners; we are crossing Friedrichstraße. There are rows upon rows of new buildings. Where the Deutsche Guggenheim exhibits classical modernism and contempo-

Old Museum at Pleasure Garden and Berlin Cathedral

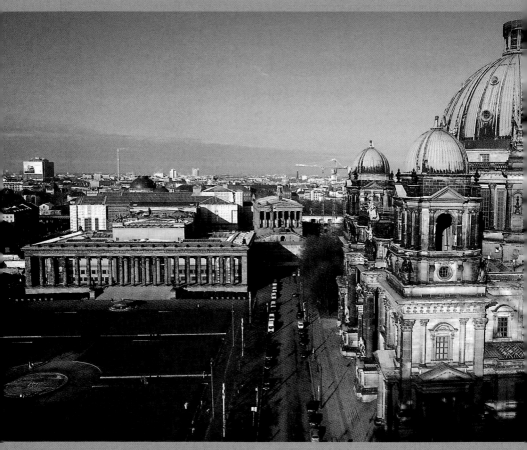

rary arts, we take a right onto Charlottenstraße; and soon we see two slender, gilded domes flash above the roofs: the Gendarmenmarkt. Those who set foot here for the first time are charmed by this masterpiece of beautiful proportions. The Schauspielhaus is one of Schinkel's most important constructions; it is flanked by the French Cathedral on the right and the German Cathedral on the left. Close by, at Jägerstraße 54, there used to be Berlin's most famous garret: Rahel Varnhagen's first salon. Two houses down we find the ancestral mansion of the Mendelssohn-Bank, founded in 1795, which presents an exhibit on the history of the Moses-Mendelssohn dynasty.

Beyond Oberwallstraße, we navigate towards a gothic brick structure: Schinkel's Friedrichwerdersche Kirche. His Bauakademie (school of architecture) was torn down in 1961; it now sits right next door in the form of a cube made of canvas, wooing us to let it be rebuilt in stone. Crossing Schinkelplatz, we walk back towards Unter den Linden. The small street Hinter der Katholischen Kirche leads us straightway to St Hedwig's Cathedral with its green dome and the most beautiful vista across Berlin's most representative square, the Forum Fridericianum, also called Opern- or Bebelplatz, with the Staatsoper; the Königliche Bibliothek (royal library), also called "Kommode" (literally, 'chest of drawers'); the Altes Palais next door, its newly reconstructed pergola presents a green feast for the eyes; and Humboldt University on the opposite side. These buildings present the pinnacle of Prussian architecture.

The master and inventor of the Forum, Frederick II, sits astride his favorite horse, Condé, decked out with tricorn and coronation mantle, riding towards Schlossbrücke – this statue, 13.5 m high, is the masterpiece of Christian Daniel Rauch: to the right, the Prinzessinnenpalais, today's Operncafé, which is connected to the adjoining, likewise neo-classicist Kronprinzenpalais by means of a covered bridge; on the left, framed by a small chestnut grove originally planted by the Soldier King, there is Schinkel's Neue Wache (New Guard House), a gem of classical clarity. The impressive Zeughaus (Armory), the city's most significant baroque structure, provides the punch line.

Then, when we sit down, on the other side of Schlossbrücke, on the lawn in front of the Altes Museum, and behind us we hear the bells of the Berliner Dom (Berlin cathedral), we feel as if we were on an island in the middle of the city. And it is indeed so: the Museumsinsel (Museum Island). Here we rest from Prussia's joyful revel in the arts and the senses, on this meadow, also called Lustgarten (pleasure garden).

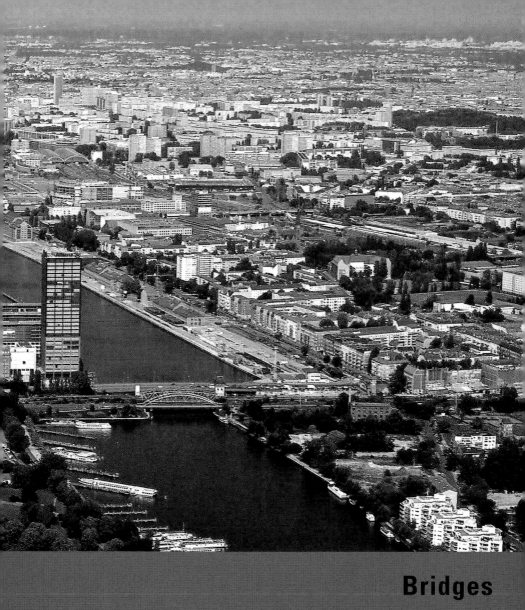

Bridges

Bridge in Government Quarter at Spreebogen (Spree curve)

Bridges

Spree, Havel and lots of canals: those were the city's main arteries for centuries. Berlin was, as a *Gründerzeit* dictum has it, "built by boat." But even earlier the city was "fed" by boat. The Prussian rulers and kings had always been heedful to care for the water traffic network and to enlarge it. It is to this network that Berlin owes a large part of its economic boom. The rivers and channels traversing the city flow for no fewer than two hundred kilometers; and more than thousand bridges cross these waters. At this number, Berlin surpasses Venice by more than double. Most of the bridges were built around the turn of the last century, when people started using the Spree for major barge traffic. Others can lay claim to a much longer history, such as the Jungfernbrücke (virgin's bridge); its lift mechanism made in Holland has weathered the last two hundred years with barely a change. The span of the youngest bridge, built in 2003, crosses over two buildings of the Bundestag (Paul Löbe Building and Elisabeth Lüders Building); in a "leap across the Spree" (Stephan Braunfels) – thus symbolizing the oneness of East and West – it accomplishes the bonds of unity.

Schlossbrücke (Palace Bridge)

Berlin's most prestigious bridge connects the former palace area with Lindenallee. Since 1991, its name has been Schlossbrücke again; it had been renamed Marx-Engels-Brücke 40 years ago after the demolition of the Stadtschloss. Its predecessor was a mere wooden footbridge called Hundebrücke (dog's bridge), because it was here, that the electors and kings with entourage summoned their packs of hounds and, moving down Linden, went hunting in Tiergarten. After the Liberation Wars, Karl Friedrich Schinkel was commissioned, in 1819, with designing a bridge made of stone; this bridge, along with the simultaneously built Neue Wache (new guard house), was to form "a harmonious whole on this beautiful street." The Schlossbrücke was constructed between 1821 and 1824 – at that time it still featured a drawbridge mechanism at its center to allow for shipping traffic. Decorated with sea horses, tritons, dolphins, and other maritime fauna, two cast iron parapets running along each side connect four granite pedestals; these are embossed with circular medallions decorated with eagle motifs designed by Friedrich Wilhelm Wolff. Schinkel had envisioned bridge ornaments crafted from copper, period pieces that were to delineate the life and sufferings of a warrior.

This design could not be realized because the city's coffers were empty. It was only after Schinkel's death that, between 1847 and 1857, his designs were turned into statues by students of master sculptor Christian Daniel Rauch – who carved them out of Carrara marble. Eight brilliantly white groups of figures rise from the bridge to commemorate the successful conclusion of the Liberation Wars. Represented are Nike, Goddess of Victory, and Pallas Athene who, as in a scenic narration, escort young heroes through the horrors of war towards peace. With his Schlossbrücke, Schinkel added a dramatic finish to the Prussian state boulevard Unter den Linden and its formidable buildings – and he elegantly attached it to the Palace, Pleasure Garden, Cathedral, and (Old) Museum. By the way, Berlin natives, never at a loss when it comes to making irreverent pronouncements, call it the "Puppenbrücke" (dolls' bridge).

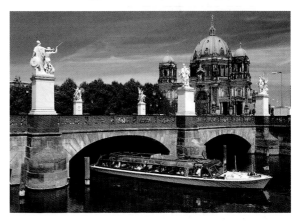

Karl Friedrich Schinkel and Neo-Classicism in Prussia

by Edelgard Abenstein

Portrait of K. F. Schinkel, 1826, painting by Carl Begas, oil on canvas, 27 x 20.5 cm, private collection

Karl Friedrich Schinkel has shaped the face of Berlin like no one else. He was the greatest and most influential of all Prussian master builders. The aesthetic quality of his work, which made him one of the most important architects of neo-classicism in Germany, radiates right into present times, because his canon of forms, culled from antiquity, has been trendsetting for 200 years. There is nothing that Schinkel would not have built: state buildings, villas and tenements, churches and barracks, monuments and bridges. There is nothing that he would not have designed: from the patterned porcelain vase to the wrought iron chair. Everywhere in Berlin we encounter his traces, and so we can say, Schinkel is not a name but a style. In his short life, he not only gave to Prussia and his capital an incomparably characteristic and graceful aspect of humane measure. But, according to his biographer Heinz Ohff, he "invented the beauty of Prussia."

Born in 1781 and raised as a pastor's son in Brandenburg's Neuruppin, Schinkel moved to Berlin with his mother, a young widow, in 1794. There, he studied under David Gilly, who co-founded the Bauakademie (School of Architecture) in 1799, as well as under Gilly's son Friedrich, who attracted attention with his sensational design for a monument to Frederick the Great. Gilly's very idiosyncratic style, imbued with suggestions of French Revolutionary architecture, wielded great influence over Schinkel's later designs. The debut piece by the barely 20-year-old architect was the Pomona Temple with Ionic portico on Pfingstberg, which was recently restored to its former beauty. From 1803 to 1805, Schinkel toured Italy and France. Since more sizable commissions were lacking during the era of the French occupation, he painted panoramas, dioramas and romantic landscapes for a living. He also fashioned a series of stage sets; in the

course of 30 years, his work appeared in more than 40 dramatizations. Next to the stage design for the world premiere of E. T. A. Hoffmann's opera *Undine*, the twelve designs he made for Mozart's *Magic Flute* were his biggest success. The palace of the Queen of the Night, with ribbons of stars on a deep Schinkel-blue canopy, counts even today among the most famous stage designs in the history of theater. On a recommendation by Wilhelm von Humboldt, with whom he had struck up a friendship in Italy, Schinkel acquired a position in 1810 with the administration of the Prussian Building Authority. In 1815, he was promoted to secret senior building advisor, in 1830 to Director of the Prussian State Building Office and in 1838 to senior land building director. This made him responsible for all larger building projects from the Rhineland to East Prussia. Again and again, he injected himself into their shaping processes so that many of them bear his signature. His masterpieces, however, were created in Berlin: the *Neue Wache Unter den Linden* (1818), the *Schauspielhaus am Gendarmenmarkt* (1821), the *Kreuzberg-Denkmal* (1821), the *Schlossbrücke* (1824), the Pavilion at *Charlottenburger Schloss* (1825), the (Old) *Museum*

Schinkel's stage design for the opera "The Magic Flute"

Blick in Griechenlands Blüte (View of the Flowering of Greece), copy of 1836 by Wilhelm Ahlborn, after a painting by K. F. Schinkel, 1825, oil on canvas, 94 x 235 cm, Alte National Galerie, Berlin

am Lustgarten (1830), the *Friedrichwerdersche Kirche* (1830), also four smaller suburban churches – such as the *Elisabethkirche* (1834) in Berlin Mitte, and the *Nazarethkirche* (1835) in Wedding – as well as the remodeling of *Schloss Tegel* as the neo-classicist *Humboldt-Schlösschen* (1824).

From the 1820s on, Schinkel had become well-known in the city thanks to his versatility. His style became a kind of commodity which circulated widely and fast. Schinkel was not only active as civil servant and architect, painter and scenographer, but also as designer who

designed simply everything: furniture, wall paper, chandeliers, parquet floors, picture frames, porcelain, iron railings, and garden benches. Thus he was inundated with a plethora of commissions, from the king himself, but also from Prussian princes, the Church, the aristocracy, and the middle classes. Even if Schinkel dreamed up rather fanciful projects in his final years – a royal castle on the Acropolis in Athens – and was always fond of painting architectural fantasies, he was anything but a utopian.

He built for the future and, in doing so, primarily

consulted antiquity. Pericles' Athens was his model for Spree-Athens, and he had a major part in its creation. Being a man of his times, he also conceived of medieval architecture as an artistic guideline. Schinkel worshipped both: He set Hellenism and the Gothic side by side, the ogival Friedrichwerdersche Kirche within eyeshot of his neo-classical Temple for the Arts. He believed in Humboldt's educational ideal as much as in the power of change. Even though Schinkel never built in a revolutionary manner, he was always open to the new. For example, the industrial architecture he encountered while traveling to England in 1826 provided him with an enduring inspiration. Its characteristic combination of brick, glass and iron showed the way into modernity and influenced his final work, which set a benchmark: the red brick ashlars of the Bauakademie, which is awaiting reconstruction. Schinkel's credo – "everywhere, one is only there truly alive, where one creates the new" – became his legacy via the Bauakademie. By the way, that he did not get rich as a result of his many talents did not disturb this most industrious architect of Prussia. He never owned a house in his lifetime and neither did he want to build one for himself. Owning property was not in to his nature. He also declined a promotion to the rank of the aristocracy. In 1836, he moved into a civil servant apartment in the Bauakademie. This is where Karl Friedrich Schinkel died on October 9, 1841.

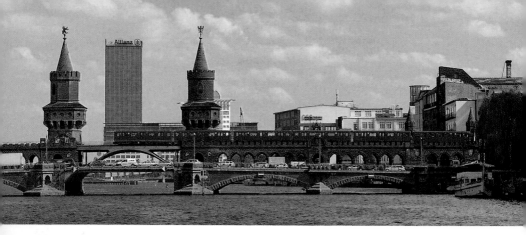

Oberbaumbrücke

For decades, Oberbaumbrücke, which links Kreuzberg and Friedrichshain across the Spree, had been a symbol for the separation of East and West. The border ran right through the middle of the river. When the Wall was built, the bridge was closed; metropolitan railway, subway and automobile traffic were discontinued. Only pedestrians with a GDR entry visa were allowed to pass. After Reunification, the bridge was renovated and a sweeping, new steel girder, designed by Santiago Calatrava, was inserted between the towers. Traffic started humming again in 1994, while the subway runs again today just as it did in 1902, on the second floor. Soon, the S-Bahn (suburban train), too, will roll once more across tracks that have already been laid. Its name brings to mind the first wooden bridge made in 1732; it was a cus-

tom's post from which at night a "tree" studded with nails was lowered as a barrier to prevent the smuggling of goods on the Spree. The lower tree was located further to the west, at the site of the future Kronprinzenbrücke, near the Reichstag building. The current Oberbaumbrücke, which was designed in 1894-1896 by architect Otto Stahn, is a neo-gothic brick structure, two stories high, equipped with arcades, battlements and two magnificent towers. It was badly damaged in World War II, and on April 23, 1945, it was partly demolished by order of Hitler so as to prevent the advance of the Soviet Army. Today, it is a traffic hub in the middle of expanding city districts: the desirable office and shopping district called Oberbaum-City which is located on the terrain of "Lampenstadt" (lamp city), at one time one of Berlin's largest industrial areas, and Rummelsburger Bucht, a residential quarter of the future.

Weidendamm Bridge

Weidendammer Brücke became famous beyond Berlin's borders due to a song about the Prussian eagles enthroned at the center of its wrought iron balustrades. The song is called *Ballade vom preußischen Ikarus* (Ballad of the Prussian Icarus); Wolf Biermann made it his farewell song to his country after being forcefully denaturalized by the GDR in 1976. But the bridge also knew happier days: here, Theodor Fontane became engaged to his future wife in 1840, after the cast iron construction had barely been imported from England and, in 1824, had been admired everywhere as one of the first of its kind on the continent. In earlier days, as so often in Berlin, a wooden draw bridge had done its work for centuries; it was first called Dorotheenstädtische, then Spandauische Brücke, because it connected the street – which was later named after the first Prussian King Frederick I – with the Spandau suburb. In 1895/96, when the Friedrichstraße train station had begun to vitalize this section of the street, it acquired its contemporary aspect. The brigde is one of the few bridges across the Spree which, out of 35, survived World War II without damages. While Moltkebrücke, due to a flawed foundation, was so impaired, only half a year after it had begun operations, that it was shut down again for a time in 1884, Weidendammer Brücke apparently stands on sturdier feet. But even this one is built on sand, as makes evident the empty area opposite, where once the old Friedrichstadtpalast stood and which still lies fallow today. Built in 1867 as Berlin's first market hall, it was reconfigured, first in 1874 to be used as a circus and then, in 1919, as the Großes Schauspielhaus, built by Hans Poelzig. It had its first glorious period under Max Reinhardt. Until the end of the 1970s, it served as the GDR's temple of entertainment, before its foundations were literally swallowed by the earth. The palace was torn down and reopened on Friedrichstraße in 1984.

Weidendamm Bridge, photo postcard, c. 1915

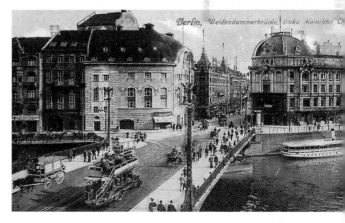

Glienicke Bridge

The border between West Berlin and the GDR ran as a white, horizontal line exactly through its center. And since absurdity knows no borders, it was actually on the GDR side that it was called Brücke der Einheit (Bridge of Unity) for over 40 years. It entered the postwar history books as a globally popular myth, since it was here that spies coming in from the cold were exchanged for spies of the West. No other border crossing between West and East Berlin, or the GDR, was so suited as airlock for agents, none other could be shuttered so hermetically against the public. Glienicker Brücke lies on a rural road between Berlin and Potsdam in the middle of woods, lakes and rivers. It spans the Havel and Glienicke Lake. Its dynamic steel construction with three arches and two twin pylons date from 1907. Demolished during the last days of the war and rebuilt to original specifications in 1950, it is the third bridge built at this location. It owes its name to the "Gut Klein Glienicke," a former farming estate at whose site sits, today, the castle, rebuilt in a neo-classical style by Schinkel, and rising from the center of a landscaped garden that feels rather Arcadian. Under the Great Elector, a modest wooden bridge had been sufficient. It was later enlarged since it constituted the sensitive bottleneck between the Hohenzollern Residence of Berlin and Garrison Potsdam with its royal summer palaces Sanssouci and the Marmorpalais (Marble Palace) sitting inside Neuer Garten. Its successor, the neo-romantic brick bridge built by Schinkel in 1834, was sacrificed to the new day, when Berlin grew up and became a big and global city; it was replaced by the bridge that is still there today.

Left: the eagle as a symbol of the Royal Prussian Dynasty, a detail of wrought iron art on Weidendamm Bridge

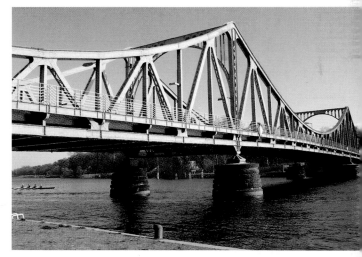

Walking Tour: Old-Berlin style

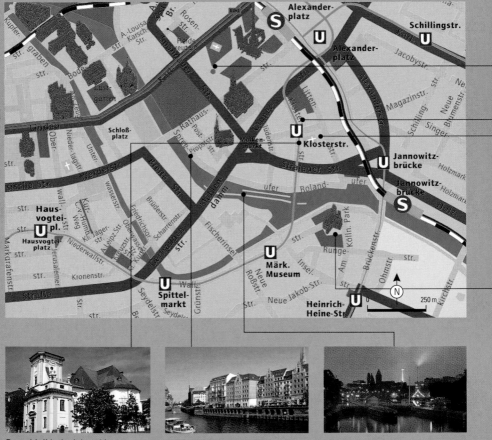

Parochialkirche (church)

Spree Shore at Nikolai Quarter

Mühlendamm Sluice

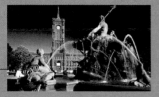
Neptune Fountain at Red City Hall

Palais Podewils

Old City Wall

Märkisches Museum

Just behind the underground station Klosterstraße, we come upon the last witness to medieval Berlin. Behind the old Parochialkirche, a remnant of the old city wall – made of fieldstones – has endured, because it served residential houses in the area as a rear retaining wall. Two patrician mansions dating back to the time of the first Prussian King prove that this area had evolved to become a prestigious middle-class quarter. Both were designed around 1700 for the first minister of state by the Huguenot master builder Jean de Bodt: the Palais Podewils, situated to the right on Klosterstraße, and the Palais Schwerin, which catches our eye on the other side of the Neues Stadthaus, on the curve of Stralauer Straße. Here at Molkenmarkt, a one-time hub of Old Berlin, big projects are in their planning stage. The buildings around the old Jüdenhof are to be resurrected, the streets are to become narrower and historical city ground plans are to be made recognizable again. Today, however, we cross the very busy Grunerstraße, cast a glance at the Ephraim Palais, a Rococo jewel, and then, attracted by the distinctive bulbous dome steeple-tops of the Niko-laikirche, we dive into what used to be the oldest city quarter until the war wreaked its damages; it was completely restored in 1987. Only the house at Poststraße, former residence of the architects family Knoblauch, is an original from 1760; its façade is adorned with a frieze of tendrils and flower oriel windows; it was remodeled in the early neo-classicist manner at a later

date. We walk along the water, take a look to the left at the historicizing wing of the Neuer Marstall and make a small excursion to the right towards Rotes Rathaus, before we cross the Spree via Rathausbrücke. On the reverse we walk past the façade of the Marstall with its triangular gable and then traverse Breite Straße, which was at one time a magnificent boulevard lined with rich middle class mansions; the sole witness to this period is the oldest residential building in the city, the Ribbeck-Haus. Via small Neumannsgasse, we now emerge in a quarter that sees few visitors as if it were a blind spot in the midst of the city. It is here, however, to the right on Brüderstraße,

Ephraim Palais

that the stronghold of German Enlightenment – showing a clearly articulated, late-baroque façade – lies hidden away: the Nicolaihaus. This was the platform from which Berlin's first salon made a name for itself. As a result, the provincial Royal Residence city caught up with the cultural centers of Europe. The publisher, author and philosopher Friedrich Nicolai bought the centenarian twin building in 1787; he had it remodeled as a publishing house and bookstore as well as a comfortable residence by his friend, the master-mason and later director of the Berliner Singakademie, Karl Friedrich Zelter. It was here that Schinkel, Schadow, Hegel, and Chodowiecki met. A series of plaques commemorates the illustrious guests. At present, the house is in the process of restoration, so that even the baroque inner courtyard is not accessible. The Galgenhaus next door, which suggests a similar architectural history, can likewise not be visited at this time. It contains the photographic collection of the Stadtmuseum. Although far younger than its noble neighbors, the home of the Saxony regional mission with its historicizing façade from the previous turn of the century also looks like a historical building compared to the prefabricated Plattenbau-buildings of the 1960s next to it.

We are led back to the present via the six-lane Gertraudenstraße, one of the main drags between East and West. We cross this broad swath and the freshly renovated towers of the Fischerkiez (fisherman's

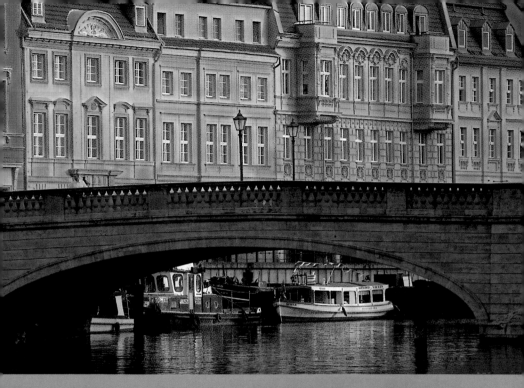

Bourgeois residences from the 18th/19th century at Märkisches Ufer

neighborhood) rise up in front of us. Catching sight of Spittelmarkt, we walk on along the banks of the Spree. Old barges bob on the water; they are the museum ships of historical harbors which tell the history of Berlin's river navigation. To the right, on promenade at Märkisches Ufer, beautiful middle-class mansions with neo-classicist façades are strung up like pearls, among these the famous Ermelerhaus. Beyond the harbor, quite close to the old city wall, Rem Koolhaas' brand-new Dutch Embassy (2000–2003) comes into view; it is made of glass, aluminum and exposed concrete and glows the color of roses in the late afternoon sun – just like the Märkisches Museum which is our last stop. This structure, however, does not require any special illumination, since – through-out the seasons – its façades, brick-red and immense, soar into the *Himmel über Berlin* (the heavens above Berlin).

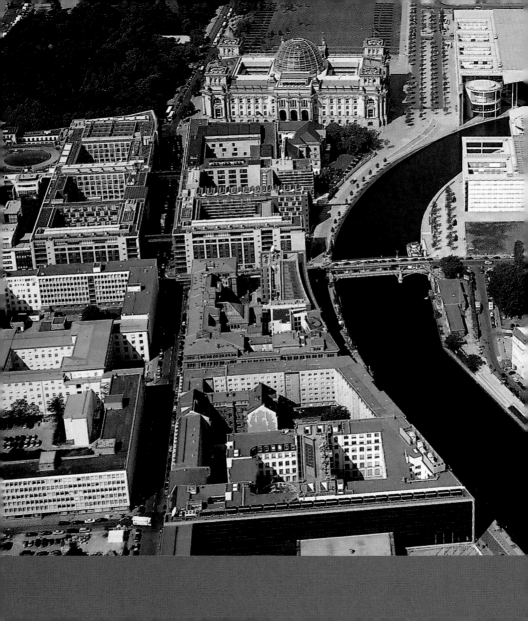

Government Quarter

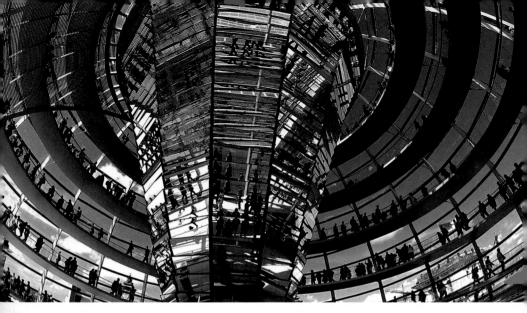

Government Quarter

Interior view of Reichstag dome

Little is left of the former control centers of political power. The old Hohenzollernschloss (Hohenzollern Castle) has endured only in the shape of its balcony from which, in 1918, Karl Liebknecht proclaimed the "free socialist republic." The GDR government affixed this relic to its new Staatsratsgebäude (Council of State Building). Wilhelmstraße, government mall of the Empire, the Weimar Republic and National Socialism, was almost wiped out in World War II. Today, the offices of the federal government are distributed among new and old buildings in the districts of Tiergarten and Mitte. Their center is the area between Reichstag and Spree; it had been a middle class residential neighborhood with late neo-classicist mansions and embassies up to the 1940s: the Alsenviertel. Hitler's architect, Albert Speer, wanted to build the Great People's Hall at this site; the better part of the quarter was razed for this purpose even before the major bomb attacks hit. After the war ended, the area lay fallow until the Wall fell and the subsequent decision was made to make Berlin the German capital. This sealed the move of parliament and government facilities from Bonn to Berlin and opened up this devastated urban territory at Spreebogen to new determinations.

Reichstag (Parliament)

Hardly any other structure represents so many turning points in German history as the Reichstag which, since 1999, has been the seat of the German Bundestag (Germany's parliament). It was here, that Philipp Scheidemann proclaimed the Republic on November 9, 1918. In the night of February 28, 1933, the dome and plenary hall burned almost entirely to the ground; this prompted the National Socialists to enact the "Reichstags fire decree" and later to push through the infamous "Ermächtigungsgesetz", which confirmed their claim to absolute power. In 1945, soldiers of the Red Army raised the red flag on its roof. The construction of the Reichstag was assigned to Paul Wallot after the 1871 founding of the Empire that made the Prussian Capital Berlin into the Imperial Capital. The massive freestone structure, reinforced with four corner towers and designed mainly in the style of the Italian High Renaissance, was erected in 1884 – 1894. While the Reichstag turned its back on the Schloss and the Government district, its main façade opened up towards Königsplatz (king's square). It was not only its dome, made of steel and glass – a technical masterpiece – that incited the disapproval of Emperor William II, since it competed with the dome of the Schloss. For him, the building constituted the "pinnacle of bad taste"; he called the Reichstag the "Reich monkey house". So it was not until 1916 that he agreed to the installation of the inscription "Dem Deutschen Volke" (For the German People), fashioned by Peter Behrens, above its western portal. Heavily damaged in the war, the Reichstag

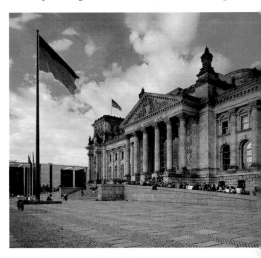

was reconstructed in the 1960s by Paul Baumgarten. After German reunification, contemporary opinion on whether or how to make use of this historically burdened building was split. Only after Christo's wrapping in the summer of 1995 did the mood change. Norman Foster, finally, was able to maneuver the historical building material and its remodeling into a highly functional parliament. His masterpiece is the new glass dome, accessible by means of a double spiral staircase, which allows all the visitors to look in on the gigantic plenary hall.

Band des Bundes

The 1991 comprehensive building plan by architects Axel Schultes and Charlotte Frank summarily declared the new government district the "Band des Bundes": like a clasp, it stretches across the Spreebogen and reaches beyond the river on either side; as such, it ties the Eastern to the Western part of the city, both symbolically and physically. The Bundeskanzleramt (Federal Chancellery, 2001) is not the largest, but the most impressive new structure of the complex. The extended concrete and sand-stone façades form a triple-winged arrangement. Only in the direction of the Reichstag, does the structure open up to reveal a showcase face featuring the *Berlin* sculpture by Eduardo Chillida. The actual center of power has its seat inside the central cube, in the Cabinet Hall on the 6th floor and, above that, in the Chancellor's Office. To the west, a bridge connects the seat of the administration with the Chancellor's Garden which continues across the water. All that remains of the historical Alsen Quarter in the vicinity of this area is the Swiss Embassy, a palatial structure built in 1871 (Friedrich Hitzig); it was given a new fortress-like annex in 2001 (Diener & Diener). The Paul-Löbe-Haus (2001) was designed by Stephan Braunfels and named after Social Democrat and President of the Reichstag Paul Löbe (1875–1967); its central hall alone with its wide bay galleries is more than 150 m long. Eight rotundas provide space for the conference halls of the Committees and offices for the Parliamentarians. The building continues as the Marie-Elisabeth-Lüders-Haus (2003) on the other side of the Spree, its two wings connected by a footbridge two stories high. Under the roof of this structure, likewise designed by Stephan Braunfels, there is enough space to fit one of the largest parliamentary libraries in the world. Elegant staircases traverse the building and lead down to the water. Its name commemorates the liberal politician Marie-Elisabeth Lüders (1878–1966). The

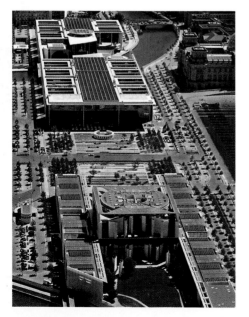

View of the government quarter at the Spreebogen

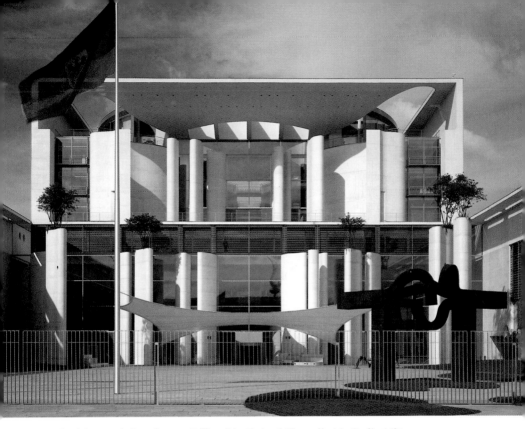

Façade of the Bundeskanzleramt (Office of the Federal Chancellor) in Berlin-Mitte

largest of the new structures of the Bundestag, the Jakob-Kaiser-Haus (2001), is named after the co-founder of the CDU (Christian-Democratic-Union, 1888–1961). The old Dorotheen Quarter with its small-scale structure is revived here in an architecture pervaded by light. Restored traditional buildings are integrated, such as the Reichspräsidenten-palais (palace of the imperial president) by Paul Wallot and the Kammer der Technik (chamber of technology). Courtyards open up towards the Spree. The entire complex of 1,745 delegate and parliamentary party offices feels like an intricate puzzle which admits various ways of looking in and through it.

Rotes Rathaus and Rathaus Schöneberg

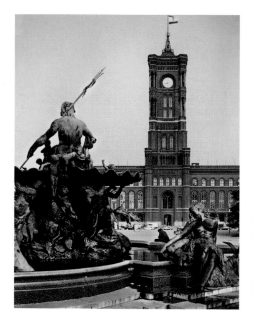

Italy and Flanders. A developing middle-class in the process of coming into its own thereby sent a signal visible from afar. The terracotta frieze encircling the first floor recounts, in 36 plates, Berlin's history up to the founding of the Empire. Heavily damaged in World War II, the building became the seat of the East Berlin magistrate after the city's division; West Berlin's government moved into Schöneberg City Hall. Its modest structure, dating from 1914 (Peter Jürgensen and Jürgen Bachmann), repeatedly entered the global field of vision on account of its acting mayors, such as Ernst Reuter and Willy Brandt. It was here that John F. Kennedy affirmed his commitment to this frontier city in his famous speech in 1963 ("Ich bin ein Berliner"). In its tower, to the present day, a replica of Philadelphia's Liberty Bell, donated in 1950 by the U.S.A., is rung every day at noon. On October 1, 1991, the Senate and Acting Mayor, however, returned to the Rotes Rathaus which has been called Berliner Rathaus ever since.

The Rotes Rathaus (Red City Hall) is named not for political chromaticity, but the gleaming bricks out of which it was built in 1861–1869, based on designs by Hermann Friedrich Waesemann, a student of Stüler's. While the round-arched style of its façade ties it to the typical architecture of Mark Brandenburg, the block-like body of the building and its stubby tower – 94 m tall and proudly topping the dome of the Königsschloss – references city hall types of

National Socialist Architecture

Bendlerblock, Court of Honor of the Memorial to the German Resistance

Hermann Göring's former ministry of air traffic survived, without damage, the aerial warfare planned at this site. With its smooth marble lime façade and its bands of windows suggestive of embrasures, this building is the only relic of the period in which Wilhelmstraße was synonymous with destructive global politics. Erected in record time in 1935/36 based on designs by Ernst Sagebiel, it was used as Haus der Ministerien by the GDR; in the 1990s, it was the home of the Treuhandanstalt headquarters. As of 1992, it was called Detlev-Rohwedder-Haus and functions as seat of the federal finance ministry. A memorial tablet on Leipziger Straße commemorates the protest event, held by construction workers

on June 16, 1953, that led to the people's uprising the next day. Other administrative structures, as well, demonstrate that architecture can serve as a warning to history; such as the federal ministry of labor and social concerns, which was the seat of Joseph Goebbel's propaganda headquarters, or the foreign office which is located in the former Reichsbank (1934–1940). The federal ministry of defense makes use of the so-called Bendlerblock, from where German generals conducted two wars of aggression in the 20th century and which was simultaneously the headquarters of the resistance fighters of July 20, 1944. Today, the memorial Deutscher Widerstand (German resistance) is likewise located there.

Walking Tour: Capital Style

Central Station

Hamburger Bahnhof

Ludwig Erhard Strand

Office of the Federal Chancellor

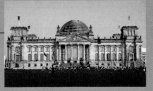
Reichstag

Haus der Kulturen der Welt
(House of World Cultures)

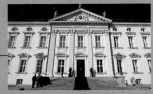
Bellevue Palace

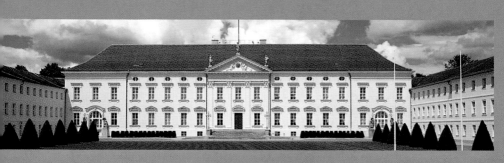

Bellevue Palace

The clock above the portal shows five thirty. Apparently, the president is at home, because the federal flag is flying on Schloss Bellevue. Now that the workday is done, it is a good time to explore the capital side of Berlin – starting from this spot. Already on Lutherbrücke, we see it present itself in wide-angle scope, lit up by the low sun. The dome of the Reichstag, International Trade Center, TV Tower at Alexanderplatz, Congress Hall, and Chancellery all rise up in a row above the Tiergarten trees. To get there, we pass along the residential complex for federal civil servants; Georg Bumiller designed it in the form of three large bends fitted along the Spree curve. It contains around 700 apartments which open up to the south, towards the water and Tiergarten park. This is a prime location, then, especially because one can comfortably get to the government district on foot; the many joggers and strollers peopling the waterfront lead the way. It is from this site that we can get the best view of Berlin's most spectacular hat, which reclines in a bold sweep on an ochre-colored oval:

the Kongresshalle. Hugh Stubbins designed it for the international architecture exhibition in 1957 to signal the bonds of German-American friendship; it was not quite as weatherproof as such a symbol should have been. After the roof collapsed in 1980 and reconstruction had finished, the Haus der Kulturen der Welt moved into the building; lovely summer evenings can be spent on the deck by the water. Here, Berlin still looks as if it had moved a bit closer to space in the swinging, or, as the vernacular has it, the pregnant 'Oyster.' In any case, it has definitely moved closer to the center of power which resides close by: The Chancellery is just next door. Unfazed by the proximity, the long distance runners run their rounds, while next to the Chancellery Garden and the bright fire station, designed by Sauerbruch-Hutton in red and green, the beer gardens are busy under the chestnut trees of the Zollpackhof. Simultaneously, as every day at 6 p.m., bells are chiming across Tiergarten. The sounds come from the Carillon, a tower covered with black slabs of granite

and located beyond the Kongresshalle. It is the biggest of its kind in Europe. Looking out from Moltkebrücke, we see the Main Railway Station present itself like a UFO made of glass and steel that landed on the banks of the Spree. From here we can survey the white "Band des Bundes" studded with the Paul-Löbe-Haus and the Marie-Elisabeth-Lüders-Haus, the home of the federal press conference and the long front of the Federal Chancellery; on the horizon, the towers of Potsdamer Platz glow in the evening sun; straight ahead, visitors trek through the glass dome of the Reichstag as if they were ants moving along an ant's trail. In front of this scene, the lone witness to the past asserts itself: the Swiss Embassy; its red-and-white national flag flies blithely on the roof. Down by the river, the mood is Mediterranean; rows of beach bars line the shore. Lately, as in Kreuzberg and Friedrichshain, the city on the Spree is playing Berlin by the sea everywhere. On the opposite shore, at Humboldt Harbor, Berlin is playing as well, if nothing but melodies of the future as yet. A new city district for the super rich is to be developed here, featuring hotels, apartments, offices, and restaurants. Construction sites will stay around for quite some time.

Going northeast, down Heidestraße, we arrive at the latest happening place of the metropolitan art scene on our right. We just have to follow the crowd, loosely streaming past body shops, freight movers and furniture warehouses, to find ourselves at the opening of one of the leading art galleries which has settled on the Spandau shipping channel along with its branch offices. There is a crowd of visitors, curators and collectors. No surprise. This industrial wasteland close to the city exudes a morbid charm. The cavernous buildings next door, the Rieckhallen, also used to be nothing but shipping warehouses; the superb Friedrich Christian Flick collection is on exhibit here. Walking back past the blackened sides of the building, we come

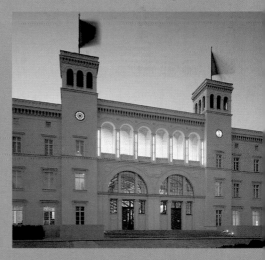

Hamburger Bahnhof in Invalidenstraße, Museum of Contemporary Art

upon the first museum for contemporary art in Berlin, the Hamburger Bahnhof. It is illuminated by Dan Flavin's neon installation; its blue-green light emanates from the slender pillared arcades above the portal and bathes the inner courtyard in a magical dusk, as it does every night.

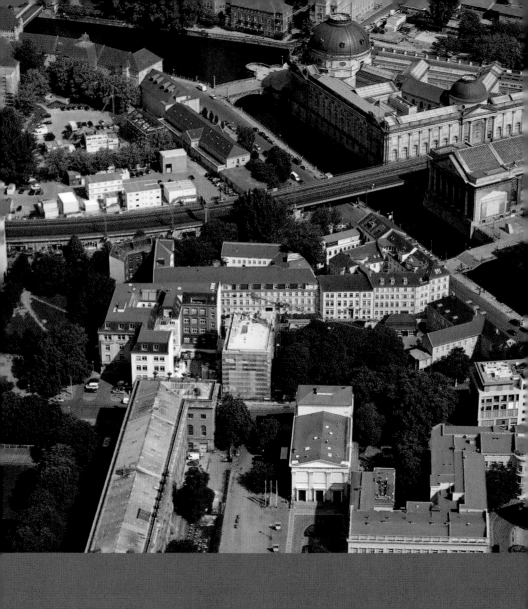

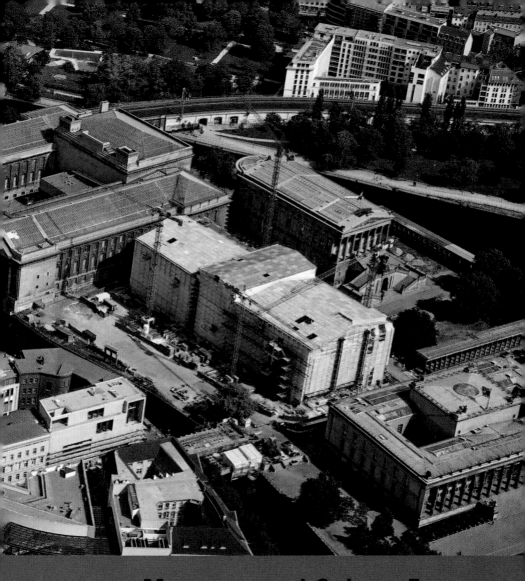

Museums and Culture Forums

Museums and Culture Forums

Berlin's crown jewels are its museums. The capital has about 170 of them, scattered across the city: From the big complexes on Museum Island, the Kulturforum at Potsdamer Platz and the center of Dahlem, to the Jewish Museum and Berlinische Galerie in Kreuzberg to the Liebermann-Villa on Wannsee; from the Natural History Museum in Mitte to Schloss Friedrichsfelde. This means a lot of national and international culture, of natural and technological history. During German Reunification, the museums and national libraries played the part of the heroic vanguard and at a speed that politics could often not rival. The spark jumped to other areas, as it had done once before during Bismarck's times, when the museums got up to speed so fast that they caught up with the world's largest museums in London, Paris or St. Petersburg. Now the former "twins" – once collecting and exhibiting separately in East and West – were reunited under a single roof. Thus the old masters of the Bode-Museum in Mitte migrated to the Gemäldegalerie at the Kulturforum, and the city-historical collection of the Berlin Museum in Kreuzberg was absorbed into the Märkisches Museum at Historischer Hafen. By the mid-1990s, the divided city of museums was a thing of the past. The unity of art was thus complete, at least on the level of topography. In another respect, though, an old character trait of Berlin has regained the upper hand. The city, always a multi-center environment, encourages competition among its various culture quarters – and this is to its benefit. Even though Berlin-Mitte, with its regained historical sites on Unter-den-Linden Boulevard and Museum Island, is experiencing a period of cultural high tide – unprecedented even during the glorious era of the 1920s – other sites are likewise gaining in significance. Around the Kulturforum, a new center is forming, comprised of movie theaters, the Berlinale Festival and the Film Museum. Just across, state representation offices and embassies with busy event schedules are coming into being. The loss of the non-European collections in Dahlem will surely leave a gap when they move – as maybe they will – into the Stadtschloss-to-be. But the area around Grunewald has a solid cultural base due to the Free University's expanding campus, and it offers choice attractions, such as the Jagdschloss (Hunting Castle) and Brücke-Museum. When the old Egyptians and their figurehead, Nefertiti, moved out of the Stülerbau at Charlottenburger Schloss, twilight seemed to take over. But when Heinz Berggruen's collection settled in across the street, a new museum district emerged as from a miraculous cell division. The Bröhan Museum and the Scharf-Gerstenberg Collection have made this area a center of gravity for classical modernism.

Museumsinsel / Museum Island

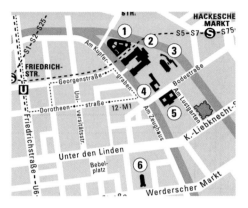

1 Bode Museum
2 Pergamon Museum
3 Alte Nationalgalerie (Old National Gallery)
4 Neues Museum (New Museum)
5 Altes Museum (Old Museum)
6 Friedrichwerder Church

One of the largest museum complexes in the world is situated on an island in the Spree; it specializes in European art and archaeology. The first structure on this site was Karl Friedrich Schinkel's Old Museum; it was already obvious when it opened in 1830 that the expansion-oriented collections required more space. Frederick William IV ordered the entire area "reconfigured as a sanctuary of the arts and the sciences" in 1841. As such, the complex of five impressive museum buildings came into being over a period of 100 years: In 1859, the New Museum; in 1876, the Old National Gallery; in 1904, the Bode Museum; and in 1930, the Pergamon Museum. During World War II, 70 percent of the museums were destroyed. "An intellectual world building," as Ludwig Justi, former director of the National Gallery, called

Museum Island, had collapsed in on itself and was only provisionally pieced together again in 1950. Then 1989/90 the political 'turnaround' occurred. In 1999, the first master plan was finalized to reconstruct the museums and redistribute the collections that had been divided into eastern and western after the war. That same year, UNESCO declared this "temple-city for the arts" a World Heritage Site. What had once begun as "the Prussian Acropolis," now is again guiding us – across a space of just 1 km^2 – through 6,000 years of history and high cultures from the Orient and the Occident, from the origins of European art in the Mesopotamian 'land of two rivers' and in Egypt, across classical antiquity, the middles ages, the Renaissance and Baroque periods, up to Impressionist paintings.

Bode Museum

Like an ark it lies in the water: On the northern tip of the island, where the arms of the Spree merge, a new museum was born around 1900; it was to house the enormously expanded holdings of the painting and sculpture galleries. One of William II's favorite architects, Ernst von Ihne, constructed the building in 1897–1904 in a neo-Baroque style, with a Florentine basilica at its center axis and a mighty dome above the entrance-hall. The museum was first named after Emperor Frederick III who had died in 1888. It acquired its current name in the 1950s, when it was reopened after renovation work to repair the war damages. At the end of the 1990s, a complete overhaul was launched and completed in 2006. Since then, the Bode Museum presents itself as the foremost port of call for European sculpture from the early Middles Ages through the 18th century, with a specialty in works from the German late Gothic period. What is enticing about its presentation is the harmonious relationship between its paintings and sculptures, a relationship pioneered hundred years ago by Wilhelm von Bode (1845–1929), art historian and curator. True to its original mandate, the museum is once again showing its Byzantine Collection, peerless in Germany, and its valuable coin cabinet, which features around half a million items and is one of the world's largest collection.

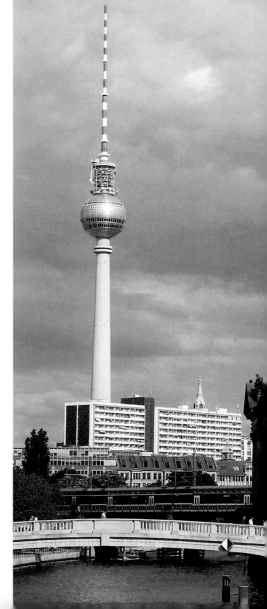

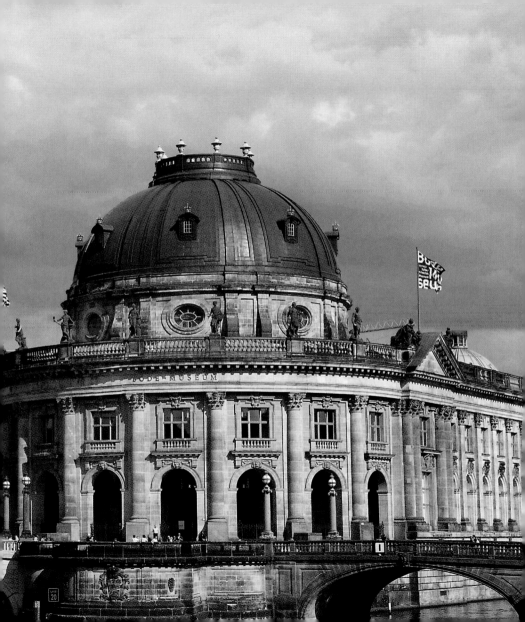

**Tilman Riemenschneider (c. 1460/65–1531),
Christ Appearing to Mary Magdalene,
from the Magdalene Altarpiece at Münnerstadt,
1490–1492**
Linden wood, 143.5 x 102 cm

In 1492, the Würzburg sculptor set up his large, 15 m high wing altar in the choir of the urban parish church of St. Mary Magdalene in Münnerstadt on the River Rhön; it had taken him all of two years to finish it. The Berlin bas-relief was taken from the left wing and presents the scene of "Noli me tangere": Christ appears before Mary Magdalene in the Garden of Gethsemane. As it is recorded in the gospel, Mary was the first to whom Christ presented himself after his resurrection on Easter morning. She is shown such grace because she had abjured her sinful way of life. The piece reveals the moment in which she recognizes the savior. Christ refuses her gesture as it signals her intention to touch him.

Riemenschneider also created the four evangelists for the Münnerstadt altar: Matthew and John are dressed in Hellenized clothing as apostles of Christ, while Luke and Markus, being students of Peter and Paul, appear as late medieval scholars. These figures, which originally were part of the altar's predella, are significant be-

cause Riemenschneider did not, as was customary at the time, paint them in color, but conceived them as monochrome. The Bode Museum owns a variety of Riemenschneider pieces that are unique in the world, including the *Mother of God from Tauberbischofsheim*, c. 1520. His 13 works are housed in their own hall; in 2007 its holdings were enriched when the group relief *Holy Anna with her three husbands*, c. 1510) was added.

Joseph Anton Feuchtmayer (1696–1770),
Maria, c. 1717–1719
Linden wood, height: 163 cm

She has always counted among the most popular figures in the museums due, in part, to the beauty of her face and her elegant figure, the magnificence of her dress and especially the bold sweep of her posture. Her identity, however, remained unknown for a long time, and so did the circumstances of her creation. Because of her beauty, she has often been taken for the Mother of God, or also for the Immaculate Virgin. Since she rises up, glancing downward, above a cloud, she must have once been placed up high. Usually, the figures of Immaculate Conception stand on a moon sickle or the global sphere, or they have one foot treading on a snake to signal victory over heresy, the turning away from true faith. As none of these insignia are present, this representation must be of Mary's Ascension, which has her looking down at the apostles who remain behind. Joseph Anton Feuchtmayer, who is called the master of Lake Constance Baroque, worked, for example, in the collegiate churches of Weingarten and St. Gallen in Upper Swabia, where he fashioned the choir stalls. He became famous for his comprehensive work on the interior of the Wallfahrtskirche Birnau on Lake Constance. The Berlin Mary is one of Feuchtmayer's early works. The newly made master, who was still working as a sculptor's apprentice in Augsburg in 1715, most likely carved her in Weingarten, where he settled in 1718. A beautiful Patrician lady of Fuggerstadt may have modeled as Mary there for his inner eye.

Wilhelm von Bode as Founding Director of the Berlin Collections

by Clemens Schmidlin

Wilhelm von Bode, photograph, c. 1925

His contemporaries characterized curator Wilhelm von Bode (1845–1929) as brilliant, ruthless, and compulsive. Kaiser Friedrich Museum on Museum Island, founded by him in 1904 and later, for an interim period, called Museum am Kupfergraben, was renamed in his honor in 1956. To live for art was not made easy for him. Raised in Braunschweig, Bode surely did exercise his eye early on at the local Herzogliches Museum where he helped reorganize the art collections and gave tours to foreign visitors. In obligation to his father, however, he first studied law in Göttingen and Berlin, until he was able to assert himself and register for lectures in art history. Throughout his life, he suffered bouts of ill health, so that his active commitment exacted an enormous willpower from him. Traveling frequently to museums and to meet collectors, as he had to, put a strain on him. In 1872, Bode started his position as plaster-of-Paris custodian in the department of sculptures at the Royal Museums in Berlin. In those days, no one believed that Berlin could one day compete for holdings in original sculptures with museums in Paris or London; that is why Berlin museums focused on collecting plaster casts. They also intended to create a replica collection of famous paintings. Bode would not have liked that, but as a fledgling art historian with a brand new doctoral title, this position was the chance of a lifetime. As soon as he took office, he was already given assignments in the gallery of paintings. He worked his way up in the hierarchy step by

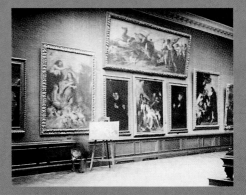

Historical interior view of Kaiser Friedrich Museum

step. After becoming director of the sculptures collection in 1883 and taking over the gallery of paintings in 1890, he could emerge as founding director of the newly built museum at the northern tip of Museum Island. "The opening was performed with great ceremony on orders of the Emperor [William II]. [...] The Basilica afforded the best place to sit and watch the festivities which were conducted very elegantly. As I could only move about in a wheelchair, I watched the celebration from a balcony above the Basilica. While making his rounds, the emperor came upstairs to greet me and to congratulate me on the successful completion of the project," Bode remembers in his autobiography. Ten years later he was raised to the peerage for his achievements.

Bode was active on behalf of Berlin's museums from 1872 to 1920 – at the end he had become their general director; this period is subsumed almost entirely in the era of empire, an epoch which accorded art collections a specifically national significance. Seen from today's vantage point, Bode's professional strategies seem quite modern: He tried to compensate for the chronic shortage of funds for art acquisition by networking with national and international collectors, donors and patrons. He founded a circle of friends, tried to get close to political decision-makers and advised private collectors, who were to be softly pressured into making donations to the Royal Museums. Bode took part in the creation and enlargement of several departments and collections at the Berlin Museums, and he initiated construction of the Pergamon Museum and Dahlem Museums. He also emerged as an explorer of art previously

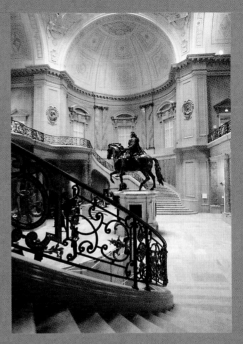

Domed hall of renovated Bode Museum with equestrian statue "The Great Elector"

neglected. He was probably drawn to the challenge of being the first to organize a collection scientifically and systematically. His publications on Dutch painting as well as German and Italian sculpture were long considered authoritative. His ideas on how to present exhibits at the Kaiser Friedrich Museum set a precedent: Works were shown in ways that combined various art forms and then placed in rooms furnished accordingly; this was to grant visitors a sensuous experience of bygone eras.

Pergamon Museum

Exactly 100 years after the opening of Schinkel's museum, the capstone was set on Museum Island. Alfred Messel and Ludwig Hoffmann designed the world's first "Architecture" museum (1909–1930) to house the collection of classical architecture – famous even then. It was built, literally, around the reconstructions of the Pergamon Altar, the Ishtar-Gate and the Processional Boulevard of Babylon. Later, the early Islamic Mschatta-façade of a Jordanian desert residence moved in. Construction was very difficult on the swampy territory of Museum Island. A precursor building was completed in 1901 but had to be demolished only eight years

later for structural reasons. Financial straits, World War I and the November Revolution interrupted the building process, so that the Museum's opening was postponed until 1930. The treasures of Museum Island were accessible to the public for only a decade; then all Berlin museums were closed one year after World War I had begun. Reconstruction of the Pergamon Museum was completed in 1956. Since that time, it has been called by its current name. At present, it is the home of the Classical Antiquities Collection, featuring Greek-Roman architecture, inscriptions, mosaics, bronze sculpture, and small artifacts. It also houses the Museum of the Ancient Near East, featuring Hittite, Assyrian and Babylonian steles, monuments and bas-reliefs, as well as the Museum of Islamic

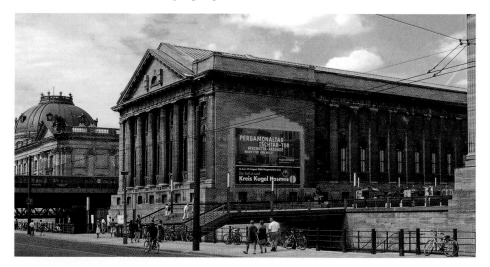

Art, featuring architectural fragments, pottery, print culture artifacts, Persian miniatures, carpets, and woodcarvings. Here, too, vigorous renovation is still very much in process, and the three-wing structure designed by Oswald Mathias Ungers will be locked by a crossbar.

Female Figure with Pomegranate, 580–560 B.C.
Marble, height: 194 cm

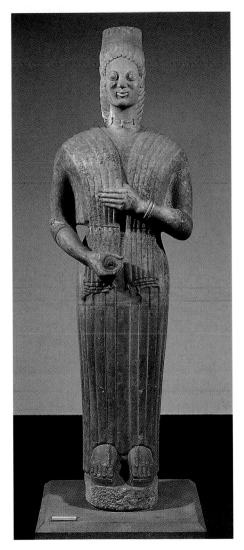

Her characteristic trait is her brilliant smile. The statue became famous as "Berlin Goddess," though it is assumed that the figure represents a female mortal. In early Greek times, figures of women and young girls were created as valuable presents for the consecration of sanctuaries, or they served as funereal figurines. Goddesses and mortals alike are decked out in fine clothes and gorgeous headdresses. These same insignia mark the Berlin figurine as a woman of distinction. Even the yellow and red paint covering her firm, clearly contoured body is still recognizable; the body was preserved almost intact. In her right hand she holds a pomegranate; its flickering symbolism allows for many interpretations. The myth of Persephone, who was abducted by Hades and held captive in the underworld against her will, has proven especially persistent. Only when she ate of the pomegranate offered her by Hades, did she succumb forever to the ruler of the dark empire, foiled by the fruit's inherent love charm.

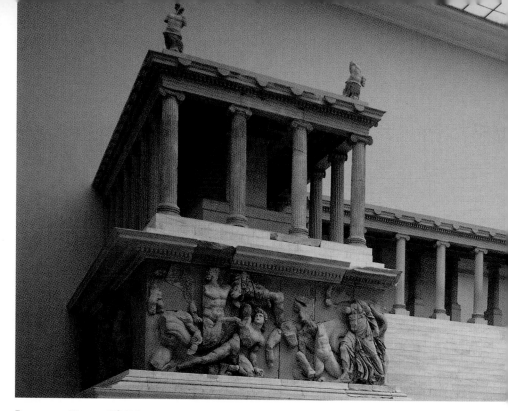

Pergamon Altar, c. 170 B.C.
Marble

The Pergamon altar is one of the most
famous structures of antiquity. It was con-
sidered one of the Seven Wonders of the
World. Above a massive fundament, into
which is carved an exterior flight of steps
some 20 meters wide, a portico rises up;
it once encircled the courtyard with its
massive table for burnt offerings. The altar

was erected in 170 B.C. during the reign
of Eumenides II. Apparently the gods
favored the inhabitants of Pergamon,
because an altar inscription explains that
the temple was created out of gratitude
for divine beneficence. In any case, no
warlike purpose seems to be associated
with it. The altar, on the other hand, is of
another nature. It represents the mythical
combat of the Giants against the Greek
gods; in this way, it furnished an analogy

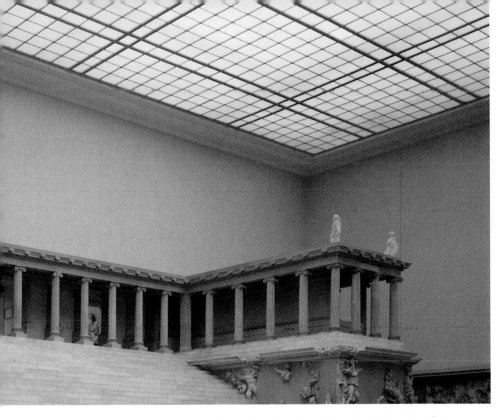

for the fight of the good, just order and civilization against evil, arbitrariness and chaos. Described at length by the ancient poet Hesiod, the "Gigantomachy" was a theme frequently reworked in Greek art. Nowhere, however, is it represented as expressively as in the frieze of the Pergamon Altar. The 113 m long frieze, nowadays lining the entire hall, once decorated the external wall of the altar. The interior frieze shows Telephos, son of Heracles and legendary founder of the City of Pergamon. The altar, dismantled during Byzantine times, had long lain buried before it was uncovered in 1878 by a German archaeological team directed by Carl Humann; it was brought to Berlin in 1880 and the following years. The reconstruction of a third of the altar as well as of the grand staircase, built to original scale, made construction of the new museum a necessity in 1901.

Pergamon Frieze, Zeus Group
(Detail of the Eastern Frieze), c. 170 B.C.
Marble, height of frieze: 2.30 m

It is a war of all against all. The children of arch goddess Gaia – the snake-footed Giants – have rebelled against Olympus to gain dominion. The survival of the Old World is at stake. Deploying all the powers under his command, Zeus enters the battle. He hurls lightning, kneads clouds into threatening mountains and opens the heavens to release torrential rains to crush the leader of his opponents, Porphyrion, along with his companions. To the left of the father of the gods fights Heracles, who can only be identified by a fragment showing a paw of his lion's pelt. The faces and bodies of the giants reveal pain, psychological suffering and the merciless nature of their extermination. Other bas-reliefs show that the goddesses Artemis, Hecate and Semele have also joined the melee. Even the mother of the gods herself, Hera, charges into battle on a chariot; and Aphrodite, the goddess of love, boldly plunges a lance into the body of a foe, in defiance of death. The representation of this battle is distinguished by its unsparing realism. No group of warriors is alike another. Physiognomies, garments, the flexing of muscles by the gods and giants, their headdresses and footgear – all vary in the details. The frieze of sculptures with its some hundred larger-than-life figures constitutes one of the most magnificent achievements of Hellenist art.

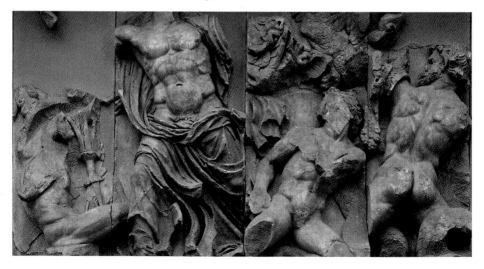

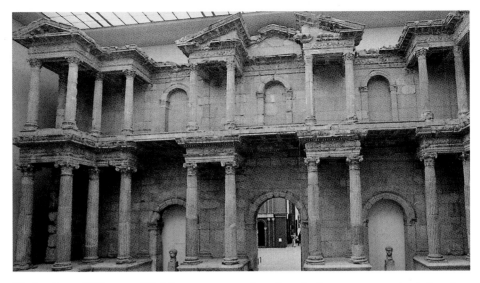

Market Gate of Miletus, c. 120 A.D.
Marble, height: 28.92 m

Originally, the gate with its magnificent façade served as the entrance to the antique city of Miletus, now located in Turkey. Probably constructed with municipal means, it rose up high above the market halls and added a highlight to the complex of prestigious buildings in the southern part of the agora. Situated on a broad avenue, a gymnasion, a glamorous nymphaeum und a buleuterion (city hall) likewise belonged to the complex. The two-story portal was probably adorned with many sculptures. It collapsed during an earthquake in the 11th century. Some of its fragments were recycled and absorbed into neighboring build-

ings, but the better part was buried underground. It was rediscovered in 1903–1905; after obtaining clearance from the Turkish authorities, the archaeologists brought to Berlin parts of its columned architecture. At the end of the 1920s, the market gate was reconstructed in the new Pergamon Museum to be as close as possible to its original setup; the work was based on measurements by architect Hubert Knackfuß, and it was directed by archaeologist Wilhelm von Massow. During World War II, it remained in the museum. After being hit by a bomb and badly damaged, it underwent repairs until 1954 – though they were provisional and not very professionally done. It is currently undergoing more restoration work slated to be complete in 2010.

Ishtar Gate, c. 580 B.C.
Colored, glazed bas-relief bricks, 14.73 x 15.70 m

The gateway with its two flanking towers bears the name of the Babylonian goddess of love, Ishtar. It constituted the northern exit from the city of Babylon, the capital of Babylonia, located on the Euphrates in what today is central Iraq. The wild animals depicted on the walls symbolize the main gods of Babylon: The lions represent the goddess Ishtar, ruler of the heavens, who was in charge of love as much as the protection of the army. The snake-like dragons represent the city god Marduk, who gave the gifts of fertility and eternal life; the bulls referred to the weather god Adad. The gate once guarded the entrance to a 90 m high *zikkurat*, a stepped temple, which stood at the head of a stately avenue traversing this ancient global metropolis. For a long time, Europe had known only the image transmitted by the Bible of the great "Whore of Babylon." Instead, Babylon on the Euphrates – set, as it was, among corn fields, palm groves and the legendary hanging gardens – was a hub of international trade and the political center of an empire quite comparable to that of the later *Imperium Romanum*. Under Nebukadnezar II (605–562 B.C.), one of its last famous kings, such riches once again flowed into the city and were reflected in architectural works previously unknown to the world. Even the façade of the throne room in the royal summer palace is evidence of that process. Like the gate, the façade was reconstructed to original scale.

Lions of the Processional Way in Babylon, c. 580 B.C.
Bas-relief made of colored glazed bricks

The Ishtar Gate stood at the end of a processional street which was lined with walls; originally, it was 20 to 24 m wide and about 250 m long. It was adorned by a frieze made of blue glazed bricks, on which, in those days, 120 bright golden lions were striding, 60 on each side. During the new-year festivities in the spring, the annual processions led through the street's shining canyon, passed through the gate and ended at the bridge across the Euphrates. In the Vorderasiatisches Museum, only parts of this complex have been reconstructed – about 30 m wide street walls have been reconstructed as 8 m wide. The animals are pieced together from countless fragments of embossed tiles to approximate the origi-

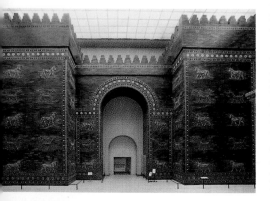

nal as much as possible. Today, the Processional Way leads to Babylon Hall, where the model of the main sanctuary of the city god Marduk, the "Tower of Babel" and a copy of the famous stele of King Hammurabi's code of law are special attractions.

Bas-Relief with Representation of the Weather God of Tell Halaf, 9th century B.C.
Basalt, 83 x 57 cm

Even a god occasionally needs weapons, especially a god who looks like a human. The wall panel from the exterior siding of the city or palace wall of Tell Halaf shows the weather god with a bundle of lightning bolts and an axe. The attributes were part of his appearance but could also be worshipped separately as his symbols. Effigies of the weather god are very frequent in the art of late Hittite principalities – of which Tell

Halaf was one. Where rain-fed agriculture was prevalent, such as in Syria, Northern Mesopotamia and Asia Minor, securing enough food for sustenance depended on how much rain fell, that is, on forces of nature, whose charioteer was the weather god. He was worshipped under various names; the most common among these was Hadad or Baal.

The larger-than-life size statue of a male discovered near Sam'al likewise represents the weather god Hadad. His weapons, the bundle of lightning bolts and axe, have not survived, but they can be supplied via the imagination, as can a base decorated with bulls. By means of an Aramaic inscription that covers his entire abdomen, the king of the principality reports that he dedicates this statue to Hadad, because the latter bestowed such prosperity and fertile growth on his land. Furthermore, he asks that he may partake of eternal life after his death. In the very lively rendition of the weather god that appears on a series of bas-reliefs from Malataya – dating back to the beginning of the 1st century B.C. – the lightning bolt itself becomes a divine being, summoned from his bedchamber and hitched up in front of the chariot along with the bulls.

Highlights of the Berlin Antiquities Collections – Archaeological Excavations in the 19th century

by Clemens Schmidlin

Carl Humann, discoverer of the Pergamon Altar

prohibited the export of any discovered archaic objects. This was quite different in the 18th and 19th centuries. The impulse to excavate frequently originated in England, France and Germany, which accorded ancient high cultures a more ideal character than their countries of origin. Excavations were conducted because Northern Europeans were interested in researching the ancient world, but also to enlarge their

Trojan pendant earrings (2,300 B.C.), discovered during excavations in Troy directed by Heinrich Schliemann, Museum for Pre- and Early History, Berlin

Classical building façades, such as that of the Roman Market Gate of Miletus, located today on Turkish territory, but also sculptures, such as the archaic statue of a youth from the Greek Island of Naxos, and Nefertiti's bust from Tell el-Armana in Egypt – works of such stature are no longer available on the art market or as new acquisitions in the museums of Central and Northern Europe. Their countries of origin have long since recognized the cultural and tourism values of their cultural legacies, and they have

own collections of art. Sculptures bought for the collection of Frederick II formed the basis of the Berlin Antiquities Collections. Included in these is the so-called *Praying Boy*, a Greek bronze statue made around 300 B.C; after its rediscovery, it was much mended and amended on orders of its numerous prominent former owners before arriving in Berlin in 1747. A collection of vases was initiated in 1805 and, as of 1833, considerably enlarged under the leadership of archaeologist Eduard Gerhard (1795–1867). Originally, these art works were dispersed among various castles. The idea of uniting them in a single public exhibition venue was born at the end of the 18th century. In 1830, the ancient works found a home in Karl Friedrich Schinkel's (Altes) Museum. Soon after, archaeological expeditions were launched with the explicit aim to enlarge the collections. Railroad engineer, architect and archaeologist Carl Humann (1839–1896) discovered the Pergamon Altar in 1878 and, in the ensuing years, excavated and expedited it piece by piece to Berlin. The Ottoman Empire cleared the goods for exportation; they were shipped by way of the German Marine. The altar was first recomposed as a detached structure standing freely inside a museum explicitly built for it; however, this building had to be torn down in 1908 due to foundational instabilities. The new building, today's Pergamon Museum, was designed by Alfred Messel and opened in 1930; in this setup, the back of the altar could nestle up against supporting walls.

"The Praying Boy" – bronze sculpture from Rhodes (c. 300 B.C.), property of the museums of Berlin

Further excavations were launched in Olympia — founding hero of classical archaeology, Johann Joachim Winckelmann (1717–1768), had already dreamed of such a project — as well as in Samos, Milet, Priene, and Didyma. Excavations at these sites are still in process today under the leadership or with the assistance of the German Archaeological Institute. This institution now works under the auspices of the Ministry of Foreign Affairs, headquartered in Berlin. Excavations, in general, no longer seek to discover valuable art objects; rather, they are conducted to amplify our knowledge of the past. And, of course, nowadays they are not fueled by an imperial sense of mission, which was still a motivating factor for the Wilhelminian Empire in its competition with the great colonial powers.

Other Berlin collections profited as well from these archaeological activities that brought

Right: Kore "Ornithe" from the Geneleos Group (c. 560–550 B.C.), Archaeological Museum Berlin
below: bas relief of bulls on Ishtar Gate, Babylon (604–561 B.C.), photograph, c. 1902

them significant new holdings. Nefertiti's bust, made of limestone and covered with plaster and paint, derives from the Ancient Egyptian New Kingdom; found by architect and Egyptologist Ludwig Borchardt (1863–1938), during excavations near Tell el-Armana in 1912 and donated by patron of the arts James Simon (1851–1932), it has been enriching the Egyptian Museum collection since 1920. Whether objects discovered during privately financed excavations under Heinrich Schliemann (1822–1890) in Troy were to go, in part, to Berlin, was unclear until 1879, because Schliemann was quarreling with representatives of Germany's archaeological faculty. It was to the credit of Rudolf Virchow (1821–1902) and his visit to the Troy site that Schliemann was freed of the suspicion that Germany had turned away from him. The first crates full of Trojan findings arrived in Berlin as early as 1881. These objects dating back to the Bronze Age were exhibited in the pre-historical and ethnological collections, which had been merged as a result of Virchow's activities.

Ludwig Borchardt, 1910, painting by
Max Liebermann, oil on canvas, 89 x 71 cm

It happens again and again that countries demand their ancient artifacts be returned to them. This desire is understandable as the Mediterranean countries have developed an interest in the ancient world that is quite comparable to that of the northern countries. Their scientific and organizational means to perform this kind of research has likewise developed. At the same time, the conditions of acquisition, seen retrospectively, are often judged differently by different countries. So it is often argued, that only the presence on site of the archaeologists saved many of the artifacts from the smelting furnaces and lime kilns; inversely, others argue that much was only broken during excavation or exportation. In principle, such debates only target famous works. The actual aim, to comprehensively preserve the cultural legacy of the ancient world, often recedes into the background during such arguments. One strategy to deal with these disagreements is to present exhibitions in new didactic formats, for example, to captivate visitors by showing them only a few, well-placed ancient artifacts, or also, if this can be done in a way that protects them, through mutual loans of such artifacts.

Adolph von Menzel –
Chronicler of the 19th Century

by Edelgard Abenstein

Art history owes a debt to historical painter Adolph von Menzel. When Edouard Manet was just 13 years old, Menzel created Impressionism in Berlin, and with nothing but a small picture without action: his *Room with balcony* (1845), where ephemeral rays of sunlight gliding over

Adolph von Menzel (1815–1905),
Self-Portrait, 1834, chalk lithograph

the parquet and a current of air making the curtains billow play starring roles. And yet, during his lifetime Adolph von Menzel became famous with his paintings on the life of Frederick the Great. However, he did not present the king posing as a ruler. Instead he preferred scenes that avoided all manner of pathos or solemnity, such as the *Flute concerto by Frederick the Great at Sanssouci* (1850–1852), during which a member of the audience gazes at the ceiling in boredom. Though very detail-oriented, Menzel lacked any sense of majestic dignity. As such, he became one of Germany's most significant representatives of Realism. And he was a witness to nearly all of the political and social turmoil of the 19th century – because Menzel lived to be nearly 90 years old. Painting and drawing, he observed how Berlin changed from a royal residence city to an industrial metropolis. Menzel was born in Prussian Breslau in 1815; his father operated a local lithographic print shop. In 1830, his family moved to Berlin. After the untimely death of his father, young Menzel took over his business and took care of his mother and siblings. In 1833, he attended Berlin Academy of the Arts for half a year and then went on teaching himself. After his first paintings which anticipated Impressionism, he dedicated himself to Realism. He painted his *The Dead of March Lie in State* (1848) as a historical painting without heroism. He received several commendations, including the Order of the Black

"Iron Rolling Mill," 1872–1875, Adolph von Menzel, oil on canvas, 153 x 253 cm,
Alte Nationalgalerie, Berlin

Eagle and he was elevated to the peerage. His contemporaries saw him primarily as a painter of the court. His themes, though, were his era and the people he brushed shoulders with. He could be found at courtly balls, on horse drawn carriages and in children's rooms, always equipped with pencil and drawing pad. No subject was too small for him; he made drawings wherever he went and waited. "His small Excellency" – Menzel was only 1.40 m tall – was a chronicler of modern life, and he embellished nothing. He painted the view from his studio window, bears in Berlin Zoo, his unmade bed, and his father's hand. He did thousands of sketches; for his painting, *Das Eisenwalzwerk* (Iron Rolling Mill, 1872–1875), the first significant representation of industries in Germany, he made more than 100 preliminary drawings. When Menzel died in 1905, he was an internationally renowned artist, and Emperor William II honored him with a state funeral – the National Gallery with a memorial exhibition.

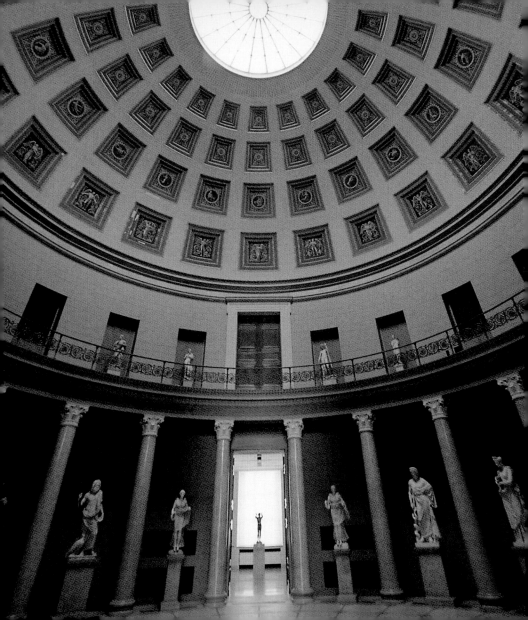

Altes Museum

Schinkel himself thought it his master-piece: this museum which looked like a Greek temple and which asserted a fourth power in the state next to palace, cathedral, and armory – that of art and culture. As the first public museum in Germany (1825–1830), the Old Museum opened royal collections to the public. The Latin inscription on the main façade says it all. The building is dedicated to the "study of any type of antiquity and of free art." Two sculptures – Albert Wolff's *Lion Slayer* and August Kiss' *Fighting Amazon* – flank the wide outdoor steps to the vestibule supported by 18 Ionic columns. These in turn are guarded by 18 Prussian eagles on the roof. The heart of the museum is the perfectly proportioned rotunda which was modeled on the Roman Pantheon (height, 23 m, Ø 23 m). The collection of antique statues found their home inside a circle of 20 Corinthian columns and in the alcoves along the upper gallery walkway.

Since 1998, the Antiquity Collection can be viewed on the main floor as well as in a second location, the Pergamon Museum. Highlights of the collection, which is organized according to themes such as "Sports," "Festivities," "Revelries," and "Gods," are, among others, the Scythian golden treasure of Vettersfelde, *the Praying Boy*, the *Enthroned Goddess of Tarent*, as well as other artifacts of Minoan and Etruscan culture. For the interim period until 2009, the Egyptian Museum has been placed on the upper floor after leaving its old home in Charlottenburg. Even though the heavy pieces, such as the temple gate of Kalabsha, cannot be shown for structural reasons, the highlights of the Amarna period compensate amply for this sacrifice.

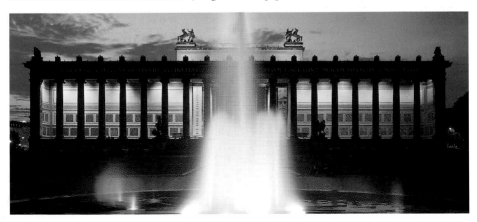

Amphora of the "Berlin Painter," c. 490 B.C.
Clay, height: 81.5 cm (with lid)

The god Hermes has sought the companion-
ship of the satyr Orcimachos. Jauntily he is
swinging two wine vessels, a pitcher and a
jug, which have obviously been emptied.
He has given his lyre, the instrument tradi-
tionally ascribed to him, to his companion,
who is likewise holding a jug. Satyr and god,
equipped with their respective typical attri-
butes, one with beard and animal tail, the
other with wings on hat and shoes, consti-
tute an uneven pair. But the painter turns
them into brothers of the moment. Andro-
gynous, fine limbed and full of grace, their
movements merge them one into the other.
The maker has been called "Berlin Painter"
ever since art history has declared the vase
with Hermes and Satyr from the Berlin
Antiquity Collection to be his work. His
identity is unknown. But sharp observation
of his style of painting, based on the Berlin
amphora, allowed art historians to ascribe
between 200 and 250 works to him, mostly
medium large to large vessels such as belly
and neck amphorae. The vases in red-figure
style from his early period, assumed to be
c. 500–480 B.C., count among the most
significant achievements of Attic art of the
period.
The Antiquity Collection is famous for its
comprehensive assortment of vases from the
classical era and for its imagery of heroes
and gods: The Attic bowl of the painter
Sosias shows the figure of Achilles bandaging
Patroclos.

Likeness of Pericles,
Roman Copy of the Original, c. 430 B.C.
Marble, height: 54 cm

When there is a battle, the Corinthian helmet covers the face like a mask. In times of peace, it is worn loosely above the brow – as does Pericles (c. 500 – 429 B.C.), the Athenian statesman and leader of the army. Full of character is his expression, his hair is kempt, his lips, lids, eyebrows are full of symmetry – this portrait obviously incarnated an ideal. No other Athenian ever achieved such a position of power, no other knew so well how to assert himself. Athens' citizens elected him strategist 15 times in a row. His rhetorical giftedness was legendary, as Plutarch has one of his contemporaries report: "When I throw him on the ground in a wrestling match, he denies having fallen, and so successfully that even those who've seen him fall with their own eyes, believe him." With the Parthenon and the Propylaea, Pericles initiated the building program of the Acropolis; as patron, he allegedly financed a prize for Aischylos' *The Persians*. Under Pericles, Athens embarked upon a period of cultural excellence. His age is named after him. The Roman marble bust of Pericles – four different versions of which are preserved, e.g., in the British Museum in London and the Vatican Museum – is probably a copy of a bronze statue created by the sculptor Cresilas. The Greek original has not survived.

How much this portrait is idealized cannot be ascertained. In one respect, however, the representation is true to Pericles' personality as handed down by tradition: The manager of politics set a high value on his dignified performance.

**Bust of Nefertiti, New Kingdom,
18th Dynasty, Amarna Period, c. 1340 B.C.**
Limestone and plaster, height: 50 cm

"The beautiful one has arrived." This is her name in translation. Nefertiti, the "most beautiful treasure" of Berlin, is still today one of the most mysterious figures of ancient Egypt. Ludwig Borchardt discovered the bust in 1912 in the Egyptian city of Achet-Aton near Tell el-Amarna, as the site is known today, where Echnaton built a city for his god. When the excavated treasures were divided between Egypt and Germany in 1913, the now world-famous bust was given to the Germans. Berlin's "Cotton King" James Simon, who had financed the expedition and thus came into possession of the artifact, donated it to the Prussian Museum in 1920. In 1924, Nefertiti was first publicly exhibited in the New Museum on Berlin's Museum Island. Nothing is known about her origins. She was the spouse of Amenophis IV, who called himself Echnaton and caused a political earthquake in his state. He turned religion and society upside down, deprived the caste of priests of their power and overthrew the gods, except for one, Aton, the sun god. For the woman at his side, the Pharaoh had made a clear choice: Only his principal consort could call herself a queen and achieve the rank of goddess. Nefertiti. The royal couple lived in a newly built, magnificent metropolis on the eastern bank of the Nile, to the north of Thebes, near today's village of Tell el-Amarna.

Their era is named after this place. The Amarna period artifacts are among the most beautiful historical artifacts of ancient Egypt. Next to Nefertiti's bust, which has retained its coloring through 3,350 years without any restoration, the museum also owns other extraordinary items, the painted relief *Walk in the Garden, the Simon's wooden figure* of Echnaton (named after James Simon who donated it), the small limestone statue of Nefertiti, and, linking both, the pair of hands from a double statue of the royal couple. This epitome of earthly harmony is an effigy of the harmony between mankind and god.

That is not lastly why the Egyptian Museum is regarded as having one of the most significant collections of Egyptian high culture in the world.

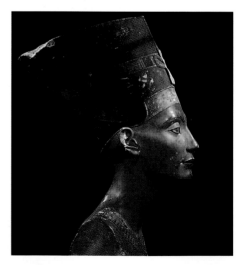

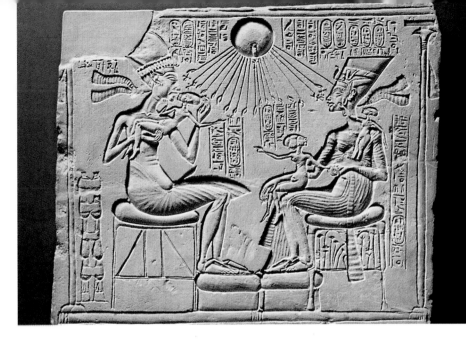

**Family altar with Representation
of the Royal Family Akhenaten and Nefertiti,
New Kingdom, 18th Dynasty,
c. 1350 B.C.**
Limestone, 32.5 x 39 cm

It is a scene imbued with intimacy. Nefertiti, Akhenaten and their three daughters receive the life-giving rays of the creator and sun god Aton. The royal family – shown in their privacy. This alone already rates as news. Always recognizable by her unique head-dress, Tefnut's crown, she is positioned – revolutionary for her time – on a par with her spouse and thus equipped with powers equal to the King's. Furthermore: Akhenaten sits on an unadorned throne, but Nefertiti sits on one that is borne by the plants of the United Kingdom. And the scene reveals that Akhenaten enjoyed spending time with his family. Through Nefertiti, woman's traditionally strong position in ancient Egypt's society is raised yet again to an unprecedented degree. The image thus announces a political program. And it is an icon of the Aton religion: Akhenaten represents the masculine, Nefertiti the feminine element of creation. Both understand themselves as gods on earth. This is unparalleled in Egyptian history. The image of the Royal Family replaced the traditional representations of various gods.

German Historical Museum

The most important, still existing baroque building in Berlin went through four architects in only eleven years: Johann Arnold Nering, Martin Grünberg, Andreas Schlüter, and Jean de Bodt. It was dedicated to assume its function in 1706: The Zeughaus served as a weapons arsenal during Prussia's ascent to the status of a major European power – which was incentive enough for Berlin March revolutionaries to raid it in 1848. After the founding of the Empire, it served as a museum of weapons and war until World War II. From 1952 to 1990, the Museum for German History of the GDR used it to exhibit its own view of the "revolutionary traditions of the German people." It was in turn absorbed by the German Historical Museum which emerged with a new outlook in 2006. Germany's history is now on exhibit in a manner inviting debate – in the European context and in its regional multiplicity. Past and present are not only modalities of the exhibits but also emerge in the way in which this traditional building and Berlin's newly configured city space co-exist: Ieoh Ming Pei, a student of Walter Gropius', designed the new exhibition hall as an airy structure made of glass and stone; it creates an optical pivot between Museum Island and Linden Boulevard, the oldest building of which is the Zeughaus.

Right: rear annex to the museum by I.M. Pei

Otto Antoine (1865–1951), Leipziger Platz, c. 1910
Oil of canvas, 51.7 x 86 cm

A horse-drawn carriage, hackney-coaches, a streetcar, a double-decker omnibus – it is the bustle of the big city. The vehicles cleave through the crowds, past vendors of any kind. They sell flowers, vegetables and balloons. The spectator is standing at the curb of Leipziger Straße leading to Potsdamer Platz. To the right looms the military guardhouse of Potsdamer Gate. In the background towers the stately Hotel Fürstenhof that – built by architects Richard Bielenberg and Josef Moser – has been dominating the square since 1907. In front of it, there crouches the small customs house of the gate, remodeled by Schinkel in 1823/24. Otto Antoine captured the hustle and bustle of Leipziger Platz around 1910 in a late impressionist manner. He had been living in Berlin since 1890, attending lectures at the Berlin Academy of Arts and studying at the studio of Franz Skarbina, a determined innovator during the Berlin Secession. Antoine's works were exhibited at the Great Berlin Art Exhibitions of 1904 and 1906. He continued to paint a variety of similar Berlin scenes, repeatedly portraying Leipziger Platz and Potsdamer Platz, until his final such painting in 1930. Antoine's portrait of Berlin big city life illustrates changes over time in a congenial manner. The speed and merciless business of the most traffic-congested public square in Europe, however, remain mostly off limits. In contrast to Hugo Krayn or Ernst Ludwig Kirchner, Antoine searched for the idyllic at the heart of the metropolitan Moloch.

Humboldt University

At the site of the current massive structure on Unter den Linden Boulevard with its three-story main tract, Frederick the Great had originally planned a royal palace. Once built on the Forum Fridericianum, across from opera, cathedral and library, it was supposed to represent the close alliance of monarchy, art and science. Nothing remains of this project but a reduced version, the town residence for the king's brother, Prince Heinrich, constructed by Johann Boumann the Elder in 1748–1766. Frederick William III donated it to Berlin's University, which then bore his name until 1946. Its founding was achieved primarily through the instigation of Wilhelm von Humboldt in the wake of the reform movements.

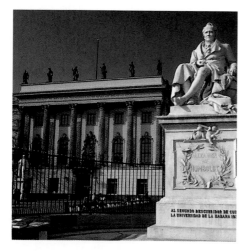

Humboldt designed a "Universitas litterarum," in which the oneness of teaching and research was supposed to be as central as the demand to teach students in a comprehensively humanistic manner. This idea was disseminated all over the world and spawned several similar institutions of learning in the ensuing one and a half centuries. Berlin University began operating in 1810. Its first elected president was the philosopher Johann Gottlieb Fichte. Besides Georg Wilhelm Friedrich Hegel, those who were most instrumental in quickly spreading the university's reputation as a hotbed for the humanities were Friedrich Schleiermacher, Ludwig Feuerbach, Jacob and Wilhelm Grimm. From the start, though, the natural sciences – led by scientists such as Christoph Wilhelm Hufeland and Albrecht Daniel Thaer – likewise determined the character of the faculties. Due to the support of Alexander von Humboldt, after whom the university was then named, it quickly became a trailblazer of many new disciplines. The outstanding scientific achievements of such scholars as Robert Koch or Albert Einstein are verified by its 29 Nobel prizes. Charité medical school was integrated in 1829; its horseshoe-like main building was enlarged when Ludwig Hoffmann added a mirroring structure in 1913–1920. After its destruction by bomb attacks in 1944/45, the entire complex was reconstructed, patterned on its historical model. Since 1949, it is named after its creator, while in the West the Free University was founded as a result of the Berlin Blockade.

Brothers Wilhelm and Alexander von Humboldt

by Edelgard Abenstein

They are one of the most famous pairs of brothers in Germany. While Alexander, as a "second Columbus," opened new horizons not only for the natural sciences, Wilhelm laid the foundations for a new theory of education and the humanities. Their father, a retired army officer and chamberlain to the crown prince, focused his attention on providing the best possible education and cultivation for his sons growing up in Tegel Palace. Their teachers belonged to the foremost circles of the Berlin Enlightenment. Predestined to occupy influential posts of the state, both of them broke with their intended careers after their mother's death. Born in 1767, Wilhelm dedicates himself less to law and more to philosophy, history and ancient languages, later also the Basque language, Indian Sanskrit and the languages of Native Americans. Two years his junior, Alexander fulfills the dream of his youth and becomes a natural scientist. In 1799, he travels from Spain via the Canaries to South America, staying on for about five years to study the flora, fauna und geology of the continent. The first leg of his journey takes him up the Orinoco and Amazon Rivers. The second leads him to Cuba and into the Andes, where he primarily explores volcanoes. During his stay in Mexico, he collects materials for a geo-

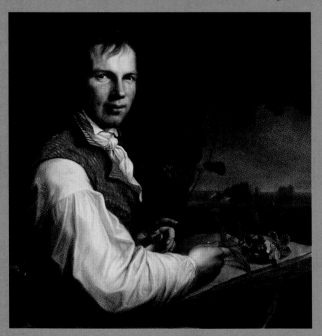

"Portrait Alexander von Humboldt," 1806, by Georg Friedrich Weitsch, oil on canvas, 126 x 92.5 cm, Berlin, Alte Nationalgalerie

graphical monograph on the former colony, the Kingdom of New Spain. Back in Europe, Alexander von Humboldt publishes his experiences in a work comprising 30 volumes. His brother Wilhelm considers him "the biggest head," made to "connect ideas, see the concatenation of things that without him would have remained undiscovered for generations." In 1829, the student of nature embarks on yet another journey, this time into the Asian territories of Russia. Upon returning, he works for a quarter century on his magnum opus, a five-volume monograph entitled *Cosmos*. It consists of nothing less than the inventory of knowledge on earth up to the mid-19th century. In 1859, Alexander von Humboldt dies at nearly 90 years of age in Berlin.

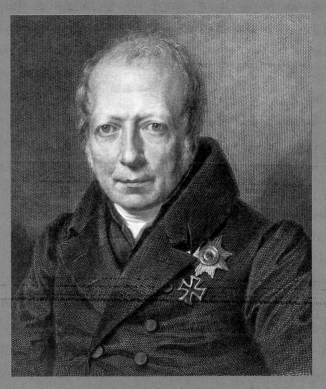

Wilhelm von Humboldt, steel engraving by J. L. Raab after Franz Krüger, c. 1840

Already fluent in Greek and Latin as a 13-year-old youth, Wilhelm von Humboldt, while studying the ancient world, discovers the purpose "of humanity's philosophical knowledge as such." He comes to see the Hellenic mind as "the ideal of that, which we ourselves would like to be and create." In 1794, he moves to Jena, where he joins the Weimar classicists. His comments on Schiller's *Wallenstein* and the latter's writings on aesthetics are as infused with a deep appreciation for art as his reading of Goethe's *Hermann und Dorothea*. Following extended visits to revolutionary Paris and the Basque country, he spends a number of years in the Prussian civil service, at first as an envoy to the Holy See in Rome, where he serves until 1808. It is in Rome, that he has the leisure, along with his wife Caroline, to transform their stately

mansion near the Spanish Steps into a social hub. Sculptors Bertel Thorvaldsen and Christian Daniel Rauch frequent their salon, as do young Karl Friedrich Schinkel, Friedrich Tieck and August Wilhelm Schlegel, who arrives in the company of Mme de Staël. Returned from his American expedition, Alexander likewise stays with his brother for several months before going on to Paris, where he embarks on the task of scientifically evaluating the materials he collected during his expeditions. In 1809, Wilhelm von Humboldt is appointed head of the Section for Culture and Instruction at Prussia's Ministry of the Interior. During his tenure, he accomplishes the implementation of a thorough educational reform; it outlines a three-tiered system that has students progress from elementary to humanist secondary school and on to the university; and it was to ensure improved educational opportunities across all social strata. As a diplomat and ambassador attending the Vienna Congress and the Bundestag in Frankfurt am Main, he repeatedly strives to find a political solution to the German question. In vain, because his attempt to implement a liberal constitution in Prussia leads to his being sidelined and, in 1819, discharged from all his offices due to his resistance to the Karlsbad Decrees. Subsequently he withdraws to his family residence in Tegel, where he studies languages up to his death in 1835. As un-

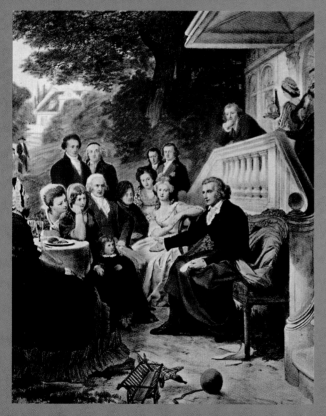

Schiller's Garden house in Jena, 1797, standing, from left: J. W. von Goethe, Chr. M. Wieland, Wilhelm and Alexander von Humboldt, after a drawing by Wilhelm von Lindenschmit the Younger

like as these brothers were one from the other – Wilhelm developed a more pronounced Prussian patriotism during his political service, a quality he occasionally found absent in his brother, who was spending so much time in that Mecca of research, Paris –, they were united in their cosmo-political approach to their respective areas of research. The legacy of the Humboldt brothers was forged by Wilhelm. Alexander explicitly refers to it in *Cosmos*, where he writes that its intent is "to suspend the borders between people that have been set up by prejudice and all kinds of one-sided views; and to treat all of humanity, regardless of religion, nation and color, as one large, closely related tribe."

This noble legacy will be embodied in the new Stadtschloss to be built in the center of Berlin. Next to the artistic and cultural objects from Africa, Asia, the Americas, and Oceania from the Dahlem Museums, the City Palace will be enriched by Humboldt University's valuable collections some of which go back to the famous pair of brothers. Thus Wilhelm's humanistic ideal of education merges with Alexander's notion of global knowledge to create the Humboldt Forum named in their honor.

Alexander von Humboldt on the Orinoco, 1877, wood engraving after a painting by Ferdinand Keller

Staatsbibliothek Unter den Linden

With over nine million books and journals – systematically collected since 1661 – its ten million manuscripts, atlases, musical notations, and maps, it is one of the largest libraries in the world. The building on Unter den Linden Boulevard is its third home. At first, the Great Elector had started to furnish a library in the apothecary wing of the Stadtschloss. This task was passed on, in 1780, to the Kommode (liter-ally, chest of drawers) on Bebelplatz, so named for its curvy shape. Originally reserved for the Prussian Court as well as select scholars, it was opened to students as well after the university's opening in 1810. Furthermore: The ascent of this institution of higher learning to the status of one of the most important universities of Germany, which would function as a model for the educational system of all of Europe and North America, could only succeed because of the proximity of the Royal Library, an already seasoned and richly stocked institution. The Kommode,

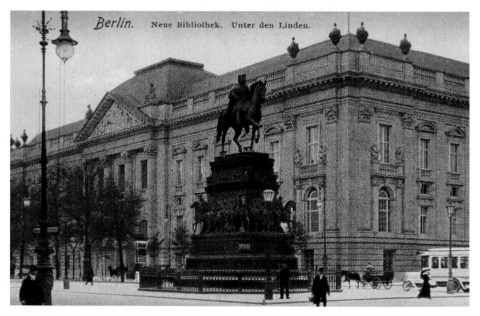

Staatsbibliothek zu Berlin (Berlin State Library) on Unter den Linden Blvd., postcard from 1915

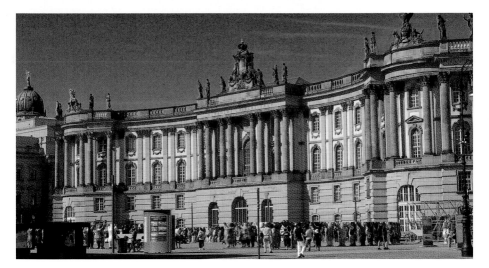

"Kommode" at Bebelplatz, former Königliche Bibliothek (Royal Library)

however, was spatially limited and therefore retired from service after 100 years; it was equipped with a new auditorium and rededicated as lecture hall on the occasion of the university's anniversary. Since then it has been used chiefly by the law school. The library migrated across the street into a neo-Baroque building constructed by Ernst von Ihne in 1903-1914. Until 1902, this site had been occupied by the Academy of Sciences; it was housed in a former Imperial Stables building which was remodeled by Johann Boumann d. Ä. in 1743. In the red hall of this structure, the first president of the academy, Gottfried Wilhelm Leibniz, presented lively lectures inspired by Queen Sophie Charlotte. Into the 1930s, the Prussian State Library belonged to the most significant libraries in the world. In the fall of 1941, its entire holdings were removed for storage at local monasteries and castles, in Southern Germany and in the regions east of the Rivers Oder and Neiße. After the war, the library system was divided as well. In West Berlin, holdings stored in the western zones became the basis for the State Library of the Prussian Cultural Heritage Foundation at Culture Forum; the eastern holdings found their way back into the Deutsche Staatsbibliothek Unter den Linden. After German Reunification, the hoard of books was likewise reunited and redistributed between the two houses.

Kulturforum
Potsdamer Straße

Located between Tiergarten, Potsdamer Platz and Landwehrkanal, the Kulturforum with its architectural singularities can be found around St. Matthäuskirche, a brick structure built by Friedrich August Stüler in 1846 in the Italian-Romanic style. European art has come to be gathered inside this complex. The idea of a new cultural center in the western part of the city goes back to Hans Scharoun who, already in his "Kollektivplan" of 1946, designed a "Kulturband" (culture strip) along the Spree and who, even in the 1950s and in spite of all political adversities, always kept in mind a unified cultural landscape for Berlin. It stipulated an additional cultural junction exactly midway between the Linden in the East and Charlottenburg Castle in the West. In this way, on the site first devastated by Hitler's architectural designs for a gigantic new capital and then utterly destroyed during the war, something new was created, starting with the cornerstones of the Philharmonie, the Staatsbibliothek and the Neue Nationalgalerie. The Museum of Musical Instruments, Kunstgewerbemuseum and the Kammermusiksaal followed suit, and even later the Kupferstichkabinett and the Kunstbibliothek. The 1998 capstone was the Gemäldegalerie following a planning and construction phase that lasted more than 30 years. The architects Hilmer & Sattler designed the sober and functional new building on the southwestern corner of the Kulturforum.

Gemäldegalerie

The collection of European paintings from the 13th through the 18th centuries rightly counts among the greatest and most important collections worldwide. It was opened in 1830 in the Königliches Museum am Lustgarten (Royal Museum at Pleasure Garden), which was designed by Schinkel; today it is called Altes Museum. Its original holdings were the art collections of the Great Elector and Frederick the Great. Under Wilhelm von Bode, museum curator from 1890 to 1929, they soon acquired international fame. Since 1904, they have been exhibited in the Bode Museum, originally called Kaiser Friedrich Museum. World War II did a lot of damage. More than 400 large-scale works were lost or destroyed. Berlin's subsequent division further disintegrated the collection. After the paintings were divided between East and West, e.g., between the Bode and Dahlem Museums, they have now been reunited at Kulturforum in the Picture Gallery. The building's core is a triple-nave foyer with a central water basin by Walter de Maria. Surrounding the foyer are 72 halls und cabinets which present c. 1,000 major works; 400 more paintings are exhibited in the Studiengalerie on the lower floor. Central to the Gemäldegalerie collection are 13th to 16th century paintings by German and Italian masters and 15th to 16th century paintings by Dutch masters. Highlights are works by Albrecht Dürer, Lucas Cranach the Elder, Hans Memling, and Pieter Bruegel the Elder. The collection's crown jewels are Dutch and Flemish masters of the 17th century, especially Rembrandt's works – and, still, *Man with a Golden Helmet* (c. 1650/55), even though it is now considered certain, that it was not painted by him and only fashioned by his workshop. Other works are portrait, genre and landscape paintings by, for example, Frans Hals, Jacob van Ruisdael and Peter Rubens. French masters are represented by Antoine Watteau and Nicolas Poussin, among others; among Spanish masters, El Greco and Diego Velázquez are preeminent, and among English masters, Joshua Reynolds and Thomas Gainsborough have pride of place.

Caravaggio (1571–1610),
Amor Victorious, 1601/02
Oil on canvas, 156 x 113 cm

Michelangelo Merisi da Caravaggio, usually just known as Caravaggio, is considered the first great representative of the Baroque school of painting.

The youthful god of love – a winner. He triumphs by his smile, and there is nothing that could dispute Amor's rank. He literally stands above it all, above science, art, fame, and power; their symbols lie scattered at his feet: Violin, lute and sheets of music, angle and compass, pen and laurel, armor and crown. Placed before a blue, star-spangled globe, he seems to possess the whole world. Provocative and self-confident, he makes fun of any kind of human ambition, of moral and intellectual values. All the while he stands on tip-toes, his left leg propped up on a table or the edge of a bed covered by draperies, a precarious position, then, which shifts his genitals, placing them almost at the center of the painting. Caravaggio's model, a handsome boy from a Roman suburb, served him also as a prototype for religious figures – which strained the moral sensitivities of his contemporaries. Hallmarks of Caravaggio's works that revolutionized 17th century painting were the use of chiaroscuro and the naturalism of his figures.

In answer to Caravaggio's tantalizingly naked, adolescent god, Giovanni Baglione created his heavenly Amor (c. 1602/03) in full armor, wrestling to the ground earthly love. The heavenly messenger restores order when he strikes out against any kind of frivolity.

**Antonio del Pollaiuolo
(c. 1431/32–1498),
Profile Portrait of a Young
Woman, c. 1465/70**
Cottonwood, 52.5 x 36.5 cm

It is one of the most famous women's portraits of the Italian early Renaissance and counts among the most noted paintings of the Gemäldegalerie. The distinguished lady with perfectly symmetrical features conformed to the beauty norms of her times: blond, light skin, blue eyes. Since the painting's appearance in 1894, there has been much speculation on its origin and creation. For a long time it was considered the work of Piero della Francesca who had painted a similar profile portrait of a woman (Museo Poldi Pezzoli, Milan). Antonio del Pollaiuolo's brother Piero (!443–1496), whose *Annuciation* is shown next door as a large Quattrocento altarpiece, was also considered as originator. Today we know, based on stylistic characteristics that stick out when compared to other paintings of the period that it was painted by Antonio. Its clear contours, carved out against the blue sky, and the robust relief on the narrow marble balustrade, but especially the finely drawn ornamental details of the magnificent robe, indicate the experience of the multi-talented Antonio del Pollaiuolo, who also made a name for himself as a goldsmith and a sculptor of bronze, and who additionally designed textiles and embroidery.

Titian (c. 1488/90 –1576),
Venus and the Organist, c. 1550/52
Oil on canvas, 115 x 210 cm

That music and Eros derive from the same family is no secret. What is surprising, however, is their combination as created by Titian. Resting on a bed of red velvet, Venus leans towards little, flirtatious Amor as if she were listening to a whispered message of love, while a noble young man is just turning away from his organ to watch the spectacle. Obeying his clients' wishes as he often did, Titian painted this constellation many times over, one of them owned by the Prado in Madrid. In 1545, he wrote to Emperor Charles V that he would soon deliver to him "a Venus" he had created in his name. In its wake, he produced, until 1570, a series of paintings, including the Berlin painting, in which music mingles capriciously with the goddess of love. While its cool, muted colors are reminiscent of mannerism, the lively movements animating the painting seem to herald the baroque. While creating his Venus-and-organist variations, the grand master of the Venetian High Renaissance also painted his famous portraits of politicians and the pope during the same period. That he knew, additionally, to wittily characterize the private side of power, is apparent from his *Portrait of Clarissa Strozzi at the Age of Two Years* (1542), another masterpiece owned by the Gemälde-galerie. As if taken from a family photo album, the little girl from the famous Florentine dynasty, dressed in the appropriate trappings of her class, bends over a stone table on which is perched her small dog. One of her hands rests on its back, the other is holding a pretzel. This picture is one of the earliest portraits of children in the history of Italian painting.

Jan Vermeer van Delft (1632–1675),
The Glass of Wine, c. 1661/62
Oil on canvas, 66.3 x 76.5 cm

An elegantly dressed, young man is observing a girl as she empties her wine glass. His hand on the wine jug, without drinking himself, he seems to be merely waiting to fill her glass again. Even though nothing ostensibly erotic is happening, a certain tension hovers over the pair. At the same time, Vermeer gives us no clue as to the relationship between the two. Whether the consumption of alcohol will end in an amorous affair remains uncertain. Vermeer merely suggests. The chitarrone lying on a chair, a frequent prop in his paintings, may represent harmony as well as a frivolous lifestyle. The heraldic design decorating the pane of the half open window shows another woman who is holding a tangle of ribbons, probably a bridle, which typically symbolized moderation. The cool elegance produced by the girl's rosy-red satin dress furthermore seems to refer to the figure's dignified family origin rather than the dangers imposed on her innocence by her excessive indulgence in wine. In spite of his small body of work comprising only about 35 paintings, Vermeer counts among the most famous of Dutch painters, specialized in exquisite, domestic interior scenes of ordinary life. His most important means of composition and expression are the use of perspective and light (which mostly originates from a source on the left). To better grasp its optical effects, he used a camera obscura, especially in his later paintings, such as in *Young Lady with a Pearl Necklace* (c. 1662/65), likewise owned by the Gemäldegalerie. For artists, its use opened up entirely new possibilities of expression and composition.

Kupferstichkabinett

Beyond the wide, sloping expanse of the so-called Piazza, there lie not only the treasures of the Gemäldegalerie. In 1994, the copper engravings cabinet opened up next door with a survey exhibit providing a sample showing of its rich holdings in woodcuts, pencil drawings and lithographs from the 14th through the 20th centuries. Its history of collection began long ago in 1652: The Great Elector bought 2,500 drawings for the court's library. King Frederick William III then founded the Kupferstichkabinett in 1831; by now it owns 110,000 hand drawings, watercolors, gouaches, and pastels, as well as 520,000 prints, books with original illustrations and some one hundred incunabula. The gamut runs from medieval manuscripts to drawings by Renaissance painter Titian and etchings by Berlin artist Daniel Chodowieckl, into the 20th century and up to photography. Especially rich are its holdings in early Italian, old German and Dutch graphic arts, and in drawings, for example by Botticelli and Dürer, as well as in works by Schinkel and Menzel.

Rembrandt van Rijn (1606–1669)
Self Portrait in Fur Hat, 1631
Etching, 6.4 x 6 cm

Rembrandt is 25 years old when he fashions this portrait, and he will soon score his first big success with his group portrait, The Anatomy Lesson of Dr. Tulp (1632). Well into his old age, he has made himself the object of his artistic reflections. His some 100 self-portraits have an important place in his body of works. To sit for them, he often selects all manner of costumes; sometimes he appears as an Oriental, at others as a Renaissance prince. But all portraits have one thing in common: Rembrandt admits insight into his own person, he uncovers psychological conditions such as fear, joy or amazement. As in this early work, he especially values the eyes as they gaze profoundly into the hidden depths of things. Rembrandt's etchings constitute one of the museum's core collections. Almost his entire body of works is on hand at the Kupferstichkabinett. Of the 150 drawings once attributed to him, only about half have stood the strict test of modern research, but even this number has not been reached by any other museum.

Musical Instruments Museum

After Hans Scharoun's death, his closest office partner, Edgar Wisniewski, took over the master's sketch and further developed his outline for the Musikinstrumenten-Museum, complete with an Institute for Musical Research. The new building opened in 1984 and is directly attached to the Philharmonic Concert Hall; right from the start, it was conceived as a stage for the active musical life as well as for musicological research, which, for example, studies the history of performance practices. The Museum was founded in 1888 by the Prussian State and was first housed in Schinkel's Bauakademie; among its roundabout 800 exhibits on display, there are quite a few rarities: for example, several German flutes, on which Frederick the Great once played his compositions; or a hammer piano built by Joseph Brodmann (1810) and owned by Carl Maria von Weber. Other items are a collapsible travel cembalo once owned by Liselotte von der Pfalz and later given to Queen Sophie Charlotte as a present; a Stradivari of 1703 and a complete collection of wind instruments from the Wenzelskirche, a church in Naumburg. The main attraction is the largest movie house and theater organ of Europe, "The Mighty Wurlitzer," which was imported by Werner Ferdinand von Siemens from New York in 1929 and set up in his private Berlin residence. Inside the museum, the complete development of European music from the 16th through the 20th century is documented – and can be listened to, in demonstrations during tours or in concerts.

Right: handwritten fingering chart for German flute by J. J. Quantz, with signature by Frederick II and the Marquis de Mirabeau, Musical Instruments Museum Berlin

TAB.

Fig. 1.

Fig. 2.

Fig. 3.

Philharmonie

The biggest concert hall in Berlin is the city's most beautiful postwar building; it is famous worldwide on account of its bizarrely folded, tent-like roof, its outer shell with its golden shimmer and its unique acoustics. The home of the Berlin Philharmonic, one of the leading orchestras in the world, constituted the prelude for the new cultural building complex at Tiergarten. The competition of 1956 had first intended a new building in Wilmersdorf. After a contentious debate, construction based on the winning design finally began at the present site in 1960. Since then, the Philharmonie is not only well known to the friends of classical music; its name resonates, too, in architectural circles, since the building was considered revolutionary even before its opening in 1963. The design was copied everywhere for countless new concert halls. For the first time in the world, Hans Scharoun placed music itself at the center of his construction that looked like a circus-tent; the orchestra podium was thus placed at the center of a large arena. On a polygonal ground plan of pentagons lying on top of and against one another, he developed the structure literally from the inside out. His design included a golden-yellow covering made of anodized aluminum panels which were added to the concert hall as late as 1978. With its unique silhouette, which also characterizes the Kammermusiksaal (chamber music hall) modeled on it and built in 1987, the Philharmonie puts its mark on the cityscape at Potsdamer

Platz. No member of the audience sits more than 30 m away from the central podium which supports the musicians. It was this democratic ideal which guided Scharoun in his design for the interior of the Philharmonie; as early as the 1920s, his ideas were paving the way for organic architecture. Like terraces on a vineyard, the rows for the audience, totaling 2,452 seats, encircle the orchestra up to the ceiling which is animated by sound sails and recessed lighting. In this way, Scharoun melded sound and space in an architectural manner. The Philharmonic orchestra and their audience have been enjoying this marvel of choice acoustics since 1963. The orchestra itself has been in existence since 1882. Conductors Hans von Bülow, Arthur Nikisch and Wilhelm Furtwängler were stylistic innovators. Herbert von Karajan, the "Titan," took over in 1954 and directed the Philharmonic Orchestra for 25 years. He was the first media star of classical music, controversial to this day. His successor in 1989 was Claudio Abbado, the "quiet magician," in 2002 Sir Simon Rattle, a rhythmic conductor with a dynamic leadership style. All of them forged the musical expression of the orchestra and amplified the famous reputation of Germany's most noble producers of sound. At present, the dignified institution is working on tapping the audience of the future. Its "Education Project" is designed to make classical music accessible to children and adolescents.

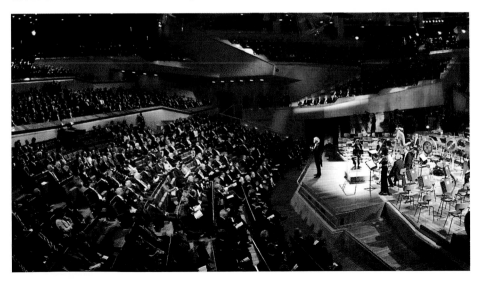

Staatsbibliothek at Potsdamer Straße

The State Library was likewise designed by Hans Scharoun; it was built from 1967 to 1978 to cap the eastern part of the Kulturforum. After Scharoun's death, its construction was taken over by Edgar Wisniewski in 1972. The new building was situated close to the Wall. On its eastern side, the library therefore needs to make do largely without any windows. Furthermore, the tall book depot was to shield the Kulturforum against traffic noise. Like the enormous body of a ship, this massive part of the building towers over its annexes in the front and communicates well with the Philharmonie via its yellow aluminum siding. Its interior is much like that of the latter; its reading rooms flooded by light were likewise shaped as an effective spatial landscape, featuring multiple galleries, split level floors and wide staircases. The library's original collection was composed of holdings by the Prussian State Library on Unter den Linden Boulevard, which had been transferred to West Germany during World War II. The residual holdings remained in their East Berlin home. After the fall of the Wall, both houses were reunited as Staatsbibliothek zu Berlin, though they were given different tasks: The library at Kulturforum is an informational and lending library for literature published from 1946 and later; its other half on Unter den Linden Boulevard is a research library for literature up to 1945.

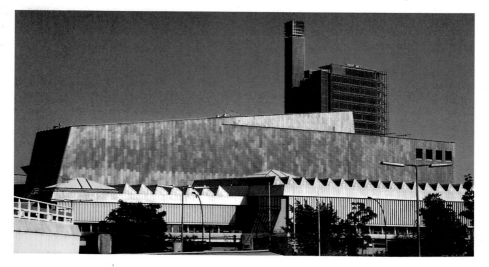

Staatsbibliothek at Potsdamer Straße **173**

Neue Nationalgalerie

Since its opening in 1968, the New National Gallery, designed by Ludwig Mies van der Rohe, has functioned as an architectural monument, whose attractiveness makes it compete with its own exhibitions. Its steel framed glass hall with cantilever, square roof ties it to a series of similar hall projects by Mies. He designed the first version of this building type for an administrative structure commissioned by Bacardi Rum in Cuba; but it was never realized. The rela-

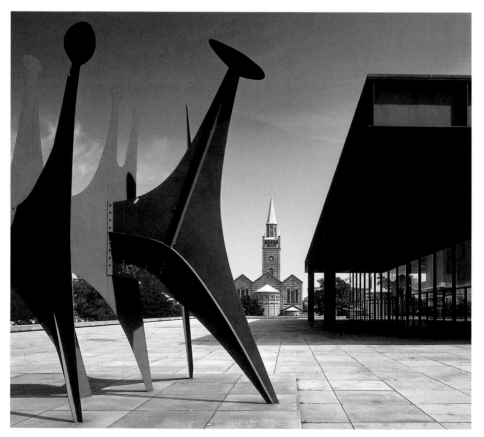

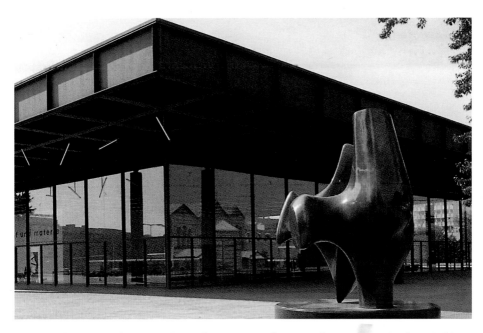

tionship between glass temple and neo-classicist buildings by Schinkel and his successors is quite striking.

Until German reunification, the new building in West Berlin served as a home for the works of the (Alte) Nationalgalerie, which had remained in the West after the war, and for the collection of the 20th century gallery, which was founded in 1945; it was to compensate for the loss of over 400 modern works caused by the Nazi regime. Since the restructuring of the museums in reunified Berlin, sculpture and paintings from the early 20th century through the 1960s are shown in the Neue Nationalgalerie; these works range from Expressionism, Cubism, Bauhaus, Surrealism, and Verism, up to Neue Sachlichkeit (New Objectivity). There is also a fine collection of American paintings of the 1960s and 1970s. Among the gallery's core exhibits are eleven paintings by Max Beckmann (which present a cross-section of his work from 1906 and beyond), works by Otto Dix, George Grosz, Hanna Höch, Paul Klee, Wassily Kandinsky, Joan Miró, and Salvador Dalí, as well as the final painting by New York artist Barnett Newman, *Who's Afraid of Red, Yellow and Blue IV* (1969/70), and whose *Broken Obelisk* (1963) also graces the entrance patio.

Neue Nationalgalerie **175**

Max Ernst (1891–1976), Capricorn, 1948/1964

Plaster of Paris, slightly colored,
246 x 210 x 155 cm

A horned man is lounging phlegmatically on a throne holding a scepter and an off-spring in his hands, a water pipe and spout is rising from his lap. Next to him sits a young woman, tenderly, with fish tail and fish symbol on her head. The title Capricorn refers to the 10th animal sign of the zodiac which in Greek and Babylonian mythology represents fertility and rebirth.

The group suggests Ancient Near Eastern cultic figures. Max Ernst created the sculpture in Sedona, Arizona, after leaving the Parisian Surrealist group in 1938 and emigrating to the United States in 1941. In 1946 he moved from New York City to Sedona where, surrounded by the archaic landscape of red mountains and impassable canyons, he fashioned the monumental, free-standing garden sculpture in 1948. He put it together by using common found objects. For the horns, neck and fishtail, for example, he used car springs and for the scepter he used milk bottles stacked one on top of another and then wrapped in concrete. In 1953, Max Ernst left Sedona to live once again in France. Nine years later, he returned to make a plaster cast of the concrete version; the latter was later destroyed. He refashioned the plaster cast in 1964 to make a bronze cast. The artist gave both, the plaster cast model and the bronze cast, as a gift to the Nationalgalerie, then directed by Werner Haftmann. The sculpture of this "most noble" couple marries animalistic and ironic aspects. This combination is fairly typical of Max Ernst and also appears in his monumental painting *Evil's Chosen One* (1928) or in *Bird on Red* (1956), which are likewise owned by the Nationalgalerie.

The painter and sculptor Max Ernst was a member of the Surrealist circle in Paris since 1922, photograph, 1966

Museum Center Dahlem

In the southern part of the city, close to Grunewald and the Free University campus, the Dahlem museums with their focus on non-European cultures have their own special message to convey. Plans to build a museum complex in the area were first conceived by Wilhelm von Bode. In 1914, Bruno Paul began construction on the first building; it was moved into only after World War II. New structures were added from 1966 to 1973 to serve as the western home for the Völkerkundemuseum and the Gemäldegalerie in divided Berlin. Today the (renamed) Ethnologisches Museum is housed at this site; with its more than 500,000 objects from all continents – including ancient America, the South Seas and Africa – it is one of the world's most significant ethnological museums. The museums of East Asian and Indian art, which were combined in 2006 to form the newly named Museum für Asiatische Kunst, are also located at this site. On exhibit are works from the Indo-Asian cultural area dating from the 4th millennium B.C. to the present day, Japanese painting, East-Asian lacquer art, and Chinese pottery. Since 2005,

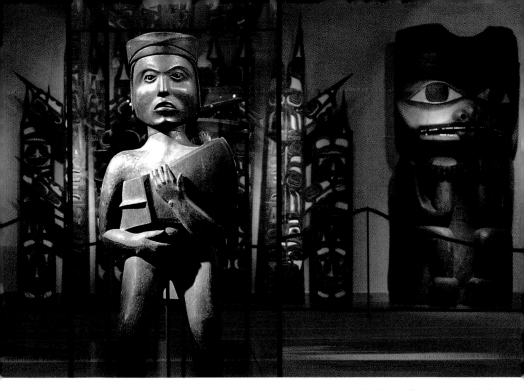

North America Division of the Ethnological Museum, in the foreground the figure of a Kwakiutl chief from the Indigenous nation living in British Columbia on nothern Vancouver Island, Canada

the Museum Europäischer Kulturen has also entered a dialog with remote regions. Housed under the roof of the Bruno-Paul-Bau, it showcases objects of daily life from the 18th century to the present day: furniture, dress, costumes, tools, and toys.

A major attraction is the Hall of Boats in the South Sea department of the Ethnologisches Museum. The most diverse types of aquatic vehicles are showcased here, from simple bark canoes to ocean-going barges; one of these is a twin-hulled boat from the Tongan Islands which may be walked on by visitors. It is a reconstruction based on sketches by James Cook. A 1907 clubhouse for men from the Palau Islands was likewise reconstructed here; its carvings and paintings tell Oceanic myths. This is unique as such structures no longer exist at their locations of origin.

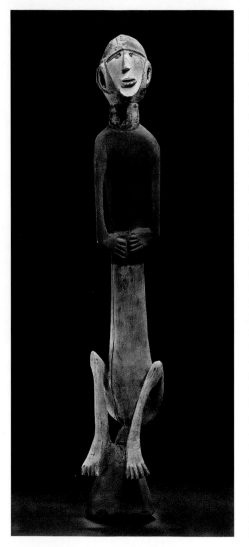

**Seated Figure With Overly Elongated
Upper Body, Southern New Ireland,
Fanamaket Region, acquired in 1908**
Wood, color, mollusk shells, 82 x 30 cm

The Melanesian island lies north of Austra-
lia. Already in the 19th century, long before
artists such as Picasso, Nolde and Breton
discovered non-European art for their own
purposes, works from New Ireland had al-
ready become known. They have only sur-
vived because they were collected for mu-
seums. At their place of origin, they served
only briefly to remind the living of the dead
or to give body to the souls of the dead. These
figures were not fashioned after nature; in-
stead, their makers observed a preexisting
code. The individuality of the person repre-
sented was translated into preselected attrib-
utes or characteristics. These were expressed
in the posture or coloring of the figure, or
they consisted of objects that once belonged
to the deceased. They contained the essence
of the dead and were therefore especially
capable of imbuing the representations with
spiritual power. This example shows a figure
with an upright, elongated upper body and
big ears, which would designate an acute
sense of hearing and marked physical prowess.
Apart from these free-standing sculptures
which were set up in men's houses, posts
were also fashioned; they were decorated
with geometrical and floral elements. The
Ethnologisches Museum owns a series of
such New Ireland carvings which, in their
multiplicity of forms and plenitude of motifs,
belong to the masterpieces of Oceanic art.

Commemorative Head of a King Oba, Nigeria, Kingdom of Benin, 18th century
Brass, height: 28 cm

After the death of the king, an altar was built for him in a closed off courtyard of the palace. Among the most important objects gathered there were copies of the dead king's head; they were cast from brass. This example from the 18th century shows the ruler with his insignia made of coral pearls, a cap-like crown, and a stand-up collar made of coral necklaces. Playing an important part, the mothers of kings were likewise honored with such commemorative heads. Besides the necklaces, they wore pointy caps to identify them. The longstanding tradition of such memorials for the dead, which goes back to the 16th century, produced a formidable craftsmanship. What is remarkable is the degree of realism with which the heads have been sculpted. The museum owns a large number of these, as it does of figural sculptures from Benin, which, in the 15th century, had developed into the center of West-African trade with Europe. Slaves and ivory were exported; brass, the raw material for works of art of that epoch, was imported. With the end of the slave trade, Benin lost its role as a trading post and was conquered by the British in 1897. The works of art stolen from the royal palace were auctioned off in London. Besides the internationally unique inventories of Nigeria, Cameroon and the Congo region, the Berlin collection, which at 75,000 items is one of the world's most important, covers the entire African continent.

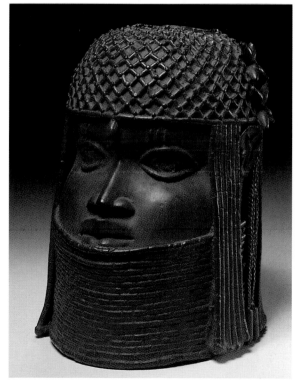

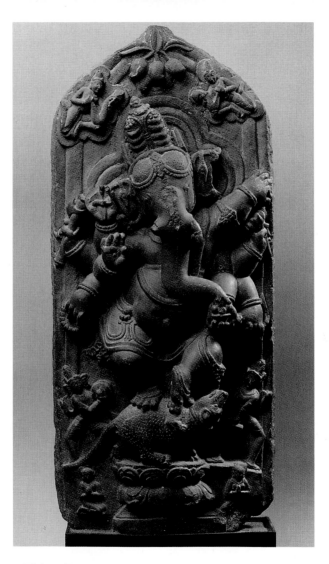

Dancing Ganesha, Northern Bengal, 11th century A.D.

Gray-black slate, 56.5 x 25 cm

In spite of his girth and short legs, Ganesha, the god of auspicious beginnings, moves decisively gracefully and with a fine harmonious balance. He conducts his dance on top of the animal that normally serves him as means of transportation, the rat. Two musicians strike up a tune. Representations with musicians, even entire orchestras, feature early in Indian artistic imagery. There are bas-reliefs with musical instruments which date back to the 1st century B.C. Representations of dance are even older and at times have been found to go back to the time of the Indus culture (2800–1800 B.C.). While dancing, the dancer's body is strongly distended and twisted while undergoing bizarre contortions. A famous disquisition on classical Indian dancing handed down to us from the 1st century A.D. indicates how highly developed the dramatic arts of that period – which were based on art music – must have been.

There are further examples which represent the characteristic dancing posture of that era, such as *The Worship of Dancing Shiva* (10th century A.D.) and the gaunt goddess *Chamuda* (11th century A.D), who is obviously exhausted from such relentless movement.

Another highlight of the museum is the famous Turfan Collection: clay and wood sculptures, murals, paintings on fabric and paper, and manuscripts from the 2nd to the 14th centuries deriving mostly from Buddhist temple caves; they were discovered between 1902 and 1914 during four Royal Prussian expeditions in the Turfan region, the northern Silk Road, Xinjiang Uygur Autonomous Region, People's Republic of China. The focal point of this section is the full-scale reconstruction of a square temple decorated with original murals from Cave 123 at the oasis of Kucha.

Asian mural from Kyzyl (c. 500 A.D.), 59 x 38 cm, from the 3rd Turfan Expedition, Museum of Asian Art, Berlin

The "Old" West

At the latest, it was the building of the Wall that made Berlin assert itself as a new museum city. Besides the "twins" – western collections that have their counterpart in the eastern part of the city – it is the newly founded museums of the period which prove it, including the Bauhaus Archive at Tiergarten, the Bröhan Museum, which along with the Museum Berggruen next to Charlottenburger Schloss, and the Scharf-Gerstenberg Collection, provides a new focus on modern art; the Georg-Kolbe Museum close to Olympia Stadium or the Brücke Museum in Dahlem. Another cultural center formed in the south of West Berlin. This is where Jagdschloss Grunewald (closed for remodeling until 2009) is located, the oldest Renaissance relic on Berlin soil. Construction began in 1542. Designed by Caspar Theyss, the hunting castle was built for Elector Joachim II; besides a depot for hunting implements, it showcases a collection of valuable paintings by German and Dutch artists of the 16th to the 19th centuries. The Haus am Waldsee presents varying exhibits of contemporary art in a grand villa setting. The old-time country estate, Domäne Dahlem, has turned into an open-air museum. Apart from an original "candy bomber airplane" from the times of the Berlin Blockade, the Allied Museum, located at the site of the former Outpost Cinema of the US Army at Clayallee, exhibits a Checkpoint Charlie cabin and just about anything that commemorates the Four Power status of the divided city.

Brücke Museum

Located close to Grunewald, the museum owes its existence to the painter Karl Schmidt-Rottluff, who was born in 1884 near Chemnitz. In December 1964, on the occasion of his 80th birthday, he donated 74 of his own works to the city of Berlin. They constitute the core of one the most significant collections of expressionist art in Germany. The museum was designed by Werner Düttmann and built in the Bauhaus architectural tradition in 1966/67. It is dedicated exclusively to the works of the artists' association Die Brücke (the Bridge), the first avant-garde artists' group in the 20th century in Germany. Founded in 1905 in Dresden, it transferred to Berlin in 1911, where it disbanded in 1913. Apart from works by the founding members Karl Schmidt-Rottluff, Ernst Ludwig Kirchner, Fritz Bleyl, and Erich Heckel, all of whom studied architecture in Dresden together, important works by Max Pechstein, Otto Mueller and Emil Nolde are likewise on display. The Brandenburgian sylvan landscape surrounding the museum effectively enters into the exhibition halls.

Ernst Ludwig Kirchner (1880–1938),
Female Artist – Marcella, 1910
Oil on canvas, 100 x 76 cm

Fränzi alias Marcella was Kirchner's favorite model. He painted innumerable variations of Franziska Fehrmann, a 9-year-old working class child from the Dresden suburbs; the interior settings varied and were furnished with manifold props. Her yellow-and-green striped dress and blue-and-black striped stockings transform the lounging girl into a tired clown. Critics have interpreted this scene as a sensitive allegory of the pre-adolescent model's co-optation by the artist. Like nature, the circus and the stage functioned for Kirchner and his friends as a world apart, a world they likened to the myth of freedom, the dream of another life. The choice of such subjects went hand in hand with the development of a distinctive style which, as it were, originated with and was brought to full flourish by Kirchner during his Brücke period. The radical simplification of forms is to be understood as a liberation from the tradition and perfectionism of academic art. Color itself

has now becomes the subject. The museum has on exhibit several major works by Ernst Ludwig Kirchner; they run the gamut from his years in Dresden via his paintings of metropolitan Berlin to the time he spent near Davos, leading a reclusive life in the Swiss Alps, where he lived and worked until his death in Frauenkirch-Wildboden.

Bauhaus Archive

This modern Berlin building was designed by Walter Gropius and constructed from 1976 to 1979; it is home to a museum, a collection of documents, and a library. The architect, who became famous as Bauhaus director, first in Weimar, then in Dessau, had worked since 1960 on co-founding the Bauhaus. The distinctive look of the white, two-story structure is due to shed roofs whose windows face northward. These are in charge of supplying a controlled influx of light and so facilitate the optimal pre-sentation of the exhibits. The clearly artic-ulated body of the structure encloses the archive and exhibition halls where special exhibitions as well as exhibits from the permanent collections are presented; the latter feature architectural models, blue-prints, paintings, photography, common-place objects, and furniture designed by such Bauhaus artists as Ludwig Mies van der Rohe, Oskar Schlemmer, Marcel Breuer, László Moholy-Nagy, and Marianne Brandt. The Bauhaus Archive owns the most comprehensive collection of items by this world-famous 20th century school of ar-chitecture, design and art.

Marcel Breuer (1902–1981),
Cantilever chair, 1928
Realization by Gebr. Thonet
Chrome-plated steel tubing, rattan reed in
black bentwood frame, 81 x 54 x 69 cm

Marcel Breuer's 1922 "Lattenstuhl" (lath-work chair) already exemplified the principles set forth by Bauhaus. Made manager of its Dessau furniture workshop in 1925, he realized his ideas in radicalized form with the help of steel tubing. He produced a series of chair designs which made use of the technical possibilities of this material, so as to simplify traditional furniture designed for seating purposes. The most advanced design is the Cantilever chair („Freischwinger"), a version of the chair without rear legs. As early as 1926, Mart Stam had developed a first such cantilever chair under the name of "Kragstuhl"; however, this one was based on a rigid tubular construction. Inspired, Mies van der Rohe, in 1927, designed for the Weißenhofsiedlung in Stuttgart a chair made of steel tubing by using its spring-like qualities. Due to its space-consuming front skids, this piece of furniture did not fit well into the rather spatially restricted low-cost apartments of the period, nor did it suit the type of societal taste advocated by Bauhaus. With his furniture and interior decors, first developed in 1925, Breuer contributed to creating a new, modern idea of habitation. This made him – beyond the 1920s – one of the most significant furniture and interior designers of the 20th century, as many objects in the museum attest to. Objects of everyday usage, such as Marianne Brandt's teapots, Josef Albers' fruit bowl or Gyula Paps' chandelier, demonstrate just as exemplarily the enormous influence the Bauhaus movement had on the development of modern design in the world.

Bröhan Museum

Art Nouveau, Art Déco and Functionalism – the Museum presents objects from the domains of fine and applied arts and from three periods. It is named after collector Karl H. Bröhan who, in 1981, donated his private collection to the city of Berlin. Since then, the fine museum is housed in a barracks building dating back to late neoclassicist times that once belonged to Schloss Charlottenburg. What is unusual is the presentation of items in the form of spatial art ensembles. In an elegant residential atmosphere, the artistic and utilitarian objects made of china, pottery clay, metal, and glass are exhibited in combination with furniture, carpets, lamps, and paintings – an interaction that likewise gives body to the equivalence of various artistic expressions. Emphasis is laid on works of the French and Belgian Art Nouveau, of the German and Scandinavian Art Nouveau, and French Art Déco. Besides furniture by Eugène Gaillard, Hector Guimard, Louis Marjorelle, Peter Behrens, or Bruno Paul, the holdings also comprise an unusually abundant collection by important manufacturers, such as KPM Berlin, Royal Copenhagen, Meißen, Nymphenburg, Sèvres, and others; for example, a spectrum of precious glasses by Emile Gallé, or Art Déco art by Edgar Brandt, silver ware by Jean Emile Puiforcat, as well as Art Nouveau faiences made by Amphora-Werke, a Bohemian factory. Its collection of paintings comprises works by Berlin Secessionists Karl Hagemeister, Hans Baluschek, Willy Jaeckel, Franz Skarbina, and Walter Leistikow. Two smaller cabinets are reserved for Belgian Art Nouveau artist Henry van de Velde and Viennese Secessionist Josef Hoffmann.

Showroom with a seating arrangement by Maurice Dufrene

**Walter Leistikow
(1865–1908),
Grunewaldsee or
Schlachtensee, c. 1900**
Oil on canvas,
80.5 x 121 cm

Rural peace below dark crowns of pine. The gaze ranges widely across a quiet lake hedged in by greenery, roaming towards where the sun, hovering low on the horizon, dips the woods into a flaming red, mirrored by the water's surface – this was the kind of ambience Leistikow liked to paint in. He often stayed for weeks on the shores of Berlin lakes, having open access to the wooded estates of his banker friends Hermann Rosenberg and Carl Fürstenberg. Leistikow's paintings show how he developed into one of the most sensitive interpreters of the Brandenburgian landscape. Expansive abstraction, idiosyncratic emphases and the ability to exclude the unimportant characterize his signature style. Walter Leistikow, born in Bromberg, painted according to nature, yet without committing to the postulates of truth and objectivity. Only "in the work shop" did he perform his "comprehensive artistic labor." Here, his "imagination took the lead." Leistikow created his works by putting his impressions of nature through an idealizing process. As such, the 1900 landscape, one of nine paintings owned by the museum, is not to be pinned down topographically. Here, two lakes are merged into a single image.

The representation of regional scenes was very popular around 1900. But Leistikow combined them with modernist Art Nouveau and Japonist tendencies. As one of the leading modern artists of Wilhelminian Berlin, he was very successful and his paintings were popular exhibition favorites; they were bought by galleries and collectors. In 1898, Leistikow was one of the founding members of the Berlin Secession, an artists' association that made Berlin the premier city of modern art in Germany.

Collection of Photography and Helmut Newton Foundation

Once upon a time there was an officer's mess building. Ceilings and walls were painted in the style of Pompeii, classical pilasters and Art Nouveau ornaments decorated the ballroom, bowling alley and shooting gallery. All that is left of this pomp is the

Star photographer Helmut Newton, internationally renowned for his frosty female nudes, picture taken in 2002 in Düsseldorf

Kaisersaal (emperor's hall), a barrel-shaped ballroom that, until recently, featured exposed masonry walls and a visible roof truss 11 m up. It is currently being renovated until spring 2009. Since its 2003/04 remodeling, which was performed by the Berlin architecture firm Kahlfeldt, two institutions have come to be housed at this location: The Helmut Newton Foundation and the Collection of Photography, a division of the Kunstbibliothek (art library) at the Staatliche Museen zu Berlin. The museum filled the Kaisersaal ruin with varying exhibitions on contemporary photography. On the lower floors, the Helmut Newton Foundation shows objects from the photographer's estate. The building across from Bahnhof Zoologischer Garten, built in 1908/09 based on designs by Heino Schmieden and Julius Boethke and inaugurated in the presence of Emperor William II, was especially significant for the photographer: It was the last thing he saw of Berlin when he boarded his train in 1938 to escape the Nazis. The return home of this native Berliner – he was born in Schöneberg in 1920 and named Helmut Neustädter – was not without obstacles. When he offered his hometown his estate, prompted in part by his friend Heinz Berggruen, he was not greeted with unadulterated approval. The city, always in financial straits, had no funds to establish an adequate museum facility. So Newton shouldered the remodeling costs as well. The master himself did not live to see its opening. He was killed in a car crash in January 2004.

Foyer of the Helmut Newton Foundation with Newton's provocative series "Big Nudes" on the walls: nude women on high heels

Museum Berggruen

Comprising 165 works by Pablo Picasso, Paul Klee, Henri Matisse, and Alberto Giacometti, this private collection is regarded as one of the most significant collections of classical modern art worldwide. In 2000, four years after the museum's opening, Heinz Berggruen bequeathed this treasure trove for a symbolic sum to his native city of Berlin. A sensation and – a gesture of forgiveness, as the benefactor said. The Jewish journalist Heinz Berggruen, born in Charlottenburg in 1914, emigrated to the United States in 1936 and founded his first gallery in Paris after World War II. Soon it developed into the first port of call

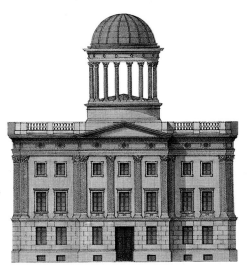

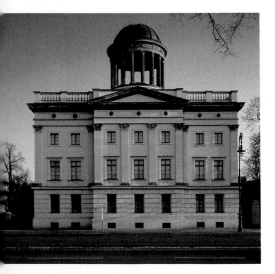

for the international arts' trade. Berggruen's highly praised friendships with the artists – above all with Picasso – and his gallery contacts made this unique collection possible. The interior of the former Garde-du-Corps building, designed by Friedrich August Stüler and located across from Charlottenburg Palace, was custom-made for the collection. Since Heinz Berggruen's death in 2007, his son Nicolas has continued the legacy of his father. He wants to bring 50 more paintings to the museum which will be housed in the neighboring Kommandantenhaus. The eastern Stüler building, once home to the Egyptian Museum, will house the Scharf-Gerstenberg Collection which includes extraordinary works of Surrealism.

Pablo Picasso,
The Yellow Sweater, 1939
Oil on canvas, 81 x 65 cm

One month after the out-break of the war, the likeness of Dora Maar was created in Royan on the Atlantic coast. Picasso painted his mistress sitting in a common wicker chair – as he often did in paintings of these years. So positioned, comments Fran-çoise Gilot, she looks alien and strangely remote: "Yet the most remarkable thing about her was her peculiar immobility. She did not talk very much, made no gestures at all, and in her demeanor there was something tran-scending dignity – a certain rigidity. There is an apt ex-pression for this in French: She gave herself as if she were the Holy Sacrament."

This untouchability seems captured in the picture. Her spade-like hands and the ribbed, yellow sweater that encircles her body like a caterpillar, speak of an irre-versible metamorphosis. Alfred H. Barr saw in it the influence of the Mannerist painter Giuseppe Arcimboldo, who had been redis-covered by the Surrealists.

Apart from this key work, the collection features over 70 high quality works by Pi-casso spanning all periods of his artistic life:

paintings, sculptures and works on paper – from his student years in Madrid to his late works. Among his most important works are the *Seated Harlequin* (1905) and *The Painter and his Model* (1939). In addition, we also find major works by Paul Cézanne and Vincent van Gogh, Georges Braque and Georges Seurat, a room full of works by Alberto Giacometti, and 20 watercolors in small formats, poetic scriptures and fragile paintings by Paul Klee.

Käthe Kollwitz Museum

This museum, located in the oldest residential building (1871) – a late neoclassicist mansion – on Fasanenstraße, is entirely dedicated to the creative activity of elective Berliner Käthe Kollwitz. About 200 drawings, graphic prints and posters as well her entire sculptural output represent the manifold oeuvre of one of the most recognized female artists of the 20th century. The museum owes its 1986 founding to gallery owner Hans Pels-Leusden, who made available many works from his private collection. Highlights of the collection are the etchings on the *Weberaufstand* (weaver's revolt, 1898), the woodcuts cycle *Krieg* (war, 1922/23), works on the theme of "Death"(1903-1942) and the *Gedenkblatt für Karl Liebknecht* (memorial page to Karl Liebknecht, 1919/20). The themes of mother-war-child likewise suffuse the entire presentation. Always clinging to realism, Käthe Kollwitz's works mirror her existential and artistic interactions with her period. The death of her 18-year-old son on the battlefields of Flanders during World War I brought her into contact with socialism and made her a lifelong pacifist. A commitment to championing the rights of underprivileged people and an extraordinary ability to express human suffering in artistic terms characterize the work of Käthe Kollwitz. During her final years Kollwitz produced bronze and stone sculpture, embodying the same types of subjects and aesthetic values as her work in two dimensions. Much of her art was destroyed in a Berlin air raid in 1943. Her self-portraits of 1888–1938 demonstrate how important accurate self-reflection was to Käthe Kollwitz all her life. The museum showcases an important cross-section of her more than 100 drawings and print graphical works of this series. We see the artist, sometimes facing us, sometimes in profile or in a close-up of her face, as *Nachdenkende Frau (pensive woman)*. Only one dip pen drawing of 1888/89 shows her laughing, her unbroken vitality radiating pertly from the picture.

Käthe Kollwitz (1867–1945), Self-Portrait, 1936
Charcoal on paper, 56 x 43/61.2 x 47.5 cm

Her gaze falling upon her own face is without mercy. There is no vanity. The artist shows an aging woman: looking inward, her lips are shut above a telling silence. This 'self-picture,' as Käthe Kollwitz called her self-portraits, is a snapshot. It captures a turning point in her biography. After the professor was forced, in 1933, to voluntarily leave the Preußische Akademie der Künste, her exhibitions were subsequently prohibited. When her works were removed from museums three year later, she wrote in her diary in November, she was under the impression of a desperate powerlessness, "[...] this peculiar silence [...]. Almost no one has anything to say to me. I thought people would come, would write – no. Something like silence about me."

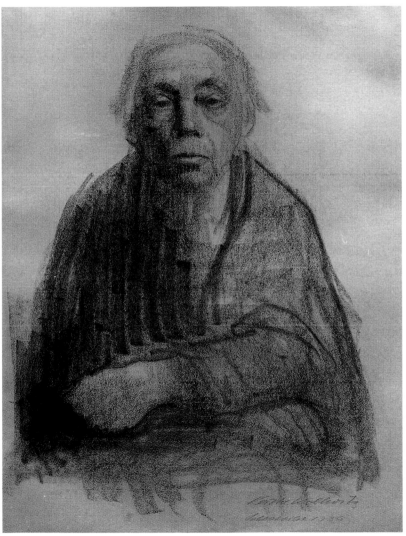

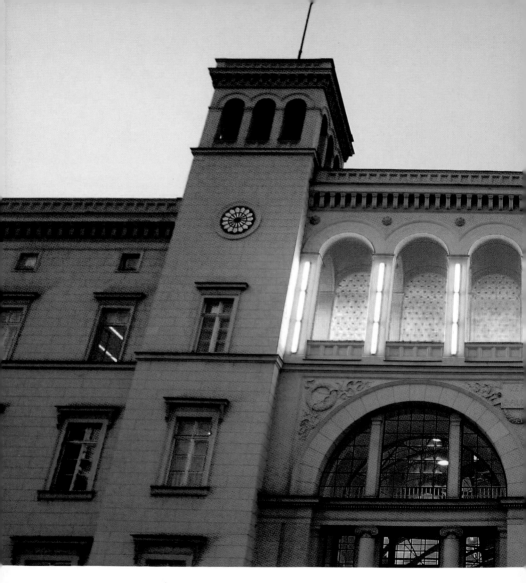

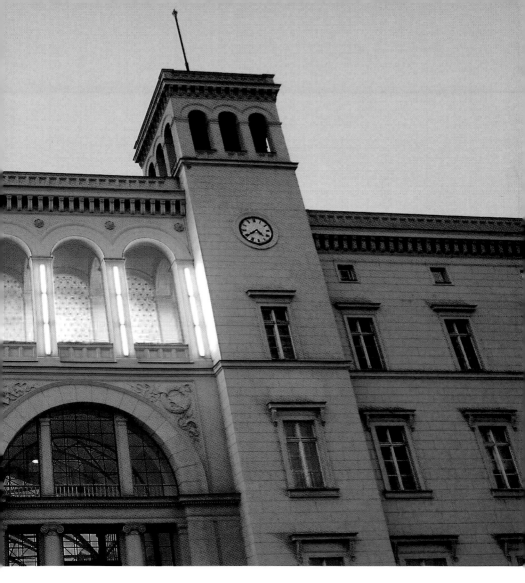

Invalidenmeile

Hamburger Bahnhof

For centuries, Invalidenstraße lay dormant like a highly guarded cul-de-sac between East and West. Its border crossing, east of Sandkrugbrücke leading to the Spandau canal, was the site of the first rush of crowds on the eve of November 9, 1989. Christophe Girot's 1997 sculpture *Sinkende Mauer* (sinking wall) commemorates this event; it is a wide ranging fountain array in Invalidenpark between the Museum of Natural history and the Museum für Gegenwart (museum of contemporary art) at Hamburger Bahnhof. Across from it sprawls the wide complex of time-honored Charité, the most famous German hospital and an international center of medicine. Founded in 1710 as a plague house in anticipation of an outbreak of bubonic plague, it came to be used as a charity hospital for the poor after the plague spared the city. Charité had grown into a city within the city by the early 1900s. Its architecture, resembling a museum made of brick, combines neo-Gothic and Art Nouveau elements. Its research and hospital facilities are state-of-the-art. The quarter's oldest and most beautiful building is Carl Gotthard Langhans' Anatomisches Theater which, like Brandenburg Gate, was built in 1789/90. Perfectly proportioned, a rotunda rises up above the small amphitheater in which animal autopsies were conducted. The *Medizinhistorische Sammlung* (medico-historical collection), started by Rudolf Virchow in 1899, is also housed on the premises.

National Museums' contemporary art has been exhibited at Hamburger Bahnhof since November 1996. The building, constructed by Friedrich Neuhaus with hints of Schinkel and Stüler and built 1845–1847, is the single remaining terminal station in Berlin; it formerly connected the German capital with Hamburg. Decommissioned in 1904, the decision was made to turn it into a museum of traffic and construction; thus, the triple-naved hall made of iron and glass was built, which still constitutes the center of the museum today. Situated close to the Wall, the war-damaged building remained empty until the end of the 1980s. Josef Paul Kleihues did the remodeling. Its central exhibit is the private collection of art lover Erich Marx that showcases groups of works by contemporary artists such as Joseph Beuys, Robert Rauschenberg and Anselm Kiefer. But new works by Thomas Struth, Rachel Whiteread and Andreas Gursky are also on display. The museum's holdings were enlarged in 2002 with the purchase of the Marzona Collection, which comprises Minimal, Concept and Land Art, and with the 2004 loan of the Friedrich Christian Flick Collection. With 150 artists the largest private collection of contemporary art, it is housed in the adjacent Rieckhallen, a former freight warehouse, which showcases works by Duane Hanson, Candida Höfer, Martin Kippenberger, Bruce Nauman, Pipilotti Rist, Thomas Ruff, Cindy Sherman, and others.

Joseph Beuys (1921–1986),
Streetcar Stop, 2nd version, 1979
29 iron components, 837 x 246 x 74 cm,
Marx Collection

Joseph Beuys, most famous for his ritualistic public performances, designed the cast iron monument in 1976 for the central hall of the German Pavilion at the Venice Biennale. It was meant to be a memorial to his memory but far transcends the biographical dimension. First, it refers to the Lower Rhine culture of his hometown, specifically the stop Zum eisernen Mann (to the iron man) at the end of Nassauer Allee in Kleve, where 6-year-old Beuys often stood waiting on his way to school. The child, of course, did not know the significance of these peculiar trophy memorials which had been installed by Prince Johann Moritz von Nassau-Siegen, soaring upward between rails and road. But

he probably perceived on an intuitive level what this site, merging 17th century relics and modern traffic engineering, was about. What was hard to see in the first version – the upright barrel of a canon, a so-called 'field snake,' its upper third adorned by a dragon's mouth – Joseph Beuys had later recast and reassigned to the four barrels of ammunition as a pacifist symbol. In the 1979 or second version, the switch point, as it often does with Joseph Beuys, points in two directions, the past and the present. The same is true for the multi-part work called *Das Ende des 20. Jahrhunderts* (the end of the 20th century, 1982/83) or *Unschlitt/ Tallow* (1977). In addition, the museum showcases around 450 drawings and provides access to film and sound material on the great shaman of art. It thus provides a full survey of Joseph Beuys' body of works that is unrivaled by any other museum.

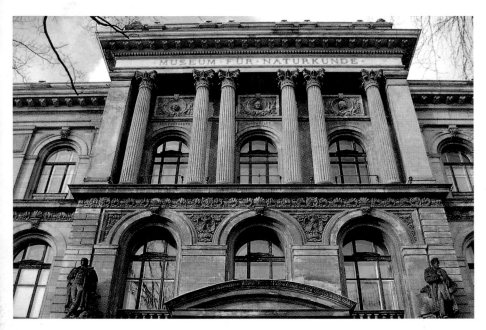

Natural History Museum

At a height exceeding 13 m, the Brachiosaurus brancai almost touches the glass dome of the atrium. It is the museum's masterpiece and the largest mounted dinosaur skeleton consisting of real fossil bones in the world. This primeval giant weighed 38 tons when it trudged through the Jurassic 150 million years ago. The Brachiosaurus was excavated by a German research team in 1909 at Tendaguru Hill in East Africa. First exhibited at its present site in 1937, it now dominates Dinosaur Hall, where six additional saurian skeletons represent all important groups of this species: primordial birds, flying Saurians, primitive fish, and dinosaurs. With about 6,600 square meters at its disposal, the Museum für Naturkunde provides an overview of the evolution of life on earth, European animals and minerals. Its oldest object – a 4.6 billion year old meteorite – has no rivals. Around fifty additional "heavenly rocks" of varying structures and colors are part of the exhibit. Flora and fauna are made especially vivid in three-dimensional large dioramas of the 1920s: The animals, from mouse to stag, present

and closed by the Gestapo in 1938. After the war, the Jewish Collection was on exhibit in the former Berlin Museum, in Philipp Gerlach's Baroque Kollegienhaus (college house), built in 1735; today this also belongs to the Jüdisches Museum. Three axes unlock the Libeskind building: The "Axis of Exile" points toward the E. T. A. Hoffmann Garden (Garden of Exile); the "Axis of the Holocaust" dead-ends in front of a steel door behind which lies hidden the empty, dark Holocaust Tower, and the "Axis of Historical Continuity" guides visitors to the exhibition. By means of personal documents, ceremonial objects, paintings, pho-

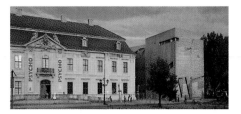

tographs, coins, books, newspapers, etc., 15 museum sections present two millennia of German-Jewish cultural history. This largest Jewish Museum in Europe also shows us how Germany was marked and shaped by the varieties of Jewish life within its borders.

Märkisches Museum – Stiftung Stadtmuseum Berlin

For over 130 years, the Märkisches Museum has been examining Berlin's historical and architectural development over the centuries, from its rural beginnings to its status as largest German city today. The structure was built from 1901 to 1907 based on designs by Berlin municipal engineering councilor Ludwig Hoffmann. In earlier times, the museum, established in 1874, was provisionally housed at Palais Podewils. Hoffmann modeled his structure on Gothic brick buildings and Renaissance predecessors. Brandenburg region already reveals itself in the architecture of this structure: The tower with its hipped roof imitates the castle tower of the Bischofsburg in Wittstock; the gable tops and other ornaments of the Gothic façade copy the Katharinenkirche in Brandenburg/Havel. The "Roland" reproduction in front of the museum's main entrance is from the same region. The interior rooms project certain moods to bring the past back to life. Swords and knight's armor are shown in the medieval armory with stellar vault, religious art in the Gothic chapel. There are some extraordinary pieces amidst this idiosyncratic architectural assemblage, for example, the sole surviving original fragment of the Quadriga on Brandenburg Gate: a horse's head. Then there are paintings by Anton von Werner and Edvard Munch, the department of Theater and Literary History from 1750 to 1933, a unique collection of jukeboxes, and the Kaiserpanorama, a stereoscopic picture show. This important historical museum building serves as headquarters of Foundation Stadtmuseum, established in 1995 in the wake of Berlin's reorganization of its city-historical collections. The foundation is composed of 13 museums located all across the city, such as the Ephraim-Palais, Nikolaikirche, and Schloss Friedrichsfelde.

Karl Wilhelm Wach (1787–1845),
Queen Luise as Hebe
in front of Brandenburg Gate, 1812
Oil on copper, 61.7 x 46.2 cm

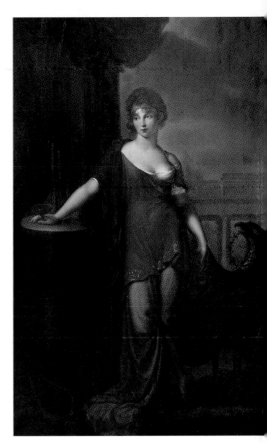

A queen with an uncovered bosom? And in Prussia at that? And whose spouse had already taken such issue with Schadow's twin-statue of the Princesses because of the way in which their bodies were visible through their garments, and who hid them in an out of the way cabinet in his palace? Wach painted his picture two years after Luise's death by copying a painting by a little known artist, Peter Eduard Ströhling (1768–1826); this original was painted in 1802 and has since disappeared. A student of Berlin Academy, Karl Wilhelm Wach had only painted religious subjects and copies of Renaissance masters up to his portrait of Luise. In his version, the Quadriga is absent as it had been taken to France as war booty and was only returned to its rightful place on top of Brandenburg Gate after Napoleon's death. Like classical Hebe, cupbearer of the gods, Luise gracefully handles wine jug and drinking cup; lyre, scroll and laurel branch in the foreground designate her as guardian of the arts. Wrapped in a tight-fitting gown, she is posing with one leg crossing the other, lasciviously, coquettishly, frivolously: "To Frederick William III it would have seemed 'disastrous' [...]" (Gisela Zick). But even if it does not seem obvious: The picture is assumed to contain religious meanings, it is a picture of invocation and of "remembrance" (Annemarie Reimer).

Luise's early death at age 34 had deeply shaken the nation; she was transformed into the "Prussian Saint." The godlike form of the adored queen, standing up to the French emperor in Tilsit to win him over in favor of peace: quite a few read this scene as an overcoming of the Napoleonic yoke.

Berlinische Galerie

Founded in 1975 by a group of art-minded citizens gathered around art historian Eberhard Roters, the Berlinische Galerie rapidly developed into an institution. After moving from site to site, the Museum of Modern Art, Photography and Architecture found a home in 2004 just past the Jewish Museum, in a former glass warehouse of 1965. The industrial hall – which is located in an area made prominent by the international architecture exhibition InterBau – was remodeled into a functional, generous house of modern art, based on designs by architect Jörg Fricke. More than 700 works from 1870 to the present are on permanent exhibit: the Secessionists and the Junge Wilde (wild youth), Dada and Fluxus, Neue Sachlichkeit (new objectivity) and Expressionism, Russians in Berlin, the avant-garde in architecture and photography, Berlin under the swastika, the city in ruins, East Berlin and West Berlin, the unified metropolis, and the creative contemporary scene. Balancing the international interests of the Nationalgalerie with the cultural-historical interests of the Stadtmuseum, this new museum collects, presents and researches art made in Berlin.

Max Beckmann (1884–1950),
The Street, 1914
Oil on canvas, 171 x 72 cm

The artist and his family, wife and son – jostled by dense crowds: That was not expected from Max Beckmann. Just prior, he had still painted historical canvases with lots of people, such as the *Sinking of the Titanic* (1912), and he had caused quite a stir with them. Now he began to be interested in daily life, contemporary themes, especially in street scenes in his Berlin neighborhood. In doing so, he followed the signs of the times. He, too, catered to the new genre of the modern big city portrait, masterfully represented in the works of the Expressionists, especially the Berlin Brücke painters. Originally, *The Street* was three times as large and produced in landscape format – a painting still very much in the spirit of the Secession, beholden to Impressionism and, as it were, realistically enriched with scenes of everyday life. Fourteen years later, Beckmann cut the picture in two; only the left half (as shown) and a smaller detail have survived. Both are now owned by the Berlinische Galerie. Beckmann subjected the Berlin street scene to the portrait format so characteristic of his Frankfurt years, where he moved 1915. It apparently no longer lived up to his freshly acquired compositional principles. What survived the cutting is the artist himself who, as is typical of his later paintings, takes center stage, as isolated as ever.

Museum of Communication

Three robots roll through the atrium, welcome visitors, give them suggestions for their tour, and inform them about the history of this house, which had opened in 1898 as the first Postal Museum in the world. The rounded, neo-Baroque corner of the large museum is crowned by a group of at-lantes, theatrically supporting the world. As allegories of science and traffic engineering, they represent the significance accorded to the postal institution at the founding of the empire. After comprehensive renovations, the house reopened in 2000 with a pompous staircase, atria, colonnades, and arcades. On display are nostalgic objects as well as items of modern communications technology. In addition to the most

famous postal stamps – the Red and Blue Mauritius – the exhibits include the oldest postcard in the world, the first telephones in Germany (made by Philipp Reis) and the "Cosmos Stamp," which once traveled into outer space with the cosmonauts. The collection and Philatelic Archive contain more than 100,000 objects; only a fraction of these fit into the exhibition areas. They document various aspects of the history of telecom-

munications, and they also show what preceded this high-speed exchange of information: the postal system as epitome of rapid transport, as medium of border transgression. Stefan Sous' installation *Berliner Luft Post* (1999) impressively stages these themes. It not only references the past; it also seeks to interpret how communication relates to the present and the future, that is, its technical dimension is interesting, but so is its social.

Museum of Technology

It is a museum city which covers the expanse of decommissioned Anhalter Freight Depot: The former railway depot and industrial area had turned into a natural landscape after the war. Its biotopes are now part of the museum's park of the German Museum of Technology which includes impressive rail engine sheds, market and cold storage buildings, water wheel and forge, mills and a historical brewery. This historical architectural complex, built around 1908 and now restored, is itself an object of the museum which came to reside here in 1982. But there is no scarcity in mobile treasures, because everything produced by engineering, industries and physics is collected, presented and demonstrated on site: locomotives, old-timer automobiles, model ships, looms, radios and cameras, airplanes, steam engines, printing presses, scientific instruments, motorcycles, coaches, household appliances and paper machines, as well as a 1958 television studio. Many historical machines are shown in action. Visitors may get involved and assist with the weaving machine or with making paper. More than 250 experiments in acoustics, optics, electricity, thermodynamics, or radioactivity are conducted in the interactive "Spectrum" department; they demonstrate how many of the exhibited appliances and machines work. The department also includes a cloud chamber and a Foucault Pendulum.

Konrad-Zuse-Computer

The world's first independently programmable computer was invented by a native Berliner. Konrad Zuse was 28 years old at the time. He had quit his position as structural engineer with the Henschel aircraft factory to tinker for two years in the living room of his parents with control units, memory drives, micro-sequences, program controls, and floating-point arithmetic. The first computer that already contained all the components of a modern computer was completed in 1938. Zuse called it Z1. By the way, he only heard of Alan Turing's ideas and the works of Charles Babbage after the war. Since Zuse was not satisfied with his firstling's performance he continued building computers. They were all designated Z but numbered progressively. While the war was still raging, Z3 was created on Methfesselstraße in Kreuzberg. In contrast to its predecessor, this computer worked perfectly. Extraordinary models were the Z11, sold to the optical industry and universities, and the Z22, the first computer with a magnetic memory. Since his journeymen's piece, including its construction designs, fell victim to the bombs, Zuse decided in 1986, to rebuild the Z1 for the museum. The exhibition displays, for the first time, almost all of the computers built by Zuse – from Z1 through Z31, including all supplementary devices and appliances – as well as the original book containing the programming language he designed: "Plankalkül." The histories of his firms and family are likewise recorded. In addition, the exhibit presents the other side of Zuse: his abstract and expressive paintings.

Martin Gropius Building

The three-story, palazzo-like building which once sat right on the border strip between Kreuzberg and Mitte, had long languished in the shadow of the Wall. It was not until 1978 through 1989 that the war-damaged building was restored. Its reconstruction revived the splendor of the original Royal Museum of Arts and Crafts, designed from 1877 to 1881 in the style of the late Schinkel School by Martin Gropius, a great uncle of Walter Gropius, and Heino Schmieden. Its richly decorated façades were recreated to original specifications, featuring varicolored bricks, decorative terracotta elements and mosaics lining the up-

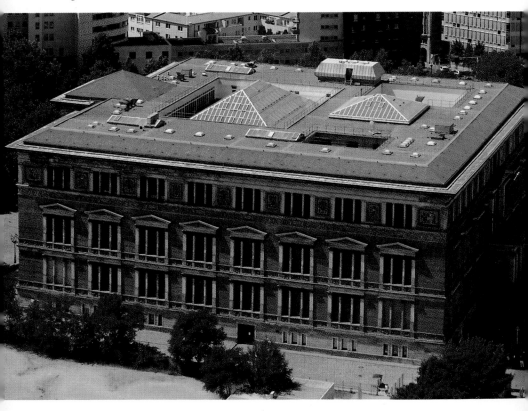

per floor. Only its northern side, which had faced the Wall, was not reconstructed until after reunification. The portal figures, blackened by soot and war-damaged, were left as they are to serve as a warning. The central atrium with its delicate columns and gallery floors offers an impressive forum for events; it lies at the heart of all exhibitions. When the Berlinische Galerie, the Werkbund-Archiv and the Jewish Collection of the Berlin Museum, housed here for a few years after 1981, moved

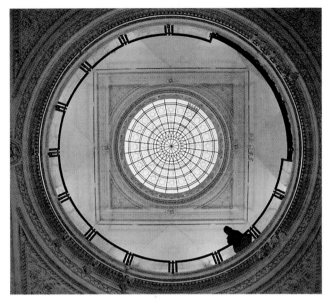

out, Martin Gropius Bouilding became a center for large traveling and temporary exhibitions. Various institutions, like the National Museums, the Berlin Festspiele and the Bundeskunsthalle Bonn, are in charge of these productions of art, history or ethnology.

The Martin-Gropius-Bau is situated at the border of an area that had hosted the headquarters of the SS and the Geheime Staatspolizei (Gestapo) during the Third Reich. At this central command post, Nazi terror was planned and administered. During excavations designed to document the area, basement walls were discovered; the cell floor of the Gestapo torture cham-

ber was revealed. In 1987, a citizen's group established the open-air exhibit, *Topography of Terror* that documents the history of the site and the function of the Nazi agencies housed at this location. Originally conceived as a transitional feature, the exhibition emerged as a permanent exhibit lasting decades. Peter Zumthor's designs for an exhibition and documentation center were not realized due to financial considerations; its half-finished stairwell towers were torn down again. Ursula Wilms is designing an objectivist-cubist structure due to be opened in 2010. Just next to it, we find the only remaining piece of the Wall in Berlin-Mitte.

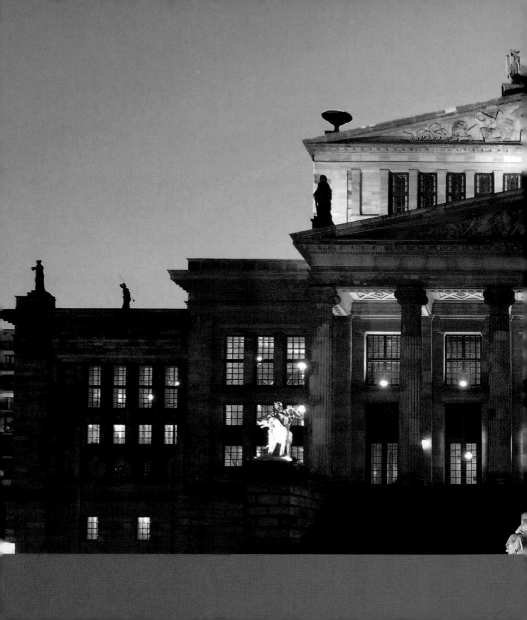

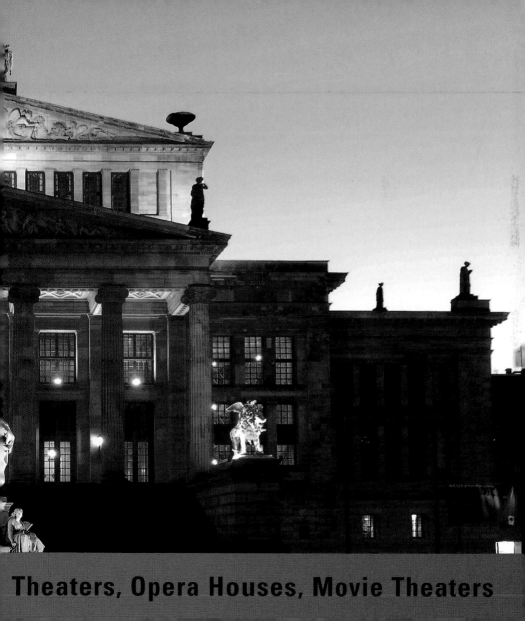

Theaters, Opera Houses, Movie Theaters

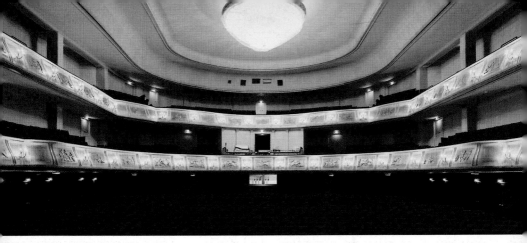

Theaters, Opera Houses, Movie Theaters

From high to off-the-beaten-track culture – Berlin has it all. Three opera houses, more than 150 theater stages and cabarets, just as many movie theaters, and eight big symphony orchestras of international standing. The vibrant metropolis has always been a magnet for the creators of culture. It owes its appeal last not least to the productive interplay between serious art and light entertainment. Its Admiralspalast recently opened in 2006, thus links up with its glamorous era, the Golden '20s. Once among the first "palaces of pleasure" of the city, it offered round-the-clock entertainment of any kind. Vaudeville shows and revues had their home in this art deco building; the Comedian Harmonists celebrated their successes, Johannes Heesters excelled in Franz Lehár's

Merry Widow, and in intermissions between shows, a luxurious steam bath beckoned to the audience. In 1896 in Berlin's New West, architect Bernhard Sehring built himself an eclecticist monumental theater on the grounds of a former coal depot belonging to dairy-farm Bolle; it presented a motley repertoire: the Theater des Westens. Where once Enrico Caruso and Maria Callas sang Verdi and Puccini, international musicals nowadays ring from its stage. Traditions have always been writ large in the cultural life of the city, but they are just as eagerly overthrown. As such, Peter Stein made world famous the Schaubühne, which had started out as an ensemble theater featuring Bruno Ganz, Edith Clever and Jutta Lampe: His Kleist and Chekhov productions and his antiquity

project became internationally popular export items. At first, the company played at Hallesches Ufer in Kreuzberg and, since 1981, in the former Universum cinema at Lehniner Platz (Erich Mendelsohn, 1926–1928). In 1999, its artistic leadership went through a generational makeover. Since then, the Schaubühne has become a site for experimental and contemporary repertory theater able to use the legacy of its famous predecessor. The Volksbühne (theater of the people) led by erstwhile *enfant terrible* Frank Castorf has long since advanced to the status of a scene classic and an internationally celebrated figurehead among Berlin stages. Alongside, small theaters likewise confidently assert themselves, such as the Sophiensäle, the Hebbel am Ufer, the independent Ballhaus Ost, and many others. There is nothing Berlin does not have. Berlin visitors are greeted daily by a choice of up to 1,500 performances.

Left: interior view of the Admiralspalast – right: Theater des Westens, musical theater

Schauspielhaus (Concert Hall) at Gendarmenmarkt

It was here that Friedrich Schiller's drama, *Death of Wallenstein,* had its much-vaunted 1799 world premiere and Heinrich von Kleist's *Penthesilea* flopped in 1876. The concerts of Niccolò Paganini and Friedrich

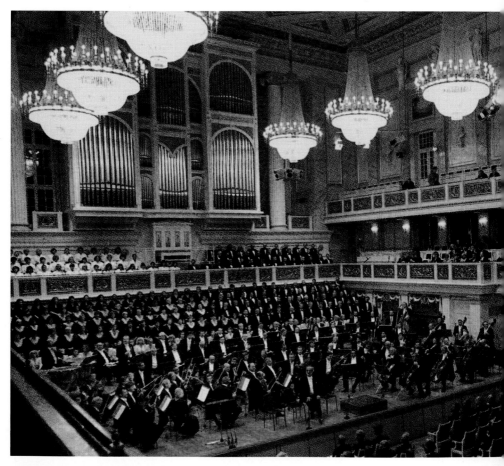

Liszt were frenetically feted, and Richard Wagner conducted his foumous *Flying Dutchman* for the first time in Berlin. Built by Karl Friedrich Schinkel in 1818–1821 and located on a square richly steeped in traditions, the Gendarmenmarkt, the Schauspielhaus positively breathes history. It is one of the masterpieces of neoclassicist architecture in Germany. Built to replace an earlier structure designed by Carl Gotthard Langhans but lost to a fire in 1817, it had its grand opening in 1821 and hosted Carl Maria von Weber's *Freischütz* in a highly acclaimed world premiere. Novelist and peot Theodor Fontane (*Trials and Tribulations, Effi Briest*) was its resident critic for twenty years. Preußisches Staatstheater Berlin (Prussian State Theater) was its name from 1919 up to its destruction in 1945. During the years of the Weimar Republic and National Socialism, it was the premier theater in Germany. In the 1920s, Leopold Jessner created for it an entirely new style of the grand gesture with expressionist decorations, embodied foremost in the famous Jessner Staircase. During the years of the National Socialist consolidation of powers Gustaf Gründgens attempted to salvage "pure art" in dark times with first-rate actors such as Elisabeth Flickenschildt, Werner Finck, Werner Krauß, Käthe Gold, and Marianne Hoppe. In World War II, the Schauspielhaus burnt down to its external walls and was only reconstructed true to the original in 1979– 1984 during the GDR era to celebrate Berlin's 750th anniversary – though its interior was completely modified. Where once was a theater with a stage, there now was a concert hall with 1,850 seats, its interior outfitted in a Schinkel-like style. In 1994, the building was renamed Konzerthaus Berlin.

Staatsoper Unter den Linden and Deutsche Oper

As soon as Friedrich II had acceded to the Prussian throne, he created a landmark with the construction of the Royal Opera House, designed by architect Georg Wenzeslaus von Knobelsdorff. However, its enormous parquet – with room for 2,000 invited guests – was seatless; only the king was given a seat. It was not until 1789, that admission tickets were sold to the public. Even today, the musical world pays attention to the house on Unter den Linden Boulevard, with Daniel Barenboim as head conductor for life. Since the merging of the various former ballet ensembles of Berlin's opera houses into the new State Ballet Berlin under the direction of Vladimir Malakhov, dance as well has found a much remarked upon home at this address. The opera house had its first artistic success after the liberation wars: Gaspare Spontini directed the house; Albert Lortzing celebrated his triumphs, as did Giacomo Meyerbeer and then Richard Strauss. Alban Berg's *Wozzeck* was born to the light of the stage at this location. Bombed into smithereens and cinders during World War II, the Lindenoper was completely reconstructed by Richard Paulick in 1952–1955. Since then it has room to seat an audience of 1,396. It features a wide variety of productions with emphases on pre-Mozart times and modernity, has film and theater directors take on the great classics, and provides a forum for dark-horse international stars, such as Rolando Villazón, who already sang here while he was still considered an insider's tip. The Deutsche Oper Berlin, on the other hand, able to seat 1,885 guests, traditionally specializes in world premieres of contemporary works, for example by Hans Werner Henze and Wolfgang Rihm, though it also feels obligated to "critically re-question" classical repertoires from Mozart to Verdi. The character of this opera house was first minted by long-term general director Götz Friedrich, who sometimes co-directed with Christian Thielemann, his general director of music. Its cuboid, concrete structure, built in the plain-objectivist manner and covered with Spree River pebbles by Fritz Bornemann in 1956–1961, replaced the war-damaged 1912 Charlottenburger Oper building. This modern new building on Bismarckstraße gave the West its only representative opera house. Today, Berlin has three urban opera houses. This is unique in the world. Their possible merger has been an object of discussion for years.

Above: Deutsche Oper at Bismarckstraße in Charlottenburg – right: Staatsoper Unter den Linden

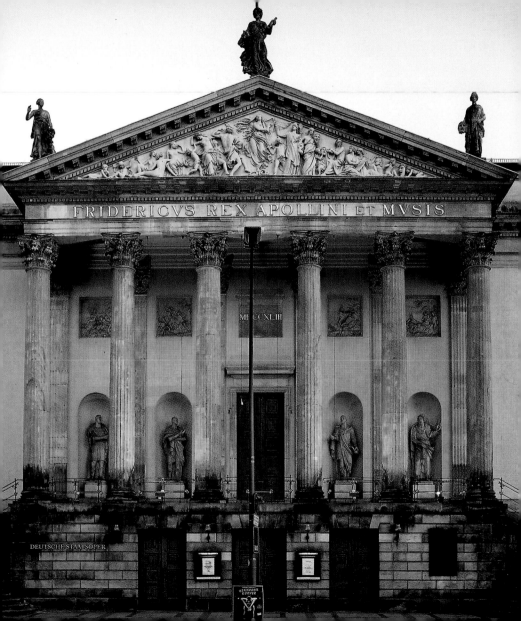

Deutsches Theater

Incredible but true: A bomb did a good deed. Up to World War II, the Deutsches Theater was tucked away in a backyard. Street frontage on Schumannstraße was blocked by a row of houses. Only when these were destroyed did the area open up to the southern square. Nothing but the auditorium of 600 seats was left of the

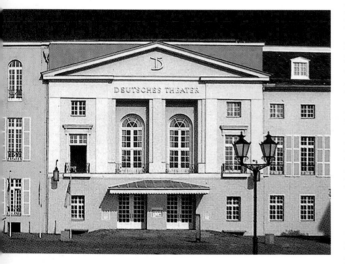

original structure built by architect Eduard Titz in 1850, the Friedrich-Wilhelmstädtisches Theater. In 1883, the theater was given its current name. Theatre manager and director Otto Brahm established naturalism by featuring Gerhart Hauptmann; Henrik Ibsen's drama *Nora* attained its first successes at the Deutsches Theater. 1905, Max Reinhardt took over direction; his novel productions of the classics – faithful to the text, psychologizing, actor-oriented – went down into the annals of stage directional history. It was Reinhardt as well who, in 1906, had a revolving stage installed and who had William Müller remodel the façade in the neoclassical manner. This same architect also transformed the adjacent casino into a stage for intimate theater, the Kammerspiele. While Max Reinhardt made the theater world famous, his first among five others comprising his Berlin empire, Heinz Hilpert tried to lead it through the Nazi era with decency and a classical-humanist program. In the GDR, Wolfgang Langhoff forged a new style of production. Today, the theater chiefly presents classical pieces, from Euripides' *Medea* through Johann Wolfgang Goethe's *Faust*. The Kammerspiele stage specializes in contemporary drama. The Deutsches Theater has always featured big name stars; its directors range from Heiner Müller to Michael Thalheimer; its cast includes first-rate actors like Jörg Gudzuhn, Ulrich Mühe, Dieter Mann, Jürgen Holtz, Kurt Böwe, and Ulrich Matthes, and actresses like Dagmar Manzel, Inge Keller, Käthe Reichel, or Nina Hoss.

Komische Oper

From Händel to Cole Porter – here the audience can understand every word because all foreign language operas are performed in German. Such was the decision of Austrian Walter Felsenstein, when he founded the Komische Oper in 1947. Ever since his first production on site, Johann Strauß' *Fledermaus*, he set the standard for opera direction. His work focused on visual presentation, such as it had hitherto only been practiced with respect to drama. It was under his general and theatrical directorship, that the Comical Opera Berlin became world famous. Renowned orchestra conductors such as Otto Klemperer, Rudolf Kempe, Kurt Masur, and later, Kirill Petrenko, also contributed to this fame. For decades, chief director Harry Kupfer was able to safeguard Felsenstein's legacy of a "realistic" musical theater with excursions into light operetta fare. His successor, Andreas Homoki, likewise dares to walk in these shows, aided by in-house directors such as Calixto Bieito, Peter Konwitschny and Hans Neuenfels. Today, classical works of opera literature and modern pieces are part of the program, as well as, additionally, a successful series of children's operas. The theater's name refers to the tradition of the late 18th century French *Opéra comique* as well as the first Berlin Komische Oper at Weidendammer Brücke, which had taken its cues from that genre. First called Theater Unter den Linden, then Metropol, the building on Behrenstraße was built in 1892 in the neo-Baroque style. Its auditorium with 1,190 seats and its magnificent staircase have wonderfully survived. Its façade, destroyed in the war, was replaced in the 1960s; its foyer has only recently been remodeled into an elegant, urban hall of mirrors by Stephan Braunfels.

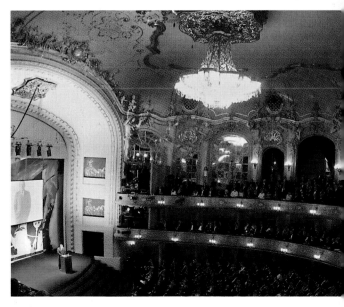

Maxim Gorki Theater

Russian dramatist Maxim Gorky, for whom the theater was named, has not been on the playbill for ages. Instead, it catches the attention by featuring contemporary authors, Berlin-specific materials as well as co-productions with renowned stages of other cities. At 440 seats the smallest of Berlin's State Theaters, it hides its elegant neoclassicist façade behind a small chestnut wood at Neue Wache Unter den Linden. The theater owes this exquisite home address to its unusual history as the oldest concert hall building in Berlin. Originally, it used to be the home of the Sing-Akademie, a renowned musical society of the Berlin bourgeoisie founded by Karl Friedrich Fasch in 1791. Karl Friedrich Schinkel, Felix Mendelssohn Bartholdy and Otto von Bismarck sang at this site. Master mason, composer and conductor Carl Friedrich Zelter, who directed the academy until 1800, initiated its construction; it was built in 1825–1827 by Carl Theodor Ottmer according to designs by Schinkel. Zelter also became famous on account of his correspondence with Goethe; he was the only one of Goethe's friends to address him with the intimate "Du" and often visited him. In 1829, the just recently opened house, much acclaimed for its sensational acoustics, hosted the first performance of the Matthew-Passion, rediscovered after Johann Sebastian Bach's death. Even then, though, it was also used for purposes other than music, to nurture civic culture: Alexander von Humboldt presented his *Cosmos Lectures* in 1827; after the March Revolution, the Constitutional Prussian National Assembly held its convention here in the summer of 1848. But mostly the Sing-Akademie gave concerts until the house was badly damaged in World War II. After its reconstruction, it served the adjacent Soviet House of Culture (today's Palais am Festungsgraben) as a stage 1947. In 1952, the theater was given its current name.

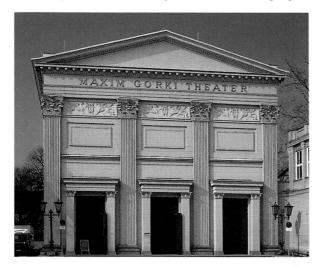

Berliner Ensemble

It was named by its founder, Bertolt Brecht. Berliner Ensemble was the name of the group gathering around the dramatist in 1949, when he had returned from his years of exile in the United States and Switzerland. Looking for a new field of operations in Germany, he received a tempting offer from GDR. After a five-year guest performance at the Deutsches Theater, he made the Haus am Schiffbauerdamm his home stage in 1954. It was here that he performed to global acclaim his plays with Helene Weigel, Therese Giehse and Ernst Busch, and that he practiced his theory of "epic theater," a radical turning away from illusionist theater. Trailblazing productions were put on stage: The Caucasian Chalk Circle, Life of Galileo, The Mother, and The Good Person of Szechwan. After Brecht's death in 1956, Helene Weigel directed the house by herself until 1971. Stage managers like Ruth Berghaus, Peter Zadek, Matthias Langhoff, Heiner Müller, and George Tabori have left their marks on the theater. At present, the former director of the Vienna Burgtheater, Claus Peymann, manages the famous stage which, after long years of abstinence, again presents pieces by Brecht, next to classics and those by contemporaries such as Peter Handke and Botho Strauß. But there was also a period preceding the grand master. Since its opening in 1892, this house, once called Neues Theater and then Theater am Schiffbauerdamm, has made

Brecht Monument, installed by stage designer Karl-Ernst Herrmann at the Berliner Ensemble

history: so in 1893 with its first (private) performance of the scandalous showpiece of its times, Gerhart Hauptmann's naturalist drama The Weavers; in 1905 with Shakespeare's Summer Night's Dream, as produced by Max Reinhardt, who thereby ushered in the era of the director's theater; and finally in 1928 with Brecht's own Threepenny Opera, which made the duo Brecht/Weill famous overnight. The great names of Berlin theater history have always already excelled on this stage, from Fritzi Massary to Corinna Harfouch, from Alexander Granach to Martin Wuttke.

The Golden Twenties, Its Theaters and the Revue

by Edelgard Abenstein

Spree-Athens is dead, and Spree-Chicago is growing up: this is what people say in postwar Berlin. A new sense of vitality is taking over. Entertainment is on the agenda – the capital invents the culture industry and is enjoying itself. Slender and athletic, so walks the self-confident lady, guided by the feuilleton pages of intaglio-printed magazines, through the New West. Skirts are getting shorter, hairdos as well. People are dancing the Charleston, the "grotesque dance," and amuse themselves by listening to the Chocolate Kiddies, who bring jazz to Berlin. The Wilhelminian epoch with its prudery has receded into the distance.

At least superficially, political calmness has descended on Germany. Inflation is overcome; wages and economic volume are on the rise. It is the period of conservative alliances, or bour-

Rehearsal of "Mother Courage and her Children," 1951; left: Helene Weigel, center: Bertolt Brecht

Stage director Max Reinhardt, photograph, c. 1925

geois bloc cabinets, which are allotted continuity in spite of rotating membership by Foreign Minister Gustav Stresemann. At 4.3 million inhabitants, the third largest city in the world is attracting talent from all over Europe. Twelve operas have their world premieres during these years. The most eminent conductors of the period are working in Berlin. Starting in 1922, Wilhelm Furtwängler directs the Berlin Philharmonic Orchestra; Otto Klemperer is leading the Krolloper, opposite the Reichstag, into a new era; Bruno Walter is competing at the Städtische Oper Charlottenburg against Erich Kleiber, the conductor of the Staats-

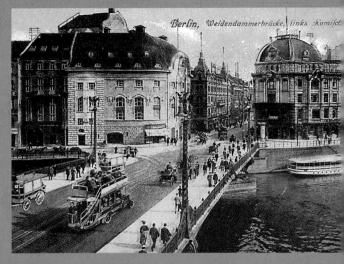

Admiralspalast and Weidendamm Bridge, photo postcard, c. 1915

oper. Paul Hindemith and Ernst Krenek are teaching at the Hochschule für Musik. Theater revolutionaries such as Leopold Jessner are jostling shoulder to shoulder, as do the great thespians, Tilla Durieux, Adele Sandrock, Elisabeth Bergner, Therese Giehse, Gustaf Gründgens, Fritz Kortner, and many others. "The city gobbles up talents," said Carl Zuckmayer, who achieved a sensational success in 1925 with his *Merry Vineyard*. The great magician of Berlin theater, however, was Max Reinhardt. He played for those people "who treated theater as a luxury item, as the most beautiful ornament of existence." For his great Shakespeare productions he had pioneered – already before the war – the use of the entire abundance of modern stage technology. With his elaborate stage decorations, he guided the theater of illusion to its sensual epitome. The myth of 1920s Berlin, however, was especially distinguished by the glimmer and glamour of the "light muse." *To All!* is the title Erik Charell gave his first show that premiered on October 22, 1924, in the Großes Schauspielhaus, where shortly after the war, Max Reinhardt had not been able to fill its over 3,000 seats with his *Oresteia.* Box office darlings, the Tiller Girls from London are engaged; they swing their flawless legs with so much discipline, as if they hailed from a Prussian regiment of foot guards. The house is always sold out. Its competitors are quick to react: Hermann Haller at Admiralspalast with

his *Where and When* and James Klein at the Komische Oper both put their money on dancing girls. Up until then, Hans Albers had jumped every night into a water basin peopled with mermaids. Now Klein's Revue is called: *A Thousand Sweet Little Legs*, and later, *Go Undress*. The theater of amusement is triumphing over all

Volksbühne at Rosa-Luxemburg-Platz

showed everything, from nude dancing to acrobatics. Even theater people with pedagogical-political expectations could not entirely avoid the influence of these new forms of expression. Erwin Piscator, who started producing at the Volksbühne on Bülowplatz (today's Rosa-Luxemburg-Platz) in 1924, called one of his first works *Revue Roter Rummel* (Red Riot Revue). His own stage at Nollendorfplatz opened in 1927 with Ernst Toller's *Hoppla, wir leben!* (Oops, we're alive!) – a scenic sequence made of filmic as well as revue elements. Even the greatest theatrical success of this era, Bertolt Brecht's

Title page of a printed sheet of music (When you see my aunt, say hi to her for me!), 1924

"serious" art forms. Of Berlin's 50 some stages, two-thirds were dedicated to entertainment. The three 'revue palaces' – Das Große Schauspielhaus, Admiralspalast and Komische Oper – altogether offered seating for over 7,000 people every evening. If the Apollotheater, Metropoltheater and Theater of the West are included, the production revues totaled 12,000 visitors daily. One hundred and sixty-seven cabarets and vaudevilles, including the large establishments of Scala, Wintergarten and Plaza,

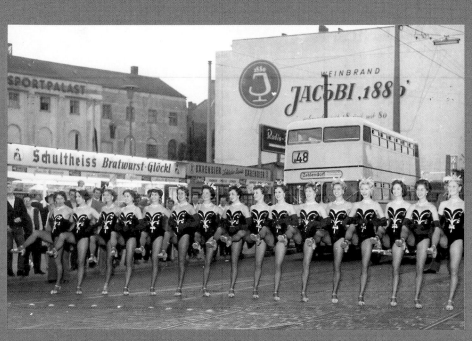

London's Tiller Girls during the international Variety Show Festival in Berlin in 1960

and Kurt Weill's *Threepenny Opera*, which world premiered at Theater am Schiffbauerdamm in 1928, owes much to this special recipe cooked up by the zeitgeist. Its enthusiastic reception shows that this piece possessed exactly the kind of mixture of modernity and entertainment that the Berlin audience was especially attuned to. Ralph Benatzky's *Im weißen Rössl* (White Horse Inn) developed into a blockbuster hit still going strong today, because Erik Charell, who had launched this musical comedy in 1930 in the Großes Schauspielhaus, modernized a run-down genre by making it similar to a revue.

For the first time, a team of songwriters and composers planned and operated with military precision, as is the norm today for every Broadway musical. In this way, the most successful operetta in the world and of all times was born.

In 1933, the Nazi dictatorship started waging a war against everything it perceived as "Big City Decadence." Creative members of the entertainment world were hit especially hard by the Nazi persecution of the Jews. War and bombs put out the lights of the amusement establishments.

Film and Movie Theaters, Babylon and International

European film history was launched at the Wintergarten-Varieté near Friedrichstraße Station, where film pioneer Max Skladanowsky showed his first silent film strip in 1895. In a backyard close by, Henny Porten and Asta Nielsen made their first appearance on camera while Berlin tinkerer Oskar Messter revolutionized the technology of projection. With key works of the expressionist era, *The Cabinet of Dr. Caligari* (Robert Wiene, 1920), *Nosferatu* (Friedrich Wilhelm Murnau, 1922) or *Dr. Mabuse, the Gambler* (Fritz Lang, 1922), German film production set industry benchmarks. Techniques of camera work and lighting as used in these works influenced international film production

wholesale. Berlin thus rose to the status of leading film city in Europe. UFA in Potsdam Babelsberg developed into the second biggest film empire after Hollywood; it produced such international classics as the silent film *Metropolis*, Fritz Lang's famous epos about a factory city of the future, which had its world premiere in 1927. Movie theaters at the time also took off on their speedy victory lap. In 1921, the city had 400 motion picture theaters with almost 150,000 seats. Alfred Döblin called them "theaters of the little people." But glamorous film palaces with ushers in uniform, orchestras with up to 70 musicians and vaudeville-style ancillary programs were also created, especially around the Gedächtniskirche. The single remaining architectural witness of those times is the Babylon movie theater in Berlin-Mitte. The movie *Miss Else* was shown in 1929, when it was first opened in this residential quarter entirely designed by Hans Poelzig. The architect's handwriting is unmistakable: It is a theater enabling guests to have a grand experience of architectural space. Its foyer presents lithe, rounded forms which repeat the momentum of the horizontal ties on the external façades. In the auditorium with gallery a flat ceiling with embedded overhead light arches above smooth walls. In 2001, the movie theater with 450 seats was reconstructed to

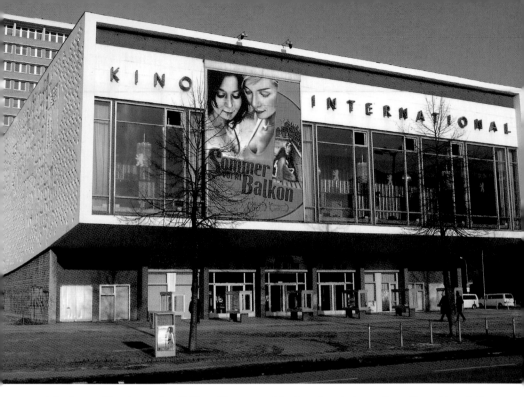

original specifications. Its Philips Cinema Organ, restored in 1999, is a unique copy. The only instrument of its kind in Germany, it still accompanies the showing of silent movies at its original location.

One of the last representatives of the picture palace era of the 1950s, finally, is the Kino International near Alexanderplatz. Like a large shop window letting the celluloid world shine out onto the street, it opens up a wide view of Karl-Marx-Allee. It was Josef Kaiser who designed Café

Moskau located on the other side of the street, the neighboring pavilion buildings, the erstwhile Hotel Berolina, all grouped around the Kino as their centerpiece; in doing so, he created one of the most intense architectural complexes of GDR urban planning. Opened in 1963, its auditorium seating 551 visitors can definitely rival the seating capacities of modern mega movie theaters. Every February during the Berlin Film Festival, the International is in the spotlight as one of the festival's venues.

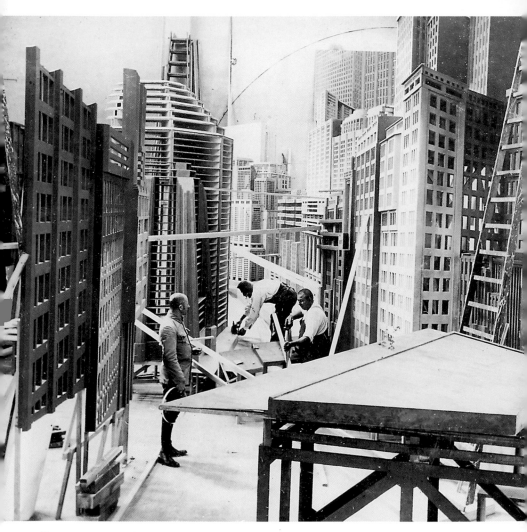

Film set construction for "Metropolis," direction: Fritz Lang, Germany 1926

Poster for Robert Wiene's feature film "The Cabinet of Dr. Caligari," 1920

Marlene Dietrich –
a "Prussian Princess" in Hollywood

by Jeannine Fiedler

When Marlene Dietrich was born in Berlin Schöneberg in 1901, William II still had 17 years to go before his resignation at the end of his calamitous regency. When she died in 1992,

Marlene Dietrich bewitches mankind as Lola in the Ufa production "The Blue Angel" of 1930.

reunified Germany was not even two years old. During her lifetime spanning almost a century, Germany had weathered the Weimar Republic, the dictatorship of the Third Reich, two catastrophic world wars, and its own partition.

During these decades, she accomplished nothing less than the creation of a myth: The pert Berlin actress turned *The Blue Angel* in 1930 and – after Hollywood had called her to California that same year – into one of the dream factory's most fascinating screen visages. Already causing quite a stir while performing on Kurfürstendamm dressed in men's clothes, the *diseuse* transformed herself into a successful entertainer when she embarked on her second career in 1950 – not only to Las Vegas, but around the world. And *La* Dietrich had moral integrity! She refused to be bought back by the National Socialists to serve as their international token star at UFA; instead, she became a US citizen, fought against Hitler's regime and was not above serving on the frontlines in any capacity during World War II.

"Her name begins like a tenderness and ends with a whiplash: Marlene Dietrich," thus did Jean Cocteau characterize the diva's personality in his famous *aperçu*. Her tenderness – that was the mask-like perfection of her beauty. As her Pygmalion, Marlene's early master and mentor, director Josef von Sternberg,

Russian film director Sergej M. Eisenstein and Josef von Sternberg with Marlene Dietrich during the shooting of "The Blue Angel," 1930

had chiseled from the frivolous, well-grounded Berlin local celebrity a rough shape in the *The Blue Angel* and then raised her as Lola Lola to cult status. But in her subsequent global successes such as *Morocco* (1930), *Shanghai Express* (1932) and *The Scarlet Empress* (1934), he created the apotheosis of beauty from the magic of light and shadow – a movie goddess for the 20th century. However, he would have liked to condemn Marlene, his "creature," to the silence of statues, thereby contradicting the myth of vitalized Galatea. Although she was allowed to act very animatedly in numerous movies lacking von Sternberg's artistic sig-

nature, film criticism recognized her thespian ability only very late in the game.

La Dietrich, and this is the whiplash, was also famous for her steely discipline, her ambition, her diligence, and her tolerance – all of them Prussian virtues that first enabled her stunning career. As for her magnificent legs that finally refused to serve her on those boards that signify the world, or for her face that had been "photographed to death," as she called it – she deprived her audience of both during her final fifteen years of life in Paris. Just as she desired, the Prussian princess of Hollywood is entombed in her native city: in Berlin.

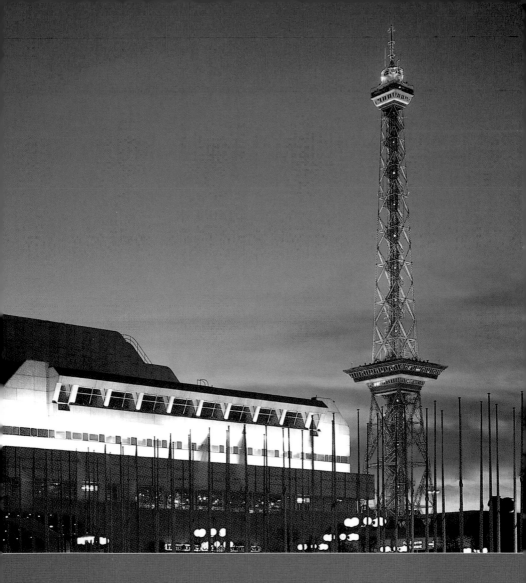

Media Centers and Trade Fairs

Media Centers and Trade Fairs

Aerial photograph of the fairgrounds with numerous exhibition halls and the Funkturm (Radio Tower) inaugurated in 1926 (right)

Where there is power, the media are not far behind. After German reunification, public-service broadcasting agencies settled only a stone's throw away from the government district in Berlin Mitte. Private media broadcasters, too, strove to be close to the Reichstag and ministries – in buildings with landmark status: RTL is occupying the former master station of the Berlin Electricity-Works at Schiffbauerdamm; Sat.1 has settled around the Hausvogteiplatz, e.g., in the old, once ultra-modern,

Manheimer Clothing Factory. Even the first German radio station set up shop in 1923 in the shadows of the political control centers on Wilhelmstraße. When it was getting too crowded in Vox House at Potsdamer Platz, the cultural and commercial hot spot of the city, they moved to the prospering West with its new quarters, to today's Masurenallee in Charlottenburg. The old trade fair, which was already bursting at the seams at Lehrter Bahnhof in 1914, was also relocated there.

Funkturm, Fairgrounds and House of Radio Broadcasting

It is an elegant emblem of the city: Nicknamed "Langer Lulatsch" (The Beanpole) by Berliners, the Funkturm (Radio Tower) started operating in 1926. Its filigree trussed steel construction, built by Heinrich Straumer in imitation of the Paris Eiffel Tower, has a height of 150 m, including the antenna; it stands – and this is unique – on china feet, insulators that prevent the discharge of energy into the ground. In 1929, the first TV picture in the world was broadcast from this site. The panoramic view from its restaurant, 52 m up, and especially from the observation deck underneath its spire, is fantastic, showing everything from the River Havel to Berlin Mitte. At the foot of the Radio Tower, the new trade metropolitan fairgrounds were also developed in those days. The comprehensive building plan (1928) by Martin Wagner and Hans Poelzig, however, was not realized. Instead, Richard Ermisch's designs were implemented in the 1930s, since they took their cues from those representative buildings which were typical of National Socialist style: Heinrich Straumer's House of the German Radio Industry (1924), which burnt down in 1935, was replaced by the Glass Gallery. Its 35 m high Hall of Honor still constitutes the entrance to the building today. Two 100 m long buildings attach to it that once provided Berlin with a pompous fairgrounds presence. The George Marshall House (1950) by Bruno Grimmek and Werner Düttmann, on the other hand, an exhibition hall made of glass, poses the starkest contrast in its lightness with the National Socialist monumental edifices. Another milestone of German radio broadcasting history rises up opposite the Funkturm and fairgrounds: Hans Poelzig's first „Haus des Rundfunks" (House of Radio Broadcasting) in Germany, built in the style of expressive Objectivity from 1929 to 1931. The building concept set standards. Its three four-story high office tracts form an interior courtyard where the acoustically sensitive studios are housed in soundproof conditions. Its three broadcasting halls are accessible via the large entrance hall – an atrium lined with circular galleries. Since 1957, the house has been used by Sender Freies Berlin (SFB), today called Rundfunk Berlin-Brandenburg (RBB). Once the largest and most modern radio house in Europe, it is still one of the architecturally most accomplished functional buildings of the 20th century in Berlin.

Stairwell in Haus des Rundfunks

We are broadcasting from Berlin –
a brief television history

by Jeannine Fiedler

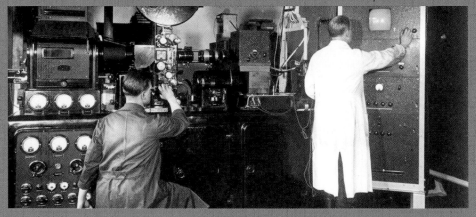

"Kinosender": first public television via light scanner in the Imperial Post Office Museum, April 9, 1935

Even the dawn of television was structured like a furious competition among inventors and their respective nations about technical novelties and first broadcastings, which were conducted, e.g., during worldwide TV test runs. Among the leading technicians of the Anglo-American world was John Logie Baird, whose inventions were used by the British Broadcast Corporation (BBC) in London, and Philo T. Farnsworth, who was the first in 1927, in San Francisco, to electronically transmit a picture from sender to recipient via an electron steel tube. However, it was the 1884 invention of a German, Paul Nipkow – the rotating Nipkow-plate perforated with spiraling holes, which disintegrated pic-

tures into light-dark signals and then recomposed them – that was the basis for several further developments of that medium – which is why he is considered the forefather of television. A decisive step was made in 1897, when Ferdinand Braun and Jonathan Zenneck developed a cathode-ray tube, also called Braun tube. It facilitated the projection of picture points in chronological sequence onto a glass plate coated with a luminescent substance. In his research laboratory for electron-physics in Berlin-Lichterfelde, founded by him in 1928, Manfred von Ardenne led this method of flying-spot scanning to maturity. In 1929, TV acquired a "face" for the first time: Two young Berlin ladies happened to

First recordings in a newly opened TV studio in West Berlin, photograph from 1951

get in front of the electronic telescope of the German Imperial Postal Service during a TV re-search program. Ms. Schura von Finkelstein and Ms. Imogen Orkutt belted a song in the form of a picture with a 30-line resolution, that is, as crude, horizontally scanned specters. Amusingly, the song thwarts the phenomenon of invisible rays in true Berlin mother-wit fashion and camou-flaged by the trappings of a good old German folksong: "Horch', was kommt von draußen rein" (Listen, what's coming in from the outside) – into the comfortable chamber, so one should like to add – either from the ether or from Braun's cathode-ray tube.

Progress was not to be impeded: Ardenne presented the first fully electronic television at the 1931 Berlin Radio Exhibition, which made the *New York Times* yield him the title page; the first public TV transmission took place on April 18, 1934, in the Berlin Krolloper; the TV station "Paul Nipkow Berlin" was the first TV station to start broadcasting, on March 22, 1935, a regular, worldwide program in 180-line high-resolution quality. In 1937, resolution had advanced to 441

lines, as compared to today's 625 lines. This his-tory of success was interrupted only by World War II, when there was neither money nor staff to develop further this medium not yet fit for the purposes of propaganda. Only 500 home re-ceivers sold at a high price could barely provide as effective an ideological indoctrination as tried-and-true radio broadcasting (received via the Volksempfänger (People's Receiver), or the hundreds of movie theaters that started every movie show with the Weekly Newsreel, pre-senting news of the Third Reich.

The TV station "Paul Nipkow Berlin" reached the peak of its 10-year broadcasting run with the transmission of the 1936 Olympic Games from Berlin. More than 160,000 people viewed the sporting competitions live in so-called "TV-par-lors" that had been installed all across the country. As the new model medium of industrial-ized countries in the second half of the century, television has not only changed our perception of the world, but the way millions of people live.

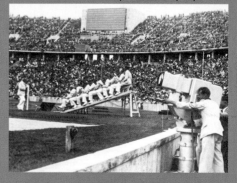

Camera team at the Olympic Games in Berlin in 1936 during the 100-meter qualifying

Television Tower Berlin Mitte

At a height of 365 m, Germany's highest structure (with its new steel tip installed in 1997, it even reaches 368 m) is simply not to be overlooked and constitutes a technical mega-achievement. Construction of the Television Tower, completed in 1969 and feted as "work of the workers," had been initiated ten years earlier by Hermann Henselmann, the architect of Karl-Marx-

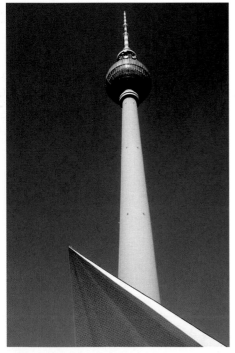

Allee. He had designed a "tower of signals," composed of a tapering concrete shaft, a glass sphere and a steel needle. "Space design" – this is what the world, enthused by space travel, called it in the western hemisphere. What was meant as a symbol for the satellite-like rise of communism, owes its existence to the fact, that the GDR needed a country-wide broadcasting facility that – as "Sozialistische Höhendominante" (socialist vertical dominant) – was placed right at the center of its capital. GDR television officially started operating in 1956 as Deutscher Fernsehfunk (German TV-Broadcasting) in Berlin Adlershof, on a site that is closely connected to the beginnings of Germany's history of aviation: the first German airport for motorized aircraft. In its hangars, converted to studios, legendary works of early celluloid history were filmed there sometime later – such as *The Indian Tomb* (1921) or *The Testament of Dr. Mabuse* (1933). High up in the air above Alexanderplatz, a panorama café inside the glazed dome of the TV Tower has been turning on its axis twice per hour to the present day; two elevators each transport up to 15 persons up and down at a speed of 6 meters per second. During storms, the spire can sway up to 60 cm, although the tower's foundation is only 5 m deep. The base of the tower is framed by pavilions, symbolizing the leaves and roots of an organic shaft with their sculptured roof areas. Today, they house the Media Center Berlin-Alexanderplatz.

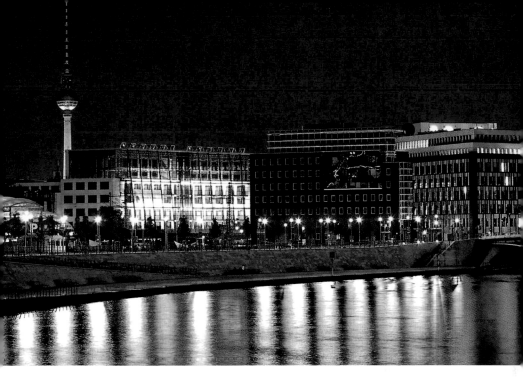

The New Media Centers

Hot on the heels of the government, daily news producers likewise scouted for new marketing sites in the capital. Thus, ARD's main studio settled strategically in the middle of the government district at the corner of Reichstagufer and Wilhelmstraße. Laurids and Manfred Ortner set up the studio as a reddish, luminescent bar hugging the curving banks of the Spree, where a restaurant attracts staff and the public. The

office tracts of the five-story studio building are connected via the large, glass-canopied hall of the editorial department at the heart of the complex. Its Wilhelmstraße façade is determined by a single large window that provides a symbolically fraught view onto the government and parliament buildings. The adjacent Federal Press Office has integrated into its own complex several old buildings dating back to the Imperial Era and the GDR, e.g., the former Postscheckamt (Postal Checking Account Office, 1913–1917), whose richly

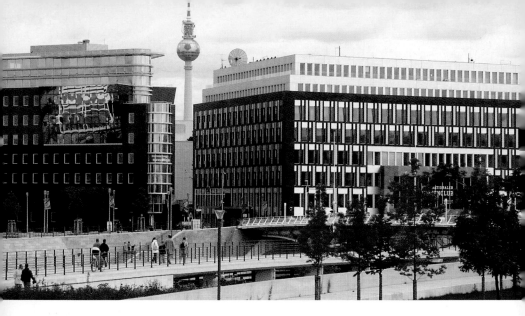

View of Federal Press Conference building on the Spreebogen

decorated façade faces the Spree, while a new, narrow administrative tract (KSP Engel and Zimmermann, 1996–2000) was built in front of the eastern gable wall. The ZDF main studio also managed to get a hold of an illustrious address: at the historical Zollernhof on Unter den Linden Boulevard. Its shell-limestone façade facing the street was renovated, while its publicly accessible courtyard was covered and its interior rejuvenated. The most beautiful building, however, is the new home of the Bundespressekonferenz (Federal Press Conference), a consortium independent of the federal government comprising about 900 parliamentary correspondents. The façade of the austerely shaped building block, is clearly articulated. The central chamber of the building (Johanne and Gernot Nalbach, 1998–2000), its Conference Hall, projects beyond its aesthetically pleasing front, coming to the fore as a large, massively framed window. The building faces the Chancellor's Office and the Paul Löbe House with its delegate offices, that is, government and parliament, but also Gustav Peichl's futuristic-looking kindergarten. During nighttime illumination, the latter glows like a precious, small Art Deco jewel case with its slightly crazy façade grid and its white neon fields.

ICC – International Congress Center

Up to the rebuilding of Potsdamer Platz, the International Congress Center at Messedamm by Ralf Schüler and Ursulina Schüler-Witte, was the most extensive of Berlin's postwar building projects (1974–1979). Surrounded by city freeways, this architecturally daring-looking complex lay like a large aluminum-clad machine at an important entrance to the city. At a total length of 320 m, it comprises 80 halls and rooms, the largest of which can seat up to 5,000 people. With 800,000 m^2 of built up space, the ICC is the largest congress center in Germany. Like no other building in Berlin, this flawlessly functioning colossus stands for the faith in technology prevalent during its period of construction and the mission statement of this city so equitable towards cars but disregardful of pedestrians. Traffic is funneled towards the interior via an "auto-foyer" eight lanes wide; an electronic guidance system leads visitors to the various halls. These are column-free – partly to avoid sound contamination – but this arrangement also renders difficult any type of remodeling. Next to international congresses and conferences, this venue also accommodates famous ballroom events. ICC's bizarre-technoid interiors additionally serve as movie sets, such as for Dani Levy's recent comedy „Alles auf Zucker" ("Go for Zucker!"). Since the ICC has accrued a sizable deficit in operating costs, in spite of its functionality, its removal was repeatedly discussed. But now the die has been cast – it will stay with the city.

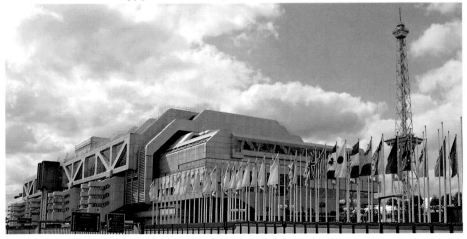

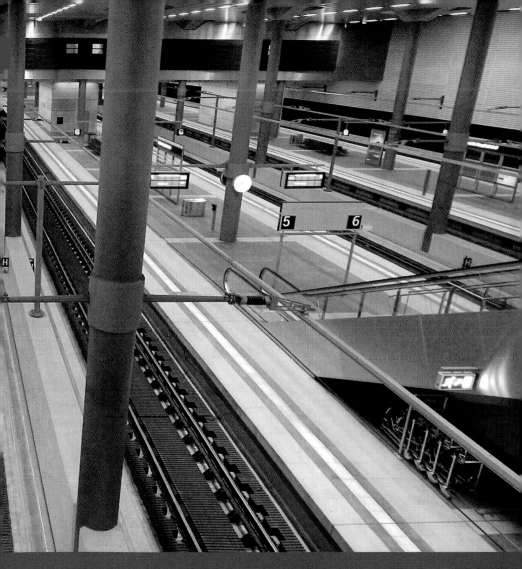

Traffic Areas and Transit Complexes

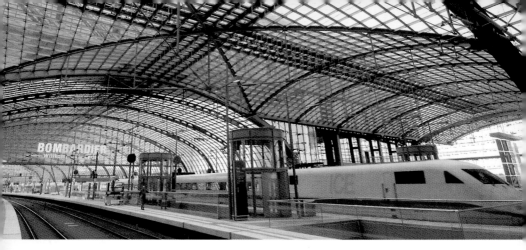

Traffic Areas

Glass Hall of the new Berlin Central Station

Berlin may be one of the youngest big cities in Europe, but its railway system is one of the oldest. Indeed, the large terminal stations of the 19th century may have been destroyed in the war and now are ruins hosting a museum, such as Anhalter Bahnhof; or they may have been rededicated, such as Hamburger Bahnhof, or newly constructed, such as Lehrter Bahnhof. But many of the underground (U) and suburban-railway (S) stations remained standing as signs of innovative applied art. Just as much as did the "Automobil-, Verkehrs- und Übungsstrecke" (automobile, traffic, and testing track, or AVUS), opened in 1921 and renowned for two centuries as the "fastest race track in the world," today guides everyone at speed limit through Grunewald park to Nikolassee.

By air, railway, or roadway – pre-war Berlin was a traffic hub of European stature. At 200,000 passengers a year, Berlin's airport in 1934 surpassed all others in Europe; with 500 long-distance trains running daily, Berlin's railway stations offered to railway traffic a central rail hub linking the East and the West. The city lost this function after its division.

Railway Stations

On the site of former Lehrter Bahnhof, built back in 1871, the largest European transfer station was constructed on a surface area encompassing 90,000 square meters: Berlin's main station, opened in 2006. It is the

central hub of the capital's entire railway transport system. This is where all lines meet on multiple levels: the north-south and east-west connections, two ICE lines, regional and S-trains, as well as, in the future, the "Chancellor U-Train." To protect the nearby government district from noise, tracks going south have been routed through Tiergarten via underground tunnels. The dimensions of this prestigious building designed by Gerkan, Marg and Partner, are tremendous: The glass hall extending along the east-westerly direction swings into the Spreebogen (Spree curve) and is 321 m long; the main concourse intersects with it and has a length of 160 m; it is framed by two parallel glass buildings, 46 m high, which cover the tracks like brackets. The construction of these two bridges was an architectural tour de force. Built vertically into the skies, they were only lowered to their horizontal position post-fabrication and with millimeter precision before an assembled crowd of 100,000 spectators. However, the station is not a fount of pure joy for everyone: The roof, initially designed to cover 430 m, was shortened by about 100 m due to cost overruns, so that, of all things, 1st class passengers of a long ICE train have to leave the train without protection against the weather. Whether the roof will be lengthened is still uncertain. The former central rail stations of the city, the Ostbahnhof and especially Bahnhof Zoologischer Garten, have lost their significance for long distance travel because of the new Hauptbahnhof. Long-distance trains first began stopping at Zoo Station, side by side with suburban trains, in 1884. From 1952 on, it was the only long-distance train station in West Berlin – with only two platforms, one of several phenomena illustrating the unnatural condition of the city during

Anhalter Station, photograph from 1935

its division, especially after the Wall was built in 1961. Nothing is left of what was formerly the largest and busiest long-distance train station in Berlin, the Anhalter Bahnhof (Franz Schwechten, 1876–1880), with its gigantic hall made of glass and steel, except the portico, which remains a war-damaged ruin. Modeled after English industrial buildings, this train station with its magnificent representational halls was not only the gateway to the south. It was here that most visitors entered the imperial capital. Guests of the state such as Czar Nicolas II were welcomed here. It was surrounded by grand hotels; directly opposite stood the elegant Hotel Excelsior. Vicki Baum's global bestseller *Grand Hotel* used this inn, at 600 rooms the largest in the city, as its setting; it featured the exclusive convenience of connecting hotel and concourse by a tunnel.

U and S Train Stations

Hackescher Market with S-Bahn (city rapid railway) viaducts in the background

Without local mass transit, modern Berlin would not have come into being. The network of the S-Bahn (city rapid railway), was developed until 1882; the underground railway opened up the urban terrain in all directions from 1902 on. Once the most innovative transit network in the world, it also reflects Berlin's architectural history. Since the city succumbed to a state of agony during its division, the old U and S stations did not fall victim to the rage of demolition as

was the case in other big cities of the West. After the fall of the Wall, the beauty of these functional buildings was finally recognized. A meticulous restoration made sure they can be admired today as remnants of historical utilitarian architecture: First and foremost are the train stations designed by Alfred Grenander, which take you back in time, providing a tour through the history of styles from the turn of the previous century up to 1920s Objectivist iconography on the line

running from Mitte to Krumme Lanke (1929). With his Wittenbergplatz station (1913), the architect created a theater of voluptuous decor, a representational stage for everyone; Alexanderplatz emblematized the city's speed with its long, geometrical lines. "A machine swallows you at Zoo station and spits you back out at Alexanderplatz," is how Arthur Eloesser characterized the state of speedy passenger transport in densely populated Berlin. Even though most of the master-builders designing the railway system are forgotten by now, testimonies to their art are still standing, like stand-alone buildings, in a cityscape long since transformed – such as the Historicist or Art Nouveau entrance halls of the suburban train stations in Nikolassee, Grunewald and Frohnau, or the objectivist-

functional complexes built in the style of New building on Bornholmerstraße. Among the most impressive achievements in public local transit planning is the East-West line of the S-Bahn, a section positioned on 731 viaducts made of masonry and running from Charlottenburg to Ostbahnhof (once called "Schlesischer Bahnhof"). The line's oldest station, opened for transit in 1882, is composed of a hall adorned with colorful mosaics and supported by elegant arches made of bricks. The station itself was first called Börse, then renamed Marx-Engels-Platz in 1951, which was misleading since the square was located 500 m away, in front of the Palace of the Republic. In 1992, the station and its adjacent courtyards were given the name of Hackescher Markt.

Subway station Krumme Lanke

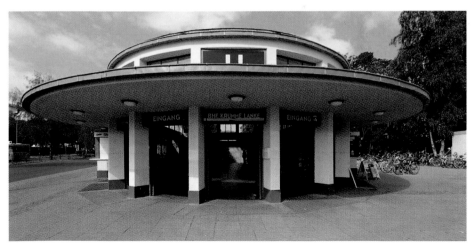

The Architect of Local Transit – Alfred Grenander

by Edelgard Abenstein

Bronze plaque in subway station Klosterstraße memorializes Swedish architect Alfred Grenander

He is the "secret master of the Berlin underground" (Aris Fioretos): Alfred Grenander, architect, furniture designer and urban planner, interior designer and innovator, had a major hand in Berlin's development into a world-class city and modern metropolis of architecture. From the turn of the century to the early 1930s, he planned and designed viaducts and stations for the Berlin elevated and underground railways that still today constitute more than half of the now much expanded network. His designs showed the way well into the 1930s; and they

still lived on when the U stations of the 1950s and 1960s were crafted. Like his famous colleague Peter Behrens (1868–1940), who worked for AEG, Grenander created industrial design as Gesamtkunstwerk, or integrated work of art. Its constructive clarity and functionality is still compelling today.

Born in 1863 in Skövde, Sweden, Grenander moved from Stockholm to Berlin in 1885, where the arts and innovation were enthusiastically embraced like nowhere else on the continent. After his studies in architecture at the Technical University he worked in the Urban Planning Office under imperial architect Paul Wallot from 1888 to 1897; and that he made a name for himself as interior designer by way of his own designs. In 1904, he represented Germany at the

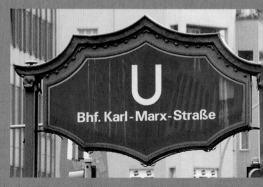

Sign above the entrance to subway station Karl-Marx-Straße

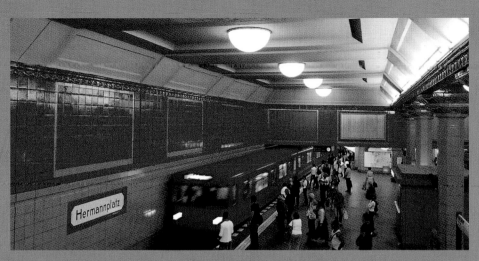

Subway station Hermannplatz, one of the few Berlin subway stations with a hall design

World's Fair in St. Louis, where his Art Nouveau-style furniture, made of exquisite materials, as well as two pavilion buildings so impressed his contemporaries, that they feted him as "regenerator of German art." Around 1900, he began designing for the Berlin Railways Association. Charlottenburg U station, nowadays called Deutsche Oper, was his journeyman's piece in a genre determined by its prosaic function, but which he knew to develop into a beautiful form in a way no one else could. He became the designer of a meticulously composed railway architecture, encompassing everything from the script used for station name-plates to arrival-and-departure boards and benches to railway cars and pavilions, all the way to the thoughtful management of light and colors. Exemplary to the present day are the clear ground plans as well as decorative designs used in building the transfer stations at Wittenbergplatz (1911–1913), Hermannplatz (1923–1927) or Alexanderplatz (1928–1930). The different-colored tiles made the stations distinctive. Thus he decorated U station Klosterstraße with copies of the glazed bricks found in Babylon which were pieced together in the Pergamon Museum to recreate the main façade of the Ishtar Gate. From floral Art Nouveau forms to neoclassicist simplification to austere industrial functionalism – Grenander emerges as surprisingly versatile. His transformer stations, built between 1927 and 1930, at Hermannstr. 5–6, for example, and the office building at Rosa-Luxemburg-Str. 2 (1928–1930) inspired by Mies van der Rohe-designs prove him to be an architect of international standing.

Tempelhof and Tegel Airports

The former drill grounds at Tempelhof Field, later used as exercise turf by pioneers of aviation, were turned into an airport and opened for air traffic in 1923; the airport was remodeled from 1935 to 1942 in the monumental style of National Socialism, based on designs by Ernst Sagebiel. Once the world's largest contiguous building, it still today constitutes one of the world's most significant transit structures. The "mother of all airports" (Norman Foster) is an avant-garde feat, able to cope with all the demands facing a modern mega-airport. Divided into two halves by its central axis – the passenger concourse – the complex was projected to contain separate levels for arrival, departure, freight traffic, hotels, a congress center and offices. Short walkways were just as important as the connection to local transit. Due to its daring roof design – a cantilever steel construction 380 m long and 40 m wide that was unique

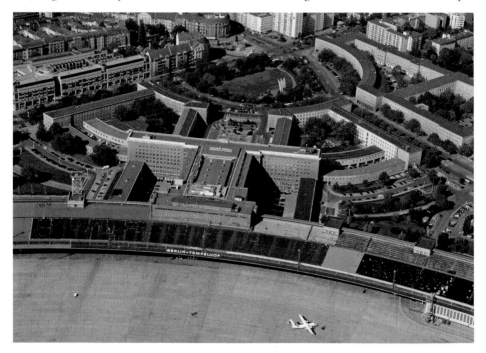

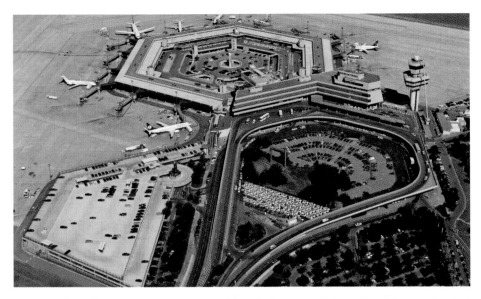

in the world at that time – passengers could enter their planes without being exposed to winds and weather. Taken over by the Russians in late April of 1945 and handed over to the Americans in July, Hitler's unfinished project inadvertently turned into a symbol of liberty and self-preservation. The airport became world famous during the Soviet Berlin Blockade of 1948/49. Thanks to unparalleled logistic achievements by the Americans, the city was supplied with provisions completely by air. In record time, 12,849 tons of freight was transported by airlift totaling 1,398 flights in a single day. Tegel Airport (1975) set new benchmarks as well. Short walkways are the norm here as well: The distance between taxi and airplane seat is less than 50 m – that is a world record. Its decentralized check-in operation spread around its hexagonal ring structure catalyzed the rise of Gerkan, Marg and Partner, the most successful contemporary German architecture firm. Their design for a "drive-in airport" – located on the former airfield of the 1948 French Military Administration – set an example for airports around the world. Since the beginning of the 1990s, a new central airport in Schönefeld has been in its planning stage; its opening in 2011 is to make Tegel and Tempelhof (already in 2008) obsolete. Both airports will then be closed forever – their potential future uses left up in the air.

Walking Tour: Technical

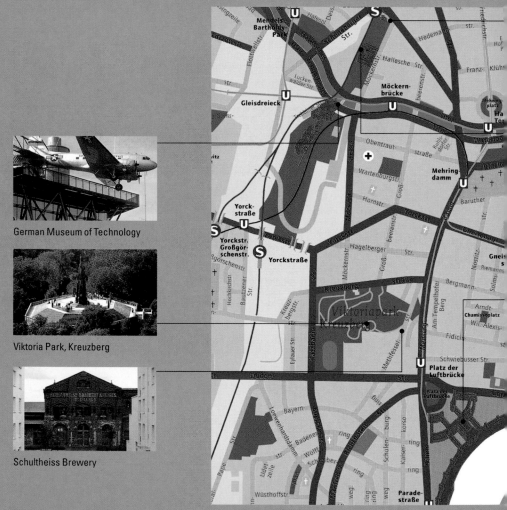

German Museum of Technology

Viktoria Park, Kreuzberg

Schultheiss Brewery

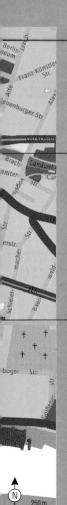

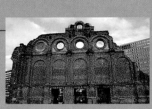

Ruins of Anhalter Station

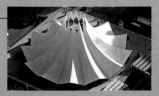

Tempodrom

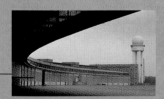

Tempelhof Airport

N
250 m

Once the largest building in the world, it is now defunct as an airport. Its future is open. Will the Babelsberg movie industry build a new dream factory here? If the present is so uncertain, we would rather cling to the past and take a walk past the Luftbrückendenkmal (Airlift Monument), lovingly nicknamed "Hunger Claw" by Berliners; it commemorates three airlift lanes used to supply Berlin by air during the blockade of 1948/49. Leaving behind the Luftbrücke, we turn left onto Duden-straße, a long building with yellow facing stones, black terra-cotta and striking lettering on its façade catches our attention: the "Haus der Deutschen Buchdrucker" (House of German Printers), built from 1924 to 1926 by Max Taut and Franz Hoffmann. Just next door, on Methfesselstraße, we can see one of Berlin's first (10-story tall) apartment high-rises, likewise designed by Max Taut (in 1954/55). A few meters further, a memorial plaque reminds us of scientist Konrad Zuse, who developed the world's first computer at this site. From modernity to a medieval dream world – that takes but a few steps; to the left, we climb up the stairs to the Viktoria terrain, which presents itself like a castle complex with its many tiny towers and crenellations. Where at first Tivoli and later Schultheiss brewed their beer in the middle of the 19th century, an attractive residential and commercial park is currently emerging. Walking past the representational manufacturer's mansion, then to the left, we arrive at the Kreuzberg (cross moun-

tain) – a hill that gave the district its name and that, at 66 meters, constitutes the highest natural elevation in Berlin. From here, the gaze can travel all the way to Mitte, to the domes of the German and French Cathedral, to the towers on Potsdamer Platz. This is where the National Monument rises up to commemorate the liberation wars; it is crowned by an iron cross. Karl Friedrich Schinkel crafted it from 1817 to 1821 from this modest but tough material that was used, since the war, for the production of commodities, ammunition, but also arts-and-crafts items.

Former Schultheiss Brewery villa

This is why "Berlin iron" developed into a major economic factor in Prussia. This landscaped area looks especially romantic because of its wild waterfall; it is an artificial imitation of the Hainfall in the Riesengebirge. Always past mossy boulders with water tumbling down them, splashing from step to step, our winding path leads through the grass of Viktoria Park down to a view of Großbeerenstraße, where, to the right, a small, cast iron "temple" from the penultimate century has survived, the so-called "Café Achteck" (or 'Octagon') – a public restroom.

The broad boulevard, bearing a name that, like many Kreuzberg streets, memorializes the site of a victorious battle against Napoleon, guides us past stucco-adorned rows of houses straight to the Landwehrkanal, where we turn left onto Tempelhofer Ufer. This waterway was created in the middle of the 19th century based on designs by Peter Joseph Lenné as a 10 km long branch of the River Spree to convey building materials to the rapidly growing city. After the canal was no longer necessary as an economic traffic route – at the latest, when the Wall was built – it was, and still is, used mostly for tour boats. Parallel to it rumbles the elevated train on iron-supported tracks that follow the former excise wall of the city, removed in 1860. Where once excise tax was collected and passports were inspected, the Berlin pioneer of electrically run mass transit, Siemens & Halske, built in 1902 and at their own expense the oldest U-train track in the city. Visible from afar, a silver

Tempodrom at Anhalter Bahnhof

propeller airplane is suspended, danger-ously aslant, above a futuristic glass body, the new building of the German Museum of Technology by Helge Pitz and Ulrich Wolff (1996–2003); the plane is a "Rosi-nenbomber" (raisin or candy bomber) of the type C-47 B, which was deployed on the Luftbrücke (air bridge) operation dur-ing the Berlin Blockade. Equally imposing, another eye-catcher rises upward, showing itself as we walk down Möckernstraße: the iceberg-like spires of the roof of the Tem-podrom by the architects Gerkan, Marg and Partner (2000/01) as an events arena for some 3,500 guests on the grounds of Anhalter Bahnhof. Only a few portal remains testify to that old train station's former glory. The cantilever, iron roof of its concourse, once spanning a width of 62.5 meters, was unique in Europe in those days. It was designed by Heinrich Seidel, who constructed the Yorck Bridges and the bridge across the Landwehrkanal; he was an engineer who decided, after the open-ing of his train station in 1880, to become a writer. He immediately wrote a bestseller about an engineer, *Leberecht Hühnchen*, whose talent lay in his "rosily shimmering" optimism. Of this nothing remains but the stones rosily tinted by sunlight.

Industrial Monuments and Public Buildings

Industrial Monuments and Public Buildings

Berlin in the 1920s was the third largest business location in Europe. Its electrical industry with AEG and Siemens and its chemical industry dominated the international market. The city's spatial dimensions were partially determined by its plants and factory facilities. Everything had begun in "Fireland" just outside Oranienburg Gate, where August Borsig established the most important Prussian railroad factory in 1837; his residence (1899) on Chausseestraße still commemorates this site today. Ernst Schering's chemical laboratory and Emil Rathenau's machine factory, AEG's birthplace, were located here. After the unparalleled economic boom during the Imperial period these enterprises had advanced to the top ranks of the innovative growth industries and "emigrated" to settle on greenfield sites. Entirely new cityscapes were thus developed, such as Siemensstadt, Moabit or the Oberspree area. Planners made sure, that factory buildings and production facilities were designed functionally cogent and yet architecturally attractive. Many of these utilitarian buildings – protected by landmark status today – have since been "re-assigned" on the level of function and filled with new vitality.

Hackesche Höfe

Their name goes back to City Commander Hans Christoph Graf von Hacke, who began driving the development of Spandauer Vorstadt (Spandau Suburb) in the middle of the 18th century. Today, this site is the heart of one of Berlin's favorite entertainment quarters. Commerce and amusement already flourished here around the previous turn of the century; and when the department store group Wertheim

opened a branch on the corner of Sophien and Rosenthaler streets in 1903, the developer Kurt Berndt knew how to read the signs of the times. In 1906/07, the largest commercial complex in Germany was created at this location, and – as is typical for Berlin – it was also used for residential purposes. That these two functional areas were strictly segregated in those days can still be seen today from the sequence of the courtyards and the looks of the façades. Only the largest courtyard, with an exit onto Rosenthaler Straße, was accessible to the public, with restaurants and ballrooms, entertainment establishments and representational business offices; to-

day it provides access to movie theaters and performance spaces. The subsequent yards, were destined for commerce; and beyond these yards lay the dignified residences with balconies. Art Nouveau artist August Endell designed the first courtyard and ballrooms. By using color-glazed bricks and windows subdivided by glazing bars, he was able to give the façades a semblance of momentum. Since they were designed partly in the Moorish style and partly patterned on Alfred Messel's department stores, the yard looks as if it were bordered by a host of diverse buildings. This complexis now among the first successful post-*Wende* renovation projects.

Kulturbrauerei in Prenzlauer Berg

Breweries

Berlin became a city of beer in the middle of the 19th century. The region's porous soil facilitated the excavation of deep cooling basements, which could be most easily dug out of the hills outside the city's gates. It is uncertain, how many smaller and large breweries were in Berlin – the numbers oscillate between 500 and 700. The largest beer producing company of all times, however, is called Schultheiss. It owes its name to Jobst Schultheiss, who acquired a brewery storage basement with bar annex on Prenzlauer Berg in 1853. His business was so good that he transformed his company into a corporation in 1871. The architect of the Gedächtniskirche was then hired to en-

large the facilities: Franz Schwechten created a neo-romanic castle complex made of yellow brick (1886–1891). After its mergers with the Pfeffer, Tivoli and Patzenhofer breweries, this traditional establishment developed into the largest brewery in Europe and, with respect to Lagerbier production, the largest in the world. Nowadays, its original site is an exemplary case for the successful conversion of old commercial facilities into a vital cultural center with a performance space, movie theater, bars, clubs, and shops: the brewery of culture. On the grounds of the old Engelhardt Brewery in Stralau, on the other hand, elegant residences are being developed, and in Moabit: supermarkets.

Water Towers and Gasometers

They put their stamp on the city's silhouette like church steeples do – and similar care was given to their architectural designs. Of 121 original water towers – the oldest in Klein-Glienicke Park at River Havel dates back to 1838 – half have survived, even though no water flows through their pipes today. Three of these are located in northern Berlin: The tower in Heinersdorf, now empty, housed a school in the 1930s; another, in Hohenschönhausen at Obersee, was home to a bar, and a third, on Prenzlauer Berg, provides residential space and serves as a cultural venue. Occasionally,

artists make use of the bizarre acoustics of this former water container for sound installations. This 44-m-tall tower was

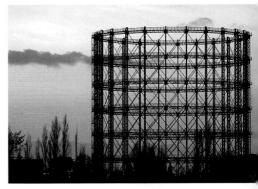

Gasometer with landmark status in Schöneberg

designed by the first director of the Berlin Water Works, Henry Gill, an English engineer, who constructed the waterworks in Friedrichshagen in the same decorative Brandenburgian style. Machine operators once lived in the tower emblematic of the area around Kollwitz-Platz; today it provides first-class residential housing. Such a future is also reserved for quite a few retired gasometers, such as the one on Kreuzberg's Fichtestraße. In World War II, it served as one of the city's largest air raid shelters; now it is to be converted into an exclusive residential space with expensive lofts. The striking gasometer in Schöneberg, on the other hand, whose holding capacity can be enlarged and reduced, will survive as a monument to itself.

Water tower on the former Windmühlenberg (Windmill Mountain), constructed 1877

AEG Turbine Hall

Ventilators, electrical boilers, company logo – painter, designer and architect Peter Behrens (1868–1940) designed simply everything. As AEG's chief designer, he made distinctive the aesthetic representation of the company, from its products to the architecture of its production facilities. His first industrial building, dating back to 1908/09, became a milestone in the history of architecture. The Turbine Hall is constructed entirely from steel, glass and concrete – the modern materials of industrial design; its visible frame consists of steel trusses and large windows slightly slanting inwards as they go up. By dispensing with ornamentation, the hall represents a total turning away from historism. With the starkly projecting, angled pediment and the concrete pylons of its frontispiece façade it looks like a temple to industry. Subsequently, Peter Behrens designed the Small Motors Factory (1910–1913) with its unadorned, pillared façade and the Assembly Hall for Large Machines (1911/12) – both of these located on Voltastraße; he also designed the AEG-owned NAG Car Factory (1913–1917) as well as the workers' settlement in city district Oberschöneweide.

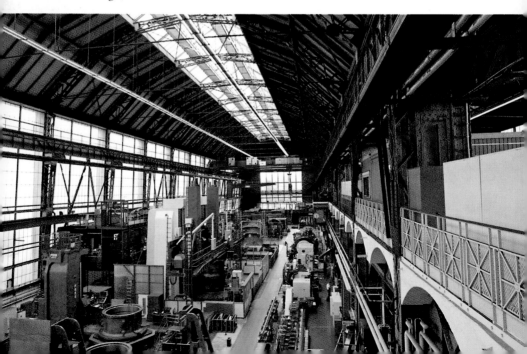

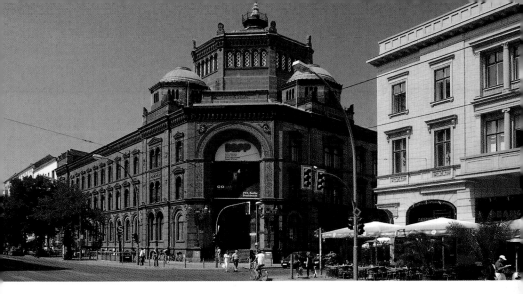

Postfuhramt

It is a proud monument to burgeoning Wilhelminian magnificence – and a sign of the increasing importance of communications starting in the middle of the 19th century. The "mail delivery office" housed, e.g., the headquarters of the expansive Berlin pneumatic postal system, the parcel counter of the post office for packages located diagonally across the street, as well as up to 240 horses in rearward stables on two floors. It took Carl Schwatlo and Wilhelm Tuckermann six years to transform the former small Postillion House of 1881 into this building – for its time the most elaborate of all administrative complexes. The Postfuhramt has all the hallmarks of a palazzo:

Above the representational corner entrance inserted into a round-arch alcove, three octagonal domes – two smaller and one large – constitute the crowning eye-catcher. The striped clinker façade is decorated with terracotta figurines in the style of the Italian Renaissance; chubby cheeked cherubs emblematize all sorts of postal activities; and the space between the round arches of the window enclosures is adorned with a series of portraits featuring discoverers and inventors who honorably served the transmission of communications, such as Marco Polo or Alexander von Humboldt, who lived up to the end of his life in a house just diagonally opposite on Oranienburger Straße. Today, the Postfuhramt is home to a gallery which regularly hosts exhibits on contemporary photography.

Shell House

The city's most beautiful façade of the 1920s fronts Emil Fahrenkamp's Shell House by the Landwehrkanal. Constructed from 1930 to 1932 as one of the first of its kind in Berlin, this steel frame high-rise originally housed a subsidiary of Rhenania-Ossag Mineral Works Corporation, which today is known as the Shell Oil Company. The Imperial Navy Office started using it in 1934; two energy supplying companies did likewise after the war: first BEWAG and since 2000, it has served as the seat of GASAG. While its façade unfurls like a wave across

six undulations, the structure simultaneously grows taller, from six to ten stories, like a staircase. Its corners are rounded as if by the movement of flow; even the steel-enclosed window ribbons flow around the corners by curving in quarter circles. The façade is faced with Roman travertine. To replace these slabs with replicas of the originals after the damages wrought by World War II, a special dispensation was obtained during comprehensive renovation in 1999, so that the already closed quarry near Rome could be reopened. No effort was shirked in other respects as well: Even details such as the brass window handles were preserved or replaced by facsimile copies.

Königliche Porzellan-Manufaktur

The Royal Blue scepter once conquered the world. Under this trademark granted by Frederick the Great, the Royal Porcelain Manufactory, or KPM, produced porcelain; it was first owned by W. C. Wegely, then by Johann Ernst Gotzkowsky, until the king acquired it in 1763. Today, it is one of the last of its kind in the world: Every piece is made by hand, classically beautiful and technologically always state of the art. In 1793, the first steam engine in Prussia was installed at KPM; in 1795, production of an "ecological" set of so-called "health dishware," without lead paint and glazes, was launched – and it was even less expensive to produce than regular dishes. After the workshop on Leipziger Straße had to make way, in 1871, for the construction of the Prussian Landtag, it moved to an area near Charlottenburg Gate by the Spree – a location convenient for transport. Its director at the time, Gustav Möller, a graduate of the Bauakademie, designed the new workshops himself and had them built from 1868 to 1872 – three of these have survived. One of Berlin's first iron truss factory halls lies concealed behind a late neoclassicist brick façade. A new type of kiln was developed that would remain, up to the beginning of the 20th century, the only one of its kind in Europe. Today, the renovated kiln hall is an industrial monument and serves as the KPM lobby featuring a museum, store and café.

Adlershof

A city for science, business and the media is being built here from scratch. On an area covering 120 soccer fields, one of the largest technology parks in Europe is currently under construction. Innovative high-tech firms are to network here with the Humboldt University's Institute for Natural Science and with institutes of research not affiliated with the academy – such as with Bessy II, located in a white, round building, 80 m in diameter, in which electrons are accelerated to almost the speed of light. The most striking structure on site is the architectural complex by Sauerbruch & Hutton, which consists of two glass buildings, one story and three stories tall respectively, that resemble amoebas. Behind curved window fronts, colored concrete segments are visible; the colors of these segments as well as those of the blinds shut against the sunlight evoke a broad spectrum of visible light. The laboratory surfaces in the Center for Photonics and Optical Technologies have to be protected from natural light, which is why a deep ground plan was implemented. The smaller of the two buildings is 7.5 m tall; it consists of a single room – a hall for scientific experiments with large equipment.

The adjacent building by Ortner & Ortner is more modest; it echoes the 1960s designs of surrounding buildings. Just across from it, the 200 m long Center for Ecological Technology by Johann Eisele, Nicolas Fritz, Helmut Bott, and Rainer Hilka, seems downright monumental. It is reminiscent of the aviation hangars that – few as they are – have survived as landmark-protected ruins in Adlershof, the cradle of German aviation.

Einstein Tower

It was considered the embodiment of progressive architecture, because it reflects the building's function in its external configuration. This structure on Telegrafenberg in Potsdam was commissioned by the Einstein Foundation and constructed from 1920 to 1924. This is where research in spectral analysis was to be conducted and where proof was to be brought that Einstein's theory of relativity could be adapted to practical purposes. Therefore a functional building was built – an enclosure for a solar observatory with a new kind of telescope specifically developed for this site that extended all the way up into the 20-meter-tall, rotating tower dome. Erich Mendelsohn designed the building in the Expressionist-Organic style. His first great work suggests a sculptural kind of architecture, streamlined, curved, and having barely a right angle. After it was damaged in the final war years by air raids, the Einstein Tower was first restored in the 1960s and then again from 1997 to 1999. The building's interior has largely survived, including the Nobel Prize winner's study with its original furniture. Albert Einstein himself, though, rarely worked on Telegraph Hill. Today, the Einstein Tower is part of the Astrophysical Institute of Potsdam University.

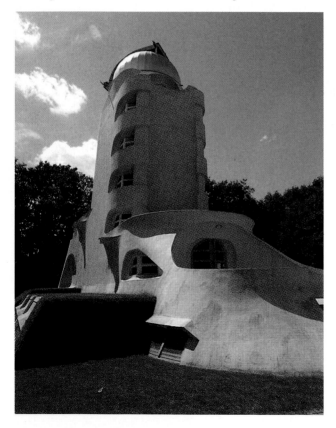

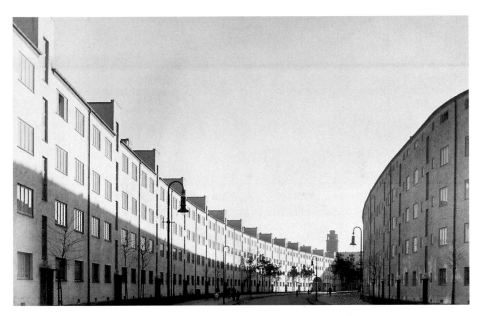

Siemensstadt

Electropolis – it is defined by the red clinker façades of its factory facilities and its massive dimensions. Covering a surface area of five square kilometer, Siemensstadt is Berlin's largest industrial complex, with 300 factory buildings and four residential settlements. Just like Borsigwalde in Tegel and Spindlersfeld in Köpenick, this city district between Charlottenburg and Spandau, too, bears the name of a captain of industry from the penultimate century. The company's administrative headquarters are located in the center of the city,

just across from the company's "technical heart," the Major Assembly Hall that was built for Werner von Siemens' invention, the dynamo.

It was the architect Hans Hertlein who developed the "Siemens style"; starting in 1912, he defined the firm's architecture for almost fourty years; and with his 70.8-meter-tall clock tower at Wernerwerk, he sent a visible signal. Hertlein even built his first high-rises as steel frame buildings. While his early brick façades still featured columns and arti-culations consisting of projecting stairwell towers, his mature buildings from the 1930s were designed as smooth cubes.

Zoological and Botanical Gardens in Berlin

by Jeannine Fiedler

Gardens for the study of animals and plants have historically emerged from the garden and landscape parks of the 18th century. The regent families desired to regale themselves with magnificent ornithological worlds which they kept close to their mansions in large aviaries. The explorations of James Cook, Bougainville

Elephant Gate, built in 1899

and other global circumnavigators, on the other hand, opened up exotic floral worlds to the European aristocracy – if they could survive months of nautical voyages in the form of seedlings or seeds, as well as the phase of acclimatization in England, France or at German courts. The fauna and flora of alien continents were in fashion; and there was competition everywhere as to who possessed the most beautiful parks, the most exotic woods and the strangest of animals.

The rather bourgeois 19th century institutionalized this luxurious pastime by making parks and gardens publicly accessible so that the common people, too, could enjoy the study of exotic animals – and not only at the fair. As early as 1844 did Frederick William IV sponsor the establishment of the first German Zoological Garden in Berlin, the ninth of its kind in Europe. Proceeding from the notion of an English landscape garden, Peter Joseph Lenné conceived this Zoological Garden, bordering on the southwestern part of the Tiergarten, which later gave its name to the West Berlin long-distance railway station. Open-air enclosures that separate "natural" animal habitats from visitors by nothing but an insurmountable moat, are nowadays embedded into a park-like area with strolling axes, day-trip restaurants, fountains, animal sculptures made by famous sculptors, rock gardens, and enclosed animal houses. About 14,000 animals are housed in this zoo, which contains the largest number of diverse species in the world. It is this zoo's eventful history,

Façade of the Zoo Aquarium

House of Giraffes in Zoological Garden

its 9,000 animals, it is the largest zoological park in Europe today; its design is based on the park of Schloss Friedrichsfelde. Ever since a glass and cast-iron frame construction was used for the signature pavilion of the London World Exhibition of 1851, glass architecture has been the preferred construction method for tropical hothouses and greenhouses in botanical gardens. One of its inventors was landscape architect Joseph Paxton who was responsible for said Crystal Palace in London's Hyde Park. Visitors to Berlin's Botanical Garden in Berlin Steglitz, officially opened in 1910, will encounter spectacular examples of this type of architecture. The steel frame construction of the main tropical greenhouse, one of the largest in the world, even survived the war. Instead of silicate glass, however, acrylic glass was used this time to cover it, since it possesses more convenient qualities. At almost 16 m high, the cold-house for subtropical plants with its three-aisled ground plan and two portal towers, is the "Cathedral" of this third-largest Botanical Garden in the world, which features 22,000 different species of plants.

which includes its destruction during World War II, that has produced its current format featuring a mixture of synchronically existing historical and contemporary zoo architectures. Thus visitors entering at the main entrances already pass by gate buildings richly ornamented with animal motifs going back to the era around 1900. Since its rebuilding in 1984, the Elephant Gate with its life-size sculptures that support an Asian-style curved roof has become a magnet for public attention. It is located next to the Aquarium, opened in 1913, whose façade impresses visitors with its reddish sandstone reliefs of dinosaurs and maritime mosaics. Graphic examples of Orientalism in zoological architecture are the mosque-like antelope house with its yellow-turquoise clinker ornaments or the Persian tower stable for horse-like animals. Modern zoological architecture and technology is represented by the Hippopotamus Aquarium, which, covered by two finely wrought glass domes, allows visitors to observe the animals both above and under water. Friedrichsfelde's Animal Park in East Berlin was created in 1954/55 following the division of Berlin. With

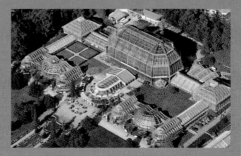

Botanical Garden with its Art Nouveau greenhouses

Embassies

The great names of world politics have always resided around Pariser Platz – the United States, France, England, and Russia – and today, they are doing so again. While many of the nations accredited as such in Germany today (currently, there are 182) retained their diplomatic seat in former East Berlin or in southwestern Dahlem, the Tiergarten has regained its earlier status as an embassy district. Though, after their war-time destruction and subsequent reconstruction, the large-scale architecture once propagated by the National Socialists nowadays bears a different aspect in such buildings as the former Japanese, Italian and Spanish embassies. Next to these old-timers, many new buildings based on successful designs call for attention, such as the Nordic Embassies by the Austrian-Finnish architects' duo Alfred Berger and Tiina Parkkinen; their Community Building behind a copper-green lamella façade demonstrates transparency and connectivity; or the adjacent Mexican Embassy designed by Teodoro González de León and Francisco Serrano with its monumental front composed of obliquely positioned, white concrete supports. For the Austrian Embassy, which constitutes the portal to the diplomats' quarter coming from the direction of Potsdamer Platz, Hans Hollein designed a tripartite complex in colorful and dynamic forms that are partly cubic, partly elliptical.

The Scandinavian Embassy Complex

Yard of Italian Embassy

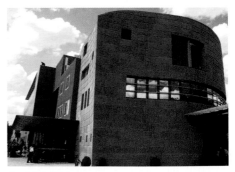
Austrian Embassy

Ludwig Erhard House

One of the great building projects of the 1990s in western Berlin was the new domicile of the Chamber of Industry and Commerce and the Berlin Stock Exchange, designed by Nicholas Grimshaw. Next to the dignified, travertine-faced old building by Franz Heinrich Sobotka and Gustav Müller, with its airy shed roof, there it lies like a gigantic, internally moving armadillo made of steel and concrete. It dominates the entire street. Fifteen steel arches – which due to the varying width of the lot billow outward toward the center until their arch-span finally reach more than 60 m – constitute the frame of a completely column-free hall. The upper five office floors are suspended in it by means of steel cables. Two atria inserted into the arches let in natural daylight and provide a view right up to the glass roof framework. From the publicly accessible lobby, where silver elevators float up and down while glass bridges connect offices high up, visitors can catch a glimpse of the stock exchange business.

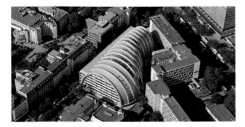

Moabit Prison

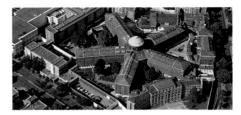

To keep walks shorts, prison and court were built in one stroke and in close proximity to each other. August Busse, who also designed the Imperial Patent Office in Luisenstadt, and Heinrich Herrmann, who – as architect of Plötzensee Prison – already had ample experience, were commissioned to do the work. The Royal Remand Center in the district of Moabit, which housed its first 150 inmates in 1881, is a star-shaped facility with five panoptical wings. This construction was entirely novel and served to better control the prisoners. The old Criminal Court that had been built simultaneously was destroyed in the war and later demolished. Right next to it, the "new" and, for its time, state-of-the-art Criminal Court was built from 1902 to 1906, based on designs by Rudolf Mönnich and Carl Vohl; due to an elaborate system of walkways, the accused could now walk unseen to the courtrooms. Among the most famous cases heard at Moabit Criminal Court was the suit against the *Captain from Köpenick* as well as the one against the Central Committee of the SED, such as Erich Honecker.

way with shops and restaurants that leads to Oranienburger Straße, we arrive first at the former Jewish girls' school, one of the last remaining buildings newly constructed by the Jewish congregation in 1930, its façade faced with iron-clinker-bricks typical of the period. The neoclassicist building next door once belonged to the Jewish hospital.

Turning left, we walk towards a gatehouse. In the early 1990s, a group of young people founded "Kunst-Werke" (art-works) in a deteriorating margarine factory; today it is

Redevelopment area, Spandauer Vorstadt

Tacheles Cultural Center

an internationally recognized institute for contemporary art. In the courtyard we come upon a bizarre café made of mirrors and glass. Traditionally a poor-people's district with low-density architecture in a run-

down condition, this entire area has by now been restored to full glamour. Today, every second building houses a gallery; designers, gold smiths and cafés have also moved in. We can freely look in on all the beautifully restored courtyards, such as the one belonging to the oldest house of the quarter at Auguststraße 69 that dates back to 1794. An inscription above the archway still announces its former Jewish owners: Süssmann & Wiesenthal. We turn left onto Große Hamburger Straße, which ends at Koppenplatz. A memorial by sculptor Karl Biedermann has been sitting on the lawn since 1996; at first, its function as a warning is barely recognizable among the playing children: "The abandoned room" – a table, a chair, another chair that has been toppled – a symbol for hasty departure, escape, deportation.

As everywhere in Spandau Suburb, only a single step separates the past from the present. We turn back now and walk along Große Hamburger Straße; because Jewish and other faiths co-existed peacefully here, it used to be called "Tolerance Street." But

Heckmannhöfe: some of the buildings are landmark-protected.

the center for deportations was also located here; in 1942, the Jewish senior citizens' home and the boys' school were turned into the city's detention camp for 56,000 Berlin Jews. The oldest Jewish cemetery was defiled by SS guards in 1943; Will Lammert's group of figures commemorates this event. Only a few of its tombstones have survived, such as that of philosopher Moses Mendelssohn. There can be no strolling through Spandau Suburb without visiting the Hackesche Höfe, the highlight of city sightseeing. It has been forgotten that more than a quarter of the old tenants used to be Jews, but when Yiddish music is played at the Hackesches Hoftheater, we can apprehend what kind of culture was lost here. A similar story is told by Rosenthaler Straße 39, where Otto Weidt was running his brush factory in a wing; he hired forced laborers who were blind and Jewish and so saved many from deportation. An exhibit on-site at the scene of events commemorates this non-Jewish everyday hero. For those who would like to visit a quarter far from the tourism crowd, we recommend a visit to the Scheunenviertel (barn quarter) near Rosa-Luxemburg-Platz, where Eastern European Jews once found refuge – this area was once the "Brooklyn" of Berlin.

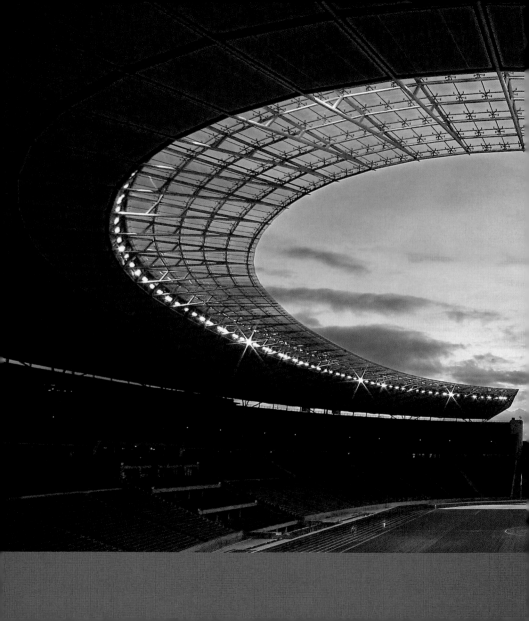

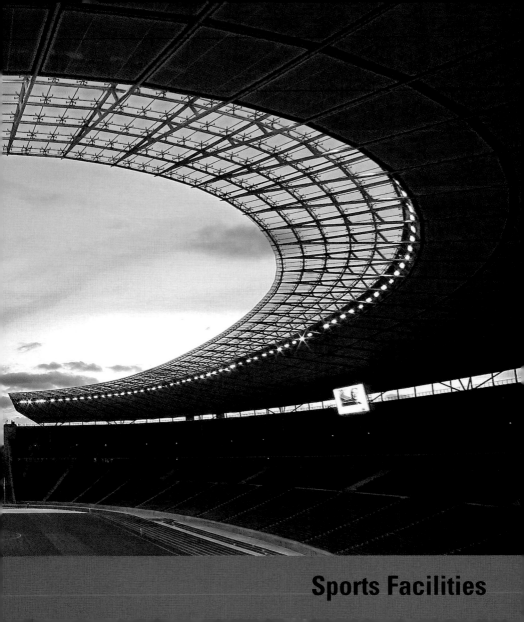

Sports Facilities

Sports Facilities

Strandbad Wannsee

Turnen, a type of physical training, was invented in Berlin. In 1811, when pedagogue Friedrich Ludwig Jahn set up the first exercise space on Kreuzberg's Hasenheide, he had a certain purpose in mind for physical education. The German fellows were to be made fit for their deployment during the liberation wars of 1813/14 against Napoleon. Political parties also had high expectations concerning regimes of physical invigoration, when, at the end of the century, they installed the first swimming pools and, before Word War I, they opened to the public, on the western border of Charlottenburg, the German Stadium – the predecessor of the later Olympic Stadium. Sports was to prepare men for military service, the "School of the Nation," and probably was also to boost the people's willingness to work. Above all, sports was to serve the purpose of bettering the people's health, given the fact that this city of rapidly expanding tenements exhibited partly catastrophic hygiene conditions.

In its clear, Objectivist architecture, Europe's largest lakeshore beach facility is an outstanding example of the social intention of Neues Bauen (New Building). Light, air and sun for the entire population: The facility on this 1-km-long stretch of sand beach was intended for mass consumption. The terraced complex designed by Martin Wagner and Richard Ermisch in 1929 comprises four long halls containing changing rooms, showers and stores. The flat roofs invite people to sunbathe; a wide pergola links the various single buildings. Originally planned on a much larger scale, the facility was not entirely realized due to the global economic crisis. True to the golden oldie "Pack your swimming trunks [...] and off we go to Wannsee," the – now newly renovated – lake beach has been a popular summer destination for Berliners up to the present day.

Strandbad Wannsee (beach area),
one of the largest lakefront beaches in Europe

Historical Swimming Halls

Bathing temples for everyone – that was the communal assignment under whose auspices the construction of public swimming facilities was promoted at the end of the 19th century. Thus the oldest, still preserved people's bath (Paul Bratring) was built in Charlottenburg (1896-1898) in the Berlin, donated in 1888 by wholesale merchant, art collector and patron of the arts James Simon. The 50 m long pool was the longest covered swimming pool in Europe. In 1993, the building was restored to its former glory as an example of Carlo Jelkmann's Neo-Objectivist building style. Heinrich Tessenow's interior design as well as Max Pechstein's glass paintings adorning the Russian-Roman pool were formi-

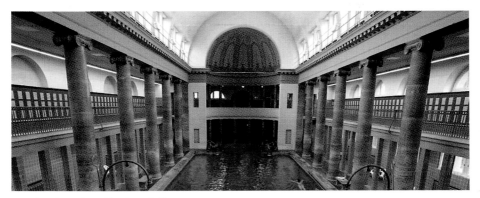

Interior view of Stadtbad Neukölln

elaborate style of the Wilhelminian period. In 1899–1902, City Building Councilor Ludwig Hoffmann designed, on Prenzlauer Berg, an architectural gem in the style of the Neo-Renaissance that still awaits renovation. In Kreuzberg, a bathing palazzo opened in 1901 and still open today, served the purpose of improving hygiene conditions. In Mitte, 310,000 residents had to wait until 1930 before their bathing facility was renovated. It was the first facility in dably reconstructed. Berlin's most beautiful city bath, however, is located in the working class district of Neukölln. Its swimming halls, faced with marble and mosaics, were designed as three-aisled basilicas in a liberal imitation of classical models. The architectural jewel of 1914 was complemented with a public library (today it is a museum for local history) to accommodate the demanding social standards of those times.

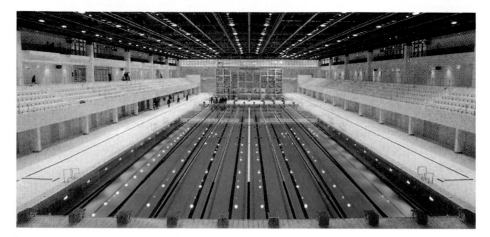

Swimming and Cycling Center on Landsberger Allee

Its roof only extends to 98 cm above the grass in the Europa-Sportpark, and yet, what is concealed underneath is one of the largest events arenas in Europe with a maximum seating capacity of 12,000 spectators: the Velodrom (1993–1997). Like a UFO after touchdown, it rests as a circle in the middle of a lawn. Located next to it, under a rectangular roof similarly covered with a silver metal fabric, is the Hall for Swimming and Jumping (1995–1999), a center for performance, school and club sport. The two buildings burrow 17 m deep into the ground and are as good as invisible from a distance – a minimalist,

self-confident counter-model to the internationally customary, megalomaniacal facilities for games and competitions. Built on the occasion of Berlin's (failed) bid to host the Olympic Games of 1993, the sports center and park was designed by Dominique Perrault, the architect of the Paris National Library, who thus successfully improved the urban infrastructure on Prenzlauer Berg, an area defined by neglected industrial complexes.

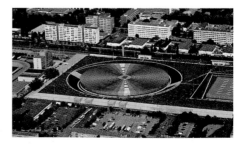

Olympic Stadium

Large arterial roads, S and U stations offered optimal transportation to get to the Olympic grounds on the western city limit. The elliptical stadium with a holding capacity of 100,000 people (today: 74,244) was built in 1934–1936. Werner March designed it with exemplary functionality by having the geometrical basic form echo the model of classical sports venues. He lowered the arena by 12 m, so as to reduce the building's monumental bulk. The west-side grandstands were interrupted by the Marathon Gate through which athletes entered, running in from the so-called Maifeld (May field). The faux-antique design of the stone facing covering the iron-steel construction goes back to Albert Speer. Gerkan, Marg and Partner converted the stadium in 2002–2004 into a modern multifunction arena capable of accommodating soccer and gave it an open roof.

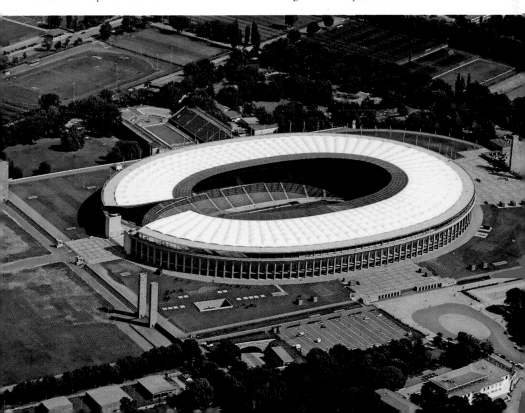

Olympic Games 1936

by Edelgard Abenstein

The era of the Weimar Republic was not yet over, when the XIth Olympic Games were awarded to Berlin in 1936. In spite of many calls for a boycott, the National Socialists successfully turned this event into an occasion for self-presentation, fooling the international public into accepting this simulation of a peaceful Germany. The Reichssportfeld (Imperial sports field) – which comprised the stadium, an open-air stage (today's Waldbühne) and a rally ground, the Maifeld with Langemarckhalle – was the first architectural mega-project of the Third Reich. To put on the show of Germany's seeming cosmopolitanism, however, its architecture was made to look much less intimidating than other National Socialist buildings. It was the first time in the history of the Olympic Games that a nation mobilized all financial and material resources for their realization. Tempelhof Airport was created; the S-stations Zoologischer Garten, Schöneberg and Reichssportfeld were remodeled; streets and squares were spruced up. In Döberitz, west of Berlin, the Wehrmacht built the Olympic Village – and used it later as barracks. The event was planned to perfection. Anti-Semitic slogans disappeared from the walls of buildings, and their use by the media, such as the hatemongering rag *Der Stürmer*, was prohibited. To prevent the looming boycott of the games by the United States, two token "half-Jews" participated in the German team. The com-

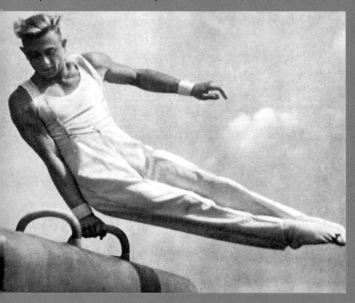

"Olympia," documentary on the 1936 Olympic Games in Berlin by Leni Riefenstahl

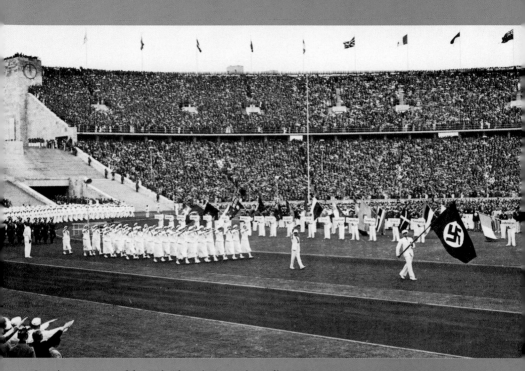

Opening ceremony of the XIth Olympic Games in Berlin, 1936

petitions were accompanied by numerous theater and opera performances as well as several exhibitions. Its three million domestic and international visitors reacted with enthusiasm, as did the majority of media representatives. The public ignored, however, that all of Berlin's Sinti and Roma had been banished from the city. A concentration camp was built in Sachsenhausen. It was, last not least, due to the skillful deployment of the modern media, such as radio, film and – in its test-phase – even television, that the Olympic Games turned into a comprehensive propaganda success for the National Socialist state. Especially auspicious for the image of the regime was their representation via 368 radio broadcastings in Europe and almost 800 overseas. Film director Leni Riefenstahl contributed essentially to the games' lasting resonance with her sensational documentary "Olympia", which had its world premiere on April 20, 1938 (Hitler's birthday), at the Ufa-Palast am Zoo.

Walking Tour: Athletic

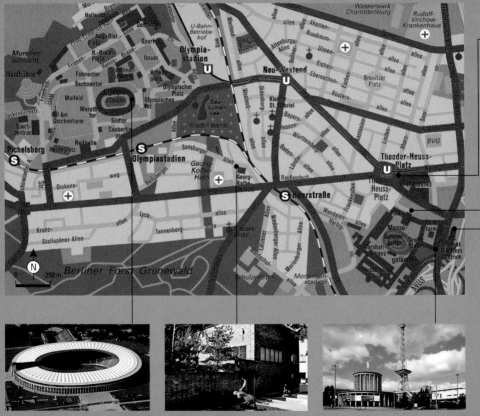

Olympic Stadium

Georg Kolbe Museum

Funkturm and Palais

Television Center at Theodor-
Heuss-Platz

Main entrance to the Fairgrounds

International Congress Center

The western part of the city is excellently prepared to welcome athletic visitors. With the Olympic Stadium, Charlottenburg is home to the second-largest competition facility in Germany. If no soccer game is scheduled, we'll take subway U 2, exit at Olympiastadion station (built in 1929 by Alfred Grenander in the style of New Objectivity), walk in the direction of Olympischer Platz and enter the giant grounds through the gate framed by the two striking, 36-meter-tall Bavaria and Prussia Towers that hold up the Olympic rings. To get an impression of the dimensions of this site, completed in time for the 1936 Olympic Games, we circle the shell-limestone-faced stadium oval, and then walk to its east along the Maifeld, where polo players once competed, until we reach the Bell Tower. This is where we have the best view of the entire grounds: there's the stadium that, since its renovation in 2004, offers seating to 74,244 visitors under a diaphanous roof; and the Marathon Gate on the western curve; and to its left, the swim stadium with its high grandstands, its two pools nowadays open to everyone. Behind it we can see the hockey and tennis courts as well as the Sports' Forum. The Langemarckhalle is located in the semi-basement of the Bell Tower, a national Nazi memorial for those killed in action during World War I; it was built at the same time as the semi-circle of the Waldbühne in the Murellenschlucht, designed by Werner March on the model of classical theaters.

The 88 steps of the wide amphitheater can seat 20,000 spectators. Today, it is a summertime venue for friends of the opera, or of jazz, rock, and film. It does not take a lot of imagination to picture how, at night, the white tent-roof seems to float above the stage when the Berlin Philharmonic Orchestra plays its customary closing piece – the unofficial hymn of the city: "Die Berliner Luft" (Berlin air), by Paul Lincke.

It is not only architecture that means to impress us with its buildings, as is demonstrated by the monumental sculptures on the former Reichssportfeld (Imperial sports field), which always enter our view on our way back: giant horses held in check by grooms, as well as athletes of the most varied disciplines, e.g., by Josef Wackerle, Karl Albiker and Arno Breker. Their stylistic markers, a radical simplification of forms, let us recognize the world of expression of 1930s neoclassicist art, as it was perfected, e.g., by Richard Scheibe and Georg Kolbe.

To get an impression of this as well, we take a walk along Trakehner Allee, which leads us past Heerstraße Cemetery, picturesquely terraced around the Sausuhlensee, where the publishing family Ullstein lies buried, also George Grosz, Tilla Durieux, Blandine Ebinger, and the art dealer Paul Cassirer, whose tomb slab was designed by Georg Kolbe; he also designed the tombs for his own (family's) grave with three fine stelae.

Waldfriedhof (Sylvan Cemetery) on Heerstraße – one of the most unusual burial grounds in the city in terms of setting and landscape garden art

From here we embark in the direction of Pillkaller Allee which ends in a small park that contains the Georg-Kolbe-Hain. Since 1957, five monumental bronze sculptures of the artist have found their home here; they were originally intended for the Sportforum Leipzig, such as the „Große Kniende" ("Large Kneeling Female") from 1942/43, "Dionysos" (1932) or "Mars and Venus" (1940). Quite close, at 25 Sensburger Allee, we come upon the residence and studio of the artist which today houses the museum. In a café under old pines, surrounded by the master's sculptures, we can explore the ambience of a Berlin sculpture studio of the 1920s the way we could nowhere else.

To get a view of contemporary Berlin, a small walk along Heerstraße towards Theodor-Heuss-Platz is on the agenda. At the end of the East-West Axis that traverses Berlin in a straight line along 17.5 km, we can experience the dimensions of this metropolis: We can see all the way to Brandenburg Gate. To our right, rising from the Fairgrounds with its filigree iron construction, is the Funkturm, our final stop. Who is tired of active athletics can take the elevator. Already during our lightning-fast ride in the glass cabin, the view opens up, showing Berlin's ocean of buildings, the ICC and the AVUS. But a sensation awaits us on the lookout platform. To the east, we scan the city's silhouette; to the south, Teufelsberg rises up above the greenery of the Grunewald with its white domes, a former United

Funkturm illuminated at night

States eavesdropping station; behind it, the Havel glitters like a silver ribbon on the horizon. The restaurant halfway up is worth a visit, too, with its all but original interior from the 1920s; when it opened in 1926, the newspaper *Berliner Tageblatt* commented on how one felt sublime here, as if "in an airship."

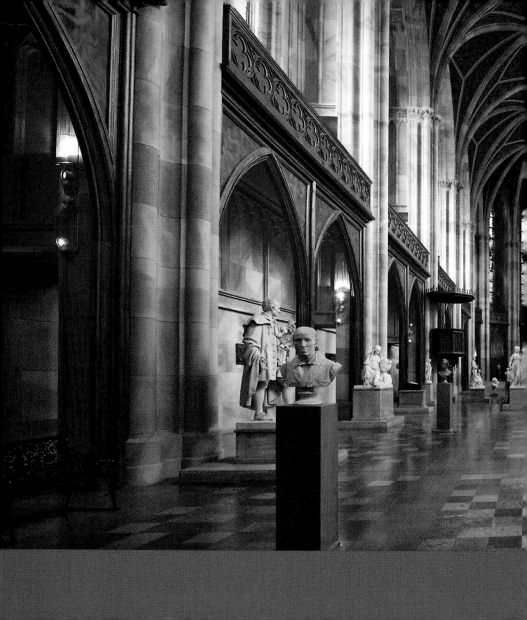

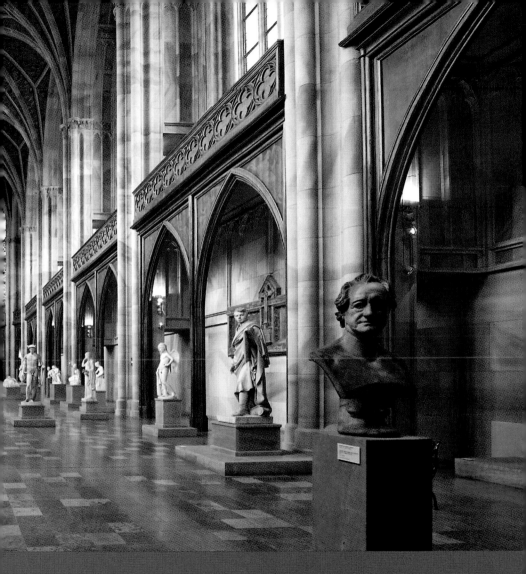

Churches and Synagogues

Churches and Synagogues

In spite of all its churches, Berlin does not present itself as a city of religious fervor. The Catholics even rate it as Diaspora, as evidenced by the rare chiming of church bells. Not for nothing is it the Liberty Bell

Neptune Fountain and St Mary's Church

buildings. Even the present bestows new sacred buildings on the city, since Berlin's history of architecture has always also been church history: The Chapel of Reconciliation, built in 2000 on the former Wall corridor at Bernauer Straße, is a religious site of remembrance. But the German metropolis is also familiar with other faiths and their houses of God: synagogues, Buddhist temples and mosques. Ahmadiyya Mosque was designed in the style of Indian tombs with minarets, domes and battlements; it opened in 1928 on Brienner Straße and was the first building of its kind in Germany.

in Schöneberg City Hall that is the most famous bell of the city; it is allowed to chime everyday at noon for three minutes without calling any of the faithful to prayer. And yet, Berlin is a city of devotional buildings. There are so many that some, like Kreuzberg's Heilig-Kreuz-Kirche, one of the biggest churches in Berlin, have been converted to concert halls, or like Spandau's Lutherkirche, to apartment

Marienkirche

The only medieval building of Old Berlin, St Mary's Church, still used as a church stands alone on an uninhabited open space, even though it once served as a sacred center for the newly formed city of Berlin and Cölln, created in the middle of the 13th century and only razed to the ground after World War II. The oldest section of this

building – made of brick set upon a rock base and going back to a building type deriving from churches of the mendicant order – is the single-naved Gothic choir of 1270/80. After a fire in the 14th century, the parish church was rebuilt without modifications. Only the tower, added in the next century and capped with a polygonal spire of neo-Gothic and neo-Classicist design by Carl Gotthard Langhans in 1789/90, gave it its unmistakable silhouette.

The richly decorated alabaster pulpit of 1702/03 was created by Andreas Schlüter, the first architect of the young Royal Residence City who also built the palace and armory during this period; its opulently decorated baldachin sets itself off from the austere, Gothic bundle pillar and unadorned walls. The "Dance of Death" fresco in the tower hall, which was rediscovered by Friedrich August Stüler in 1860, is unique and one of the oldest of its kind in Germany. This 2-meter-high and 22-meter-long mural of 1485 recounts in 28 scenes how Death takes the representatives of spiritual and secular ranks into his empire. The work was created under the influence of the 1484 plague epidemic, as was the scroll covered with Low German verses. It is considered the oldest example of Berlin poetry. In front of the entrance, a stone cross of atonement memorializes Provost Nikolaus von Bernau who was murdered in 1325. Damaged in World War II, St. Mary's Church was restored in 1945– 1950 when its original white interior was restored. About at the same time as the

church, the Heiliggeist-Kapelle (Holy Ghost Chapel) was built a stone's throw away by the old city wall. The early Gothic brick building with its stellar vault from the 16th century is used today by Humboldt University.

Nikolaikirche

Merchants, fishermen and craftsmen once worshipped here. It is the oldest witness to the city's history that is made of stone. Its construction was most likely begun in 1230, when Berlin was granted the city charter. The pillared rock basilica was completed about ten years later. In the 14th and 15th centuries, the church was remodeled and its present triple-naved structure with cross ribs and stellar vaults was built; the Marien-kapelle (Chapel of the Virgin Mary) with its decorated stepped gables was donated in 1452. In 1876/77, the church was given a Neo-Gothic upper section. Shortly before the war ended, the church was badly damaged by bombs; the interior was gutted; most of the pillars of the nave collapsed. Only when the Nikolai Quarter, likewise destroyed, was rebuilt as an old-town simulacrum on the occasion of Berlin's 750th anniversary, the church was reconstructed as well. Many of its furnishings that had been preserved elsewhere were reintegrated. Since 1987, St. Nicholas Church has been used as a concert hall and museum which allows visitors to re-experience Berlin's early municipal history up to the end of the Thirty Years' War.

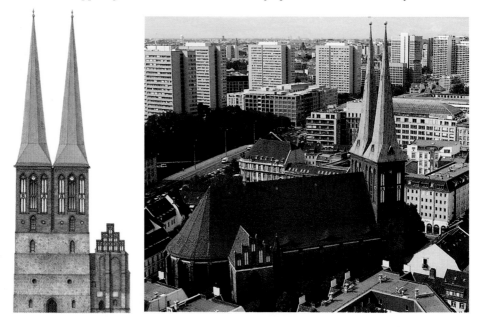

Friedrichwerdersche Kirche

It is the first of Schinkel's buildings that consists entirely of unplastered bricks. For this major work of German Neo-Gothic architecture with its cubic twin towers (1824–1830), the master of neoclassicism for once did not take his inspiration from classical antiquity. Instead, he resorted to the English archetype for college chapels. By choosing the technology of raw brick construction, he continued a domestic medieval building tradition and thereby revived the use of this material, which, in stoneless Prussia, was inexpensive, if weather-resistant; due to its beauty, it set a precedent in Berlin church construction of the 19th century. For the interior design, Schinkel likewise made use of old technologies. He had brick masonry patterns painted onto the stucco of the vault and sandstone ashlars onto pillars and walls. The cast iron folding doors on the twin portal are decorated with circular medallions featuring angels by Friedrich Tieck. After suffering heavy war damages, the church was reconstructed in the 1980s and converted into a museum of sculpture. Under the bright stellar vaults, the Berlin school of sculpture presents itself with works such as Johann Gottfried Schadow's *Two Princesses*, works by Christian Daniel Rauch and Emil Wolff, and Theodor Kalide's revolutionary *Bacchante on the Panther*,' 1848. Portrait busts of important persons of the Goethe Era complement the sculpture exhibit: Immanuel Kant, Johann Wolfgang von Goethe, Wilhelm and Alexander von Humboldt, and other personages of this period so significant for German intellectual history. On the gallery level, another exhibit documents the life and works of Karl Friedrich Schinkel.

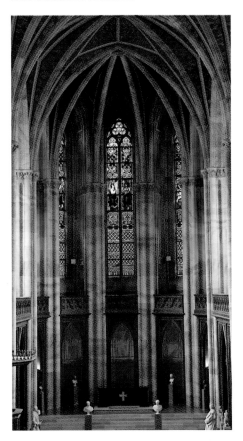

Parochialkirche

Its Italian influence is unmistakable: Designed by Johann Arnold Nering and enlarged by Martin Grünberg, this church (1695–1705) has a design unique in Berlin. A porch-style front building crowned with a tower attaches to its cross-shaped central structure with four semicircular apses in the interior. In 1944, the church was gutted by fire, the top portion of the tower with spire caved in. It was finally reconstructed in 1991, although its interior design was much simplified. Today, it serves as a hall for traveling exhibitions. The second oldest house of God in the city is located in its vicinity, the Franziskaner-Klosterkirche (Franciscan Cloister Church), a brick building dating back to about 1260; Berlin's first high school moved in right next door in the 16th century, the Gymnasium Zum Grauen Kloster.

The church was badly damaged in the war; the remnants of the adjacent monastery were razed later. Today, the church ruin serves as a gallery for open-air sculpture; e.g., the Eosander Portal capitals of Berlin Palace are exhibited here.

Sophienkirche

Among central Berlin's most picturesque views is that from Große Hamburger Straße onto the tower of St. Sophie's Church. Framed by two Neo-Baroque residential buildings, a compact tower shaft rises up containing two graceful belfry floors with bells that are topped by a copper dome. Built in 1729–1735, this is the only Baroque tower in Berlin that has survived intact throughout the centuries. The interior hall of the church was remodeled in 1892 in the Neo-Baroque style. The residential buildings, built in the same style in 1905, flank the church with austere symmetry. Among those buried in its small, tree-covered churchyard are Carl Friedrich Zelter, the director of the Sing-Akademie; historian Leopold von Ranke, and Anna Louisa Karsch, nicknamed "die Karschin," Germany's first woman author able to make a living by writing. Rearward Sophienstraße with its lovingly restored residences from the 18th and 19th centuries counts among the best of old Berlin's preserved residential streets.

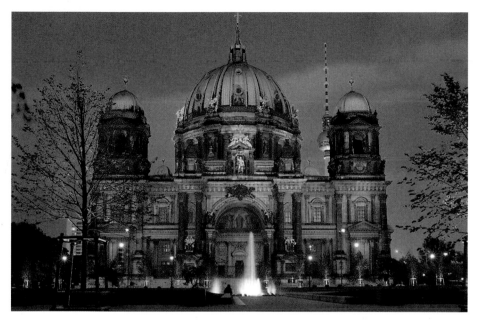

Berlin Cathedral

Some criticize it, calling it too pompous: The most important sacred building of Germany's late Wilhelminian *Gründerzeit* period is not one of those city emblems loved by everyone. Its history began in 1465, when the St. Erasmus Chapel on Spree was elevated to the stature of collegiate church by Pope Paul II. "Domkirche" was used for such collegiate churches at that time. Rulers were buried here later; location and design of their graves suffered changes over the course of the centuries.

They were finally relocated to the eastern border of the Lustgarten, where Frederick II had built a new Baroque cathedral by Johann Boumann the Elder in 1750, which was remodeled in 1816–1821 in the neoclassicist style based on designs by Karl Friedrich Schinkel. This old arrangement was no longer enough to satisfy the imperial hunger for representation. William II had the cathedral torn down without further ado and replaced by a new one, built between 1893 and 1905 by Julius Carl Raschdorff. The entire venture was an imperial project, because Berlin Cathedral was to be the main church for Protestants

and outrank its Catholic counterpart in Cologne. That is why St. Peter's Basilica in Rome was selected as its model. The massive courtly and memorial church of the Hohenzollern is inspired by Italian High Renaissance and Baroque designs. Its domed central building, the Church for Feasts and Sermons with over 2,000 seats, is made from Silesian sandstone; the main portal opens upon the Lustgarten like a triumphal arch. Its Baptismal and Matrimonial Church are located on the south side. Its organ with 7,269 pipes, 113 registers and four keyboard consoles was built in 1904 by Wilhelm Sauer; it was the largest in the country at the time. In 1944, the cathedral was heavily damaged in bombing raids; its reconstruction was begun in 1974, and in 1993, after its interior renovation had finally been completed, it was solemnly reopened. The dome reaches a height of 74 m; it is decorated with mosaics designed by Anton von Werner. Two hundred and fifty steps lead up to the cupola. Members of the Hohenzollern dynasty rest in 90 caskets in the royal crypt underneath the cathedral. Most significant are the magnificent sarcophagi of Grand Elector Frederick William and Electress Dorothea, presumably designed by J. A. Nering, as well as Andreas Schlüter's luxurious caskets that are the final resting places of Queen Sophie Charlotte and King Frederick I.

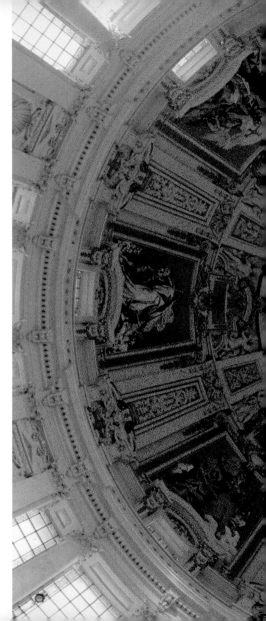

Mosaics in the dome of Berlin Cathedral depicting the eight Beatitudes from the Sermon on the Mount

The Romanisches Café –
Famous Venue for Literati and Artists

by Edelgard Abenstein

It had the charm of a train station waiting room but one could sit there for twelve hours nursing a single cup of coffee, which was ideal for people low on funds. Those arriving in Berlin in the 1920s wanting to be poets, painters or film directors first visited this most famous of all artist eateries on Kurfürstendamm. This is where contacts were established, jobs given out and names made. The Romanisches Café was located opposite Kaiser Wilhelm Church, about where the Europa Center now stands. It owed its name to the Neo-Romanesque style its builder, Franz Schwechten, had bestowed on the entire complex consisting of the church and two flanking houses. First frequented by representatives from the domains of politics and economics, it became the most renowned venue for literati and artists of the Weimar period after World War I. It replaced the nearby Café des Westens as networking hub where artists and patrons met – those who had become famous and those who wanted to be so. Its guest list reads like a "Who's who" of the culture industry in the Golden Twenties: Max Reinhardt, Alfred Kerr, Claire Waldoff, Otto

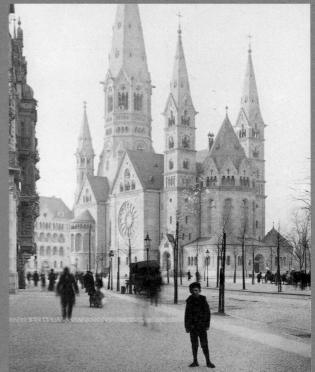

*Kaiser Wilhelm Church,
photograph, 1896*

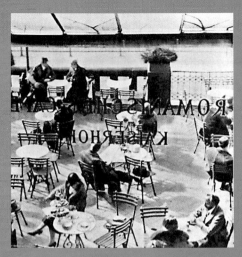

Lunch hour at Romanisches Café on Auguste-Viktoria-Platz, photograph, 1929

Dix, Alfred Döblin, Hanns Eisler, Irmgard Keun, Kurt Tucholsky, Else Lasker-Schüler, and many others. All of them were there: Princes of painting like Max Slevogt, successful gallery owners and publishers like Alfred Flechtheim and Bruno Cassirer – who claimed that no literature could be made without a coffeehouse. Elegant parlor communists had their own little table with Leonhard Frank as their unofficial chairman; George Grosz was dressed after the English fashion with Homburg hat and Leonhard sported a monocle, silk shirt and cane made of rhinoceros skin. "Poets dressed up as poets," thus Hermann Kesten pointedly called the guests in his memoirs. "It was important to be seen day after day, week after week, month after month," neo-Berliner Elias Canetti recognized. He thought

Bertolt Brecht's arrogance "in his proletarian costume" dreadful but found all the more interesting the *femmes fatales*, such as nude dancer Anita Berber, who was always surrounded by a swarm of admirers. "There are people, who have been waiting here for twenty years, day after day, for talent to arrive," wrote Erich Kästner, who like many of his colleagues did not live far from the coffeehouses of Kurfürstendamm. "They are versed to an astonishing degree in the art of waiting, if in nothing else," he mocked. All the while, many a career was launched in the Romanisches Café. Some led all the way to Hollywood, such as that of penniless Billy Wilder of Vienna, who marketed his experiences as a gigolo to the newspaper *BZ am Mittag* for a feature article under the title "Waiter, bring me a dancer please!" He plotted his first screenplay at a table of the Romanisches Café – along with Robert Siodmak who made his debut movie from it: *People on Sunday* (1930, co-directors Fred Zinnemann and Edgar G. Ulmer).

Exterior view of Romanisches Café, photograph, c. 1935

Kaiser Wilhelm Memorial Church

It was the emblem of the free West during the Cold War, the globally acknowledged symbol for West Berlin's endurance and its desire for reconstruction: the tower ruin of the old Memorial Church that now exists in a symbiosis rich in contrast with a modern architectural ensemble made of glass, steel and concrete. This Neo-Romanesque church, built in 1891–1895 by Franz Schwechten, was to serve as a glorious future memorial to the first German Emperor. With its tower, 113 m tall, it was the highest building in Berlin; as the center of the grand-bourgeois New West, it served purposes of national representation more than religious concerns. However, the building attracted strong criticism especially from circles of the bourgeoisie; in the 1920s people even demanded its demolition. It was only as a ruin, still standing after the bombing of November 23, 1943, that Berliners became attached to it. When the "Hollow Tooth" was to yield its site to a new building in 1956, they protested most vehemently. This is how, in 1959–1961, a quadripartite new building, designed by Egon Eiermann, was built around the memorial. The ensemble consists of an octagonal church hall with a small rectangular sacristy, a hexagonal bell tower and a square chapel. All buildings are covered with flat roofs; their walls, partly composed of honeycomb grids, consist of concrete frames that enclose a total of 33,000 glass bricks made in Chartres. They plunge the church interior into a deep blue twi-

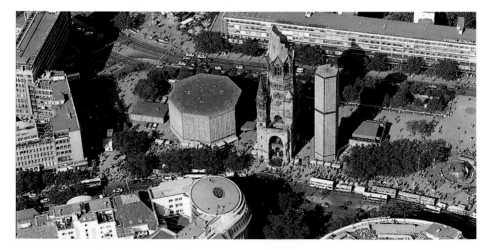

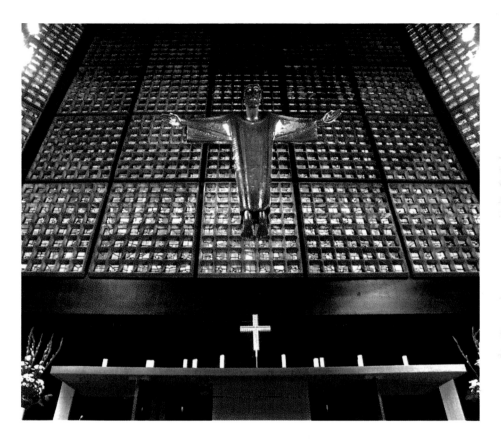

light. Karl Hemmeter's golden Risen Christ floats above the altar: This meditative ambience at the heart of one of the liveliest open spaces in City West is truly unique. The ruin houses a memorial hall with mosaics and architectural fragments from the old church; at its center, there is a statue of Christ, as well as a cross made of nails from Coventry Cathedral, which was destroyed by German bombs. Outside the Gedächtniskirche lies Breitscheidplatz, one of the most popular venues of the city; it features Joachim Schmettau's playful Earth Ball Fountain, aptly nicknamed "Wasserklops" (something like 'water dumpling') by the Berliners.

Rahel Varnhagen and Jewish Culture in Berlin

by Edelgard Abenstein

Rahel Varnhagen, drawing by Wilhelm Hensel, 1832

called von Varnhagen, was the most renowned *salonnière* in Berlin around 1800.

She was born in Berlin in 1771 as the eldest daughter of Jewish merchant Markus Levin, who had been granted a "general privilege" by the king making him as good as equal to his Christian middle-class peers. Thus he took this opportunity to invite Berlin society into his residence. Actors, military men and diplomats were among his guests. And yet, like many Jewish girls, Rahel was tethered by an orthodox education. Curious and thirsty for knowledge from an early age, she complained: "I was taught nothing." She asked young Ludwig Tieck to advise her on reading matters: "Help me so I won't stay ignorant!" From then on, she read her way independently through a curriculum of literature and philosophy; Fichte's writings on the liberation of self became her *vade mecum*; she was enthusiastic about Goethe, whom she later visited several times and whom she revered all her life. He inducted her as "beautiful soul" into his novel *Wilhelm Meister*. She attended the private lectures given by

She was neither powerful nor beautiful, not of noble descent and not even very well educated. And yet, she came to be one of the most important women in Prussia, for, as an unmarried Jewish woman, she was able to take her place at the center of Berlin society. Rahel Levin, later

"Social Gathering at Rahel Varnhagen's," hand-colored etching by Erich M. Simon, undated

August Wilhelm Schlegel, who bored her, though, as "an obdurate weakling who knows nothing of love." His brother Friedrich, however, a passionate visionary, was close to her, especially when he entangled himself in an *amour fou* with her good friend, banker's spouse and Moses Mendelssohn daughter Dorothea Veit. When the latter left her husband and children to live with Friedrich, Berlin acquired a royal scandal and literary history, by way of Schlegel's autobiographical novel *Lucinde*, its first *roman à clef* on romantic love. While lending her friendly support to this couple, Rahel herself was not very fortunate in this respect. She had her moment of opportunity, though, in 1790 when her father died and the family moved to 54 Jäger-straße. Here, she self-confidently furthered her father's tradition of sociability by continuing to invite people for tea, now served in her suite under the roof. Barely 19 years old, Rahel Levin became a feted patroness in a very short time. Her modest "Stübchen," or little parlor, soon developed into the intellectual center of the city, since the young Jewish lady had a talent for

311

Bettina von Arnim (1756–1793), painting by Achim von Arnim, the poet's grandson, c. 1890, after a contemporary miniature, Gut Wiepersdorf

communication, and people scrambled to be invited by her. All of them attended, her Jewish friends, the sons and daughters of Moses Mendelssohn; Henriette Herz, that other Berlin *salonnière*, and her husband, physician Marcus Herz. Above all, however, it was the writers of Romanticism who regularly frequented her parlor: the brothers Wilhelm and Alexander von Humboldt, Friedrich de la Motte Fouqué, Adelbert von Chamisso, Ludwig Tieck, E. T. A. Hoffmann, War Councilor Friedrich von Gentz, the theologian Friedrich Schleiermacher, as well as already well established Jean Paul, the master of fleet-footed satire. The latter later praised Rahel as the only woman "in whom I found true humor." From its inception, the salon counted among its guests a veritable Prince of Hohenzollern and a nephew of Frederick the Great's, Louis Ferdinand, a highly talented musician and darling among women, who had embarked on a stormy relationship with the ravishingly beautiful wife of a banker, Pauline Wiesel, another close friend of Rahel's. Merely decent middle-class women were rarely to be seen at the Jägerstraße salon. Aristocratic ladies, however, had no objections to socializing with women of – for those days – rather questionable reputations, such as the actress Friederike Unzelmann whose lifestyle was rather "loose," or Karoline von Schlabrendorf, who liked to show up in male drag. Guests attending social rounds at Jägerstraße formed a rather motley crew, and they were all held together by Rahel's wit, originality and liveliness. What counted here were the guests' literary and musical penchants, their intellect, not their family background. And thus this garret room, where the legacy of Berlin Enlightenment intersected with the sentiment of Romanticism, came to be the model for a new kind of sociability. It was often imitated. As *salon* hostesses, young women like Rahel were able to suspend the conventions of the period. They engaged in conversation, instigated debates, had the courage to articulate their own opinions, and treated men like equals. A new era had dawned. After Napoleon's march through Brandenburg Gate politics determined day-to-day life, for the most part. Rahel Levin withdrew, her engagement with Count Finckenstein was broken – he did not want to confront his family with

a Jewish spouse after all. Following years of financial distress, she had herself baptized in 1814 and married pale Karl August Varnhagen, 14 years her junior – she was 43 years old. After traveling halfway across Europe with her husband, she hosted – up to her death in 1833 – another salon at 20 Französische Straße, and then another in 36 Mauerstraße, a finer, more elegant, more dignified address. And once again everybody who was anybody attended: Hegel, rector of the university; Mendelssohn Bartholdy; Prince Pückler-Muskau; Bettina von Arnim; and young Heine. The latter elevated her who had long since become a German celebrity to the rank of "wittiest woman in the universe," and even in his Paris exile, he still thought of Rahel's Berlin salon as "the fatherland" *par excellence*.

Henriette Herz, wood engraving after a painting by Anton Graff, 1792, from: Der Bär, vol. 10, no. 4, Berlin 1883

E. T. A. Hoffmann (1776–1822), after Wilhelm Hensel, 1821

Philosopher Moses Mendelssohn (1729–1786)

Synagogues

The golden dome of the New Synagogue on Oranienburger Straße is visible from far away. This famous building, which suggests Moorish architecture, was designed by Eduard Knoblauch in 1859 and completed by Friedrich August Stüler in 1866; it was the house of God for the largest Jewish congregation in Germany. Its inauguration was attended, among others, by Prussian Prime Minister Otto von Bismarck, as well as the Crown Prince and his spouse. The ceremony was conducted in the main prayer room that could seat 3,000 people. Only slightly damaged during the pogrom night of November 9–10, 1938, owing to the intervention of a courageous Berlin police officer, the synagogue was largely destroyed during bombing raids in 1943. In 1988, reconstruction began of its lobby and hall of representatives. The main prayer

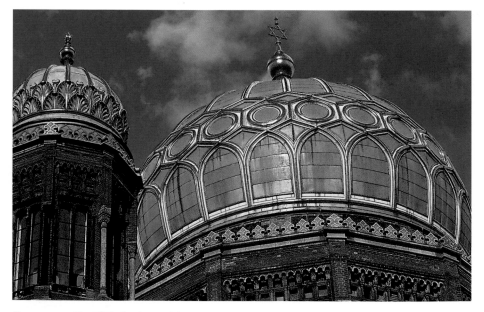

Reconstructed in 1988, the dome of the New Synagogue on Oranienburger Straße glows golden in the evening light.

The "Tablets of Law" – the mosaic above the portal of the Synagogue in Prenzlauer Berg on Rykestraße

room, however, was not reconstructed; its original dimensions are designated by a white pebble field. As Centrum Judaicum, the synagogue today is a museum, a community house, and a site for prayer and memorial. Other Jewish facilities are located nearby, especially the Anne Frank Center and the Central Council of Jews in Germany; kosher stores and restaurants have settled here – Oranienburger Straße has once again become a center of Jewish life in Berlin.

The only Jewish house of God that is left of the 17 pre-war synagogues in Berlin is located in Prenzlauer Berg on Rykestraße; it was most beautifully restored in 2007. Built in 1903/04 based on designs by Johann Hoeniger, this synagogue with space for 1,200 faithful is the largest one in Germany, and it is one of the few that has survived Nazi terror and wartime bombing with minimal damage. The enormous building cannot be seen from the street. The

synagogue was deliberately built in a backyard so as not to provoke anti-Semitic aggression as was the case on Oranienburger Straße. Upon entering the yard, the impressive representative façade consisting of a brick basilica becomes visible; it has a Romanizing design and is consciously linked to Occidental tradition. This shows that Jewish sacred buildings around the turn of the century before last no longer wanted to look like folk tales from the Arabian Nights cast in stone. Pillars support the galleries in the interior; above the cross rib vault of the exedra at the end of the central nave extends a blue star-spangled night sky, as if Schinkel had painted it – a bold statement of commitment to assimilation.

Drawing of the New Synagogue

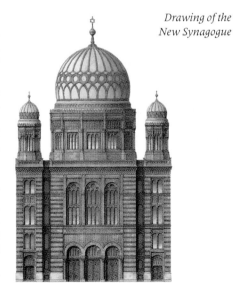

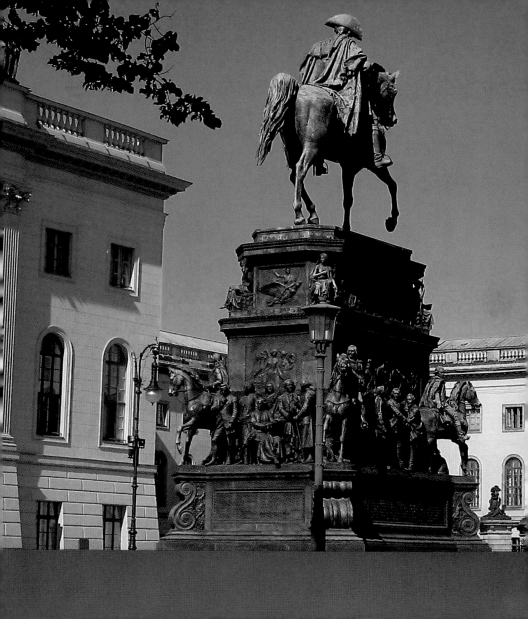

Memorials

Memorials

From the Cemetery for those who fell in March, the final resting place of the victims of the 1848 revolution, via the House of the Wannsee Conference, where in 1942 the "final solution to the Jewish question" was decided, to the Memorial Site Hohenschönhausen, the former detention facility of the Ministry for State Security in the GDR – Berlin has many monuments testifying to the vicissitudes of its history. How the city itself sees its past is documented by its memorials. Ever since politics in Berlin have again acquired a stage for self-presentation, the significance of these witnesses to historical legacies has increased as well.

New Guard House (Neue Wache) – since 1993, the Memorial for the Victims of War and Tyranny

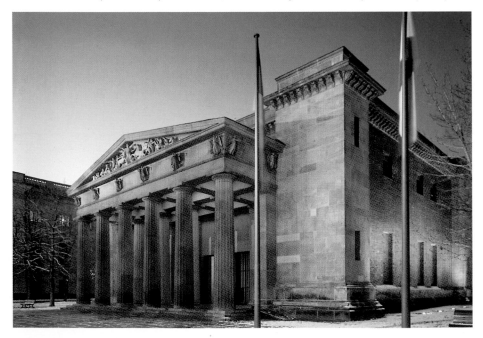

Neue Wache

Schinkel's first great work in Berlin was simultaneously the first nationally representational building: It was built after the French occupation: the Neue Wache (1816–1818) – Greek temple and Roman fort in one. Although it was used as a simple guardhouse (to protect the king), it was also seen as a memorial to the liberation wars. As such, the building on Unter den Linden Boulevard was flanked by the statues of Generals Scharnhorst and Bülow that, along with small goddesses of victory attached to the frame as well as the Victoria in the tympanum of the portico, were to commemorate the happy ending to a difficult time.

The somewhat smaller anti-Napoleonian Generals Blücher, Gneisenau and Yorck were placed on the other side of Linden Boulevard; they were all sculpted by Christian Daniel Rauch who completed them by 1855. With the end of the monarchy, the guardhouse lost its function; in 1931, Heinrich Tessenow remodeled it into a modest cenotaph to those killed in action. The GDR then turned it into a Memorial for the Victims of Fascism and Militarism and in 1950 banished Scharnhorst & Co. to the Prinzessinnengarten, or the depot. Since 1993 – after reconstructing Tessenow's version and installing a much enlarged copy of Käthe Kollwitz' sculpture *Grieving Mother with Dead Son* – the guardhouse has been serving as the Central Memorial for the Victims of War and Despotism. Up to the

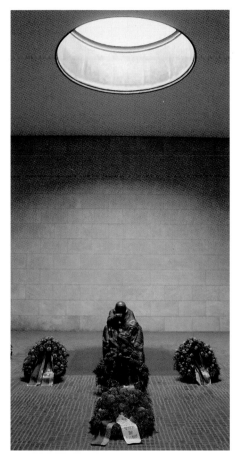

present day, the city has abstained from letting the generals return to their ancestral site. Scharnhorst and Bülow are currently standing at the border of Bebelplatz from where they gaze at the Neue Wache.

Holocaust Memorial

The most significant memorial site built since the founding of the federal republic is the Monument to the Murdered Jews of Europe; it is a labyrinth without a center. It consists of a ground-level field covered with stelae only varying in height: 2,711 concrete pillars, 0.95 m wide and 2.38 m long, rise from between 0.5 m to 4.7 m above ground; they are distributed across an unevenly sloping terrain of about two hectares. Voices strongly in favor of a memorial first emerged in the 1980s. It was built in 2003–2005 based on a design by Peter Eisenman.

The field of stelae is located on first-class Berlin territory – the tourist district between Brandenburg Gate and Potsdamer Platz. There is hardly another site in Germany as impregnated with history as this one: The stelae are standing where Goebbels hid in the bunker, not far from the spot where Hitler's corpse was burnt. After the war, it was here that the Wall and the death strip cut the city and the terrain in two. The message sent via the selection of such a space impressed New York architect Eisenman: "No other nation in the world would have made available such a significant site at the heart of its capital."

Situated in an underground hall at the southeastern border of the memorial site, the Place of Information complements the Holocaust Memorial. Jewish victims are remembered by name and exemplary family history. Only underground does the historical extent of what is memorialized above become recognizable: the Holocaust, the murder of millions of people in German extermination camps.

While the proponents of the memorial considered it essential for the sake of remembrance, its detractors took umbrage at the size and monumentality of its design. Polemicists believed that the memorial was meant to simply dispose of the National Socialist past, while others opined that all victims of the Nazi dictatorship should have been deserving of a memorial. By now this excitement has subsided. Even the Friends of the Jewish Museum, for whom Eisenman's design seemed to plagiarize Libeskind's Garden, have calmed down; for there is also a field of columns in the Jewish Museum which likewise suggests a feeling of vertigo – of a shaky, unstable ground.

Bendlerblock

Built in 1911–1914, here was the Imperial Navy Office in 1918, then the Reichswehrführung (Imperial Armed Forces' Command), and later the High Command of the Wehrmacht. It was here that Hitler gave his infamous speech of February 3, 1933, on the "conquest of new living space in the East" to the Reichswehrführung. But above all it was the events of July 20, 1944, that took place here. Bendlerblock was the Berlin headquarters of the conspirators against the National Socialist dictatorship; it was here that its overthrow with the help of Count Claus Schenk von Stauffenberg was hatched. After his assassination attempt on Hitler in his Führer headquarters in East Prussia had failed, he was shot in the inner courtyard of the Bendlerblock that same night, along with the other leading figures of the coup d'état, Generals Beck and Olbricht, Major Mertz von Quirnheim and First Lieutenant von Haeften. A cenotaph created in 1953 by Richard Scheibe commemorates this event. Other members of the German Resistance, such as Carl Friedrich Goerdeler and Count Helmuth von Moltke, who belonged to the Kreisau Circle, were decapitated or hanged in Plötzensee Penitentiary. In front of the former barracks, site of the execution, where the beam equipped with hooks for hanging can still be viewed, there is a memorial stone as well as a stone urn with earth gathered from all National Socialist concentration camps. Church Maria Regina Martyrum (1960–1963) remembers nearby the victims of National Socialism.

Berlin Wall Memorial Site

In the summer of 1961, people jumped from the windows of their houses, desperately intent on escaping from East Berlin that had been locked down overnight into the freedom of the West. Bernauer Straße, located at the border of Wedding (West) and Mitte (East), was the site of tragic escape attempts, since the Wall in this area plowed through densely populated terrain, past front doors and balconies. It brutally separated families and neighborhoods forever. Thirty-seven years after the construction of the Wall, on August 13, 1998, the official Berlin Wall Memorial Site was inaugurated at the corner of Ackerstraße. The tower with panorama platform, designed by Andreas Zerr, Peter Hapke and Claus Nieländer, provides a view across the preserved sections of the border facilities that once divided the city: The frontline border wall was 3.6 m high, smooth and bare. Behind it lay the guarded, nocturnally illuminated death strip. GDR Border Patrols were explicitly authorized to use weapons as a means to prevent any escape from the Socialist Republic. The memorial encloses a piece of borderland, 80 m large, with two walls that are six meters high; the former death strip can be seen through narrow gaps in the walls. A Center of Documentation as well as a Chapel of Reconciliation (Rudolf Reitermann, Peter Sassenroth – 2000) are also part of the Wall Memorial. In 1985, the GDR had a church of the same name blown up for the sake of "heightening security at the state border to West Berlin."

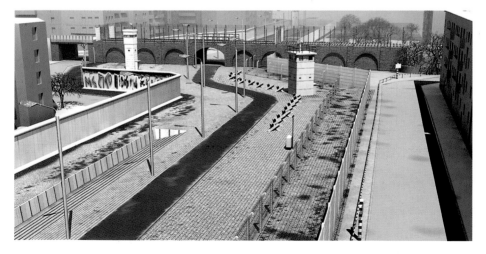

The Berlin Wall –
A Monument to Inhumanity

by Jeannine Fiedler

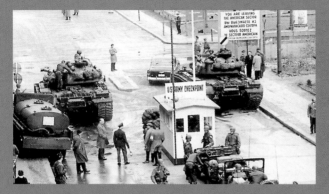

Border crossing "Checkpoint Charlie," photograph, 1961

"No one has the intention of building a wall!" Thus Walter Ulbricht shot down the question of a West German news media correspondent on June 15, 1961, during a press conference in East Berlin. This reply turned out to be a blatant lie only two months later, since the chairman of the Council of State and most powerful man in the GDR had, by this time, already engineered everything to facilitate the final lockdown of the "Eastern Zone" against the West "for the protection of the people of the GDR." The Wall as "anti-imperialist protective barrier" of the "Socialist Workers' and Farmers' State" was to preserve the greatest socialist experiment on German soil. The GDR closed its border to the Federal Republic as early as May 26, 1952. Their action sent a clear political signal condemning

the ratification of the Germany Treaty that granted the Federal Republic a higher degree of sovereignty by the Western Allies. The "green border" between the Western sectors of the American, British and French Allies and the Eastern Sector controlled by the USSR, which up to this point could be crossed without any problems, was now outfitted with barbed wire and zones of exclusion. Berlin – called "Capital of the GDR" in the East and the "final refuge of freedom" in the West – was not exempt either: 99 of 277 streets that connected West Berlin with East Berlin or with the greater Berlin area in the GDR were closed. The three sectors subsisting under the flags of the Western Allies were now as good as isolated; any border crossing between sectors was now put under stricter scrutiny. However, if a GDR citizen in those years wanted to defect to the "capitalist enemy country," Berlin still provided the best opportunities. Until 1961, it was still possible to take the city railway or streets that were not yet closed off and not lose life or limb in the process of crossing between ideologies and Cold War camps. It was the desolate economic situation in the GDR that caused its citizens to

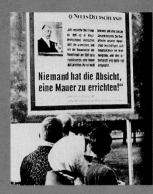

Building the Berlin Wall:
West Berlin poster informing
the people of East Berlin,
photograph, 1961

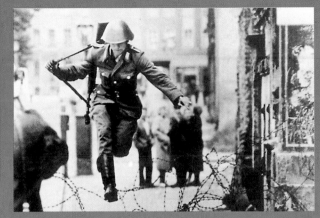

A member of the National People's Army makes a last ditch escape
into the Western Sector, August 15, 1961.

emigrate; and it was the shattering of hope — the wish for a less rigid socialism, so bitterly disappointed during the failed people's uprising of June 17, 1953 – that caused the numbers of GDR refugees to rise exponentially during the 1950s. Reprisals against the population and the massive expansion of East Germany's Ministry for State Security, the Staatssicherheitsdienst (Stasi) subsequently contributed to the situation. In 1959, 145,000 citizens said goodbye to the GDR and East Berlin. In 1960, the number of refugees increased to 200,000; three quarters of those chose to escape via West Berlin. When the wave of refugees crested in the first six months of 1961, already 155,000 GDR inhabitants had reached the "Golden West" and turned their backs on the socialist part of Germany. The SED Regime, however, did not want to let this stream of people that robbed it of its

"human material" leave unimpeded. In the early hours of August 13, 1961, armed units of the GDR Border Patrol and members of a GDR para-military organization started to seal the sector borders to West Berlin with rolls of barbed wire, and to construct a barricade about 163 kilometer long around the Western section of the city which would divide Berlin in two parts for the next 28 years.

Though many people on both sides suffered from the pain of separation and experienced the blows of fate, West Berliners, henceforth treated as "Islanders" hunkering down in the ultimate Western "bulwark" against the Eastern Bloc, were highly subsidized and furnished with privileges. For almost three decades, their lot was to live a life of "splendid isolation." This special status was further advertised by top-class heads of state visiting from the Western

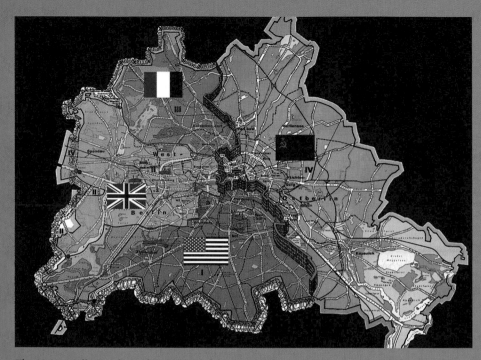

The 1960s Wall Map shows the partition of the city into three West Sectors and one East Sector.

world: With his commitment pledge – "Ich bin ein Berliner!" – United States President John F. Kennedy demonstrated his great respect for the city on June 26, 1963, in front of Schöneberg City Hall. Before, in the late 1960s, East Berlin as well acquired a special role as the GDR's radiant flagship metropolis created by the socialist will-to-achieve, about 53,000 Eastern and 13,000 Western workers lost their livelihood in the respectively other economic system. Moreover, subway and city railway transit through the sectors was initially suspended along the border between the two halves of the city; more streets were closed: 192 main roads and byways constituting the city's lifelines were suddenly cut off. Nevertheless, until the early evening of August 14, 1961, 6,900 citizens were still able to escape to West Berlin across the initially only provisionally fortified sector borders. But even after the borders were sealed and secured by the GDR institutions in charge, about 475,000 people fled to

the West along the inner German border between the years 1961 and 1989. Too many of them, however, had to pay for their desire for freedom with their lives: According to official counts, more than 125 people died at the Berlin Wall alone!

After 1961, the border facilities were repeatedly expanded and developed into complex systems of fortifications. Even the components of the Wall underwent a period of development until they had finally become the compact, ready-made slabs that were four meters high, cast from concrete and crowned by a round concrete tube. The inventory of border devices further included floodlights, watchtowers, electric fences, and vehicle barriers that were to secure a strip up to 100 m wide. Border facilities in Berlin were punctuated by seven inner-city border crossings that, initially, were used almost exclusively by people going from the West to the East, as laid out by the transit visa regulations. From 1964 on, a special regulation also permitted GDR senior citizens to once a year visit relatives in West Berlin or the Federal Republic.

After the Iron Curtain between Hungary and Austria had become increasingly porous by summer 1989, and the peaceful revolution in the GDR had finally occasioned the opening of the Berlin Wall on November 9, 1989, the historical monument was soon reduced to only a few traces left standing along its entire length. In no time at

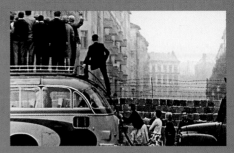

A bus serving as observation deck in front of the Wall in the Wedding district, photograph, 1961

all, the people's will had demolished it by the blow of the hammer. Today, the Wall Memorial Site at Bernauer Straße in city district Wedding is an official institution of the Land of Berlin with the mandate to document the Wall and its terrors. A section of the original border strip can still be visited here.

Remainder of the Wall at East-Side Gallery

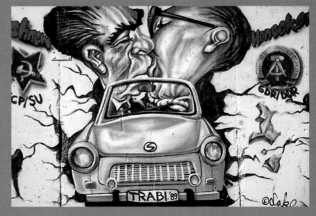

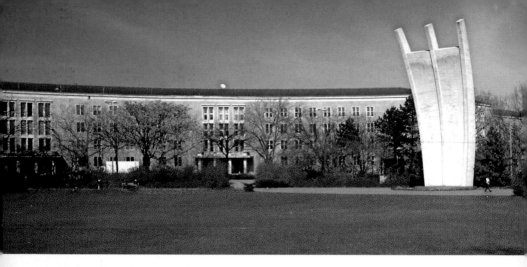

Luftbrückendenkmal

The memorial to commemorate the blockade of West Berlin has been soaring skywards since July, 17, 1951 in front of the main entrance to Tempelhof Airport. In the night of June 24, 1948, the Soviet occupying power replied to the currency reform in the West sectors by blocking all land and waterways into the city. In a moving speech – "Peoples of the world! Look upon this city!" – Governing Mayor Ernst Reuter called on the world for help. The American Military Governor Lucius D. Clay reacted instantly: The semi-city of two million inhabitants was to be supplied by air – an absurd idea that spawned a logistical feat. Two days after the blockade was implemented, the first provisions were already flown in: coal, foodstuffs, medicine. To secure

the electrical power supply, an entire power plant was flown in by the Allied squadron. The *Rosinenbomber* (raisin bombers), as Berliners called the freight planes, landed not only in Tempelhof but also on the airports in Tegel and Gatow; seaplanes even landed on Lake Wannsee. When the Soviets gave up after eleven months, inadvertently auspicious bonds had been forged between the vanquished and their occupying power; West Berlin had become the frontline city of Western self-preservation; the occupiers had turned into "our" protectors. Eduard Ludwig's (1906–1960) sculpture, twenty meters high and nicknamed the Hunger Claw, symbolizes the three airlift lanes that connected Berlin to the Western areas. A bronze plaque remembers the names of those who lost their lives during the blockade: 31 American and 41 British pilots as well as six German assistants.

Soviet War Memorials

After the end of World War II, the Red Army installed three war memorials in Berlin. The gigantic facility with mausoleum, memorial grove, stone flags, and sculptures is dedicated to the 20,000 Soviet soldiers killed in action during the battle for Berlin; it is located in Treptower Park, the largest Soviet military cemetery in Germany. The enormous memorial (1946–1949) in the center of the park features a soldier who is holding a child on one arm while, with his right hand, he is clutching a lowered sword that has smashed to pieces a swastika. Another Soviet war memorial is located near Brandenburg Gate on the terrain between Reichstag and Reichskanzlei (Imperial Chancellery) that was conquered after bitter fighting during the last days of the war. The concave pillar architecture with a central bronze statue of a Red Army soldier was the first new structure (1945/46) ever to be built after the armistice; two Soviet tanks, allegedly the first to have rolled into Berlin, flank the memorial. A third, equally monumental war memorial is located in Schönholzer Heide, north of Berlin, where more than 13,000 Red Army soldiers lie buried. The building material for all three complexes was taken from Hitler's Reichskanzlei, from administrative buildings and mansions, as well as from a stone depot east of the River Oder that had been set up for the construction of a National Socialist triumphal arch in Moscow.

Soviet War Memorial in Treptow Park, with c. 5,000 single graves

This "recycling" by Soviet architects was influenced as much by symbolism as by their own pragmatism.

Walking Tour: Socialist

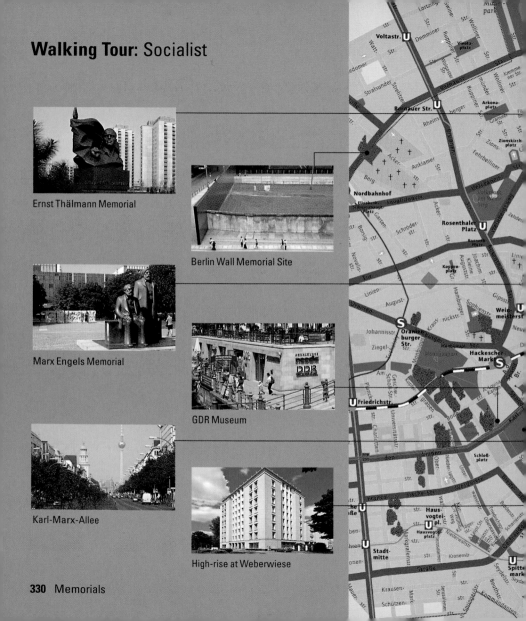

Ernst Thälmann Memorial

Berlin Wall Memorial Site

Marx Engels Memorial

GDR Museum

Karl-Marx-Allee

High-rise at Weberwiese

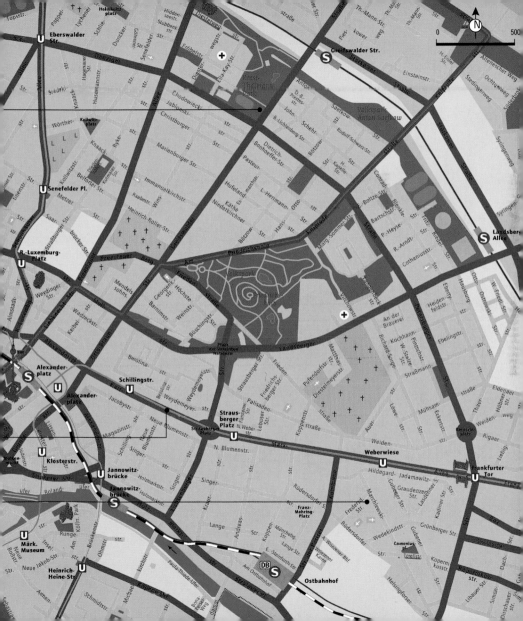

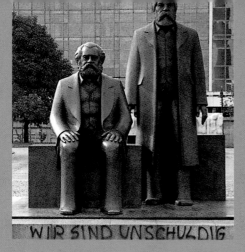

WIR SIND UNSCHULDIG

Marx Engels Memorial, with spray-painted slogan "We are innocent", tagged by unknowns

Nowhere has the epoch of German socialism now more than 40 years old left behind more traces than in Berlin: precast concrete slab *(Plattenbau)* high-rises, monuments to the history of the labor movement, squares and streets where the propagandistic program of the socialist system has been cast in stone. Only the most monstrous of East Berlin edifices, the Wall, has been preserved by nothing more than fragments. There are many places where its trace is reduced to a mere double row of cobblestones running along a street to mark its former course. We'll start our walking tour in Bernauer Straße, which acquired its sad notoriety in 1961 when people escaped by jumping from the windows of their East Berlin houses onto Western sidewalks; we continue along the former Wall strip

now furnished with a memorial site and the newly built Chapel of Reconciliation to Eberswalder Straße. This area of one and a half kilometers will be the site where, on our right, a new memorial will be developed by 2009 based on a design by Mola Winkelmüller Architects in cooperation with sinai.Faust.Schroll.Schwarz; it will be made from lightweight iron bars through which people can walk but which, to people looking up the street, will appear like a closed wall. History is told on boards full of photographs.

Now we follow the bend in the street going towards Danziger Straße (we could also take the streetcar Line M 10), take a peek into the Kulturbrauerei at the corner of Schönhauser Allee. After a few meters we look down Husemannstraße in the direction of Kollwitz-Platz to see one of those rare architectural ensembles dating back to the Wilhelminian *Gründerzeit* that was already renovated during the GDR era. Likewise created in 1987 was the Ernst-Thälmann-Park at Danziger and Greifswalder Straße – an object of prestige that includes the Zeiss Mega-Planetarium and a residential complex for 4,000 people with pond and memorial. The monument by Soviet artist Lew Kerbel is 13 m high, 16 m wide and made of bronze and Ukrainian granite; it is dedicated to labor leader Ernst Thälmann who was chairman of the Communist Party of Germany until 1933. This wide-open, landscaped park was chosen as its site because the *Protokollstrecke* (protocol lane) for members of the Politburo led past

it. That's what people called the arterial road to Wandlitz, home to Honecker and Co.; this location had the effect that the façades in Greifswalder Straße, like a Potemkin village, were given a new coat of paint more often than elsewhere.

Our next stop leads us down the hill into the flatlands of Alexanderplatz where like nowhere else the city with its tall precast concrete slab high-rises and gigantic street installations looks as if the GDR's architectural creed had been realized. Even the TV Tower rising up above everything cannot change this with its silver dome and high spire so reminiscent of 1960s-era euphoric dreams of outer space. Beyond the draughty square, we reach the Marx-Engels Forum (1986) in the middle of a green space: The bronze double statue of the two namegivers created by sculptor Ludwig Engelhardt is complemented by marble and bronze reliefs as well as four stainless steel stelae in which are embedded images memorializing the labor movement.

On the Spree Promenade across from the park, beyond the Berlin Cathedral, we come upon the "Ostalgia" Museum, arranged around Club Cola, East Jeans and a Trabant in a fully furnished living room in a typical GDR *Plattenbau* including kitchen, household items and groceries. Next door we find an eavesdropping apparatus of the State Security, personal photo albums to look through, and lots of opportunities for interaction. The GDR Museum is a house of memory conjuring odors, noises, and bygone East German everyday life.

On the other hand, socialist Berlin appears highly formal in its architectural showpiece, Karl-Marx-Allee, which we approach by walking along Karl-Liebknecht-Straße and by once again cutting across Alexanderplatz. The avenue is most impressive when looked at head-on from the center of the street so we can see down its full length; then the two towers at Frankfurter Tor look like arches of triumph between which the rows of houses recede into infinity. To get there we need to cover about two thousand meters of monumental neoclassicism, past the Kino International; past Café Moskau in front of Strausberger Platz, recently acquired by Nicolas Berggruen, son of the late art collector, who wants to restore it to its former glory; past Henselmann's High-rise at Weberwiese to about Proskauer Straße, where this grandiose architectural style comes to an end.

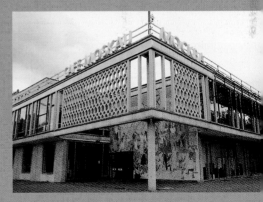

"Café Moscow," former GDR showcase restaurant

Cemeteries

Cemeteries

Invalidenfriedhof (Invalids' cemetery) – built in 1748, the city's second oldest military cemetery

If cemeteries are open history books, then Berlin knows more of it than any other big city in the world. Unlike in Paris, London or New York, Berlin's dead are not buried in large central cemeteries. They find their final rest in over 200 larger and smaller cemeteries and churchyards all across the Berlin municipal area. This distribution is a result of Berlin's historical development as the city was forged through the merger of several settlements. The oldest graves are situated in the immediate vicinity of their churches, such as in the churchyard of Parochial Church on Klosterstraße, which was created in 1705 and is still in existence today. Later, the congregations buried their dead outside the city walls – since 1735, in front Hallesches Tor (Halle Gate), or in Dorotheen-städtischer Friedhof (cemetery of Doro-theenstadt) in today's Mitte district. The cemeteries on Bergmannstraße as well as the churchyards on Hermannstraße in to-day's Neukölln were established in the 19th century. Cremation was first permitted in 1911, even though Rudolf Virchow had spoken out in its favor for reasons of city hygiene as early as 1875. This is when the first crematoria were built.

Dorotheenstädtischer Friedhof

Without a doubt, most of the city's very important persons are buried in the small, romantic graveyard located on northern Friedrichstraße. When it was established in 1763, the area beyond the city gates was pastureland; later, Dorotheenstadt developed into a dignified city quarter close to the university. This is why many professors are buried here, among them Johann Gottlieb Fichte (1762–1814), Georg Wilhelm Friedrich Hegel (1770–1831) and Christoph Wilhelm Hufeland (1762–1832), but also successful industrialists, such as railway pioneer August Borsig (1804–1854). In 1956, Bertolt Brecht found his final resting place here, just next to the house on Chausseestraße, where he lived until his death. Many East German creators of culture followed suit: Johannes R. Becher (1891–1958), Hanns Eisler (1898–1962), John Heartfield (1891–1968), Helene Weigel (1900–1971), and Anna Seghers (1900–1983). Even today, this cemetery has tremendous appeal as is evident from the more recent tombs, ranging from Heiner Müller's (1929–1995) to George Tabori's (1914–2007). The famous quartet of Prussian neoclassicism not only worked here on an artistic level; Schinkel, Schadow, Rauch, and Stüler are also buried here. The most significant tomb can be visited at the French Cemetery, which was established in 1780 for Berlin's Huguenots and is separated by a wall: the Ancillon Monument, one of Schinkel's final works designed for Friedrich Ancillon (1767–1837), tutor to Frederick William IV. The large, chapel-like canopy tomb of wholesale merchant and patron of the arts Ludwig Ravené (1793–1861), by Friedrich August Stüler, is located close by. The second cemetery of the French congregation located further to the north on Liesenstraße contains the graves of Theodor Fontane (1819–1898) and others.

Invalids' Cemetery

At one time, it was the most distinguished final resting place of the Prussian military. The "Heroes' Cemetery" was established after the first Silesian War in 1748 as a burial site of the adjacent Invalidenhaus for officers and war veterans. Today it testifies to the city's devastation left behind by the Wall, since the Invalidenfriedhof was situated in the middle of border territory. To obtain an unobstructed view and a clear line of fire, the GDR had much of it leveled. Of its 3,000 graves, only about 200 have been preserved. The architecturally most important tomb was designed by Schinkel in 1824 for military reformer Gerhard von Scharnhorst (1755–1813). The lion sleeping on a freestanding marble sarcophagus was created by C. D. Rauch; the bas-reliefs were fashioned by Friedrich

Tieck. Several generals are buried there, among them Karl Friedrich Friesen (1784–1814), a friend of *Turnvater* Jahn's and the founder of the German gymnastic movement. In 1848, soldiers killed during the March Revolution were buried here, while its civilian victims were taken to the newly established Friedhof der Märzgefallenen in Friedrichshain. A remainder of the Wall cutting through Invalidenfriedhof has been preserved as a memorial, as has the watchtower on Kieler Straße, which today looks almost harmless, now that it is enclosed by houses six stories high. Next to it, an informational panel documents the fate of Peter Göring, a border guard shot to death here in 1962. The Alter Garnisonfriedhof on Linienstraße is another military cemetery. Adolf von Lützow (1782–1834), a general in the Liberation Wars, and poet Friedrich de la Motte-Fouqué (1777–1843) are buried there.

Weißensee Jewish Cemetery

The history of the Prussian Jews in the 19th century is told by the largest Jewish cemetery in Western Europe; it contains 115,000 graves. It was an epoch of emancipation and social advancement. Plain stones and simple memorial plaques, consistent with the principles of traditional Jewish grave design, are found next to highly representational tomb groups. Comparable to the style of Christian cemeteries around the turn of the century, the wall architectures and mausoleums here, too, exhibit an extraordinary magnificence. Department store king Hermann Tietz (1837–1907) is buried here, as are newspaper mogul Rudolf Mosse (1843–1920), publisher Samuel S. Fischer (1859–1934) and painter Lesser Ury (1861–1931). Many very old gravestones have been preserved, such as that of Louis Grünbaum, who was the first to be entombed here. Moreover, the cemetery contains the burial urns of 809 Jews murdered in concentration camps and the graves of 3,000 people who committed suicide during the era of National Socialism, as well as the grave of resistance fighter Herbert Baum (1912–1942).

Max Liebermann (1847–1935), Leopold Ullstein (1826–1899) and Giacomo Meyerbeer (1791–1864), among others, are buried in the older Jewish Cemetery on Schönhauser Allee, which looks very weathered and is cover-ed with creeper plants.

Berlin's oldest Jewish cemetery, established in 1672 on Große Hamburger Straße, no longer exists. Its 3,000 graves were destroyed by the Gestapo. Today, a memorial site with a few Jewish memorial slabs commemorates the dead, among them Moses Mendelssohn (1729–1786), who was buried there in 1786.

Municipal Cemetery Stubenrauchstraße

Berlin's most famous lady has found her final resting place here in the "III. Städtischer Friedhof Stubenrauchstraße": Marlene Dietrich. True to her wishes, she was interred near her mother after she died in her Paris exile in 1992. Since then, the small Friedenau cemetery has become a site of international pilgrimage – even though Berliners never quite got along with their sole international star. Born in 1901 at nearby 65 Leberstraße, Marlene lived in the 1920s at 54 Kaiserallee (today's Bundesallee) and left for Hollywood after her success in the *Blue Angel* (1930). She became an American citizen and resisted the Nazis with her "anti-patriotic attitude." Today, her tomb is the most visited gravesite in the city. The officer's daughter had her modest tombstone embossed with a line from the sonnet "Farewell to Life," penned by Theodor Körner, the great freedom fighter: "And reaching now the limit of my life." Another prodigal son of Schöneberg is resting not far from here, photographer Helmut Newton, born Helmut Neustätter at 24 Innsbrucker Straße in 1920. In 2004, when he was laid to rest in a memorial tomb, his estate, in an act of reconciliation, was also returned to his hometown. Even in the 1920s, the small churchyard in Friedenau was called "Artists' Cemetery." Composer Ferruccio Busoni (1866–1924), in charge of the Master Class at the Prussian Academy of Arts and a teacher of Kurt Weill's, was given a stately funeral here in those days. Sculptor Georg Kolbe designed his tomb, a tall stone pillar crowned with a bronze Genius suspended in ecstasy, in 1925. Expressionist poet Paul Zech (1881–1946) is also buried here, as is painter Jeanne Mammen (1890–1976) and author Dinah Nelken (1900–1989), whose books sold several million copies.

Cemeteries Outside Hallesches Tor

Memorials from the baroque and neoclassicist periods, from *Biedermeier* and Art Nouveau, magnificently stud the large burial site on Mehringdamm, which contains five of Berlin's oldest cemeteries. Among the 80,000 dead entombed on site, there are Georg Wenzeslaus von Knobelsdorff (1699–1753), architect to Frederick the Great, as well as his court painter, Antoine Pesne (1683–1757); architect and Schinkel-teacher David Gilly (1748–1808); actor and theater director August Wilhelm Iffland (1759–1814); Rahel Varnhagen (1771–1833), to whom Berlin owes its salons and culture of sociability, and her husband Karl August (1785–1858); the beautiful Henriette Herz (1764–1847), who, as a baptized Jewish woman, consciously selected a cross made by Schinkel for her grave; and actor Johann Friedrich Fleck (1757–1801), whose urn grave, designed by Schadow, is marked by a tombstone bearing the masks of tragedy and comedy. Composer Felix Mendelssohn Bartholdy (1809–1847) and his family are entombed here, as are E. T. A. Hoffmann (1776–1822), and Adelbert von Chamisso (1781–1838), whose fairy tales about Peter Schlemihl and the shadow that was sold came to be considered the essence of a literature on the romantic soul. Other witnesses to the passing of history are resting in the adjacent cemetery on Bergmannstraße, such as Schiller's lady friend Charlotte von Kalb (1761–1843) and Prussia's most famous painter, Adolph von Menzel (1815–1905).

Villas and Settlement Construction

Märkisches Ufer

Opposite Fischer Island with its 25-story high-rises, a small unique remainder of Old Berlin seems to have endured through the ages. Along the promenade on Spree Canal, where museal barges bob up and down in the water of the Historical Harbor, stand a row of Baroque and neoclassicist middle-class houses. The oldest, No. 18, most likely built by Martin Grünberg around 1700, was conjoined with its neighbor, No. 16, another Baroque stucco building three stories tall, during their restoration in 1973; until 1994, it housed the memorial site for Berlin painter Otto Nagel. Today, it is the home of the Bild-archiv Preussischer Kulturbesitz. The Märkisches Ufer is rightly considered an exemplary model of reconstructive heritage preservation, since its building gaps caused by the war have been closed by means of historical originals previously located elsewhere. As such, the Ermeler House, No. 10 – named after one of its owners, Wilhelm Ermeler, a manufacturer of tobacco products, as is proclaimed by the frieze above the portal – was relocated to this site, along with its neoclassicist façade, from Breite Straße. Together with house No. 12, which only had to cross the river, it now constitutes the Art'otel Ermelerhaus. Its interior contains portions of its original magnificent furnishings as well as its late Baroque staircase railing.

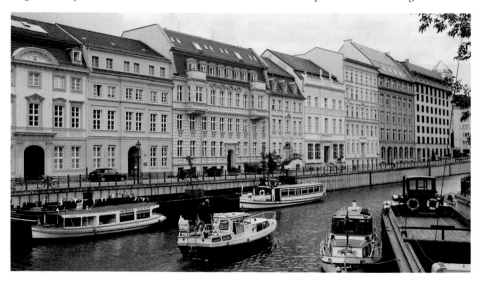

Böhmisch-Rixdorf

"Is this Berlin?" Thus Prague native Egon Erwin Kisch marveled. "An almost displaced idyll between barn fronts and garden fences." That was in 1926, and even today, the Bohemian village lies like a relic from another planet in the middle of lively Neukölln, the quarter once called Rixdorf. Far beyond the former gates of the city – this is where in those days Frederick William I exercised his settlement politics that were discussed all across Europe. Because they were reputed to be reliable, industrious and tolerant in spite of their religious zeal, he granted asylum to the Bohemian Protestants who had to leave Bohemia – which belonged to Catholic Austria – because of their faith. From 1737 onwards, about 2,000 Moravians settled as small farmers and textile workers around Richardplatz where they built houses in the tradition of their homeland. Their village still remains visible today with its two-story, narrow houses and small industrial yards along Richardstraße and Jan-Hus-Weg is a copy from the 19th century that is not entirely true to the original, since the original buildings were destroyed in a large fire in 1849. The schoolhouse of the brethren on Kirchgasse No. 5 dates from the early days of the colonists as does a gravestone in the Bohemian cemetery from 1755 that still bears a Czech inscription.

A historical farmhouse in the Bohemian village

Max Liebermann: Berlin Painter and Gardener

by Edelgard Abenstein

Self-Portrait, by painter Max Liebermann

He was an institution not only in Berlin. Max Liebermann, who made Impressionism fashionable in Germany, was one of the most important trailblazers for modernism. The son of a Jewish textile manufacturer was born in 1847 in Berlin. When he first embarked on his artistic career, he fought vehemently against the rules of rigid academicism. Initially, Liebermann painted in the naturalist style and then encountered the method of open-air painting on several of his travels to the Netherlands and Barbizon. This is

also where he came upon the themes for his first important works – among them, *Women Plucking Geese* (1871/72), *The Weaver* (1882) and *The Net-Menders* (1887/89) – which, without melodramatic histrionics, raised the worker to the level of artistic motif. This netted him the epithet, "Painter of Ugliness." Only after turning more and more towards subjects taken from the lives of the better bourgeoisie he became a celebrated painter of the turn of the century. In Berlin's politics of art, as well, Max Liebermann played a decisive role. Already in early 1892, he founded the Berlin Secession along with Walter Leistikow and Max Slevogt. He was appointed professor at the Royal Academy of Arts and was president of the Prussian Academy of Arts from 1920 to 1932. As an elegant citizen blessed with a pointed wit – "I am in my daily habits a perfect bourgeois [...] and I work with the regularity of a tower clock" – he maintained an open house on Pariser Platz next to Brandenburg Gate. The intellectual elite of his period were his guests and sat for their portraits: Fontane, Einstein,

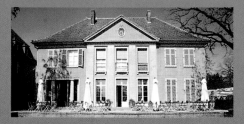

Liebermann Villa, now an art museum

"The Flower Terrace in the Wannsee Garden Facing Northwest," by Max Liebermann, 1921, oil on canvas, 50.3 x 75 cm, Städtisches Museum Gelsenkirchen

Käthe Kollwitz, Harry Graf Kessler, Heinrich and Thomas Mann. "In the person of Liebermann, I admire Berlin," confessed the poet of the *Buddenbrooks*. All his life, Liebermann searched for harmony in nature, his model, as is reflected in the choice of his subjects: He painted boys bathing and summer guests out strolling on the beach, beer gardens, quiet tree-strewn avenues, and increasingly his small garden empire in the south of the city. In 1909, he had a summer house built on Lake Wannsee which he proudly called "my castle on the lake." Here he found calm away from the bustle of the big city. He put Paul Otto Baumgarten in charge of building the villa; he himself designed the garden along with

Albert Brodersen, although he also took advice from Alfred Lichtwark, director of the Hamburg Kunsthalle, who was an enthusiastic "garden reformer." With the mixture of vegetable and flower garden in front of his house and a flower terrace, hedges, and trees, he created the motifs for his late works. More than 200 of his works painted in a carefree Impressionistic style were created at Lake Wannsee. After the National Socialist seizure of power, the painter-prince and Berlin citizen-of-honor resigned from public office; his paintings were maligned as "degenerate." Two years later, on February 8, 1935, Max Liebermann died. His wife Martha eluded deportation to Theresienstadt by committing suicide in 1943.

Villa Colony Alsen

Even before the *Gründerzeit*, Berlin's bourgeoisie felt the pull of the countryside. They escaped from the tenements and built quarters made of villas that granted them a socially homogenous privacy, such as in Lichterfelde-West (1860), the first one of its kind. Colony Alsen developed farther to the south, on the hilly shores of Small and Large Lake Wannsee; in 1872, its founder, banker Wilhelm Conrad, named it after the Danish Island Alsen that had just been conquered. Lenné student Gustav Meyer conceived the woodsy area as an intellectual middle-class counterpart to nearby landscape garden Klein-Glienicke. This is how Alsen Colony developed c. 1870 into one of the finest Berlin summer retreats; and for many it also became a permanent residence – with its own train connection. Only a few of the numerous dream chalets,

castles, sailing clubs, and *Gründerzeit* associations are preserved today, such as the *Landhaus* (1899–1902) of publisher Carl Langenscheidt, built in the timber frame style with stables and coachman's quarters, at 1/2 Colomierstraße; or Haus Springer of publisher Ferdinand Springer, built in 1901/02 by Alfred Messel, 39/41 Am Großen Wannsee; or Villa Herz, built in the Neo-Romanic style, 52 Am Großen Wannsee; and Villa Leo/Arons, built in 1875 by Kyllmann & Heyden for banker Heinrich Leo.

56/58 Am Großen Wannsee is the address of Villa Marlier, built in 1914/15 by Paul Otto August Baumgarten, who had already designed Liebermann's summer house, for Mr. Marlier and spouse. In 1941 it was made to serve as an SS guesthouse and conference building; on January 20, 1942, the Wannsee Conference on the "Final Solution to the Jewish Question" was held here. Today, the villa is a center for research and a memorial site.

Grunewald Villas

Berlin's most exclusive residential area is located in Grunewald. When the suburb of villas was still under construction shortly after the founding of the Reich, Otto von Bismarck already requested that its sylvan "idyllic-Brandenburgian" character be preserved. Four artificial lakes were created: Dianasee, Koenigssee, Herthasee, and Hubertussee. As a result, not only had swampy areas been drained and valuable lakeshore parcels been produced; a picturesque ambience had likewise been secured. When the city railway was built c. 1890, the new locality was instantly connected to the city center; the 1899 train station, designed by Karl Cornelius, promised a noble arrival. This presented sufficient motivation for the urban bourgeoisie, factory owners and journalists, artists and bankers, to move into the West. Alfred Kerr, who lived here from time to time, called Grunewald a "millionaires' cow-town." The star architects of the period designed in all kinds of styles, such as Bernhard Sehring who, in 1903/04, built the Löwenpalais, one of the largest and most magnificent buildings with historistic décor, for Emilie Habel, a member of the family of the imperial cellar master; it is located at 30 Königsallee. Hermann Muthesius designed the house of factory owner Bernhard at 11 Winklerstraße; it was built in 1905/06 as an incunabulum of reformed country house architecture against historizing eclecticism. Adolf Wollenberg constructed Villa Harteneck at 7 Douglasstraße in the austere, neoclassicist style. As in many Berlin locations, even at the heart of this most beautiful architecture, a dark chapter of German history has inscribed itself. It was from Grunewald Train Station that Jews were deported to the concentration camps.

Max and Bruno Taut

by Edelgard Abenstein

Portrait of Bruno Taut, 1934

New Building in Berlin is a word with four letters: Its name is Taut. From 1924 to 1932, Bruno Taut enriched Berlin's cityscape like few other architects did. His designs were used for the construction of housing developments with more than 12,000 apartments. Things were rather lively, because Bruno Taut loved colors. He considered them as elementary as concrete and brick. His brother Max, four years his junior, was quite different; he focused on the construction of schools and austerely objectivist trade union and office buildings; the depart-ment store of the consumer cooperative society on Oranienplatz was his creation. The brothers were both born in Königsberg, one in 1880, the other in 1884. After attending architectural trade school as well as making a few stops en route, they both aimed for Berlin. Once there, Bruno Taut established his first firm with partner Franz Hoffmann; Max joined them later. After they married a pair of sisters, one the older, the other the younger, their careers took off into separate directions – though they retained their partnership firm. In 1913, Bruno Taut obtained his first sizable contract to design the garden city of Falken-berg. Even for this contract he already prac-ticed what later on came to be known as "New Building." So that the apartments could be supplied with sufficient light and air, he had the buildings laid out along a north-southerly axis. The façades were furnished with intensive

Architect and author Max Taut, Photograph 1962

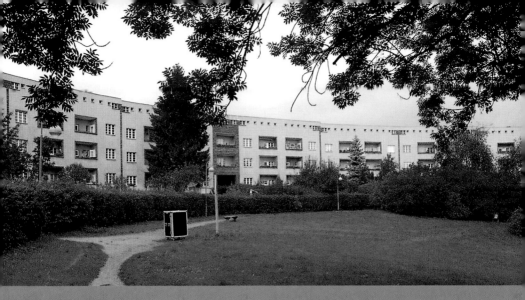

Horseshoe Settlement (Hufeisensiedlung), designed by Bruno Taut and Martin Wagner, 1925–1933

colors, which led to angry protests and netted the settlement the name of "Colony Paint Box." After designing the much noticed "Glass House" for the 1914 Werkbund Exhibition in Cologne, and publishing his architectural visions in the picture cycles entitled *Alpine Architektur* (1919) and *Die Auflösung der Städte* (1920, The dissolution of cities), as well as an intermezzo as Municipal Building Councilor in Magdeburg, he was lured back to Berlin by Martin Wagner. Bruno Taut was hired as architect in chief by GEHAG, a non-profit residential building society that financed the lion's share of Berlin's housing development projects under the direction of Wagner. From then on, things proceeded swiftly. In 1925, Bruno Taut started designing the Britz Horseshoe Settlement; in 1926–1932, the woodsy housing development Onkel Toms Hütte in Zehlendorf; in 1927, the residential facility Grellstraße on Prenzlauer Berg; and in 1929, the residential estate called Wohnstadt Carl Legien. Taut's multi-colored flat-roof-buildings were not always appreciated. They provoked fans of traditional architecture, as in Zehlendorf, where a veritable "roof war" broke out; its results are still visible today to visitors of the small street Am Fischtal: One side of the street features Taut's flat-roof buildings, the other sports row- and double-houses with saddle roofs authored by Heinrich Tessenow in 1928/29. In 1932, Bruno Taut left for Moscow, a year later he immigrated to Japan and then to Turkey, where he died in 1938. Max Taut survived his brother by 30 years.

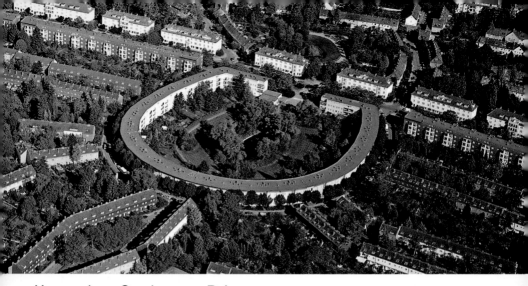

Horseshoe Settlement Britz

The Hufeisensiedlung is one of the most renowned settlements of the Weimar Republic, and it is the first mega-settlement of subsidized housing created after World War I. Along with City Building Councilor and architect Martin Wagner (1885–1957), Bruno Taut designed it as a radical reply to Wilhelminian tenements; it was realized from 1925 to 1933 as a residential facility of a new type, governed by the motto "light, air and sun."

The horseshoe ground plan of the central apartment block was developed in response to an existing pond, which Taut turned into the center of an elliptical, green, common courtyard. Its entrances accented by blue stairwells, the entire complex is a settlement idyll in the middle of the city. More rows of houses surrounded by greenery approach the horseshoe in the form of rays. The buildings heading the rows contain stores and a restaurant. The 1,072 apartment units and single-family homes were reserved for low-income renters. To keep building costs in check, digging and transport were mechanized. The production in series required simple and inexpensive forms: By means of standardization, flat roofs, standardized window sizes and the deployment of paint, which Bruno Taut praised the "cheapest means of design," it was the economic construction of a mega-settlement that here had its trial run.

Ring Settlement Siemensstadt

The Siemensstadt ring settlement, designed in a much more urban style than the horseshoe settlement, was a new way of building. The residential complex consists entirely of multi-story ribbon buildings. Its builder was Siemens AG who, in addition to their factory facility with characteristic red clinker brick façades, also built this white-plaster settlement for its low-wage employees. Its close proximity to the site of production was a novelty, as was the impressive number of commissioned architects who belonged to the architects' association "Der Ring,": Walter Gropius, Otto Bartning, Fred Forbat, Hugo Häring, and Paul Rudolf Henning. The comprehensive design for the 1,380 apartments was produced in 1929–1932 by Martin Wagner and Hans Scharoun; the latter also designed a portion of the buildings with shipping motifs, such as bulls-eyes and rounded elements. The four- and five-story houses that are surrounded by public green spaces mostly face south to provide the best lighting for the apartments. This ring-settlement thus became a model for other residential building projects. In the early 1930s, the workers' settlement in North Charlottenburg was patterned on it first; many postwar housing developments followed suit later. The UNESCO decided to award the World Heritage status to Siemensstadt as well as to the Horseshoe Settlement Britz,

the White City estate in Reinickendorf, the Schillerpark settlement in Wedding, the Falkenberg Garden City in Treptow-Köpenick, and the Carl Legien estate in Prenzlauer Berg district.

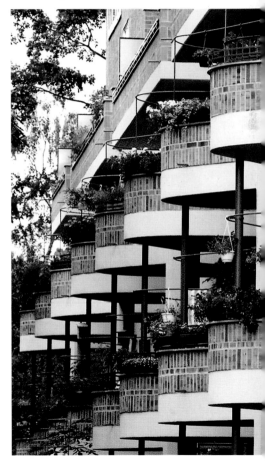

Hermann Henselmann –
Doyen of GDR Architecture

by Edelgard Abenstein

Hermann Henselmann, photograph, c. 1965

He built the window to the East, the "First Street of Socialism." His name is linked to the only European boulevard constructed after the war: the principal thoroughfare once called Stalinallee – today's Karl-Marx-Allee. Hermann Henselmann, architect-in-chief of the capital of the GDR, was born in 1905 in Roßla, in the Harz Mountains, as the son of a cabinet maker. After finishing his apprenticeship in his father's shop, he attended the school of arts and crafts in Berlin-Friedrichshain in 1923 to study interior design and architecture. His major role model was Le Corbusier, whom he met in 1930. Under the impact of this encounter, he soon embarks on his own professional career. In 1930, Henselmann, assisted by set designer Alexander Ferency, designs Villa Kenwin near Montreux in the style of New Objectivity. After a few years of independence – he builds single-family homes, e.g., in Kleinmachnow – Henselmann is maligned by the Nation-al Socialists but is able to keep his head above water with civilian contract jobs. In 1945, he reorganizes the Weimar Academy of Design in his capacity as its director by reviving Walter Gropius' Bauhaus curriculum of 1919. Four years later, he is offered a position by the Institute of Architecture of the German Academy of Sciences in Berlin, which is headed by Hans Scharoun, the great urban planner of the post-war era. His activities at the institute are Henselmann's springboard into the future. In 1951, he is made director of the institute of the newly founded German Academy of Architecture; and he is on site when, in the summer of that year, the go-ahead is given to rebuild Stalinallee. To take on East Berlin's premier project of prestige, Henselmann is appointed to the managerial

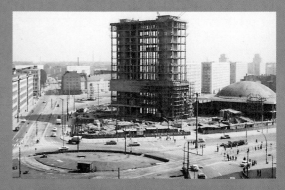

Alexanderplatz 1963: view of the House of the Teacher and Congress Hall

board of the design collectives headed by Richard Paulick, Egon Hartmann, Hanns Hopp, and Karl Souradny. His initial design for the High-Rise on Weberwiese is true to the architectural idioms of international modernism and leads to controversial reactions by GDR politicians. Party Chief Walter Ulbricht inserts himself into the fray. Henselmann is forced to revise his plans in favor of traditional motifs deriving from Schinkel's neoclassicism. The realized design corresponds to the architectural style officially advocated in the era of socialist neoclassicism under Soviet guidance. Subsequently, Henselmann designs the great representational buildings capping the entrances to the avenue: the tower-houses at Frankfurter Tor and Strausberger Platz. For the first time, ready-made concrete elements are put to use; they are the precursors of subsequent *Plattenbau* (prefabricated concrete slab) construction. Officially named "Chief Architect of Greater-Berlin" in 1953, Henselmann initiates a competition on the "socialist remodeling of the center" and presents his own design for a Tower of Signals, 300 meters tall, a modified version of which later becomes the Television Tower. In designing the House of the Teacher and the Conference Hall (1961–1964), he inaugurates the turn away from Stalinist neoclassicism and opens up GDR architecture to an international modernist style influenced by industrial building strategies. Henselmann died in 1995 in reunified Berlin.

Landmark-protected residence on Karl-Marx-Allee, designed by Henselmann

Karl-Marx-Allee

Its length is 1.7 km, which makes it the longest architectural memorial in Germany. Karl-Marx-Allee, called Stalinallee until shortly after the construction of the Wall in 1961, showcases the architecture of Socialist Realism. After the devastation wreaked by World War II, the former Große Frankfurter Straße was widened to 90 m and rebuilt, in 1952–1960, as GDR showpiece boulevard with two monumental public spaces by the architectural collectives of Egon Hartmann, Hermann Henselmann, Hanns Hopp, Kurt W. Leucht, Richard Paulick, and Karl Souradny. The residential buildings flanking the avenue are up to 9 stories high, faced with hundreds of thousands of Meißen ceramic tiles and decorated with balustrades and columns. The "residential palaces for the people" built in the typical wedding-cake style of the Stalin Era provide space for 3,000 apartments, which even in those days were outfitted with district heating and garbage chutes. During its construction, the GDR government raised work norms by ten percent on June 1, 1953, which occasioned the workers' uprising that was violently quashed by Russian tanks on June 17. Emblematic of the avenue are the two tower buildings at Frankfurter Tor; they are modeled on motifs borrowed from Gontard's towers on Gendarmenmarkt.

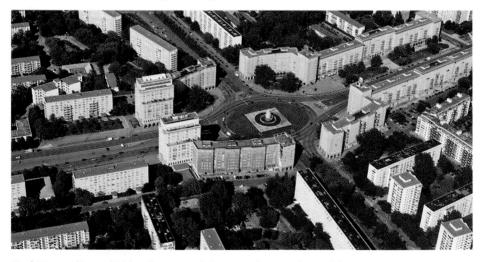

Karl-Marx-Allee and Lichtenberger Straße intersect via an oval roundabout on Strausberger Platz.

Le Corbusier House

By far the largest house designed for the 1957 Interbau Exhibition, this one was too big for the Hansa quarter. Therefore, Le Corbusier was provided with a hill near the Olympia Stadium for his "Unité d'habitation," so that his building – 17 stories high and 140 meters long, its layout following the course of the sun – could unfurl its full impact as a free-standing structure. Already by the end of the 1920s, Le Corbusier had developed the idea of residential high-rises in the middle of landscaped open spaces as an alternative to the densely populated old town quarters. He conceived of his residential blocks as vertical, autonomous garden cities with their own stores, post office and hair salon. Before designing the Berlin "Unité," he had already realized similar residential building types. The structure rests on wedge-like supports and rises up above the treetops of the woods and villa region. Its more than 500 apartments, mostly designed in the style of maisonettes, are grouped around nine interior streets that provide

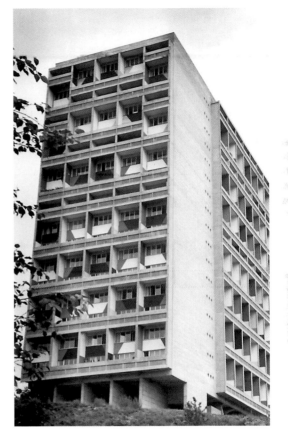

Residence "Radiant City" designed by Le Corbusier, photograph, 1959

access to the complex. In spite of numerous modifications to the original design, the structure of the "machine for living" has been considered difficult to the present day: Many of its apartments that have since been converted into condominiums may have found their enthusiasts, but others always end up vacant again.

Awakening after the War:
International Architecture Exhibitions

by Edelgard Abenstein

Berlin in 1945 was "Europe's largest, contiguous territory in ruins." About 40 percent of its residential area was destroyed; up to two-thirds of its downtown area was nothing but debris. The catastrophe of the world war, it was thought, could only be overcome by a radical turning away from the past. This opinion catalyzed, in a "second destruction," the demolition of large sections of the city. Furthermore, the formerly largest industrial metropolis of the continent had lost 85 percent of its economic power through bombs and disassembly; of 4.3 million Berlin citizens, only about 2.3 millions were left. Only the 1947 Marshall Plan with its billions of Deutschmark in aid revived the economy. The architectural model for reconstruction in the West was Weimar Republic Modernism, whose protagonists now returned from their United States exile to Germany as advocates of the International Style. The East, under Soviet occupation, paid homage to a monumental type of neoclassicism. Both systems were in direct competition not only on a political level. As a reply to the GDR's propagandist success in building Stalinallee in 1952, West Berlin called for the Interbau one year later. The international architecture exhibition pledged its allegiance to the modern architecture of the Western world. With its centerpiece, the new Hansa quarter at the edge of Tiergarten, West Berlin wanted to show the international public how a city destroyed can be rebuilt. The Interbau understood itself as a programmatic refusal of National Socialist imperial architecture. That architects were in-

Upper left: Girl with doll's stroller in front of a residence in the Hansa Quarter, photograph, c. 1957 – below: Water fountain at newly remodeled Ernst-Reuter-Platz, photograph, 1960

View of the new Hansa Quarter buildings; in the foreground: a futuristic bank, photograph, 1959

vited from countries that had been hostile nations during the war just a few years prior, was perceived as a sign of reconciliation. Walter Gropius, Max Taut, Oscar Niemeyer, Alvar Aalto – all in all, more than 50 high-ranking designers of 13 countries interpreted their ideas of modern building. Thus, 1,160 apartments were developed in this model quarter, in a green space, in the middle of the city. The

Interbau included the Le Corbusier House in Charlottenburg as well as the Kongresshalle (today, the House of World Cultures), the boldest construction of 1950s Berlin and a present of the United States to the Western section of the divided city. The show fell in line with a tradition composed of a whole series of architectural exhibitions, such as the *Deutsche Bauausstellung* of 1931 on the Berlin Mes-

segelände, or the exhibition called *Die Wohnung* of the Deutscher Werkbund in Stuttgart in 1927, which provided the framework for the development of the Weißenhofsiedlung. The Interbau was a huge success. Almost a million visitors, every third one a guest from East Berlin and the GDR, streamed into the Hansa quarter in the summer of 1957. From Zoo Station, guests could waft in on the chair-lift ropeway. The fully furnished model apartments imparted a new, untroubled feeling of vitality. Even the belfries of the two new churches with their slender, filigree towers conveyed this sense of the lightness of being.

Entirely new priorities were set some 20 years later during the International Architecture Exhibition's (IBA) run from 1979 to 1987. It was a result of a turnaround in West Berlin urban planning, which defined itself against satellite settlements and slash-and-burn renovation. Instead, the city was to be revitalized – especially Kreuzberg that, due to its location on the border to East Berlin, had been slated for total demolition. New concepts of urban planning that had hitherto been tested in the form of isolated case studies only, were now implemented for the first time in large numbers across a broad spectrum of usages. Under the direction of Josef Paul Kleihues, the IBA-New was set up, which was to take on the "critical reconstruction" of the historical city ground-plans. The city, undermined by war and demolition, was to be enriched with new architecture in such a way as to consider former lots, alignments and eaves heights. For the IBA-Old, architect Hardt-Waltherr Hämer bet on "careful urban renewal," that is, the renovation of old-style buildings in problem districts inhabited by foreigners, squatters and other marginal groups. He pressed for self-help and individual responsibility, and he turned concerned parties into constructors. About 7,000 apartments were renovated, some 2,500 were newly built, e.g., at the fringe of the Tiergarten, on Prager Platz and Tegel Harbor. About 150 international design firms participated, among them Rob Krier, Peter Eisenman, Aldo Rossi,

Residence in the Hansa Quarter, photograph, 1959

The new construction on Fraenkelufer (1982–84) in the district of Kreuzberg constitutes a prime example of "careful urban renewal" as propagated by the IBA.

and Rem Koolhaas. The Jewish Museum by Daniel Libeskind also goes back to IBA designs. This concerted effort of architectural fantasy led to the IBA and its methods being passionately discussed not only among international circles of experts, but also by the public at large. It is to the credit of the IBA that the walled city, cut off from the fray, has once again caught up with international architecture. Municipal history was rediscovered. To use it as an architectural impulse has since become standing practice for urban planning. Even the second IBA was a showpiece project of the West. After the fall of the Wall and the building boom in the new city center, it naturally lost some of its attractiveness.

Both architectural exhibitions have had a tremendous impact on Berlin: They initiated actions, conveyed the feeling of reaching out to new horizons, contributed to new forms of living and exemplary urban repair, and they came to be a model copied the whole world over.

Hansa Quarter

"Every house is a diva" – this was the unwritten motto of the master plan for the Hansaviertel. Accordingly, each one of the 36 buildings bears the signature of a renowned domestic or international architect. In loose arrays, diverse variants of subsidized housing are distributed across a landscaped green space in the form of point block or slab block buildings as well as single family bungalows and row houses. The high-modern ensemble was created for 3,500 renters, nowadays mostly owners. The two churches, departments store, library, theater, and school were later joined by the Academy of Arts. Across from it, three-story houses designed, e.g., by Max Taut, nestle up against Hanseatenweg. Behind them, four high-rises stand tall like a wall to the north; they are designed by Luciano Baldessari of Milan, and others. The most famous buildings of the Hansa quarter include an eight-story tower sitting on V-shaped supports with a detached elevator shaft by Oscar Niemeyer, the architect of Brazil's capital Brasilia, at 4–14 Altonaer Straße; the Fins' House by Alvar Aalto with roof access for all of its inhabitants, at 30–32 Klopstockstraße; and the ten-story residence by Walter Gropius, at 3–9 Händelallee. Like a gatekeeper of the city within the city lies the Berlin Pavilion at S-railway station Tiergarten. In the meantime, a fast food chain has moved in there.

IBA Buildings in Kreuzberg

During the International Architecture Exhibition IBA of 1979–1987, for the first time since the arrival of modernism in Berlin, the historical proportions of the city, its old ground plan, were made the basis of urban planning and not the hope of a future as fantastic as possible. This was an architectural design revolution, its first commandment being that new houses were to fit into traditional block perimeters. Up to the present day, the results of the new building program in southern Friedrichstadt are impressive: such as the residential and commercial buildings by Aldo Rossi at 1–4 Kochstraße; or those by Peter Eisenman at 62/63 Kochstraße; Zaha Hadid's oblique house on Stresemannstraße that is one of her first realized designs; and the residential complex by John Hejduk, at 96–98 Charlottenstraße. The residential courtyard by Hans Kollhoff, e.g., helped regain an ambience for the house that had hitherto existed in isolation. The entirely different "Art Nouveau-like" gatehouses by Hinrich and Inken Baller closed two buildings gaps on Fraenkelufer with a dissonant Baroque triad. IBA gave a new face to the quarter: young, dynamic, bold – and just in time before the fall of the Wall – because ever since then, Kreuzberg is once again located in the heart of the city.

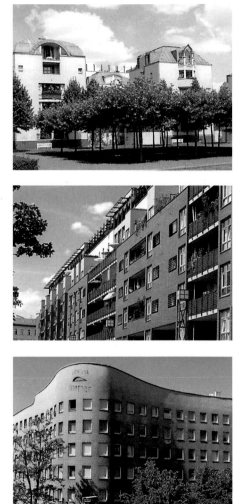

Above and center: Residential Park by Hans Kollhoff, et al. – below: residence called "Bonjour Tristesse" on Schlesische Straße

Walking Tour: Bourgeois

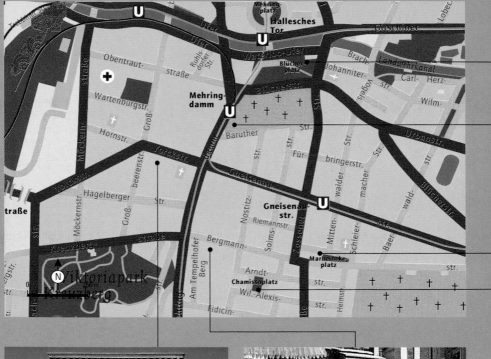

Riehmers Hofgarten

Bergmannstraße

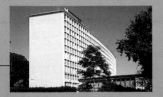

American Memorial Library

Cemetery at Hallesches Tor

Market Hall at Marheinekeplatz

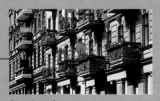

Chamissoplatz

Whoever wants to experience a living, historical Berlin city district should go to Kreuzberg, the "open air museum" of Wilhelminian *Gründerzeit* architecture. Barely another quarter shines as brightly as this one, its streets preserved with as good as no building gaps. Once we leave the subway station Hallesches Tor and walk past the slightly curved building of the American Memorial Library – which was constructed in 1954 with donation moneys from the United States – we are already in the thick of it. While to the left, the brick-built Heilig-Kreuz-Kirche (holy cross church) that is topped with a large dome rules the square, we arrive on wide Mehringdamm, where to the right, a gray building complex with battlements and corner towers has taken over the entire residential street: the former barracks of the Prussian Guard Dragoons dating back to 1853, today's Internal Revenue Office. We peak into the yard: Where soldiers used to drill, the former stables have been renovated to pristine condition. Across the street, we walk through the entrance of one of Berlin's oldest cemeteries that in 1735 still lay far outside the city gates. Famous personalities of the 18th and 19th centuries are laid to rest here, from E.T.A. Hoffmann to Rahel Varnhagen, from Knobelsdorff to Pesne; in the cemetery nursery, we can get a map showing the layout. It gets lively again on Yorckstraße, part of a ring of boulevards outside the old excise walls that was dedicated to Prussia's anti-Napoleonic heroes: Yorck, Gneisenau, Bülow, and Kleist. Not-

withstanding military tradition, bourgeois, urbane Kreuzberg starts here, with its typical mixture of residential buildings and small businesses, taverns, restaurants, and entertainment venues.

Across the street, the two towers of a narrow-chested church amidst tenements are remarkable: St. Bonifatius, built in 1907 by Max Hasak. To avoid the steep tax on façades, this Catholic Church squeezed itself inexpensively into the lot prescribed by perimeter block development, since its builders in their Protestant-dominated Diaspora had few financial means at their disposal. But in the rear, not only does its have an extensive nave but also a calm, green inner courtyard, framed by residential buildings. Immediately next to it, two atlantes on a richly adorned façade catch our eye; underneath, a large gate opens onto a passageway, the entrance to Riehmer's Hofgarten (backyard garden), a five-story residential complex flanked by Yorck-, Großbeeren- and Hagelberger Straße. Master mason Wilhelm Riehmer built this little realm in 1881–1899 for the well-to-do middle class composed of merchants and members of the military in a magnificent Neo-Renaissance style. If we step through the round arch portal into the interior courtyard, we can see how the building master devised a new and unique form of residential construction, contrary to customary Berlin practice that prescribed pompous façades up front and light-deprived courtyards in the rear; Schinkel-style street lamps

Detail of façade from the entrance to Riehmers Hofgarten at Yorckstraße

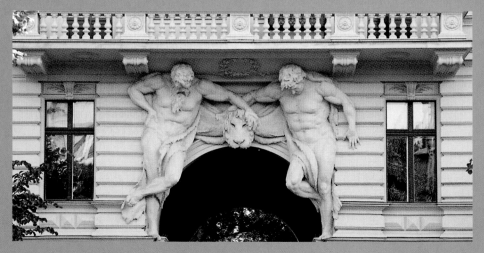

illuminate the garden as if it were a relaxation space. Leaving this refuge of Wilhelminian affluence, we rejoin the bustle of Kreuzberg's *Kiez* – beyond Mehringdamm, we reach the quarter's promenade for strolling, Bergmannstraße. Here, strict Prussian perimeter block development presents itself, deriving from Hobrecht's urban planning of the 19th century; this area is also the showcase territory of 1970s era "careful urban renewal." As in a timelapse sequence, the houses of Bergmannstraße, which were built in 1870, to Nostitzstraße on our right, present the various styles of the period, sometimes decorated with gable-topped

Marheinekeplatz with Market Hall

risalits crowned with statues, on to Arndtstraße, which is flashy with pronounced sculptural, neo-Baroque forms created in 1877–1888, up to the Neo-Gothic water tower on Fidicinstraße dating from 1888. The heart of the area, though, is Chamissoplatz: cobblestones covering the streets, gas lamps, an old water pump under the trees. A charming idyll, that seems to duck and retreat under this onslaught of admiration. It is still a popular location for the shooting of historical movies. At the end of Friesenstraße, a long building made of brick, glass and iron stretches out sedately: the Marheinekehalle. It was opened in 1892 as the penultimate of Berlin's 15 original market halls. Most of them were larger and more representational than this Kreuzberg version. And yet, this one was the only one to stubbornly hold its ground against wartime destruction, supermarkets and decay. Recently renovated, it is radiant in the bright sunlight, always more than simply a place to shop for groceries. It is an exuberant memorial to itself.

Palaces and Gardens

Palaces and Gardens

From the Renaissance to neoclassicism – the palaces and manor houses built for their own use by the Hohenzollerns and other aristocratic dynasties in Berlin and environs offer a diverse picture of courtly art and architecture. They served as hunting castles, summer houses, farming estates, and residences for families with large, complex family trees. To construct them, the best architects of the period were put under contract. Their designs and artistic ideas set benchmarks; they influenced the development of Berlin's surroundings as well as the physiognomy of the city itself. The palaces were models, copied frequently and enthusiastically. From the noble 17th century palaces in Friedrichstadt to the Wilhelminian *Gründerzeit* villas of the grand bourgeoisie in Grunewald – the treasury of forms deriving from palace architecture was shamelessly copied.

Nowadays, most of the palaces, surrounded by extensive landscaped grounds and greens, are much frequented places of excursion, museums, sites of extraordinary art collections, or historical backdrops for festive events. Solely the palace at the heart of Berlin, the most significant of the architectural heritage sites of the Hohenzollern dynasty in Prussia, has been irrevocably lost since its demolition in 1950 – and yet, it, too, will be recreated in a new guise on its former site.

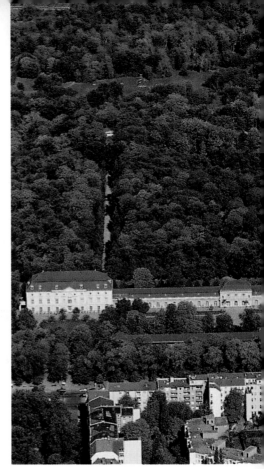

Charlottenburg Palace

The beginning of its history was the desire for a "maison de plaisance." Its name-giver, Sophie Charlotte of Hannover-Braun-

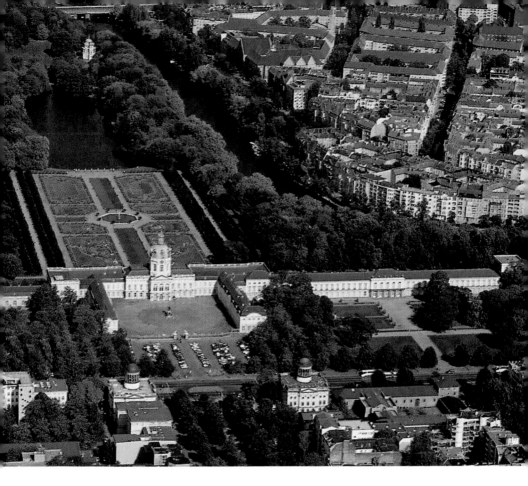

schweig, was an unusual princess, highly educated, friends with Gottfried Wilhelm Leibniz, appreciative of music – and she is the ancestral mother of all Prussian kings. In 1695–1699, she had a small summer residence built outside the gates of Berlin

that was based on a design by Johann Arnold Nering; it was a building two and a half stories high with eleven axes whose center, on the side of the garden, is accentuated by an oval hall decorated with columns. This oldest section was expanded

A New City Palace for Berlin –
Many Bones of Contention

by Jeannine Fiedler

The best evidence of a functioning government by the people – and democracy is just that – are public discourses about the planning of urban space. Up to its dedication in 2005, the Monument to the Murdered Jews of Europe had undergone an 18-year-long phase of discussion, competition and planning. Heated debates about a lobby and a street of arts and cultures, that was to subterraneously connect all the collections on Museum Island, have been going on since the mid-1990s. As early as 1992, entrepreneur Wilhelm von Boddien advocated for the reconstruction of City Palace, which once constituted the striking vanishing point of Unter den Linden Boulevard as seen from Brandenburg Gate and the "head" of the former Prussian center of power between Forum Fridericianum and Museum Island. Since then, suggestions on the use of the original palace area have been legion. Calls for the preservation of the Palace of the Republic have long since fallen silent; its deconstruction is almost complete. Reduced to concrete and tinted glass, the symbol for the GDR dictatorship was constructed by the GDR in an ideological gesture of differentiation in 1973–1976 on the very terrain of the Hohenzollern Palace, blown up in 1950; this can be read as an architectural version of staircase wit as applied to German history, since it derives its impetus from the same attitude that fueled the late Wilhelminian era: Things are looking up – now with a vengeance! Merely dismantling will have consumed c. 60 million euros by the date of its completion in 2009. Expenditures for asbestos abatement and restoration might well have run up into the three digit millions and such a sum would not have been justifiable compared to building anew. In 2002 and 2003 the Bundestag decided: Picking up the cubage

"Schlüterhof courtyard of City Palace," painting by Eduard Gaertner, c. 1830, oil on canvas, 97 x 155 cm

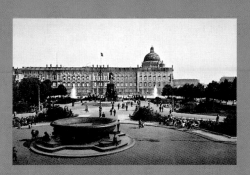

City Palace and Pleasure Garden (Lustgarten) with granite basin, hand-colored photograph, 1898

of City Palace, the building is to be outfitted with three Baroque exterior façades – facing away from the Spree – as well as the famous Schlüterhof with three Baroque interior façades. Since the federal government is to bear the main burden of the cost of construction – a very low-end estimate stipulates that it will add up to about half a billion euros – the previous notion of splitting its use three ways by giving equal shares to museums, the library and the university, has given way to privileging the federally financed Stiftung Preußischer Kulturbesitz and the use by its museums. The "palace" will of course be none such, even if the Federal Treasury authorizes the reconstruction of the most magnificent parlors or historical enfilades (room sequences); instead, it will be an all-round architectural construct housing museums, performance venues and an agora – a production-mall for art and culture. The Humboldt Forum – such is the name for the projected multifunction building – will provide all of 1,000 m² space for the terrific natural science collections of Humboldt University; libraries are getting a measly 4 000 m². The collections of non-European cultures, currently housed in Dahlem, will finally be exhibited on an equal footing with Museum Island's European-Oriental treasures of art; this move was advocated by Klaus-Dieter Lehmann, president of the foundation until February 2008. Since these collections take up an area comprising 31,000 m², they were granted "sovereignty of usage." The agora is to provide space for restaurants, theaters, movie theaters, and workshops on 14,000 m² of space. Whether Hermann Parzinger, Lehmann's successor as Berlin's most important museum manager, will succeed in transforming the noble ideas of his predecessor into an internationally unique cultural center by 2013 – a center which will flexibly transform themes into exhibitions and which will even be granted curators and novel, mobile museum technologies – only time can tell.

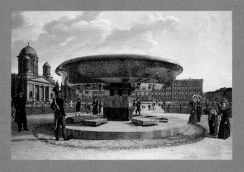

"Granite basin in Pleasure Garden," painting by Johann Erdmann Hummel, 1831, oil on canvas, 65.5 x 87.5 cm, Märkisches Museum, Berlin

Peter Joseph Lenné –
Gardener in Prussia's Arcadia

by Jeannine Fiedler

Peter Joseph Lenné, lithograph, c. 1850

Peter Joseph Lenné influenced the presentation of the Prussian landscape garden like no one else did. The art of gardening he developed during his half century of activity came to be considered not only an aesthetic but also an atmospheric staple of the cultural regions in and around Berlin. In 1990, Lenné's garden empire between Peacock Island and Werder was declared a World Heritage Site due to its featuring a unique ensemble of natural design and architecture. As commissioned by the Royal Prussian Court and especially as sponsored by art-minded Regent Frederick Wil-

liam IV, Lenné helped his contemporaries attain a "purification of taste," primarily by turning their attention towards "the culture of the land and the beautification of the land." By perceiving landscape scenes and urban green spaces in terms of knowledge as well as pleasure, the eye of the beholder was to envision a genuinely German "garden style"; this style was as much to be derived from a long history of European landscape and garden design, as it was to make use of numerous models applied in a variety of forms.

Lenné came from a family of Walloon gardeners who had moved from Liège to the Rhineland in 1665. Since then, they had served the Cologne electors as royal court gardeners in Poppelsdorf, the third electoral residence after Bonn and Brühl. Born in the year of the French Revolution on September 29, Lenné was to follow in the footsteps of his fathers. Although his father, Peter Joseph Lenné, the Elder, insisted on an academic education, his offspring dropped out of college at age 16 after taking a few classes in scientific botany. In 1808, shortly before his 19th birthday, he completed his subsequent apprenticeship as a gardener under the tutelage of his uncle, Joseph Clemens Weyhe, court gardener in Brühl. Study tours led him to Southern Germany and, in 1811/12, to France. Under the care of professional colleagues of his father's, the brothers André and Gabriel Thouin in Paris who were among the most influential of botanists

Plan of Sanssouci and Charlottenhof by Peter Joseph Lenné, lithograph, 1836

and garden architects of their time, Lenné's training acquired additional scientific accents and a masterful polish. The sinuous pathways and the harmonious spatial order that were design features of Gabriel Thouin's landscape gardens, or "jardins romantiques," as practiced during the French Empire and Restoration under the Bourbons, came to be one of his models for future projects. Lenné attended lectures by Jean Nicolas Louis Durand at the Paris Poly-

technic; he was an assistant to the great architect of the Revolution, Étienne Louis Boullée, who had developed a novel grid system for a simplified type of urban planning. What he had learned in Paris, he perfected during a third study tour to Switzerland and Southern Germany in 1812, during which he very likely met the creator of the Nymphenburg landscape garden, Friedrich Ludwig von Sckell: Landscape design features reminiscent of Sckell later on

also appear in Lenné's designs. Through the intercession of Lenné the Elder, he was able to realize his first larger landscape design in the service of the Habsburgs: the landscape grounds of Laxenburg Castle, the summer seat of the Viennese Court. In 1816, Lenné followed a call to the Potsdam residence of the Kingdom of Prussia. After the end of the Napoleonic Wars, gardens and parks in Potsdam and Berlin lay in shambles. Lenné earned his first merits by designing the New Garden in Potsdam. But he had laid the foundation for his creation of the "Island of Potsdam," the moody northern Arcadia, in 1816 when he started work on Glienicke manor, an estate on the River Havel, which at that time was owned by Hardenberg. Nostalgia for the Mediterranean regions, so prevalent at the time, was fused at this location with the melancholy charm of Brandenburgian water landscapes, which use as their ally the famous

indigo illumination above the reflective surface of the Mark Brandenburg. While exploring the *genius loci* – first universal rule before designing a garden or park – Lenné recognized its singularities and, through subtle intervention, allowed already existing harmonies to resonate: He molded soft hills and grassy valleys, created intricate pathways through groves and shrubs that were arranged as naturally as possible, and led wanderers towards landscape scenes that were always new and surprising, as he wanted his grounds to be full of people. The vista points open onto wildly romantic chasms, onto the River Havel all the way to the Heilandskirche (Church of the Holy Redeemer) at Sakrow, or onto staggered natural scenes laid out before artificial ruins and neoclassicist elegance. To use the elements of a template, to refine it all the while retaining its naturalness and yet subordinating it to a central idea –

Plan of Pfaueninsel (Peacock Island), 1829

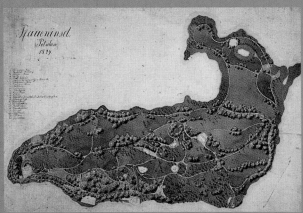

this is where the creative work of a gardener has its origins; and Lenné proved himself over and over again as a masterful organizer. Glienicke was the glorious beginning of Lenné's congenial collaboration with contemporary master builders, above all with Karl Friedrich Schinkel and Ludwig Persius. In the coming decades, Lenné's body of works unfolded according to three diverse principles of design: After the "pure art of gardening" practiced during his apprenticeship and years of travel, he embarked, around

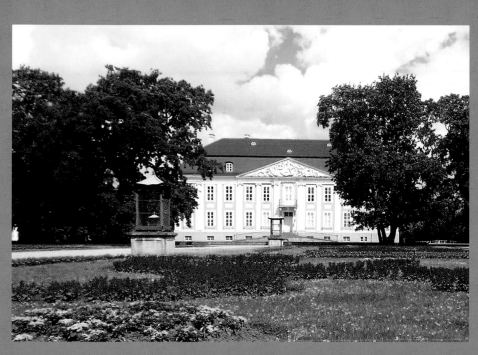

Friedrichsfelde Palace, the garden grounds were landscaped by Peter Joseph Lenné in 1821

1820, on a phase of generous pleasure grounds and landscape gardens, which are famous for their lines of sight and their natural integration of decorative elements as well as exotic plants or trick fountains. Glienicke belongs to this category, but so does Peacock Island, the redesigning of Park Sanssouci, the garden grounds of Friedrichsfelde Palace (today's Tierpark Berlin), the Russian Colony of Alexandrowka in Potsdam, or the grounds of Caputh Palace, to name but a few of the more than 120 parks he designed until 1840. Then

Lenné, too, started appropriating historizing characteristics that revived the forms of bygone styles, such as the Renaissance and Baroque – as was the fashion in the middle of the century. In 1840, Frederick William IV entrusted him with additional urban planning projects in the Berlin region, which he completed with a growing sense of social responsibility. In 1854, he was named general gardening director of all royal Prussian gardens. When he died in 1866, Lenné left behind innumerable traces of his creative spirit in all of Germany.

Jagdschloss Grunewald

For 400 years, the Berlin Court enjoyed the pleasure of hunting in the woods and lakes around the white Renaissance castle. Elector Joachim II had the fortified place of excursions built in 1542, most likely by Caspar Theyss, one of the master builders of the Hohenzollern residence. An inscription above the portal proclaims still today: "Zum grünen Walde" (to the green forest), a name that was soon applied to the region itself. In the 17th century, the two-story building was raised another floor; until 1709, it was a water castle surrounded by a moat. The large hall with a painted wood ceiling is the only secular room in Berlin that has been preserved from the days of the Renaissance. Representational baroque expansions and smaller buildings on the

courtyard were added in the 18th century. Around 1830, the Lord of Glienicke Palace, Prince Carl of Prussia, reintroduced *parforce* hunting: "Par force de chiens" (by the force of dogs), so was the game chased and intercepted by the pursuing hunters. Numerous paintings in the palace showcase this type of courtly entertainment; they also show monstrous representations of animals that suited the Baroque predilection for the spectacular. Serving as a museum since 1932, this building contains – in a living-room ambience – exhibits of furniture, porcelains and pewter ware, as well as more than 200 paintings by German and Dutch painters, e.g., by Peter Paul Rubens, Jan Gossaert, Jan Steen, Anton Graff, Franz Krüger, and Antoine Pesne. The main attraction, however, is the largest Cranach collection in Berlin; it contains 30 paintings, among them famous works by Lucas Cranach, the Elder: *Joachim II as Electoral Prince* (c. 1517/18), *Judith with the Head of Holofernes* (1530), the *Resurrection of Christ* (c. 1537/38). There are several works by his son, Lucas Cranach, the Younger; among them is a portrait of the castle's builder, Joachim II, at about age 50 (c. 1555).

The palace is currently under renavation; but the depot for hunting implements showcases an exhibition on the history of the palace and the "courtly hunt," as well as numerous archaeological finds dating as far back as the 16th century. The café and museum shop will move into the former 18th century carriage house; the old

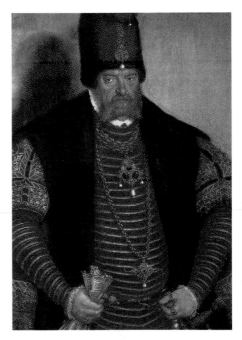

Joachim II Hektor, painting by Lucas Cranach, the Younger, c. 1555

kitchen building will host events centered on the hunt that will also illustrate courtly ceremonies and festive culture. Jagdschloss Grunewald will be reopened in 2009 with a big Renaissance exhibition that is to present, for the first time, all of the paintings by Cranach, by both father and son, in Berlin. Later, other artists as well may reoccupy their ancestral space next to the famous painter duo at the picturesque woodsy idyll between Potsdam and Berlin.

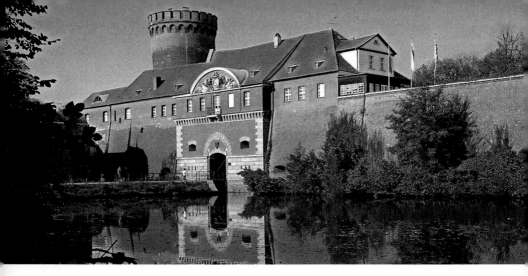

Spandau Citadel

It is among the best preserved fortresses in Europe. Its highest elevation, the Julius Tower – 32 m tall – is the oldest secular building in Berlin. However, it only acquired its current battlements in 1838; they are based on a design by Schinkel. Spandau Citadel was created on the territory of a Slavic settlement. In the 16th century, it had become a mighty fortress able to secure the city that was located on the trade route going from the Rhineland to Poland. Francesco Chiaramella da Gandino, the first Italian master builder in the service of the Brandenburgians, designed the facility based on northern Italian models with four arrow-headed bastions that, consistent with the simplest hierarchical principle,

were named, "King," "Queen," "Crown Prince," and "Brandenburg." The military outpost, entirely surrounded by water, was completed by the end of the 16th century; it was not until 300 years later that new buildings were added to the interior of the facility. The fortress was considered invincible. The Swedes used it during the Thirty Years' War; during the Seven Years' War, Queen Elisabeth Christine and her royal household looked for shelter from the Austrians inside its walls. Only once, in 1813 during the Napoleonic occupation, did a martial conflict occur there. The citadel was also a prison, and it proved its mettle as a state vault. Julius Tower preserved the electoral silver hoard; and from 1874 to 1919, it safeguarded the French reparation monies. Today, the building houses the Museum of Municipal History, Spandau.

Pfaueninsel

At one time, the reedy island in the middle
of the River Havel was a love nest – Pea-
cock Island. Here, Crown Prince Frederick
William (II) spent his first secret ren-
dezvous with the court trumpeter's daugh-
ter, Wilhelmine Encke, before almost 30
years later – the girl had long since become
his mistress and confidante – he had a castle
built on this secretive island. Wilhelmine,
alias Countess Lichtenau, joined him in
1794 to contribute substantially to the
planning of the summer residence, which
has the air of an artful ruin. Most of all,
the completely preserved interior décor is
to her credit, which provides a unique tes-
timony to the era of early neoclassicism.
Numerous Rome citations in the intimate
series of rooms testify to this lady-builder's
nostalgia for Italy, as do the classically
themed wall panels and the delicate and
discrete paintings on the walls and ceilings.
The wallpaper is as colorful as its Paris
model. The room called "othaheitisches
Kabinett" was designed as a bamboo hut,
following a description in Georg Forster's
reports on the South Pacific. From here,
the gaze can travel freely across the water
to the Royal Palace, the marble mansion
in the New Garden in Potsdam. Stendhal,
on Peacock Island, was to have felt him-
self transported to a southern ambience –
"like the Borromean Islands" in Lago Mag-
giore. And Fontane called the island a
"mysterious oasis in Brandenburg." Frede-

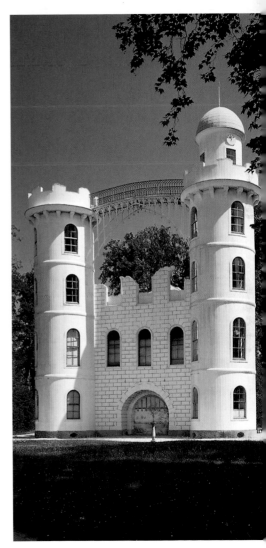

rick William III had other buildings (1824 – 1832) added to the island that were all based on Schinkel's designs, e.g., a Gothicizing Cavaliers' House, into which was integrated the late Gothic façade of a patrician mansion in Gdansk that had been threatened with demolition; a Swiss chalet, as it was very much the fashion at the time; and a boat house called 'Frigate Shelter' – recently reconstructed. In the northeast of the island, the dairy farm (c. 1795) rises up from the landscape garden – it was designed by Lenné after his model, the Parisian Jardin des Plantes. The ballroom on the upper floor, richly ornamented with Gothicizing decorative paintings and stucco work, has been preserved largely in its original form. The Temple to Louise features the sandstone portico originally intended for the Charlottenburg Mausoleum; it was transferred here in 1829. For its former inhabitants, Peacock Island was a refuge beyond courtly ceremony.

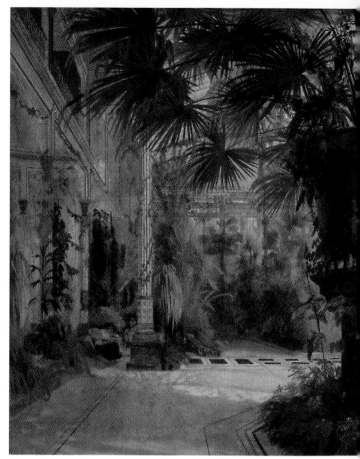

"Palm House on Peacock Island", painting by Carl Blechen, 1832

Klein-Glienicke Palace

On a hill gently sloping towards the River Havel, Prussia plays at being Italy. The country seat with a southern feel was created by Schinkel in 1825–1828 for Prince Carl von Preußen, who had just returned from his grand tour to Italy. The palace, formerly the farming estate of State Chancellor Karl August Prince von Hardenberg, was given a summery-carefree aspect by the master of neoclassicism. The two-story, angled main building as well as the Cavalier Wing and the Court Ladies' Wing, both attached by 1829, enclose an Italian garden courtyard with a fountain. The antique artifacts attached to the walls had been brought home by the prince returning from his travels. The front of the castle – with balcony, wide free-standing staircase and garden terrace – is accentuated by a big fountain flanked by two gilded lions; it was designed by Schinkel after a model in the Villa Medici in Rome. To the north of the complex lies the courtyard of the carriage house that today houses an elegant restaurant; on the banks of the Havel sits the ochre-colored casino in the style of an Italian villa with pergolas. The park, 116 hectares large, was divided by Lenné into three sections, according to the English principle: into flowerbeds, pleasure grounds around the castle and a spacious "landscape" that has northern European nature change into an "Alpine" scenery and finally into Mediterranean regions. Ludwig Persius designed

suitable buildings for them, the Sailors', Gardeners', and Machine Houses. On the southern border of the palace grounds, Schinkel created two vista points, a graceful Tea Pavilion and a round temple designed after the Monument of Lysicrates in Athens; its roof rests on Corinthian columns. The master builder himself gave them names in the manner of high Romanticism: Small and Large Curiosity.

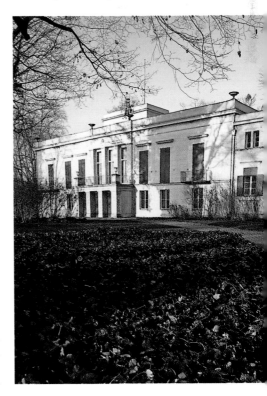

Babelsberg Palace

North of the city of Potsdam and directly facing Glienicke rises Babelsberg Palace. Down the slope towards the Havel, Prince William, the future king and first German emperor, had a summer seat installed in 1833. Schinkel designed the palace in the style of English countryseats. Imitating Tudor style models, he created a picturesque arrangement with a polygon shaped like a tower as principal building; it is equipped with oriel windows, battlements and counterforts that look like turrets, as well as an arcade. Large ogival windows strung closely together grant charming views of the landscape. The master builder and Princess Au-

gusta, the prince's spouse, repeatedly had differences of opinion. The princess wanted a lavish décor; Schinkel designed measured Gothic forms. His successor, Ludwig Persius, likewise had to submit, if reluctantly, to the princely desires. Only Johann Heinrich Strack met his client's wishes on the level of taste. In 1844–1849, he enlarged the palace with an annex capped by a tower; its octagonal ballroom was two stories high. The facades were adorned with small towers, oriel windows and other decorative baubles that lent the ensemble the appearance of a medieval castle. The interior looks Gothic as well; it is decorated with stellar vaults and the walls are painted in the Old German style. Lenné designed the park as an English garden. In 1843, Hermann von

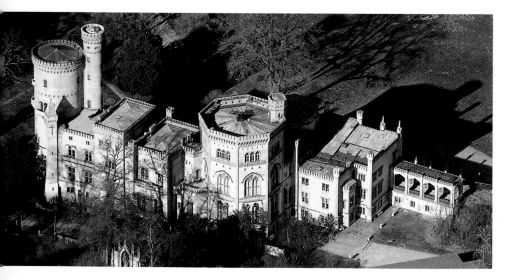

Babelsberg Palace, contour engraving by Ferdinand Berger after a drawing by Schinkel, from: K. F. Schinkel, "Sammlung architektonischer Entwürfe", 26, 1838 (Collection of architectural designs)

Pückler-Muskau took over and redesigned it in his own style. He installed panorama pathways with theatrical lines of sight. Integrated into the landscape are diverse ancillary buildings, the kitchen building (1844–1849, Johann Heinrich Strack), the machine house on the shore of Glienicker Lake (1843–1845, Ludwig Persius), Flatowturm on the hill (1853–1856); and the sailor house (1842), which copies the façade of Stendal City Hall. A special attraction is the Court Gazebo from Berlin's City Hall, dating back to the 13th century – one of the oldest architectural artifacts of the Hohenzollern residence. When the Rotes Rathaus was constructed in the city, it was removed and transported to this site in 1871/72, as a morning gift for the landlord, the freshly crowned Emperor.

Walking Tour: Ritzy

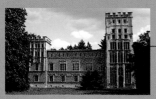

Cavaliers' House on Peacock Island

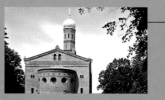

Sts Peter and Paul

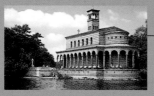

Church of the Holy Redeemer

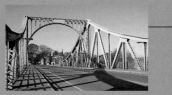

Glienicke Bridge

Babelsberg Palace

Klein-Glienicke Palace

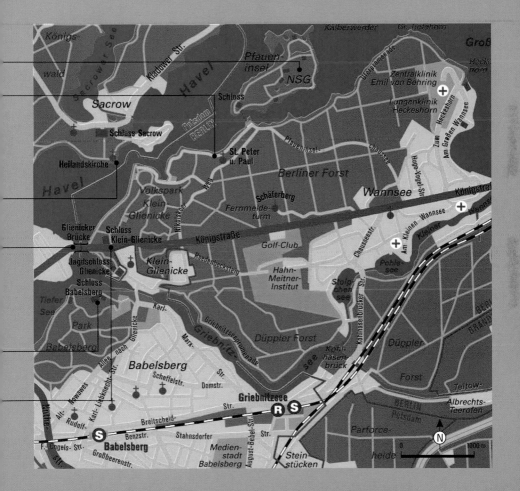

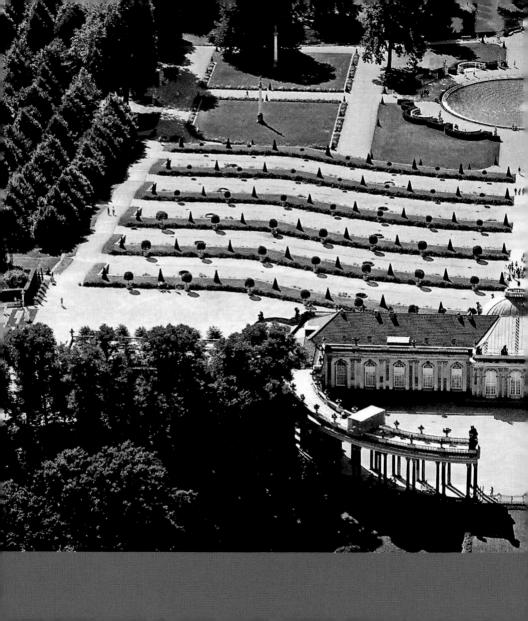

Potsdam

Potsdam

Sanssouci Palace

Surrounded by canals and numerous lakes, the city on the River Havel was the second residence of the Prussian kings and the German emperors. Even though World War II bombs badly damaged the historical city center and demolition madness by GDR urban planners destroyed all over again what was still standing, Potsdam today is regaining its baroque aspect not only in the Dutch Quarter and the Russian Colony, but along the lengths of entire streets. Magnificent villa districts at the edge of parks and lakes testify to the former splendor of this royal city. Above all, what has survived is Potsdam's unique ensemble of palaces and large parks; starting in the mid-18th century, it was created by Prussia's most important landscape architects, master builders, painters, and sculptors. In 1990, UNESCO declared the entire artistic and natural landscape of Potsdam a World Heritage Site. It includes the wide parks of Sanssouci, the New Garden, Babelsberg Palace, Glienicke, and Peacock Island. This is Prussia at its best. While standing in Palermo, Crown Prince Frederick, son of Wilhelm I and the future Emperor Frederick III (1831–1888), unselfconsciously came to the conclusion: "Actually everything looks like Potsdam." He had a point.

A bungalow as royal palace that can make do with twelve rooms. Since it was entirely tailored to his needs, Frederick II gave it a name suited to a villa meant for his private purposes, "sans souci" – "without a care." It was the view across the Havel landscape, suggestive of the woods and lakes of the Rheinsberg region – the idyllic place where he spent his years as a crown prince – that determined the selection of this location for his summer residence. Originally, a vineyard was created at this site based on

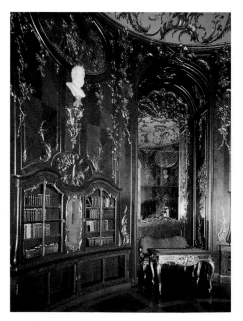

Below: Library in Sanssouci Palace – right: colonnade of columns at Sanssouci Park

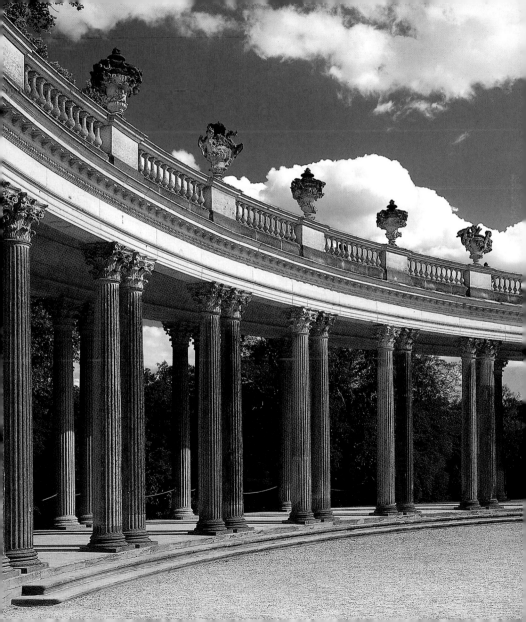

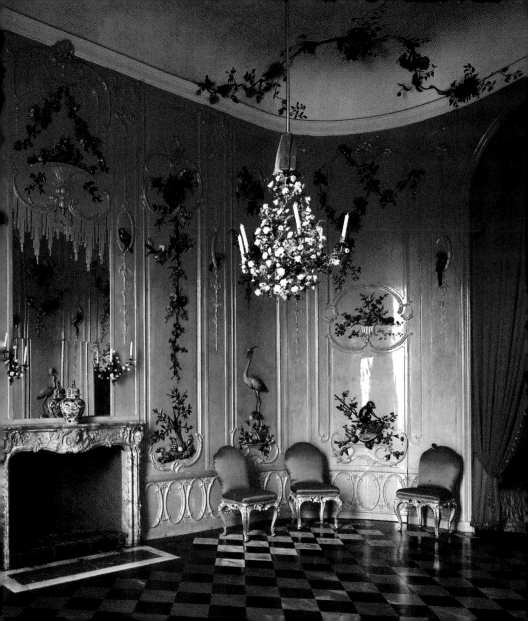

the king's designs: "No sunbeam may idly and lazily sneak past" – so it was declared by royal command. Its six terraces are bent, describing concave curves; not only wine but also peaches and figs were thriving inside glazed niches. In 1745, Frederick II assigned Georg Wenzeslaus von Knobelsdorff, who also created the 290-hectares large park, to build the vineyard palace in the style of French Rococo; the palace was based on the king's own ideas and completed in only two years. The southern façade is designed as a feast of Rubensian physicality. Between the long windows that extend down to the ground, pairs of Bacchantes made by Court Sculptor Frederick Christian Glume support the frame in the form of caryatids. The north side, where a semicircular colonnade encircles the court of honor, bears a more serious aspect. Frederick outlined the layout of the interior rooms of the palace with a ground plan. The center consists of two halls; adjacent to them are the king's apartments, "pour le roi," to the east; the guestrooms, "pour des étrangers," lie to the west. Even the interior décor was determined by the viticultural motif, "Wine." Even the vestibule, subdivided by ten Corinthian columns, is adorned by reliefs showing turbulent scenes from the myth of Bacchus. Golden ornaments with wine leaves and grapes are showing off their splendor on the wing doors. In the elliptical marble hall, three French doors lead out into the vine-

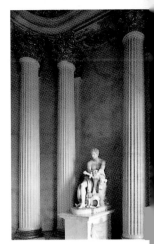

yard. Like a miniature Pantheon, the room is crowned with a cupola opening up to the skies. On the cornice are allegories of the arts accompanied by learned putti. In the concert room – one of the most beautiful rooms of German Rococo – the favorite motif of the epoch, the Rocaille, celebrates veritable victories on walls and ceilings. Decorative ornaments composed of shells, leaves and vines twirl around paintings on the walls by Antoine Pesne that present scenes from Ovid's *Metamorphoses*. After the death of the king in 1786, the study and bedrooms were remodeled by Friedrich Wilhelm von Erdmannsdorf in the neoclassicist style. By contrast, decorated with flowers, fruits and animals, the most beautiful of the guestrooms is kept cheerfully naturalist; it is named after Voltaire even though the writer and philosopher did not live here but in City Palace. Frederick the Great lived in Sanssouci for 39 years. It was his wish to be buried there as well – in a tomb on the uppermost vineyard terrace, next to his favorite dogs. His wish was answered – even though it took until 1991 to do so.

Left: Voltaire Room in Sanssouci Palace –
right: vestibule in Sanssouci Palace

Chinese Tea House

An idea of the king: a picnic in the middle of the park. Ladies and gentlemen camped out under palm trees and drinking tea. People play music and prattle away; a tent-like roof protects them from the sun. To make the scene visible from afar, everything is dipped in gold. Located in the park about 700 m southwest of Sanssouci Pa-lace, the Chinese Tea House carries Rococo playfulness to extremes – as it does the China craze that had infected courtly culture all over Europe in the 18th century. Johann Peter Benckert and Johann Gott-lieb Heymüller created this bizarre staffage "à la chinoise." That the sculptors were not quite able to get the Far Eastern facial features right was probably the fault of the models, who were procured from the im-mediate vicinity. Johann Gottfried Büring

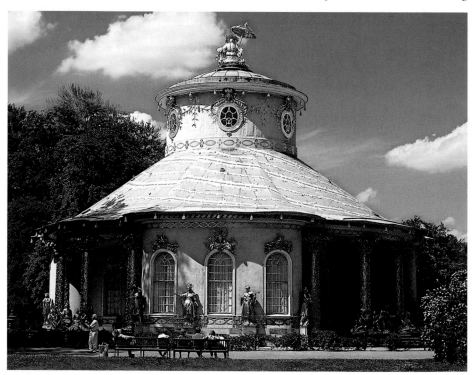

built the pavilion on a clover-leaf ground-plan in 1755–1764 on the order of and after sketches by Frederick II. The walls of the interior are adorned with golden consoles which display 18th century porcelains. The large ceiling painting shows an exuberant Chinese society in the illusionist manner. The walls of the small rooms are covered with silk wall hangings; mirrors decorated with opulent floral wreaths gleam down from the ceiling. The original furniture has not survived. The tambour on the roof is crowned with a gilded Chinese figure holding an open umbrella. Originally conceived as ornament for the flower, fruit and vegetable garden, the pavilion was later spotlighted by Lenné as a visual focus in the spacious landscape garden. Likewise borne along by the Chinoiserie fashion, Büring, in 1763, built a kitchen building (later remodeled) a small distance away from the Tea House, which supplied guests of the pavilion with provisions. What was thus conceived as decorative garden architecture, also occasionally served as exotic backdrop for smaller festivities. Another structure created under the

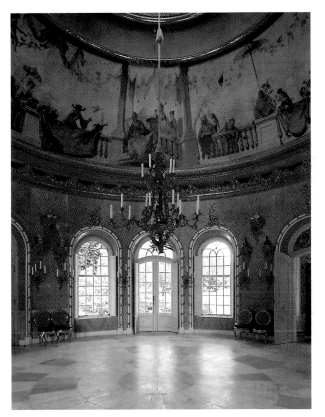

influence of Chinoiserie was the Dragon House, situated on Mount Klausberg, a hill on the northern border of the park; it was built in 1770–1772 by Carl von Gontard as a small Chinese house, in the form of a Chinese pagoda. It served as residence for the vintner who took care of the local vineyard. Today, it is home to a café.

Belvedere on Mount Klausberg

The vista tower stands like an exclamation mark on Mount Klausberg; it is the final architectural deed done in Sanssouci by Frederick the Great. True to its name, the views from Belvedere are panoramic, taking in the hilly landscape and the city of Potsdam. Georg Christian Unger designed the vista point in 1770–1772 as based on the king's desires. His model for the two-story building with two balconies and a crowning cupola was a drawing by Francesco Bianchini that showed Nero's Marcellum in Rome. Burnt down during the final days of war in 1945, the gutted structure was rebuilt in an exemplary manner until 2002. Inside, the upper room is ablaze with late Friderickian splendor; its walls are covered with delicately green celadon and its cupola contains the reconstructed bird painting.

The first Belvedere in Potsdam set an example that encouraged imitation. Barely hundred years later, the Belvedere on Pfingstberg was built by Ludwig Persius and Friedrich August Stüler as a twin-tower structure in the style of an Italian Renaissance villa.

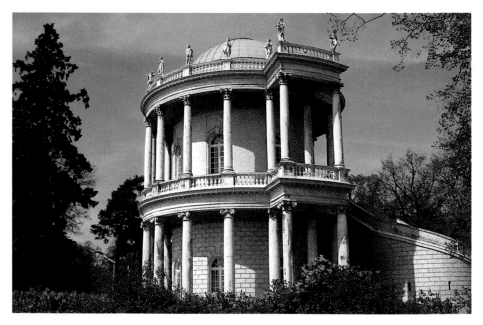

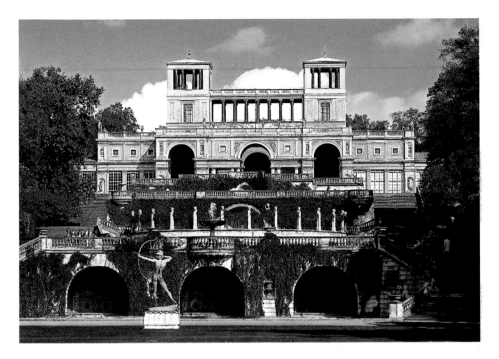

Orangery

It is an homage to the Renaissance palaces of Tivoli and Florence: Crown Prince Frederick William (IV) drew up the first outlines in 1830 under the impression of his travels to Italy. In 1840, he initially commissioned Ludwig Persius to do the designs; then Friedrich August Stüler took over, until Ludwig Ferdinand Hesse completed the building to the north of Sanssouci in 1864. While the central tract with its twin towers remained true to the king's design that was patterned on Villa Medici in Rome, the corner buildings quote the Uffizi façade that faces the Arno River. The imposing ensemble composed of Plant Halls and central Orangery Palace, including sculptures, arcades and terraces, is an impressive example of the power exerted by a single fixed idea – an idea called "Italiensehnsucht," the longing, or nostalgia for Italy. And yet, the Orangery in its balanced proportions and monumentality radiating out into the park does exhibit a measure of independence. More than 300 m

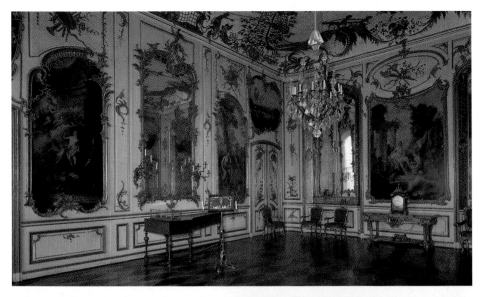

gallery. High-quality artisanship is also evidenced by the inlaid floors, for example in Grotto Hall, also called Shell Hall, and in the Princes' Quarters, where the parquet floor plays up its fantastic trompe-l'œil effects. The theater in the southern main wing is one the few palace theaters in Germany still in use today that have survived from the 18th century. Diverging from the traditional design of Italian box-style theaters, rows of seats are arranged in a semicircle similar to classical amphitheaters. Therefore, there is no Royal Box either. The king would customarily sit in the third row at eye-level with the actors.

Above: Concert Room in Sanssouci Palace – below: detail of wall décor in Grotto- or Shell Hall at Neues Palais/New Palace

Frederick II and the Craft of Applied Arts in Prussia

by Jeannine Fiedler

Frederick William I (1620–1688), great grand-father of Frederick II, is considered the first important sponsor of applied arts in Mark Brandenburg. He saw himself confronted with the task of a lifetime since he had to rebuild his country after the devastation caused by the Thirty Years' War. In order to compete with the magnificent dynasties of other German courts, but also to avoid the costly import of luxury items from France or Italy, he invited diverse craftsmen from all over Europe to settle in Brandenburg through pronouncing his Edict of Potsdam in 1685. The very existence of the religious community of the Huguenots, who had been expelled from France for their faith, was secured by this call. There were many industrial craftspeople among the 20,000 or so Huguenot refugees; with their industrial skills and business sense, they reenergized Brandenburg's industries, above all its once flourishing textile

"Flute Concert of Frederick the Great," by Adolph von Menzel, 1850/52, oil on canvas, 142 x 205 cm

workshops. During the next 100 years, Berlin artworks from tapestry workshops and silk weaving mills under Huguenot management or from Prussian furniture, silver and porcelain manufactories were among the most magnificent in Europe, and those of the highest quality. They may have graced the palaces in the royal cities of Potsdam and Berlin, but the regent also cared for the people by encouraging the mass production of inexpensive commodities, since their fabrication supplied them with jobs. Due to his pragmatically circumspect and reformist policies, which paved the way for Prussia's rise to the status of a major power and which secured a place for the Hohenzollerns among the leading dynasties of the Old World, Frederick William I was also called the Grand Elector.

Under his son, Frederick I (1657–1713) who became king in Prussia in 1701, the new royal representation was deemed of great importance. As for most of the European sovereigns during the period of Absolutism and High Baroque, Frederick I's model was France's Sun King Louis XIV. Industrial arts in Prussia thrived remarkably and – in the service of the monarch – kept supplying palaces and manor houses with the finest luxury commodities. King Frederick William I (1688–1740), son of Frede-

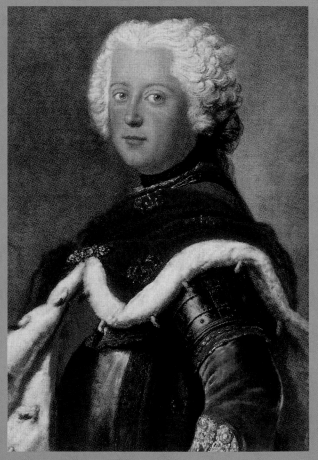

*"Frederick II as a young man",
painting by Antoine Pesne*

rick I, however, did not take to applied arts at all. Except for a purely economic interest in stock materials such as sheep's wool, which could be produced even by Prussia that was so poor in raw materials, his main attention was focused on the art of war and the creation of an army fit for battle. Since the Soldier King did not spare even his own son from hard military exercise, Frederick II (1712–1786) thought the fulfillment of his royal duties an "abominable craft." He was called Frederick the Great even while he was still young; and Prussia owed him enormous territorial gains that were possible only through his military tours de force during the three Silesian Wars. Thus, as a result of his conquest of Silesia and West Prussia, the surface of the empire almost doubled in size; furthermore, the development of new provinces as well as repeated mobilizations also led to an economic expansion. But the heart of the sensitive Prussian king – who had many artistic talents, composed and played music, and engaged in literary and philosophical pursuits – was in the arts: "Nothing bestows on an empire more splendor than the arts that flourish under its protection," such was Frederick's conviction as a crown prince; it also put its mark on his activities as a monarch.

Frederick II and Voltaire – wood engraving (1857), after a drawing by Wilhelm Camphausen, from: F. Bülau, "Die deutsche Geschichte in Bildern," Dresden

During the course of his 46-year-long regency, the arts and crafts experienced an unparalleled boom; they allowed Prussia to catch up with the major powers of its time and to even surpass them in the areas of education and the sciences. Be it with respect to the construction or remodeling of his palaces – above all Sanssouci Palace and the New Palace in Potsdam; or the interior decoration of his suites, from the "foot wall paper" (the rug) to the silk brocades of his wall coverings, to the décor of the stucco works on walls and ceilings; be it with respect to furniture, silk fabrics, porcelains, or silver and golden dishware that was traditionally melted on the occasion of new coronations to be redesigned and recrafted to suit the tastes of the new potentates or to make it compatible with new fashions; or be it

Frederick the Great and Voltaire, photo engraving after a gouache, c. 1900, by Georg Schöbel

even with respect to the art of building vehicles, which required skills in many crafts, and which therefore was especially sponsored by the king as a luxury trade that helped support the institution of domestic industrial arts: Frederick always advised his friend and Court Architect Georg Wenzeslaus von Knobelsdorff by sharing with him his own ideas, sketches and outlines; he also advised architect and decorator Johann August Nahl on interior design; and the outstanding cabinet-makers Heinrich Wilhelm Spindler and Johann Melchior Kambly, as well as sculptor Johann Michael Hoppenhaupt, the Elder, on royal carriages. This epoch, so influenced by royal inspiration and fantasy on the level of style, has not been called Frederickian Rococo for nothing. The graceful lightness of décor with delicate color values, the playful naturalness of plant and animal representations, the elegant grace of furniture and mirror compositions made from choice materials such as tortoiseshell, mother of pearl, ivory, cedar wood, and silver- or gold-plated sculptured fittings – this is what bestows on the epoch its Prussian radiance, and what bespeaks the signature of Frederick the Great. Among his favorite penchants was the collection of precious snuffboxes that were his steady companions on his travels or even on his forays into the battlefields of war. He left behind 300 of these precious objects that include magnificent tobacco boxes made from his favorite gemstone, the greenish Chrysopras, which are among the most valuable. But his greatest pleasure was the development of his Königliche Porzellanmanufaktur (KPM, Royal Porcelain Manufactory). Financed by his own

privy-purse, Frederick bought the manufactory from the insolvent Berlin entrepreneur Johann Ernst Gotzkowsky in 1763 for 225,000 thalers. Out of admiration for the famous Meißen Manufactory in the Kingdom of Saxony, a serious competition developed for the most valuable and best results of this noble material, which was often decided in favor of KPM. For this project, as well, the king was not only the "best customer of his own manufactory," but also an enthusiastic designer of his porcelains whose technical production he studied meticulously and on which he commented most knowingly. – In his tolerant state, everyone was to be "happy after his own fashion," thus went another motto of the "Old Fritz." During the decades of his reign, Prussian artisans became quite wealthy after the fashion of their king, famous, too, and maybe even happy.

Holländisches Viertel (Dutch Quarter) on Mittelstraße, photograph, 1912

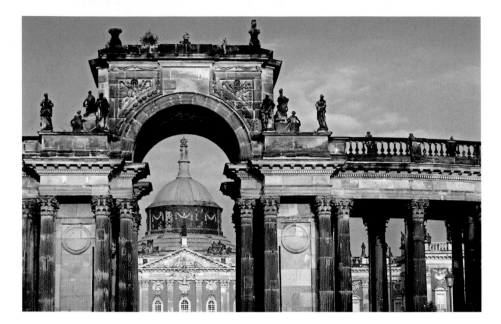

The Communs

In no way do the opulent twins opposite New Palace lag behind the main building in terms of magnificence. What looks like a twin palace is no such thing in reality – this, too, then is a "Fanfaronnade." The kitchen and utility rooms were housed there, as well as the servant and royal household quarters – the so-called Communs. The buildings were connected to the main residence by a subterranean tunnel. Besides serving practical purposes, they also provided a forceful counterpart to the palace – and they served as architectural backdrop, to conceal the wasteland lying beyond. The two Communs, which resemble villas built by Palladio, are linked by a colonnade decorated with Corinthian columns and an Arch of Triumph in the center. Originally designed by French master builder Jean Laurent Legeay, Gontard took over the design and was also in charge of construction 1766–69. After 1830, the northernmost of the two buildings was turned into the fanciest barracks building of the Prussian state. Today, it houses Potsdam University, which also occupies its southern pendant and the buildings lying to the rear.

Mount of Ruins

The 73-meter-tall "Ruinenberg" owes its name to the artificial ruins assembled on its top. Frederick II had a water reservoir installed there to supply the fountains and greenhouses of Park Sanssouci. Since the hill lay within the line of sight of the palace, he commissioned Knobelsdorff to beautify the view by means of a landscape of ruins, as had become fashionable at the time in England. The architect along with Innocente Bellavite, an Italian painter of stage décor, used stone to build the theatrical props: a round temple with a domed roof that had caved in; a high, curved wall resembling the Roman Colosseum and four Ionian columns. In 1845, Frederick William IV, who valued vista points very highly, added the 23-meter-tall Norman Tower – the only one to be destroyed during the war but now reconstructed. The installation, by the way, did not satisfactorily perform its assigned task during the times of Frederick the Great. Only once, on Black Friday in 1754, was the fountain in front of Sanssouci Palace to have spouted upwards. After that, never again. Only when the Steam Engine House was built in 1841, did the water reservoir live up to its purpose on Mount of Ruins.

Charlottenhof Palace

"The sky today was not more beautiful by a single hair than between Zehlendorf and Steglitz." So wrote Crown Prince Frederick William (IV) from Brescia to his "Most Beloved Angel" in Potsdam, Elisabeth of Bavaria. What was lacking under domestic skies for him to be "as happy as in Italy," he dreamed up and designed himself and then had Karl Friedrich Schinkel set up in Park Sanssouci: a summer residence after the model of Roman villas. The construction goes back to a one-story farming estate built by master builder Büring in 1756, which Schinkel, in 1826–29, transformed into a neoclassicist gem by adding forms from the architectural repertory of Antiquity – an open, Doric portico, a pergola and a terrace. He was helped

The Tent Room, designed like a tent and covered with blue-and-white drapes, was the court ladies' and guests' bedroom in Charlottenhof Palace.

by Peter Joseph Lenné, who conjured up an English landscape garden out of the terrain that had hitherto been used for agricultural purposes. He allocated geometrically designed gardens to the castle, which stretch from the Machine Pond across the Rose Garden and Poets' Grove, with busts of Italian and German poets, all the way up to the Hippodrome, created in the 1930s. The bourgeois and neoclassicist elegance of this small summer residence is celebrated just as much in its interior. To the left and the right of the vestibule and dining hall are nine small rooms resembling bourgeois parlors. Simple, downright parsimonious, are the furnishings designed by Schinkel. The more exuberant are the colors. The luscious red on the wing doors and the transparent sky-blue on the dining room

Vestibule with fountain in Charlottenhof Palace

walls let us forget all austerity. The ladies of the court and the guests slept in a pavilion room with blue and white stripes, which appeared just as novel as the window shutters painted in Bavarian country colors that alluded to the crown princess' ancestral provenance. Humboldt was a guest for five summers and is said to have written there the lion's share of his magnum opus, the *Kosmos*. Up to the present day, Charlottenhof has been furnished mostly the way it had been when it was inhabited by the crown prince couple in 1830. It is the only one of Schinkel's works to have survived intact. Surrounded by the likewise preserved garden landscape by Lenné, it is neoclassically beautiful.

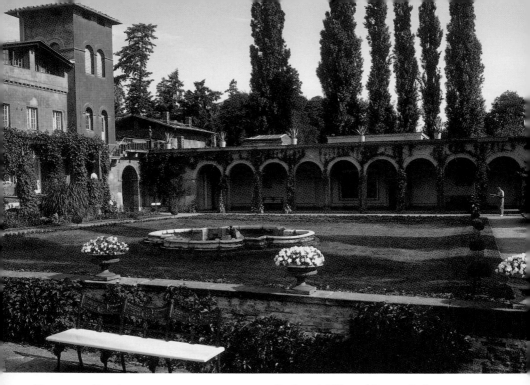

Roman Baths

*Gardener's Villa and Roman Baths
in Sanssouci Park*

Italy seems on the threshold once again: Charlottenhof Palace was still under construction when the first designs for the Roman Baths were made in 1829. And once again, the seasoned designer team was composed of Schinkel, Lenné and the builder, Crown Prince Frederick William (IV), to which later was added Schinkel's student, Ludwig Persius. What they produced was to be trendsetting, on a stylistic

level, for Berlin and Potsdam villa architecture for the next 100 years. Several loosely but meaningfully related buildings compose a picturesque ensemble, which is most beautifully reflected by the adjacent Machine Pond that was installed to feed the fountains. Florentinian villas from the 15th century and Sicilian farmhouses with simple forms, flat roofs, towers, balcony platforms, and loggias acted as god-

fathers. The so-called Italian Villa, residence of the courtly gardener, was joined in 1830 by an antiquitizing little temple by the water, the Tea Pavilion. Two years later, the small gardening assistants' house and the large entrance arbor were added, as well as the arcade hall which served as Orangery.

The actual baths, constructed by Ludwig Persius in 1834–1836, consist of the Atrium and Thermae Hall and are furnished in the Pompeian style. The interior is lavishly de-corated with marble and pewter statuary. The first room is adorned with two sculptures, Dionysus and Apollo, as well as a bathtub made from green jasper – a gift of Russian Czar Nicolas I. The interior open-air courtyard, or Impluvium, is visible through an opening.

Today, the Gardeners' House of the Roman Baths hosts traveling exhibitions on the former builders of Sanssouci and the multitude of epoch-making artists who helped Prussia attain its architectural wealth.

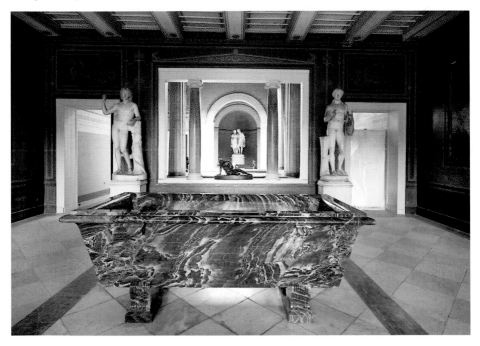

Atrium of the Roman Baths in Sanssouci Park, design by Karl Friedrich Schinkel, 1826

From Louise to "Dona" – Prussia's Queens

by Holger Möhlmann

She was the "Prussian Madonna," the "guardian genius of German affairs" and a model for the 19th century German woman: Louise of Mecklenburg-Strelitz (1776–1810), Prussia's most famous female royal. In a poem written in 1798, August Wilhelm Schlegel even calls her the "Queen of Hearts" – 200 years before Lady Diana. No other Prussian queen has been the subject of so many books; no one but her was made the starring character of a movie. There are many reasons why the young princess – who was married to future Frederick William III in 1793 – became such a myth: Louise was beautiful, graceful and sensitive. She was considered akin to the people, and she truly loved her husband. She lived in Prussia during its darkest epoch yet: the period of the French occupation that began in 1806. Her life was full of events that contributed to the legends created about her: her flight to East Prussia in the dead of winter, her pilgrimage to Tilsit to appeal to Napoleon. And last not least, it was her early death that idealized the young queen by transforming her – who had been in favor of the war with France and who had sacrificed herself for her humiliated country – into a tragic figure of light. Her subjects thought her a martyr; the German Empire, founded in 1871, made her a

Queen Louise of Prussia, painting by
Gustav Richter, 1879, oil on canvas, 243 x 151.5 cm,
Wallraf Richartz Museum, Cologne

national icon; male members of the ruling cast adored her as the ideal woman. Louise was considered a patient sufferer in the service of husband and fatherland. The countless Louise Schools and Louise Associations springing up all across the empire were thus not only to honor the memory of the deceased, but above all to educate contemporary girls so they would turn into virtuous women in the mold of Louise. As much as William I – who became king in 1861 and emperor in 1871 – encouraged the cult that had grown up around his mother Louise, as little did he get along with his own wife – because Augusta of Sachsen-Weimar-Eisenach (1811–1890) was anything but a quiet sufferer. "Feuer-kopf" (spitfire) – so did William call his quarrel-some spouse who interfered uninvited in affairs of the state and who insisted on telling her hus-band her opinions, even when they were cate-gorically different from his own. In contrast to idealized Louise, that is, Augusta was a true pacifist whose political penchant was for the West and who desired a liberal German Empire along the lines of the English prototype. Brought up at the enlightened and art-minded Wei-mar "Musenhof" (the Court of the Muses), she thought Spartan and army-enamored Berlin her "purgatory." Augusta established important charitable societies, but she was never loved as a popular mother to her country – because in spite of her many modern ideas, Augusta was distant and cultivated an appearance marked by majesty and ceremony: "She was 'the Em-press' even unto death" – thus wrote Victoria, her daughter-in-law, about Augusta who lay in state, "and surrounded with all the pomp and pageantry that she loved so much."

Empress Augusta, after a painting by Franz Xaver Winterhalter, c. 1850

Victoria of Sachsen-Coburg and Gotha (1840–1901), princess of Great Britain, who had married Frederick, the Prussian crown prince, in 1858, seemed to have a lot in common with her pre-decessor, at least at first sight. Vicky, as Queen Victoria called her highly talented, eldest daugh-ter, likewise advocated with all her might for a liberal Germany. But the progressive forces fell behind no later than by 1862, when Bismarck

Empress Auguste Viktoria, photograph, 1914

assumed his post as Prussian prime minister, and the crown princess was isolated even within the imperial family. She and the conservative emperor were poles apart, while Augusta, so intent on preserving social appearances, had little use for Vicky who was not interested in ceremony. A large part of the population was in any case suspicious of "the English woman" – she was suspected of caring too much for the interests of her country of origin. Relegated to the sidelines, both on the level of politics and the family, the crown prince couple led a life at the fringe of the court. When William I died in 1888, his son's cancer of the larynx had advanced to such a stage that he survived his father by a mere 99 days. Henceforth, his widow called herself Empress Frederick. "Standing above most of the women of her time in terms of intellect and noble will, she was the poorest, unhappiest woman who ever wore a crown" – these words were written by Vicky's son, Emperor William II. His wife, Auguste Viktoria of Schleswig-Holstein-Sonderburg-Augustenburg (1858–1921), was the exact opposite of her mother-in-law: While Vicky had political ambitions and often criticized her imperial son, Dona, as Auguste Viktoria was called in the innermost circle of her family, was content with playing the role of a loyal wife and a mother of six sons and a daughter. Never once did she criticize the emperor. She had next to no interest in politics, indeed, never even read the paper, and instead dedicated herself wholeheartedly to her children. Even though this mindset of hers made her agree with the erstwhile ideal of womanhood, by no means did it net her anything but friends: Dona was "just like a good, quiet, gentle cow who calves, slowly eats her grass and chews the cud" – such was the verdict pronounced by a lady of the court who thereby spoke for all of Berlin's noble society who could not reconcile themselves with their staid empress. The common people, however, took very much to Dona, especially since she was able to combine her charitable activities with a very personal style of empathy. Though neither Auguste Viktoria nor her two predecessors became a legend. Prussia's most important and legendary queen was and remains Louise, or better: the woman she was thought to be.

*Detail of the painting
"Crown Princess Victoria,"
by Heinrich von Angeli
(1874), oil on canvas*

Marmorpalais

It is apparent at first sight: The palace built on Heiliger See and but a short walk from Sanssouci by Frederick II's successor, shortly after his assumption of office, is an architectural novelty. With its construction, builder Frederick William II blazed a trail for neoclassicism in Prussia. Designed by Carl von Gontard and built of red brick in 1787–92, the Marble Palace is a two-story building laid out on a square ground-plan. It owes its name to the decorative and structural elements made of gray and white Silesian marble that adorn its exterior façade. On the flat roof of the cube-shaped body of the building, to which were added two lateral wings, there sits a miniature Belvedere with the entire

New Garden spread out at its feet. Johann August Eyserbeck, son of the architect who designed the Dessau-Wörlitz landscape gardens, turned these grounds into an early neoclassicist/culture-of-sensibility landscape with lines of sight, hills and bizarre, architectural staffages that are composed directly into the landscape: Next to the kitchen building, constructed by Gontard in 1789 as an antique temple ruin sinking into the pond, Carl Gotthard Langhans and Andreas Ludwig Krüger created the Dutch Establishment, the Orangery with Egypticizing décor (1791), a pyramid serving as a cold room (1791), and the Gothic Library (1792). The architect of Brandenburg Gate also designed the interior rooms of the palace – but not by himself. Wilhelmine Encke, the king's mistress, who was made Countess Lichtenau in 1796, essentially contributed to the selection of furnishings, paintings, wonderful silk hangings in the king's apartments, Wedgewood chinaware in Concert Hall, and the wall décors all the way up to the reliefs by Johann Gottfried Schadow. Everything testifies to an exquisite taste and a pronounced sense for the pragmatic. The vestibule on the ground-floor opens up brightly onto the hall with the grand staircase that stretches upwards throughout the entire height of the building. As befits a summer residence, the adjacent dining room was designed as a cool grotto hall. The palace, always an intimate palatial structure, was recently restored. Repairs on the exterior are still in process.

Pomona Temple

Pomona Temple on Pfingstberg, 1800, watercolor over ink on paper, 13.0 x 18.4 cm

Basically, it is nothing but a small picnic pavilion. It was named after the Roman goddess of field crops, Pomona. That fit in with its setting, the southern slope of a vineyard, and with its owner, the daughter of Potsdam headmaster and wife of Privy Councilor Carl Ludwig von Oesfeld, who had this garden built for his spouse. Presumably for financial reasons, he commissioned a student of the Academy of Architecture, who was all of 19 years old. His name: Karl Friedrich Schinkel. Completed in 1801, Pomona Temple is the debut piece by the greatest architect of Prussia – and everything is already there: Antiquity, grace and austerity, precision and wit. Schinkel designs the little temple as a square room fronted by a hall supported by Ionian columns. The roof can be

reached by means of a staircase tower. On top of it sails a tent-roof with blue and white stripes. It has charm. From 1945 to 1990, Pomona Temple lay in inaccessible territory just next to the Soviet Army's "forbidden city" – and it deteriorated. Today, immaculately reconstructed, it provides radiant testimony to a private renovation initiative of the early post-*Wende* period.

Russian Colony Alexandrowka

Thirteen log cabins with carved wooden gables, artful ornaments and wooden balconies – up to the present day, Colony Alexandrowka has existed as a unique testimonial to Russian architecture outside of its country of origin. Its development commemorates a tragic chapter in Prussian-Russian history. After Prussia's defeat by Napoleon in 1806 and its subsequent compulsory alliance with France, it had to accept prisoners of war from Russia, even though the two countries had traditionally been linked in friendship. After the Liberation Wars and their joint victory over Napoleon, the former prisoners voluntarily stayed on in Potsdam and, as a sign of Prussian-Russian solidarity, were given a settlement; commissioned by Frederick William III, it was designed in 1826 by Lenné in the form of a hippodrome into which is em-

bedded a St. Andrew's Cross. In 1829, in memory of Czar Alexander I who had died four years earlier, as well as for the benefit of the Russian-Orthodox Congregation, a small cross-domed church was built by Schinkel on a hill above Colony Alexandrowka. Following an elaborate restoration, the church today again presents itself in its original pink and white colors and with five domes in typical Russian onion style.

Cecilienhof Palace

Cecilienhof became famous as the site of negotiations by the victorious Allied Forces in the summer of 1945. Harry S. Truman, Clement Attlee as successor to Winston Churchill and Josef Stalin were the signatories to the "Potsdam Agreement" of August 2, 1945, which determined the future of postwar Germany. The conference hall and study rooms of the delegations are open to visitors of the Potsdam Conference memorial site, as are the private apartments of the crown prince couple. A section of the palace is serving as a hotel. What looks like an English country manor is actually the last palace to have been built by the Hohenzollerns. Crown Prince William had it constructed in 1913–17 by Paul Schultze-Naumburg. Picturesque timber-frame buildings are grouped around five interior courtyards; they are of varying heights and decorated with projecting gables, gate buildings and ornamental chimneys. A large living room takes up the central area of the main building. The parlor and scriptorium of Crown Princess Cecilie are situated to its right; to its left lie the crown prince suite with smoking room, wood-paneled after the English model; the library; and a breakfast room styled like a garden pavilion that provides access to the dining hall. The upper floor contains bedrooms, a bath and a hunting room, as well as the "Marshal's Table", a second dining room where gentlemen sat down to dinner. Among the capricious peculiarities of the interior rooms is one room that the princess, who loved water and boats, had designed after her own wishes: a small room designed in the form of a ship's cabin and furnished with the original interior of an old imperial yacht.

The round table in the historic conference room at Cecilienhof Palace

Potsdam City Gates

The garrison town of Potsdam was once surrounded by fortifications that predominantly served as excise wall and to prevent soldiers from deserting or bootlegging. The wall linked the gates of the city, three of which still exist today. The Jägertor (Hunter's Gate), leading to the north, is the oldest; it was built in 1733. Its two pillars, made of plastered brick masonry, are connected by sandstone frames crowned by a group of sculptures. The larger Nauen Gate dates back to 1755 and constitutes one of the first examples of England-inspired Neo-Gothic architecture on the European continent. It guarded the way to the Dutch Quarter – to the present day, a showcase district made of brick; Frederick William I, the Soldier King, assigned Johann Boumann the Elder in 1732 to build it for immigrants from the Netherlands. After the Seven Years' War, Brandenburg Gate – facing west – was built. Frederick II had it constructed in 1770 by Carl von Gontard and Georg Christian Unger as a symbol of victory, which is why it resembles a Roman Arch of Triumph. Its model was the Arch of Constantine in Rome.

Brandenburg Gate in Potsdam designed by the architects Carl von Gontard and Georg Christian Unger

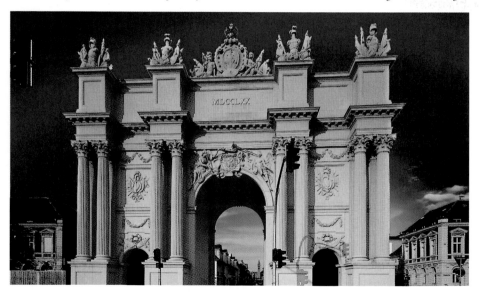

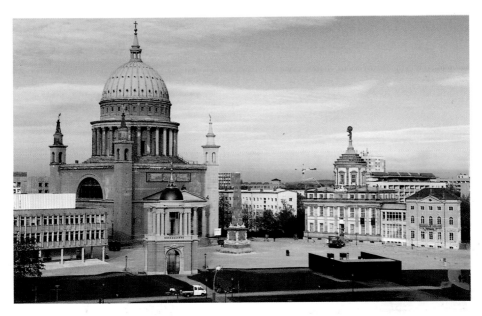

Old Market

There is not much left to show that, until 1945, the historical center of Potsdam was located between Nikolai Church and the developed waterfront at Alte Fahrt – once the representational focus of a royal residence city. Only Old City Hall, built by Johann Boumann the Elder in 1753–55 and outfitted with a Palladio-style façade, colossal columns and a dome, as well as Knobelsdorff's residence of 1750, were rebuilt after war damages; their reconstruction was started in 1960. Even the marble obelisk of 1753 was returned to its original spot in 1979 – though its form was modified. The Old Market used to be the site of City Palace, built by the Great Elector in 1664–70 and later repeatedly remodeled: Knobelsdorff, especially, began transforming it into a glorious Baroque structure in 1744. After being thoroughly gutted by a bombing raid in 1945, the ruined palace was demolished in 1959/60. Its Fortuna Portal, built by Jean de Bodt and dedicated in 1701 on the occasion of Prussia's elevation to the status of kingdom, was recreated to original specifications in 2002. The reconstruction of the palace façade for the new building that will house the Landtag is also a done deal. The entire square will be redesigned.

Marstall/Royal Stables

Across from the Old Market lies the only building of the palace ensemble to have survived both the war and the postwar periods, the former Marstall. Built in 1685 as an Orangery based on a design by Johann Arnold Nering, the Soldier King had the building transformed into the stable for his royal horses in 1714. It received its current shape in 1746 by Knobelsdorff. Above the portals, the dramatically animated groups of riders by Friedrich Christian Glume date from the same period. Since 1981, the Film

Museum Potsdam has its home in the Marstall. Less glamorous than its new counterpart at Potsdamer Platz in Berlin, it exhibits eight decades of Babelsberg film history from the Ufa and DEFA eras by means of costumes, original photographs and film clips, e.g., by Zarah Leander, Lilian Harvey, and Hans Albers. The focus of the collections lies on the film and cinema history of the Soviet occupation zone and the GDR, film art in Eastern Europe, children's films, and the history of German film technology. The in-house movie theater shows, e.g., silent movies accompanied by a 1929 Welte theater organ.

Pump House

It was common in the 19th century to copy foreign architectural styles. But only romanticists could get the bright idea of dressing up 81 horsepower as a mosque. The "Dampfmaschinenhaus" at Neustädter Havelbucht was created at the behest of Frederick William IV, who had it built by Ludwig Persius after the Moorish model "with a minaret for a chimney" in 1841–1843. The highest building in the region at the time, it most likely owes its elaborate design to its exposed position on the shores of the Havel, because it could be seen from the royal garden terrace at Sanssouci. Its interior concealed a technical subtlety: the strongest steam engine in Prussia, built by the as yet young entrepreneur Johann Friedrich August Borsig (1804–1854). Borsig was a German businessman who founded the famous Borsig-Werke factory in 1837. With assistance of the Dampfmaschinenhaus, water was pumped from the River Havel up to Mount Ruin to feed the trick fountains in the park and the main fountain in front of Sanssouci Palace. Fueled by steam power, the latter reached a lofty height of 38 m. Today, this task is carried out by electric pumps. The retired predecessor can be visited in its historical building.

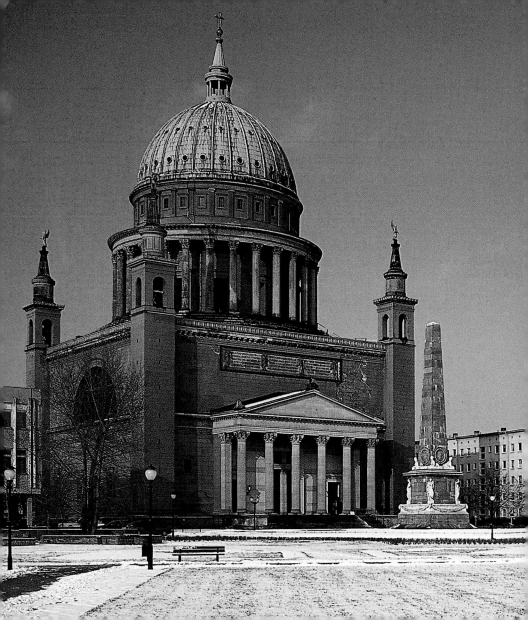

Nikolaikirche

Its dome has been dominating the skyline of the city of Potsdam up to the present day – it is an architectural marker often used by European cities to compete with Rome. Nikolai Church has its origins in a single-room church built in 1724 by Philipp Gerlach that burnt down in 1795. Its reconstruction was postponed until 1830. Schinkel designed a domed central structure that, above all, took its cues from London's St Paul's Cathedral, but at first outfitted with a flat saddle roof. Only in 1843, under Frederick William IV, did the church acquire its 78-meter-tall tambour cupola under direction of Stüler. The four corner towers were not envisioned by Schinkel but were considered necessary ingredients for reasons of load stability. While the original design of the external structure was faithfully reconstructed after the war, the interior was modified: the galleries supported by Corinthian columns were moved to the front by 2 m, to create space for additional rooms. The original interior ground-plan with a Greek Cross layout pattern is thus no longer recognizable after this modification.

French Church

No crosses, no baptismal font, no altar – Knobelsdorff designed the small central building reminiscent of the Roman Pantheon

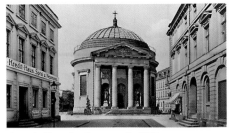

French Church, photograph, 1912

and St Hedwig's Cathedral in Berlin for the Huguenot congregation in 1752. Frederick II donated the completed church to the Potsdam Congregation on September 16, 1753 – the day its architect died. The façade is adorned by a Tuscan portico gable; the niches to the right and to the left of the entrance are decorated with allegorical statues by Friedrich Christian Glume. Illuminated by high lateral windows, the interior – resembling an amphitheater – is bare of church ornaments in compliance with the rules of the French-Reformed liturgy. After 1990, the almost entirely dilapidated building was restored and today it again serves as a House of God. The French Church is located on Bassinplatz, which obtained its name under Frederick William I. A water reservoir had been installed on this site in 1737–1739 that was to serve the drainage of the area and that was connected to Heiliger See through a canal. It was filled in starting in 1825. Since 1870, the square has been dominated by the Catholic church of St Peter and Paul, which was designed by Frederick August Stüler.

Walking Tour: Arcadian

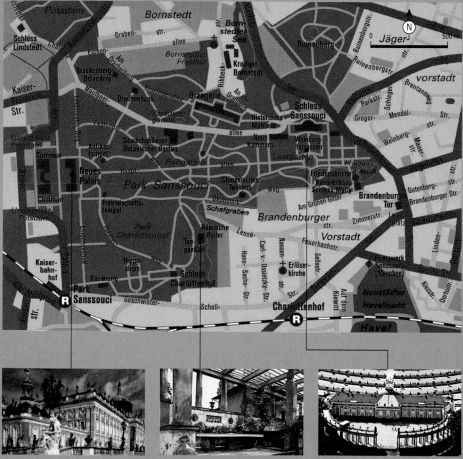

New Palace

Roman Baths

Sanssouci Palace

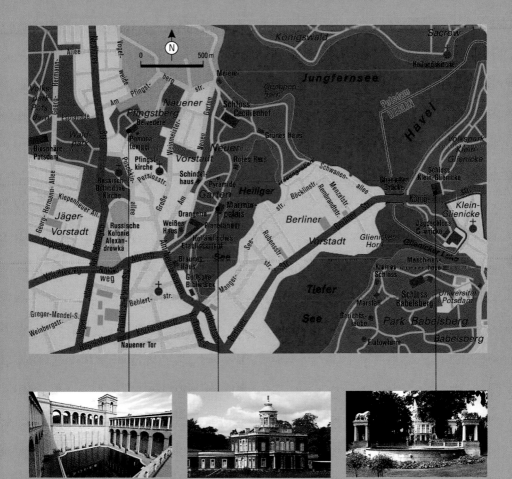

Belvedere

Marmorpalais (Marble Palace)

Fountain in Klein-Glienicke Palace

Coming from Berlin and driving towards Glienicke Bridge, we enter a different century. It is here that Prussian Arcadia begins, such as it was invented by Schinkel, Lenné & Co. Initiated by five generations of art-minded monarchs who were gifted with aesthetic taste and unusual artistic talents, the Havel landscape with its lakes, islands, hills, and woodsy coves were molded into an ensemble composed of gardens and parks unique in Europe. It is possible to comfortably explore them all on foot in the course of a single spring day. We enter the open-air museum of Prussia's nostalgia for Italy in the New Garden at the end of Schwanenallee. The view over the water is tantalizing. Spread out in front of the red-and-white cube that is the Marble Palace, Heiliger See (Holy Lake) looks like a stage set; soon, after the last tarps used for renovation have been removed, people will stroll down the stairs again towards the shore. The water is rippling; the crowns of mighty, old trees are rustling in the breeze. To our right lies Jungfernsee (Lake Virgin) — Holy Redeemer's Church and Peacock Island are outlined in the distance; in front of them, between the trees, rise the half-timbered gables of Cecilienhof, across from them sit the Green House and the Red House; behind them, like a spiritualist exclamation mark, stretches the tip of a pyramid, while the silhouette of Potsdam Tower on the left peeks out from among the greenery. And when we turn around on our own axis, we see the yellow pergola of Glienicke Palace flash delicately through the trees; Glienicke Bridge gleams silver in the sun. An idyll. The New Garden was the first romantic park, with which Frederick William II had "Empfindsamkeit," or the culture of sensibility, helped to come to power. But the Prussian-blue landscape is not only edible from down here. On the left, we can see our next stop from afar: the Belvedere on Pfingstberg. On our way over, we walk past a series of impressive palaces, among them the late neoclassicist Villa Henkel with its filigree tower arrangement and Schinkel's merry Pomona Temple. Frederick William IV's favorite structure rises up from the top — the highest spot in Potsdam. Lookout towers were especially important to this regent dreaming of

Pheasant House in Sanssouci Park

Italy, since only from them could the beautification of the landscape be surveyed in its entirety. The Belvedere made that eminently possible. Standing on top of its towers, we do not only have at our feet the island of Potsdam, the Roman dome of Nikolai Church, Telegraph Hill, Flatow Tower, Babelsberg, and Sacrow. When the weather is nice, we can see all the way to Alexanderplatz in Berlin. Leaving this airy height, our path leads down into shady shrubberies, past the old Jewish Cemetery and Alexander Newski Church on Kapellenberg, which is as much ablaze with red and white as

Friedenskirche (Church of Peace) in Sanssouci Park

are the blossoming apple trees at the Russian Colony Alexandrowka – an artifice not at all accidental that was created by Lenné who had an exemplary spectrum of fruit varieties cultivated at this site. So we are guided to the next great Potsdam park – to Sanssouci – by loosely distributed, prettily spruced up villas in the Italian country house style. At the end of Hegelallee, we take a right into Schopenhauerstraße; we can already see the "Roman" Arch of Triumph in the distance. More stops: Friedenskirche – the Church of Peace that is Persius' own Roman San Clemente set into Brandenburgian sand; the Sicilian Garden and the gorgeous Orangery. To those who would like to experience more southern flair, we recommend an excursion to the "Italian village" of Bornstedt

to see the Krongut (Crown Farming Estate), constructed in 1848 in the Florentine style, and the village church, remodeled in 1855 as a basilica with campanile. Arcadia's crown jewels await us on our way back to Sanssouci Park: Charlottenhof Palace and the Roman Baths. The best way to see these icons of Mediterranean sensibility is with our backs to the New Palace, after we've walked through the gate of the dairy farm. Large lawns are spread out, small groves are standing in picturesque groups, pathways are curvy as though scattered across the grass by a limber hand. Landscape and architecture seem to obey only one law: They seduce us into moving constantly so that we recombine the view into ever new scenes – in a realm built of dreams, in any season.

Appendix

Glossary

Apse (Latin; Greek hapsis, "connection, rounding, arch"): a niche, constructed over a semicircular or polygonal base and topped with a semi-dome; usually houses an altar. Choir room adjoining the main choir room or that reserved for the clerics; also known as the exedra. Small ante-apses are often located on the lateral or side aisles.

Arcade (French arcade, "candle arch"; Latin arcus, "bow [hunting weapon]"): a row of arches supported on one side by columns.

Architrave (Greek archein, to commence, master, and Latin trabs, beam): the main beam supported by uprights, e.g. columns, and which bears the weight of the superstructure. It may be devided into three horizontal sections.

Art Deco (French art décoratif, "decorative art"): collective term for the dominant artistic movements in applied arts, interior design, and small sculpture, especially in France, between 1918 and 1932. Originating from French "art nouveau," Art Deco reflects the increasingly technological environment with its geometric structures, symmetrical forms, sharp angles, straight lines, and bright colors. The use of expensive, luxury materials such as polished stones, fine woods, enamel, and chrome often meant that very few pieces were produced. The term comes from the "Exposition Internationale des Arts Décoratifs et Industriels Modernes" (International Exhibition of Modern Decorative and Industrial Arts) in Paris in 1925, but has only been in common use since 1966.

Art Nouveau: an international style movement appearing in the 1890s, known in Germany as "Jugendstil," in England as "Modern Style," and in Austria as "Sezessionsstil." As a defense against the widespread academic and historical tendencies of the 19th century (Neo-Romanesque, Neo-Gothic, etc.), it sought a link to the dynamics of the times in ornamental, plane, and linear forms with plant forms, such as flowers and leaves. Art Nouveau came to be applied to all areas of life, including architecture, the fine arts, and arts and crafts, the latter being given a position equivalent to art.

Atrium (from Latin "anteroom," "hall"): an open courtyard enclosed on three or four sides by an arcade or colonnaded walk and situated in front of the western end of a church. Atria often have fountains in the middle.

Berlin Block: an urban block of buildings cover-

Berlin Block in Wedding district

ing the entire construction depth (perimeter block development), typical of the Berlin Wilhelminian period (Gründerzeit); its defining characteristics are its special dimensions, plurality of backyards, and mixed uses.

Bel Étage, or bel-étage (French "beautiful story"): the main story of a stately home, where the reception rooms are located. It is usually above the ground floor. Smaller and more modest

buildings define the "beautiful story" as the area above the ground floor. In Italian the public first floor is called "piano nobile."

Capital (Latin capitulum, "small head"): head or topmost member of a column, pilaster, etc. Capitals are distinguished in terms of their decoration, for example stiff-leaf, bud, Gothic crocket, etc.

Classicism (French classique, Latin classicus "exemplary," "first-class"): the artistic period from 1750 to 1840, which adopted Classical antiquity (5th century B.C. to 4th century A.D.) as its model. In Prussia, its major phase starts in 1786 under Frederick William II.

Colonnade (French colonnade): row of pillars with a straight entablature without arches.

Column: load-bearing tapering structural element, usually circular in plan, which may be divided into a base (bottom), shaft (middle), and capital (top). Most names given to column types refer to the type of shaft, e.g., monolithic (made of one piece of stone), drum (constructed using drum-shaped sections of stone) or fluted (with vertical channels).

Cupola, dome (late Latin cup(p)ola "[upturned] small cask"): ceiling or roof form, vault on a circular, polygonal, or rectangular plan. The transition from the square plan to the circular cupola plan can be executed in the following ways: 1. by means of a sail dome, whereby the base of the dome circumscribes the square plan; 2. by means of pendentives, curved, almost triangular spandrels rising up from the four supporting piers to the circular or elliptical base of the drum or cupola; 3. by means of a hemispherical dome, which is like a sail dome but is used when the space to be domed is smaller than the square plan.

Tunnel vault

Groin vault

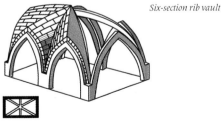

Rib vault

Six-section rib vault

Vaults

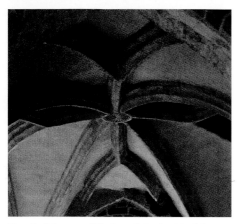

Detail of the net-ribbed vault in the "Gothic House" in Alt-Spandau

Eaves Height: since implementation of the Hobrecht Plan of 1862, eaves height in Berlin is 22 m, measured from ground to drip edge at the roof.

Enfilade (French, "succession"): a succession of rooms, the doors of which all lie on one axis, so that when open there is a view through all of the rooms. Developed around 1650 in France, the enfilade is a typical design feature of Baroque palaces and hotels.

Expressionism (French; expression, "expression"): art movement dating from the beginning of the early 20th century (the Fauves, Die Brücke [The Bridge], Der Blaue Reiter [The Blue Rider]), which was articulated primarily in painting and graphics, less so in sculpture. In a counter-reaction to the visual model of Impressionism, which had already been called into question at the end of the 1880s, and a reaction to Naturalism and Academism, the followers of Expressionism sought to intellectualize and objectivize, thereby eschewing a faithful reproduction of reality. Strong, undiminished colors that cannot be harmonized with natural coloring express a subjective view of reality, the visualization of that which is essential.

Fresco wall painting which is painted on the final layer of lime plaster before it dries.

Frieze (medieval Latin frisium "fringe," "tip"): painted or sculpted continuous strip-like horizontal wall decoration which is used to decorate, articulate, or enliven a wall surface.

Gallery: a space longer than it is wide and which has windows on one or both sidewalls. The gallery established itself as a room of ostentatious splendor in the French chateaux (Fontainebleau) in the 16th century. Upper corridors in theaters and churches, as well as open hallways and walkways are also called galleries.

Volute with an Ionic capital

Gothic (Latin gotico, barbaric, nonclassical): an architectural an artistic style of the Middle ages originating in northern France in about 1150. It lasted there until c. 1400, although it persisted elsewhere until the early 16th century. The term is derived from the Germanic tribe, the Goths. Specifically Gothic features in architecture include the pointed arch (which was broken in

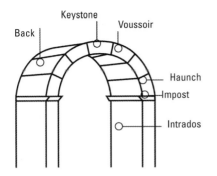

Arcade

the crown) and the groin vault (two tunnel vaults of the same size crossing each other at right angles), and the external addition of flying buttresses (arches and piers to reinforce the walls in absorbing the pressure of the vaults and the roof). The overall impression of Gothic buildings is their upward motion, and their segmented walls and windows. The ultimate Gothic building was the cathedral.

Historicism (Latin historia, "knowledge, history"): a concept of history that began in 1839 and understood every historical event in the wider context of what had gone before. In terms of art history, historicism refers to an artistic principle prevalent since the 19th century. According to this theory preceding phases in the development of art were consciously adopted in whole or in part and used in new ways.

Loggia (Italian): open roofed structure supported by pillars or piers, i.e., a gallery, arcade, or colonnade.

Mansard roof: (French) hip roof, the lower slope of which is steeper than the upper one. This makes it better for extensions, for instance, for

Two columns joined by an architrave

homes. It was named after the French architect François Mansart (1598–1666).

Mezzanine (Italian mezzano, Latin medianus, "middle"): a low intermediate floor or entresol where less important rooms are usually located. The mezzanine is above the ground floor, the main floor, or beneath the eaves. The mezzanine is a favorite design element in Baroque and Classical castle architecture that served, where appropriate, to create a functional addition of intermediate floors, which also balanced the structure aesthetically.

Classical Column Order

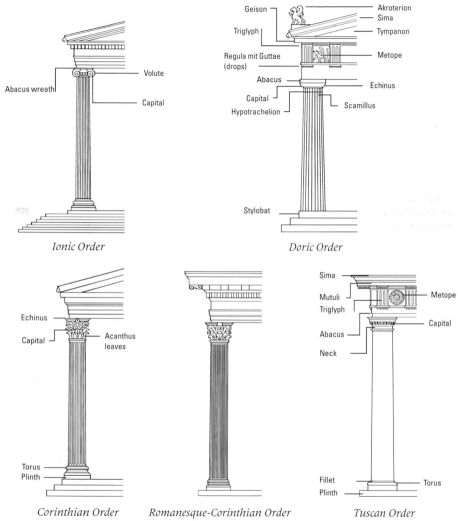

Ionic Order

Volute

Abacus wreath

Capital

Doric Order

Geison

Akroterion

Sima

Triglyph

Tympanon

Regula mit Guttae (drops)

Metope

Abacus

Echinus

Capital

Hypotrachelion

Scamillus

Stylobat

Corinthian Order

Echinus

Capital

Acanthus leaves

Torus

Plinth

Romanesque-Corinthian Order

Tuscan Order

Sima

Mutuli

Triglyph

Metope

Abacus

Capital

Neck

Fillet

Torus

Plinth

Order of Architecture: ancient/classical fixed system of architecture, where column, capital, architrave (the main beam bearing the weight of the superstructure), and cornice (horizontally projecting wall molding) are aligned with one another. Greek architecture has three varieties: the Doric, Ionic and Corinthian Orders. Roman architecture largely adopts them, but there are some variations, such as the Tuscan Order with Doric elements and the Composite Order with Ionic and Corinthian characteristics.

Pediment: top part of the wall of a building, closing the end of a pitched roof. Also an element crowning a door, window, or niche. Pediments can be triangular or segmental (with curved top) and can be broken or open, with a gap at the bottom or top respectively. They are characteristics of Classical, Renaissance, and Baroque architecture. The enclosed surface, the tympanum, is often elaborately decorated.

Point Block (Building): multi-story building, usually set on a square base that is accessible only via a single vertical core (stairs, elevators), in contradistinction to a straight-line block, set on a rectangular base and with several access cores.

Portico (Latin porticus "porch"): structure consisting of a roof supported by columns at regular intervals, typically attached as a porch to a building and often crowned with a gable or pediment.

Risalit (Italian risalto, "projection"): center part of a facade, highly popular in Baroque and 19th-century architecture, in which one element projects, to its full height, from the building line.

Rocaille (French "scree, grotto, shellwork"): asymmetrical wave- and shell-patterned decorations in the Rococo.

Rotunda (Latin rotundus, "round, rounded"): a small construction over a circular base; also a circular room inside a large complex.

Secession (Latin; secessio, "separation"): the separation of a group of artists from an already existing, traditional association or a demonstrative separation from the academic Salon system, e.g., the Munich Secession of 1892 under Franz von Stuck (1863–1928), the Vienna Secession of 1897 under Gustav Klimt (1862–1918) and the Berlin Secession, founded in 1898 by Max Liebermann, Walter Leistikow, and Max Slevogt.

String course: horizontal projecting band or molding on a wall or façade that delineates the horizontal zones.

Tympanum (Greek "drumskin, drum"): recessed area over a portal or the surface in a gable.

Veduta (Latin veduta, view, prospect): a highly detailed, strictly realistic, usually large-scale painting of landscapes or townscapes. These paintings contrast with vedute ideate, consisting of imagined landscapes or townscapes depicting imaginary buildings.

Vestibule (Latin vestibulum, "forecourt"): a porch in front of a building, in front of the entrance to a house in ancient Rome.

Vault (Lat., volvere, to turn): a curved ceiling, usually constructed of wedge-shaped stones. Unlike domes, vaults are also found over rectangular rooms. Abutments such as walls or columns absorb the pressure and thrust of the arch.

Zeilenbau, or Straight-Row System: equally tall, parallel, residential buildings, all oriented in the same direction; in the 1920s seen as the urban planning model of the future by Walter Gropius, Martin Wagner, and others.

Biographies

Behrens, Peter (4/14/1868 Hamburg – 2/27/1940 Berlin), was already successful as painter, graphic artist, designer, and – in 1892 – as founding member of the Munich Secession, before he started teaching at the Darmstadt artist colony in 1899 (–1903); it is there on Mathildenhöhe, the center of German art nouveau, that he built his first house in 1901. His architectural ideas had a seminal impact on early 20th century modernism. Behrens became *spiritus rector* for later masters such as Le Corbusier, Walter Gropius and Ludwig Mies van der Rohe, all of who periodically worked at his studio. In 1907, Emil Rathenau appointed him artistic consultant to the AEG ("Allgemeine Elek-tricitäts-Gesellschaft"/General Electricity Association) in Berlin. AEG's 1909 turbine hall became an architectural icon due to its radically new glass and steel construction. In 1929, he participated in a competition to remodel Alexanderplatz; his office buildings made of ferroconcrete, the gate-houses *Berolina* and *Alexander*, were completed in 1932; they are the last surviving witnesses to the original architecture.

Berggruen, Heinz (1/5/1914 Berlin – 2/23/2007 Paris), was one of the most important art collectors of the 20th century. The son of a stationary shopkeeper on Olivaer Platz in Berlin-Wilmersdorf immigrated to the United States in 1936. Here he successfully resumed his studies in literature and art history, which prepared him for his future calling as a journalist and art critic. All but ten years later, he was to quit this field of activity in favor of a career led by coincidence but also by his great enthusiasm as art dealer and collector.

After World War II, he made France his new home. Works by Paul Klee, the first of which he had already acquired in 1940 in Chicago, and works by his friend Pablo Picasso, whom he represented as art dealer, constituted, along with others by Cézanne and Matisse, the first building blocks of his private collection. His temporary return to his native city – where he set up home along with his collection in the Western Stülerbau, vis-à-vis Charlottenburg Palace – as well as his "gesture of reconciliation" – which, in the year 2000, made him sell his spectacular art objects to the Foundation of Prussian Cultural Heritage for a fraction of their true value – secured Berggruen the highest regard and presented Berlin with yet another cultural highlight.

Brandt, Willy (12/18/1913 Lübeck – 10/8/1992 Unkel), was called Herbert Ernst Karl Frahm at birth. A member of the SPD since 1930, he immigrated to Norway in 1933, where he took the name Willy Brandt and worked on exile issues for the "Sozialistische Arbeiterpartei" (SAP, Socialist Workers' Party). In 1945 he returned to Germany as a correspondent for Scandinavian newspapers. He was a member of the Bundestag from 1949 to 1957 and from 1965 until his death; and he was chancellor of the Federal Republic from 1969 to 1974. It was during his 1957–1966 term in office as youngest governing mayor of West Berlin that the Wall was built in August 1961. Brandt understood his principle task as federal chancellor to be the cautious rapprochement with the GDR and to engage in a politics of détente and adjustment with the countries of the Eastern Bloc. Brandt's genuflection before the Warsaw Ghetto Memorial in 1970 is inscribed in the annals of political history as a gesture of humility

Albert Einstein (1879–1955), photograph, undated

By making stage props strange through the alienation effect, Brecht's audience was to learn to detach from customary identification with dramatic heroes and to observe a critical distance. Brecht published his first drama, *Baal*, in 1920; in 1924, he and Carl Zuckmayer jointly worked as dramaturges at Max Reinhardt's German Theater in Berlin. Next to his dramas called "Lehrstücke," or pedagogical pieces – including *The Resistible Rise of Arturo Ui*, 1941, *Galileo Galilei* (1945) or *Mother Courage and her Children* (1941), which gave his wife, Helene Weigel, her lifelong casting role – it was primarily the *Threepenny Opera* that established the global reputation of its author Brecht and its composer Kurt Weill, following its world premiere in 1928 at the Berlin Theater am Schiffbauerdamm. After emigrating in 1933 to live in various places in Denmark, Finland and the United States, Brecht decided in 1949 to live and work in East Berlin, capital of the GDR. In 1954, he and his theater company, the Berliner Ensemble, moved to the Schiffbauerdamm. Brecht not only decisively shaped the theater of the young socialist republic; he also had a major influence on generations of dramatic authors to come.

towards the victims of German arbitrary rule. In 1971, he was awarded the Nobel Peace Prize for his politics of reconciliation.

Brecht, Bertolt (2/10/1898 Augsburg – 8/14/1956 Berlin), did not only revolutionize 20th century German-speaking stages with his epic theater.

Einstein, Albert (3/14/1879 Ulm – 4/18/1955 Princeton, N.J.), successfully jumpstarted a debate among physicists of his own and subsequent generations with his 1905 work entitled, *On the Electrodynamics of Moving Bodies*; it not only revolutionized the physical sciences but also, as it were, inaugurated the atomic age. This so-called "special," but also the "general" theory of relativity, as published in 1916, changed the natural sciences and existential categories of thought like almost no other theory before it. Findings to the effect that body mass increases with increased speed, that mass and energy are essentially identical or that space and time fuse to form a "four-dimensional continuum," prepared the way for nuclear weapons as much as space travel. Einstein, who was awarded the 1921 Nobel Prize for physics, recognized both the risks and the blessings of modern sciences for humankind. During his entire lifetime, he cautioned people to respect reason, peace and humanity. After spending his youth in Munich and then working for the Patent Office in Bern, Einstein was invited by Max Planck in 1914 to be a full-time member of the Prussian Academy of Sciences in Berlin. That same year, he was also appointed director of Berlin's Kaiser Wilhelm Institute for Physics. In 1933, Einstein, a Zionist, immigrated to the United States, where he was active at the Institute for Advanced Studies in Princeton until his death. Numerous places and institutions in the greater area of Berlin are named after Einstein. The Einstein House in Caputh near Potsdam, which he used as a summer house and refuge for work from 1929–1932, is open to visitors.

Gropius, Martin (8/11/1824 Berlin – 12/13/1880 Berlin), studied at the Bauakademie Berlin from 1849 to 1855 and counted Karl Friedrich Schinkel and Karl Bötticher among his role models. Apart from working privately as a building contractor, Gropius taught at the Bauakademie from 1856 onward. In 1866, he and Heino Schmieden co-founded the partnership firm "Gropius & Schmieden," which existed until Gropius' death; its contracts included numerous public buildings such as hospitals or concert halls. The Martin Gropius Building, an important Berlin exhibition hall, is based on designs by Gropius and Schmieden and was built posthumously in 1881 as a museum of arts and crafts. As director of the Royal Art School Berlin, Senate member of the Academy of Arts and senior manager of the Prussian art schools, Gropius exerted a major influence on the reform of art education in the Kingdom of Prussia. He also designed furniture, wallpaper and textile patterns. His great-nephew, Walter Gropius, likewise became an architect and founded the Bauhaus in Weimar in 1919.

Hobrecht, James (12/31/1825 Memel/East Prussia – 9/8/1902 Berlin), lived through an eventful period of apprenticeship and training which was disrupted several times by military service, such as during the March Revolution in 1848. A surveyor by trade, he worked for a railroad company before successfully taking his foreman's exam at Berlin's Bauakademie in 1849; in 1858, after studying agricultural and building engineering, he took his "Water, Roadways and Railroad Master Builder's Exam." As Government Master Builder for the Royal (Building) Police, he traveled to Hamburg, Paris and London in 1860 to conduct inspections of the local sewer systems. Using the urban planning insights he collected during his travels, he created a state-of-the-arts net-

work of building lines consisting of circular and arterial roads for Berlin, Charlottenburg and other adjacent communities. The Hobrecht Plan, effective as of 1862, constitutes, up to the present day, the basis for Berlin's entire building and traffic configuration. Collaborating with his brother, Berlin's Senior Mayor Arthur Johnson Hobrecht, and physician Rudolf Virchow, Hobrecht developed a sewer system consisting of canals and sewage fields which was installed in 1873–1893; it was the most modern and cleanest in the world for its time. As city building councilor, Hobrecht was also in charge of street and bridge construction. Berlin's inner-city shipping traffic owes its existence to his shoreline stabilization measures.

Knobelsdorff, Hans Georg Wenzeslaus, Baron of (2/17/1699 near Crossen/Oder – 9/16/1753 Berlin), began his career – faithful to old family tradition – by joining the Prussian Army. After his discharge for medical reasons, he took lessons from court painter Antoine Pesne to become a painter. By way of drawing buildings, he was led toward architecture and, as he had done before with painting, he was self-taught. As "cavalier architect," he brought to the Rheinsberg court, home of Crown Prince Frederick, all manner of technical information and sophistication which he picked up during his travels in Italy, France and Flanders; this initially promoted a close congenial collaboration between the two men. Their affection suffered a marked decline in the coming decades, when the son of the Soldier King, now called Frederick the Great, went to war himself and no longer believed he could rely on his court architect. Knobelsdorff conferred on Frederickian representational and pleasure architecture its classically simple iconography, which took its cues from the English Palladianism of Inigo Jones or William Kent, and which later on culminated in Schinkel's neoclassicism. His interior designs, however, were closer to Rococo and late Baroque decorative arts. Among his outstanding works are buildings on the Berlin Forum Fridericianum, such as the Opera House (1740–1742), Monbijou Palace (1738–1742, destroyed), the New Wing ("Knobelsdorff Wing") of Charlottenburg Palace (1740), and Sanssouci Palace (1745–1747), as well as other structures located in Potsdam.

Langhans, Carl Gotthard (12/15/1732 Landshut/Silesia – 10/1/1808 Grüneiche near Breslau), was an academically trained mathematician and jurist, who came to architecture, his later field of activity, by way of self-teaching. In this, he was influenced by the writings of the Roman architect Vitruvius and his *Ten Books on Architecture*, as well as by his contemporary, Johann Joachim Winckelmann, who had helped stoke 18th century enthusiasm for classical architecture with his art-historical observations. When his talent for architectural engineering was first recognized, Langhans' obligatory studies in Italy were financed by his first client, Prince von Hatzfeld. Later, journeys to England, Holland and France were added – all financed by the king's privy purse. In 1775, Langhans came to be Senior Building Councilor in Breslau and was appointed manager of the local War and Territorial Chamber. Frederick the Great's nephew and successor, Frederick William II, called him to Berlin to head the Upper Building Administration in 1788. On the threshold between high baroque and neoclassicism, Langhans unabashedly took

Erich Mendelsohn (1887–1953),
photograph, undated

whatever styles he wanted from the iconographic repertoire of his time, without developing a signature of his own: While the Belvedere in Charlottenburg Palace Gardens (1788–1790) still faintly echoed the Baroque and Brandenburg Gate (1791) quoted the Propylaea on the Acropolis, his German National Theater at Gendarmenmarkt (1800–1802, was replaced by Schinkel's structure after a fire) was beholden to neoclassicism. Brandenburg Gate only developed into a symbol of German nationalism after Langhans' death and during the German liberation wars against Napoleonic oppression.

Mendelsohn, Erich (3/21/1887 Allenstein/East Prussia – 9/15/1953 San Francisco), studied architecture at the Technical Universities of Berlin and Munich. After serving for three years in World War I, he opened an architecture office in Berlin and was active as a member of the artists' association "November Group" and in the "Workers' Council for Art". His building for the Astrophysical Institute in Potsdam, the so-called *Einsteinturm* (1920), is considered a prominent example of Expressionism in architecture to the present day. Together with Ludwig Mies van der Rohe and Walter Gropius, he created the Berlin association of progressive architects called "The Ring" in 1924. Until the seizure of power by the National Socialists, Mendelsohn was able to realize several apartment complexes, retail stores and office buildings; in their organic iconography, these buildings prefigured elements of the American "streamline" and greatly influenced Berlin's urban appearance, such as the domestic and movie theater complex *Universum* at Kurfürstendamm (1927/28, today's *Schaubühne*). He immigrated to Palestine via the Netherlands and England; there he designed hospitals and university buildings in his own Jerusalem office starting in 1934. Living in exile in the United States as of 1941, Mendelsohn was initially active as advisor and lecturer, but in 1947, he resumed his former practice as architect by taking on large building projects and synagogues.

Persius, Friedrich Ludwig (2/15/1803 Potsdam – 7/12/1845 Potsdam), took his surveyor's exam at the Berlin Bauakademie in 1821 and started working as building conductor in Potsdam that same year. He became a member of the Architects' Association in 1824; and, in 1826, he passed his building master exam, again at the Bauakademie. Having served as Royal Court Building Inspector since 1834, he was appointed court architect in 1841 by Frederick William I. Early on in his career, in 1821, on Count Potocki's estate in Cracow, he began working with Schinkel, whom he perceived as a master. He completed his building

master's studies by traveling from 1840–1845 throughout Germany, to Paris and to Italy, before his early death cut short his creativity. Next to Stüler, Persius was Schinkel's most important student; he adopted the latter's late neoclassicist notions and, by mixing them with elements from the Italian Renaissance, used them in several buildings constructed primarily in Potsdam and its vicinity. Persius served the project of ingeniously embedding architectural structures into the landscapes shaped by Lenné and thereby contributed immensely to the glory of Prussia's Arcadia – that unique merger of nature enhanced by design and architectural impressions. Among his major works are the Church of the Redeemer, 1844, the Church of Peace – completed by Stüler based on Persius' designs – as well as buildings located on the grounds of Klein-Glienicke Palace and Sanssouci.

Poelzig, Hans (4/30/1869 Berlin – 6/14/1936 Berlin), studied structural engineering at Technical University in Berlin-Charlottenburg. He was called to teach stylistics at the Royal Arts and Crafts School in Breslau, becoming its director in 1903. Still wholly in thrall to the spirit of Expressionism, the school under Poelzig developed into one of the most progressive institutions of its kind. As chairman of the Deutscher Werkbund, founded in 1907 by Hermann Muthesius, he was likewise influential in successfully reshaping this economic and cultural "association of artists, architects, entrepreneurs, and experts" from 1919 onward. Back in Berlin, he started serving as director of a master studio for architecture at the Prussian Academy of Arts in 1920; he received a professorship at his *alma mater* in Charlottenburg in 1923, became a member of the executive board of the Federation of German Architects in 1926, and was director of the Unified State Schools for Fine and Applied Arts in Berlin for three months in 1933, before the National Socialists fired him in April. In spite of some expressionist echoes in his decorative use of red clinker bricks or colored tiles, Poelzig belonged to the avant-garde of New Objectivist architects with such projects as his remodeling of Reinhardt's Großes Schauspielhaus (1918/19) and the Haus des Rundfunks (1929) in Berlin, or his design for the administrative building for IG Farben in Frankfurt/Main (1928–31).

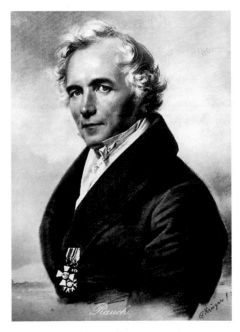

Christian Daniel Rauch (1777–1857), drawing by Franz Krüger, 1835

Rauch, Christian Daniel (1/2/1777 Arolsen – 12/3/1857 Dresden), was the son of a valet serving the Prince of Waldeck. In spite of poverty, his father tried to give him a good education. At age 13, Rauch started training as a sculptor, but his apprenticeship and ambitions were put on hold for a while due to deaths in his family, since he now had to provide for them by taking the place of his brother as valet to Frederick William II. During the same period, he also studied art history and archaeology at the Berlin Academy of Arts. Court sculptor Schadow discovered his talents, while Rauch served Louise of Prussia as her traveling companion, and in 1803, he accepted him as his student. 1804–10, Frederick William III granted him leave for a long-term study abroad in Italy; in Rome, he joined the German colony of exiles gathered around Wilhelm von Humboldt, who later on became his sponsor. His first important commissioned work was the sepulcher for Queen Louise, who had died young and was much adored; it established his artistic reputation because of the way he had sculpted the marble – with much naturalness and grace. 1815, the monument was installed in her mausoleum on the palace grounds in Charlottenburg. His other major works include the statues of Bülow, Scharnhorst and Blücher, positioned in front of Schinkel's Neue Wache (1819), as well as the equestrian statue of Frederick II on Unter den Linden Boulevard (1851). The dawn of nationalist feeling informing the neoclassicism of his master, Schadow, congealed to bourgeois idealism in Rauch's works – which was in keeping with the climate of political restoration that shaped his era.

Schadow, Johann Gottfried (5/20/1764 Berlin – 1/27/1850 Berlin), already took drawing lessons while still a child, before he decided in 1778 to be a sculptor; he became a student of Jean Pierre Antoine Tassaert's and enrolled in further studies at the Academy of Arts in Berlin. After an exhibition as modeler in the Royal China Factory, he was put in charge of the Court Sculptor Workshop in 1788, succeeding Tassaert. Commissions by way of the Royal Building Authority led to his collaboration with Carl Gotthard Langhans, its director. Langhans' Brandenburg Gate with the Quadriga, a figural group made by Schadow (1793), has remained their most widely admired and famous collaboration. However, Schadow acquired his reputation as founder of the Berlin School of Sculpture and as teacher of such renowned students as Christian Daniel Rauch or Friedrich Tieck through his tombs and monuments, his full-body statues and busts, the most famous of which include the tomb of Prince Alexander von der Mark (1790) and the twin statues of Princesses Louise and Friederike of Prussia (1797). From 1815 up to the end of his life, he was director of the Academy of Arts in Berlin. An eye disease hampered his creative ability in his old age; his creative genius, however, was not content to express itself solely through sculpture, but also in caricatures and drawings. In 1803, Schadow was one of the founding members of the first German chess club.

Scharoun, Hans (9/20/1893 Bremen – 11/25/1972 Berlin), studied architecture at the Technical University in Berlin-Charlottenburg in 1914 and volunteered for military service during World War I. In 1919, he joined the expressionist architecture association called "Gläserne Kette" (Glass Chain); that same year, he took over the architecture firm of his mentor, Paul Kruchen, in

Breslau, where he was a professor at the Academy for Arts and Crafts from 1925 up to its closure in 1932. He became a member of the architects' group "The Ring" in 1926. Along with the 1920's avant-garde of architecture (e. g., Ludwig Mies van der Rohe, Walter Gropius and Le Corbusier), he constructed the Modernist "Model Settlement" in Stuttgart Weißenhof in 1927. His development plan for the large subdivision Siemens-stadt called for functional structures that respected human dignity; in doing so, it provided a program for govern-ment subsidized housing of the future beyond all boilerplate constraints. During the Third Reich, he was forced to design externally "assimilated" struc-tures, primarily built private homes and already planned for peace. As Municipal Building Councilor and director of the Department of Building and Municipal Housing, as well as a full professor of architecture and city planning at the Techni-cal University (as of 1946), Scharoun made outstanding contributions to the reconstruc-tion of the West sectors of war-ravaged Berlin. Apart from commissions in other West German cities, Scharoun only constructed one single building outside the coun-try: the German Embassy in Brasilia (1963–69). The Philharmonic Concert Hall (1957–63) is

Andreas Schlüter (1659–1714), wood engraving, c. 1879, after Ferdinand Weiss, hand-colored at a later date

considered his *magnum opus*; the State Library (West) of the Foundation of Prussian Cultural Heritage (1964–78) was completed only after his death. His organic iconography – that always treats a building's function as authoritative – made Scharoun one of the trailblazing architects of the 20th century.

Schlüter, Andreas (7/13/1659 Gdansk – 5/19/1714 Saint Petersburg), son of sculptor Wilhelm Schlüter, received his schooling in his native city by Sapovius, another sculptor. His first contracts, such as the pediment reliefs for Krasinski Palace, led him to the royal seat of Warsaw, until he was called, in 1694, to the court of Elector Frederick III (who became Frederick I and King of all Prussians in 1701). All but a year later, the king sent his court sculptor on tour in France, the Netherlands and, in 1696, to Italy, to purchase casts of famous sculptures. The works of Michelangelo and Gian Lorenzo Bernini were among those exerting the greatest influence on Schlüter, who was also in charge of work performed at the palaces of Bornim, Caputh, Glienicke, and Fahrland. In the waning 17th century, he was entrusted with important projects for the residence of the future Prussian rulers: the statuary of the Armory (starting in 1696) and the remodeling of the City Palace (starting in 1699), which he turned into a prominent secular building in the classical Baroque style. The capstone reliefs of dying soldiers in the Armory courtyard that seem to indict war – while the (surviving) reliefs on the external façade serve its glorification – were among the most expressive sculptural works of their time. Additionally he designed the famous Amber Room. After a Coin Tower he designed failed during construction and the City Palace suffered visible damage, Schlüter fell from grace and was dismissed in 1713 by the Soldier King, Frederick William I. In the last year of his life, spent as architect, sculptor and teacher at the Czarist Court in Saint Petersburg, Schlüter again bequeathed his stylistic signature to a royal European city, as he had done previously in Berlin.

Siemens, Werner von (12/13/1816 Lenthe near Hannover – 12/6/1892 Berlin), had already successfully designed numerous inventions while he was still a young artillery lieutenant versed in all the natural sciences. As such, he developed galvanizing technology, invented a new regulator for steam engines, a new printing method, and around 1847, the seamless cable covering made from gutta-percha, a precursor of insulated electric cables. His electrical pointer telegraph with auto-disruptive device convinced master mechanic Johann Georg Halske to jointly found a firm. "Siemens & Halske," the experimenter and the constructor, complemented each other so well in furthering their "Telegraphenbau-Anstalt," that – in the wake of the industrial age's great demand for electro-technical innovation – it grew into one of the world's leading enterprises (and it still is so today). Their firm established itself with a feat of progressive engineering, when they laid underground telegraph lines all along the Berlin-Anhalt railroad track. In 1866, its reputation was further enhanced by Siemens' invention of the dynamo-electric machine, which transferred electricity across vast distances. Siemens built the first electrical locomotive in 1879, sponsored construction of Berlin's elevated railway, provided electrical street lighting to the mperial capital, and made essential contri-

butions to ensure that Berlin developed into one of the most important locations for industries. His active interest in social causes was legendary. As such he presented his staff members with bonuses and retirement funds on the occasion of successful productions, and, in 1873, he introduced the nine-hour workday.

Simon, James (9/17/1851 Berlin – 5/23/1932 Berlin), was the offspring of a well-to-do textile and cotton merchant. In 1890, he took over the enterprise of his father and uncle and continued to manage it successfully; he was considered one of the wealthiest merchants under William II. To heed the call of the muses, as Simon had wanted to from the start, was possible now that he was engaged in all manner of cultural and social activities. Highly respected in social circles, he belonged to a small circle of Berlin Jews – derogatorily called "Emperors' Jews") – whose economic and political councils were often attended by Albert Ballin, manager of HAPAG, and Walther Rathenau of the AEG, among others. Having become an avid collector of exquisite art objects, Simon shared the emperor's enthusiasm for antiquity and spent a fortune on the Emperor William Society for the Advancement of Sciences. Joined by the director of the Berlin Museums, Wilhelm von Bode, he also directed and financially sponsored the German Oriental Society. A major discovery during an archaeological dig in Egypt in 1911 was the almost entirely intact bust of Nefertiti, which was now conferred into Simon's hands, since he had funded the enterprise. As one of the most generous patrons of the Wilhelminian Period and the Weimar Republic, however, Simon presented his magnificent collections, some of which he had compiled under the scientific direction of Bode, to the Berlin Museums as a gift. The lion share of his donations, which amounted to almost a third of his yearly income, Simon tacitly used for social causes, since for him, wealth was always also an obligation.

Stüler, Friedrich August (1/28/1800 Mühlhausen/ Thuringia – 3/18/1865 Berlin), was enrolled at the Berlin Bauakademie. As early as 1820, he was hired as construction manager in Naumburg and Schulpforta. He and his friend Eduard Knoblauch co-founded the Berlin Architects' Association in 1824. Again joined by Knoblauch, he completed his study tours in France and Italy in 1829/30, since these were obligatory for all architects and artists. During the same period, he worked at the Berlin Court Building Administration under Schinkel, whose succession in all engineering and aesthetic questions he shared with Persius, the other great Schinkel student, during the reign of Frederick William IV. In 1842, Stüler was appointed "Architect to the King"; in 1850, he was made Ministerial Advisor in the Ministry of Commerce, Industry and Public Works. Parallel to his classical career as a court architect, Stüler also created a rich, architectural oeuvre which was not limited to the Berlin area, but also encompassed the Old Stock Exchange in Frankfurt/Main, the Nikolai Church in Potsdam, the Luther-House in Wittenberg, Königsberg University, and the National Museum of Stockholm, among others. Two projects, however, were of outstanding significance to the King, who himself was a passionate observer of building projects and who personally supplied preliminary drawings for numerous buildings: the reconstruction of Hohenzollern Castle near

Hechingen (starting in 1850) – the ancestral castle of the Prussian Kings – and the New Museum (1843–55) on Berlin's Museum Island. The Old National Gallery on the same site was built by Johann Heinrich Strack based on Stüler's designs. Here, Stüler proved himself to be a master straddling stylistic epochs, able to interweave elements of neoclassicism with budding Wilhelminian historism.

Zille, Heinrich (1/10/1858 Radeburg near Dresden – 8/9/1929 Berlin), whose family had fled from creditors to Berlin in 1867, endured a childhood full of deprivations. It was in his parental basement flat at Schlesischer Bahnhof that Zille first encountered the "Milljöh," the Berlin proletariat,

Heinrich Zille (1858–1929), photograph, c. 1918

which was to supply him with the prototypes for his future graphic work. In 1872, Zille started out by taking classes in lithography, which he completed as a night school student at the Royal Academy, where he studied under Theodor Hosemann, a painter and caricaturist. From ladies' fashion to household implements to advertising and kitsch motifs – he painted anything to make money. He improved his technical dexterity in graphics and printing by working for a lithography shop. Around 1900, his first drawings were exhibited by the Berlin Secession. From 1877–1907, he was employed with the Berlin Photographical Society; when he was unceremoniously fired after 30 years of service, he lost his livelihood; but this loss also signified for him, now fifty years old, the dawn of the successful second half of his life as an enormously popular, independent artist. From 1903 on, he was a member of the Secession, and as a protégé of Max Liebermann, he had countless numbers of his drawings published in many magazines such as Munich's satirical "Simplicissimus," or "Die lustigen Blätter"; these drawings were full of life, containing often accusatory, but mostly good-humored studies of his milieu. He himself provided their captions, the famous "Zille bon-mots." With portfolios, artist's prints and picture-books, he cemented his reputation as an outstanding German draughtsman whose affection was reserved for people equipped with the "Berliner Schnauze" – the ability to speak sassy Berlin slang. The subject of many honorific tributes, he was appointed professor and member of the Academy of Arts in 1924. His photographic legacy, which proves him a significant documentarist and comprises about 500 motifs, was not rediscovered until the 1960s.

Brief Graphic Genealogy of Building in Berlin

by Jeannine Fiedler

To contemplate historical, architectural typologies in Berlin always also means to look at breaks in contemporary history and the development of urbanity informing this city and its history so rich in vicissitudes. In the wake of its belated becoming capital in 1701, the year of the coronation of the first Prussian King, Frederick I, and, eight years later, the merging of the cities Berlin, Cölln, Friedrichswerder, Dorotheenstadt, and Friedrichstadt, to form the capital and royal residence city of Berlin, this at first rather modest provincial metropolis sustained a rapid period of growth; architecturally and historically seen, this growth occurs during the late baroque and early neoclassicist periods as well as during a phase of political reorganization in Central Europe. Striving for influence and territorial expansion, the Kingdom of Prussia externally consolidated its share in the precarious balance of powers; internally, the bourgeoisie, becoming gradually more established, kept gaining in importance thanks to the Enlightenment and the rights allotted to it via the system of social castes. While the high nobility still had freestanding city mansions built for themselves, the middle classes lived in early versions of what later came to be so characteristic of Berlin: row houses or perimeter block development. Seldom taller than four stories, the narrow façades of bourgeois homes, equipped with four to eight windows, presented themselves as austerely

articulated and only modestly decorated: Baroque exuberance and Rococo mannerism were rather alien to Prussian ideology and its Protestant work ethic. So-called "Immediathäuser," houses for state servants subject to royal command, already showcased Berlin sobriety with respect to urban architecture. These residential buildings, constructed by order of Frederick the Great to develop Linden Boulevard, and other places, had eaves with a height of 18 m; in the 19th century, it was changed to 22 m – a fixed height which is mandatory for Berlin to the present day. Neoclassicism, driven toward perfection by the genius of Schinkel and his students, Persius and Stüler, determined the first half of the 19th century; it is the only architectural style indigenous to the Prussian Kingdom. Its successor, Historism, whose stylistic repertoire of Gothic, Renaissance and Baroque forms primarily shaped the façades of public buildings such as courts, administrative offices and railway stations, had little impact on residential and apartment buildings – until the beginning of the Wilhelminian *Gründerzeit* period in 1871; at this time, an architectural model essential for Berlin was created, since it promised to alleviate the pressing housing crisis of this mega-city juggernaut, now a metropolis counting one million inhabitants: the *Mietskaserne*, tenement buildings behind which were often stacked a labyrinthine multitude of courtyards

that could even connect residential streets. Depending on one's neighborhood, or *Kiez*, and the building owner's standards, they could look very different – unadorned and dismal in working-class quarters; or, in tune with bourgeois tastes, decorated with opulent façades full of caryatides, faux-antique friezes and columns. The *Neues Bauen* (New Building) avant-garde of the 1920s took firm leave of all Wilhelminian pomp. The then newly inaugurated *Sachlichkeit*, a sober, objectivist style featuring bare façades, reserved characteristics and markedly lower floor height, is still practiced today, a few postmodern aberrations notwithstanding. What has categorically changed are building materials and new utilitarian designs for external shells, which have to comply with new ecological standards on energy conservation. Since the fall of the Wall and the retrieval of its status as capital, the "new Berlin" wants to recover its "typical" Prussian-Neoclassicist aspect in a lot of places; however, this is not always possible given that its building volume has expanded exponentially. Whether with respect to residential or functional buildings, after Berlin's destruction during World War II and its partition lasting about 30 years, any aesthetic-architectural uniformity is out of the question. And yet, Berlin thrives on its dynamic new beginnings. Its resultant architectural variety makes the city a fascinating urban organism.

The following drawings by Lidiarte Berlin seek to offer a survey of the stylistic epochs spanning three centuries, as described above.

Ribbeckhaus, Breite Straße 35 (Alt-Cölln): oldest surviving residential building of the city; built in 1624 by Privy Councilor Hans Georg von Ribbeck; acquired in 1628 by Duchess Anna Sophia von Braunschweig-Lüneburg, who added a third floor; since 1659 used first by the Royal Stables, and later by the Royal Upper Treasury Chamber; gabled façade and portal still under the influence of the late Renaissance; many times remodeled up to the present day; used by the city library

Galgenhaus, Brüderstraße 10 (Alt-Cölln): one of a handful of surviving civic buildings; built in 1688 for Chamber Councilor von der Happe; from 1737 on, the house served as provost's residence for the Petrikirche; remodeling with addition of neoclassicist façade in 1805; some rooms still furnished with the original baroque décor

*Palais Wartenberg (Old Post Office),
Burgstraße/ Königstraße (Alt-Cölln): prior
to its destruction, located on the Spree across
from the Royal Palace; designed by Andreas
Schlüter and built in 1701–1704 in the
Baroque style; Frederick I bestowed the
magnificent building on his General Post-
master and Prime Minister Kolbe von
Wartenberg; today, one stucco ceiling of the
palace adorns the main section of the restau-
rant in the Museum for Communication*

*Palais Podewils, Klosterstraße 68–70
(Alt-Berlin): one of the oldest surviving baroque
structures; built by Jean de Bodt in 1701–1704
as private residence for Chamber Secretary Caspar
Rademacher; acquired in 1732 by Heinrich
Count Podewils after whom it is named; the
central window axis is accentuated by twin
pilasters and a balcony, it is crowned by a
tympanon; frequently remodeled and expanded,
the building today serves as a cultural center for
musical, theatrical and literary events*

*Palais Krosigk, Wallstraße (Neu-Cölln
am Wasser): not preserved; presumably
designed by engineer and architect Heinrich
Schmutze in 1705 as a three-story baroque
mansion for the aristocracy; its façade and
balustrade lining the flat roof were richly
decorated with figures*

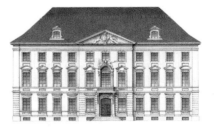

*Palais Kreutz, Klosterstraße (Alt-Berlin):
not preserved; built in 1714–1716 by Baroque
building master M. H. Böhme; elegant
aristocratic mansion with striking center
risalit, richly decorated portal and tympanon*

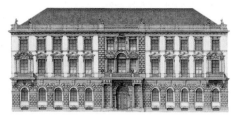

Residential House at Gendarmenmarkt (Mitte): not preserved; built in 1780 by Frederick II's Architect of the Imperial Court, Carl von Gontard, in the style of Frederickian Rococo; furnished with stately apartments; later housed the head office of the Prussian Lottery

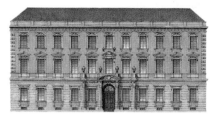

Residential House, Charlottenstraße (Mitte): not preserved; built around 1780 by Frederick II's Architect of the Imperial Court, Carl von Gontard, in the style of Frederickian Rococo; furnished with stately apartments

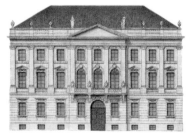

Residential House, Schützenstraße (Mitte): not preserved; built around 1785 by Frederick II's Architect of the Imperial Court, Carl von Gontard, in the style of English Palladianism

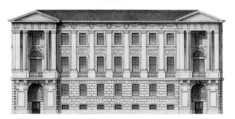

Residential House, Behrenstraße (Mitte): not preserved; built in 1792–1794 in the Neoclassicist style; one of numerous middle-class residential homes designed by Georg Christian Unger that – at the request of Frederick the Great – were to look like noble mansions

Ermelerhaus, Märkisches Ufer 10 (orig. Breite Straße 11): one of a few surviving Patrician dwellings; probably remodeled as a Rococo mansion in 1760–1763 by Friedrich Wilhelm Diterichs; original interior décor has been preserved; Wilhelm Ermeler acquired the house in 1824 after its façade had been reconfigured in the Neoclassicist style; his salon turned it into one of the intellectual venues of Berlins

Palais Solms-Baruth, Behrenstraße (Mitte): not preserved; Karl Friedrich Schinkel's master instructor Friedrich Gilly built this austere, two-story urban mansion with garland frieze under the roof cornices for the Counts of Solms-Baruth in 1798–1800

Palais Redern, Unter den Linden 1 (Mitte): not preserved; urban mansion owned by Friedrich Wilhelm von Redern, General Manager of the Royal Stages in Berlin; Karl Friedrich Schinkel remodeled it for him in 1829–1833 in his signature style of Prussian Neoclassicism; today, the Hotel Adlon is located on its site

Knoblauchhaus, Poststraße 23 (Mitte): solely surviving structure of the historical buildings covering the Nikolaiviertel in the 18th and 19th centuries; built in 1759–1761, remodeled in 1835, it housed the silk factory "Seiden Band Fabrik Carl Knobloch" and was residence to the Knoblauch family; as a branch of the Märkisches Museum, it serves today as an example showcasing bourgeois domestic culture during Berlin's Biedermeier period

Leipziger Straße	55, 73, **70–71**, 107, 271
Ludwig Erhard House	61–62, **279**
Luftbrückendenkmal/Airlift Munument	259, **328**
Lustgarten	67, 69, 87, 90, 161, 303–304, 379
Lutherbrücke	110
Marienkirche	39, **298–299**, 333
Märkisches Museum/Foundation	
Stadtmuseum Berlin	96, 98, 114, **206–207**, 208,
	345, 383
Märkisches Ufer	99, **346**, 471
Martin Gropius Bau	**214–215**, 458
Maxim Gorki Theater	**226**
Mehringdamm	341, 369, 371
Mehringplatz	20, 23, 40
Moabit Prison	**279**
Moltke Bridge	93, 111
Municipal Cemetery Stubenrauchstraße	**340**
Museum Berggruen	114, 184, **192–193**
Museum Center Dahlem	**178–182**
Museum Island	33, 83, 114, **115–151**,
	378–379
Museum of Communication	**210–211**
Museum of Decorative Arts	160, 214, 384
Museum of Natural History	114, 198, **200–203**
Museum of Prints and Drawings	136, 160, **167**
Musical Instruments Museum	160, **168**
Neue Nationalgalerie	160, **174–177**
Neue Wache/New Guard House	27, 67, 69, 81, 83,
	87, 89, 226, 318, 319
Neues Museum	27, 115, **136**
Neues Palais	26
New Synagogue	281, 314–315
Nikolaikirche	97, 206, 298, **300**

Oberbaumbrücke	**92**
Old Palace	48, 83
Old Postal Service Building	**269**, 280–281
Olympic Games 1936	32, 243, **290–291**
Olympic Stadium	43, 79, 184, 286, **289**, 292–293,
	361
Palace Bridge	21, 27, 67, 83, **87**, 89
Palace of the Republic	33, 69, 253, 378
Palais of Prinz Heinrich	21, 26, 48, 67, 152
Palais Podewils	97, 206, 469
Palais Schwerin	97
Pariser Platz	20, 23, 32, **40–41**, 69, 81, 278, 350
Parochialkirche	26, 69, 97, **302**, 336
Pergamon Museum	115, 121, **122–131**, 133, 136,
	143, 255
Pfaueninsel	386, 389, **393–394**, 398, 401, 404, 446
Philharmonie	160, 168, **170–171**, 172, 464
Potsdamer Platz	30, 31, 33, **44**, 51, 76, 111, 114, 151,
	160, 170, 240, 247, 260, 278, 321, 440
Prinzessinnenpalais	83
Rathausbrücke	98, 376
Red City Hall	28, 39, 97–98, **106**, 397
Reichstag	27, 29, 31–33, 72, 77, 81, 92, 102,
	103, 104–105, 109–111, 229, 240, 329
Ribbeckhaus	98, **344–345**, 468
Riehmers Hofgarten	368, 370, 472
Romanisches Café	75, **306–307**
Schauspielhaus (Concert Hall)	
at Gendarmenmarkt	23, 27, 47, 83, 89, **220–221**
Schöneberg City Hall	**106**, 298, 326
Shell House	**270**
Siegessäule/Victory Column	27, 77, 79

Siemensstadt	264, **275**, **357**, 463
Sophienkirche	**302**
Soviet War Memorials	329
Spandau Citadel	**392**
Spittelmarkt	**55**, 71, 97, 99
St Hedwig's Cathedral	21, 26, 48, 67, 69, 83, 152, 443
Staatsoper Unter den Linden	21, 26, 30, 48, 67, 69, 83, 152, **222**, 229
State Library Potsdamer Straße	160, **172**
State Library Unter den Linden	69, **158–159**, 172
Straße des 17. Juni	62, 77, **79**
Tauentzien	59, 66, 73, **74–75**
Technical University	54, 79
Tegel airport	**256–257**
Tegel Palace	90, 154, **381**
Television Tower	77, 110, **244**, 333, 359
Tempelhof airport	**256–257**, 259, 290, 328
Theater am Kurfürstendamm	75
Theater des Westens	62–63, 218–219, 230
Tiergarten	61–62, 77, 79, 81, 87, 102, 110–111, 160, 170, 184, 251, 276, 278, 344, 362
Tower Buildings at Frankfurter Tor	359, 360
Unter den Linden	18, 21, 30, 32, 43, 48, **66–69**, 71, 76, 81–83, 87, 89, 114, 148, 152, 158–160, 172, 222, 225–226, 246, 319, 378, 467
Wannsee	114, **286**, 328, 344, 351–352, 400–401
Weidendamm Bridge	**93**, 225, 230
Weißensee Jewish Cemetery	**339**
Wilhelmstraße	21, 41, 102, 107, 240, 245
Zoological Garden	30, 56, 62, 141, **276–277**

Potsdam

Babelsberg Palace	**396–397**, 398, 400–401, 404
Belvedere on Mount Klausberg	**410**
Cecilienhof Palace	**437**, 446
Charlottenhof Palace	387, **424–425**, 426, 447
Chinese Tea House	**408–409**
Communs	**422**
French Church	**443**
Marble Palace	95, 393, **432**, 445–446
Marstall/Royal Stables	**440**
Mount of Ruins	**423**, 441
Neues Palais	**414–416**, 419, 422, 444, 447
Nikolaikirche	439, **443**, 447, 465
Old Market	**439**
Orangery	376, **411–412**, 427, 432
Picture Gallery	**413**
Pomona Temple	88, **434**, 446
Potsdam	14, 18, 22, 26, 30–31, 95, 232, 274, 388–389, 391, 393, 396, 400–401, **402–447**
Pump House	423, **441**
Roman Baths	**426–427**, 444, 447
Russian Colony Alexandrowka	389, **434–435**, 447
Sanssouci Palace	22, 26, 95, 387, 389, **404–407**, 408, 410–411, 413–416, 419, 423–424, 426–427, 432, 441, 444, 446–447
Potsdam City Gates	**438**

Illustration Credits